Endang Sri Hardiati & Pieter ter Keurs
Editors

Indonesia

The Discovery of the Past

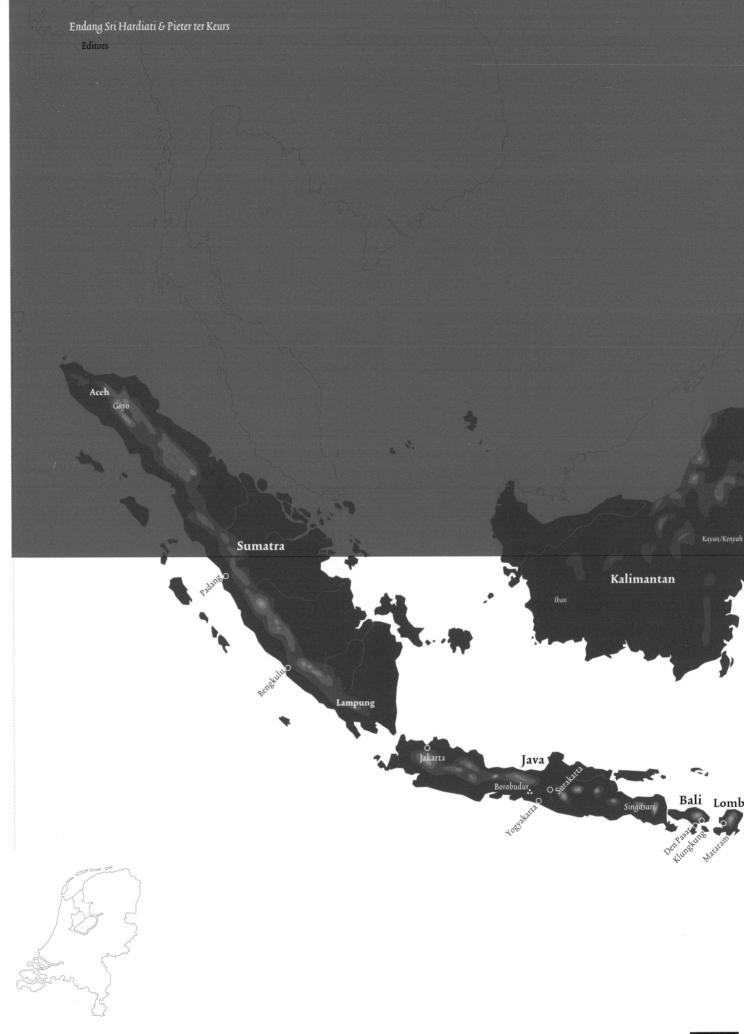

Endang Sri Hardiati & Pieter ter Keurs

Editors

Aceh
Gayo

Sumatra

Padang

Bengkulu

Lampung

Jakarta

Java

Borobudur
Surakarta
Yogyakarta
Singasari
Bali
Lombo
Den Pasar
Klungkung
Mataram

Kayan/Kenyah

Kalimantan

Iban

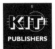

KIT
PUBLISHERS

Indonesia

Sulawesi

Moluccan Islands

Bone

Gowa

Ambon

Papua

Kai Islands

Asmat

Flores

Leti Islands

Lesser Sunda Islands

Timor

Marind Anim

This catalogue has been published on the occasion of the exhibition, *Indonesia: the Discovery of the Past*, held at the National Museum in Jakarta (15th August 2005 - 13th November 2005) and in The Nieuwe Kerk (The New Church) in Amsterdam from 15th December 2005 to 17th April 2006. It has been organised by the National Museum of Ethnology in Leiden, the National Museum in Jakarta, and Stichting Projecten (Projects Foundation) of De Nieuwe Kerk in Amsterdam.

The exhibition held at the National Museum in Jakarta has been supported by the following sponsors

Ministry of Toerisme and Culture

The exhibition held at the Nieuwe Kerk in Amsterdam has been supported by the following sponsors

Founding Sponsors

FORTIS BANK

Buhrmann

Chief Sponsors

KPMG

Get*r*nics

Media Partners

KUNST

Project Sponsors

ONDER
MUSC
LTUUR
NETEM
SCHAP
Ministerie van Onderwijs,
Cultuur en Wetenschap

Buitenlandse Zaken
Ontwikkelings
samenwerking

The Amsterdam City Council

4

Contents

Indonesia and the Netherlands have a long and complex common history. From the arrival of the first Dutch ships in 1596, right up to the present, both countries have been intimately connected, although not always in a positive manner. Moreover, since Indonesia became independent in 1945, the relationship between both countries has had its high and low points. Despite everything, the Indonesian cultural inheritance has virtually in its own right always – as much in Indonesia as in the Netherlands -constituted a bridge connecting Indonesians and Dutch museum specialists, scholars and the wider public. This has recently led to cooperation between the Indonesian National Museum in Jakarta, the National Museum of Ethnology (Rijksmuseum voor Volkenkunde) in Leiden, and the Nieuwe Kerk (New Church) in Amsterdam. The book that lies in front of you is one of the results of this cooperation.

The Indonesian National Museum and National Museum of Ethnology have much in common. Several collections assembled by the same collector or deriving from the same archaeological site, came to be divided between the two museums. Such sharing, especially during the second half of the nineteenth century, was an intentional policy of the Government. This episode, concerning the division of collections between Jakarta and Leiden, is a central focus of the exhibition and catalogue. As part of the cooperation project known as the Shared Cultural Heritage, the Indonesian National Museum, the National Museum of Ethnology and the Nieuwe Kerk now exhibit the first results of research over the exciting story of collection in colonial conditions, research that, besides, has only recently been put together and that contains many promising aspects for further development.

The unique, temporary bringing together of the collections from the Indonesian National Museum and the National Museum of Ethnology offers the visitor in Jakarta and Amsterdam a full chance to get to know the world's greatest and most beautiful collection of Indonesian cultural objects and with the manner in which they were brought together. For the latter, we must thank the passions of individual collectors, scientific and military expeditions, archaeological finds, and the gifts of missionaries and chiefs.

A large project such as the Shared Cultural Heritage needs financial support from several sources. Besides the three institutions that have organised this exhibition, several other partners have made financial contributions to the project. The support of HGIS-Cultuur (a fund deriving from the Dutch Ministries of External Affairs and of Education, Culture and Science) was indispensable. The Indonesian Ministry of Culture and Tourism has reserved all exhibitions held in 2005 for the Shared Cultural Heritage. The most important private sponsor has been KLM Cargo which, has been prepared to pay for the major share of transportation costs. Besides these financial resources, we are also very grateful for the support of the regular and chief sponsors of the Nieuwe Kerk (of the first, Fortis Bank Nederland, Buhrmann, and of the second, KPMG and Getronics), to whom we are very grateful.

We wish the visitors to the exhibition and the readers of this book an inspiring exploration of the complicated story of the collection of archaeological and ethnographic objects in a politically controversial context.

6

Intan Mardiana Napitupulu
Director of the Indonesian National Museum, Jakarta

Steven Engelsman
Director of the National Museum of Ethnology, Leiden

Ernst W. Veen
Director of the Nieuwe Kerk, Amsterdam

The Director's Foreword

The historical background of both the Indonesian National Museum in Jakarta and the National Museum of Ethnology in Leiden is especially interesting. Both museums grew out of the colonial period, when Indonesia was a possession of the Netherlands, the consequence of which is that the collections of both institutions are comparable since many objects have derived from the same collectors and the same sites. The objects composing them were collected during scientific expeditions, military conquest, or by government officers and missionaries The instructions of the colonial administration demanded that all objects should be sent to the Batavian Society of Arts and Sciences (Bataviaasch Genootschap van Kunsten en Wetenschappen) at Batavia (now Jakarta), where they were subsequently divided into two parts, one remaining in Batavia and another part sent to the Netherlands; most of the latter went to Leiden and some to other locations. This policy of the government explains the considerable similarities of the collections of the two museums.

From the middle of the nineteenth century to the period of the struggle for independence, it was practice to send a proportion of the collected objects to the Netherlands. As a result, the National Museum of Ethnology in Leiden possess numerous Indonesian collections that have not yet been seen by an Indonesian. For a long time, many Indonesians have wanted to take a look at these parts of their cultural heritage stored in a foreign country. This is why the Leiden Museum was asked by Indonesia whether it was prepared to exhibit its Indonesian collections in the National Museum in Jakarta. Consultations resulted in the two museums developing a common project called the 'Shared Cultural Heritage'.

The purpose has been to exhibit a number of collections from both museums originally collected by the same collectors and at the same locations. At the current time, there is increasing scholarly interest in the origins of such collections. Information about the contexts in which collections were made – by whom, by what means, and to what end it had been undertaken – gives extra significance to objects exhibited in the museum.

The purpose of the joint exhibition is the strengthening of relationships between the two museums, especially with respect to research on collection, management of collections, and educational programmes. Moreover, Indonesians will obtain a real chance to gain familiarity with parts of their cultural heritage that are now located outside their own country, and especially the masterpieces of the Singasari Temple.

Besides the fine stone sculptures of this temple, archaeological finds can be seen that come from Candi Borobudur, Muteran (Kediri, East Java), Puger Wetan (Jember, East Java) and Combre (Gunung Wilis, East Java). Moreover, ethnographic objects from almost all parts of the archipelago may be viewed. The exhibition should lead to greater comprehension of the diversity of Indonesian cultures and to more insight concerning the context in which the collections of the two museums were built.

Endang Sri Hardiati
The Indonesian National Museum , Jakarta

Pieter ter Keurs
The National Museum of Ethnology, Leiden

The Editors' Foreword

This book, together with the associated exhibition, aims to examine the significance of cultural heritage; the heritage of nations is also that of humanity as a whole. The public should become more attentive to the importance of this theme by visiting the exhibition, participating in the concurrently held seminar, and through indirect interaction using the media. A cultural legacy, such as that displayed in the exhibition, is a potential source of identity and pride. At the same time, it should lead to an understanding that humanity is something that must be treated with care.

There is now universal recognition of the significance of cultural heritage, together with consensus about the urgency of safeguarding this important material. The wider public will become familiar with the problem by having direct access to objects of value. For this purpose, the masterpieces of the Singasari Temple and of other fine collections are displayed in the exhibition, while, the catalogue also goes on to consider the significance of this kind of historical work of art, together with that of the context in which ethnographic objects were collected in the colonial period. The exhibition and this book also reminds one of the need to establish a strategy concerning access to such objects; optimal conditions for safeguarding and protecting them, while making them accessible, need to be ensured for cultural works, for their value is priceless.

The collecting of ethnographic and archaeological objects during the colonial period resulted in the building up of collections held by the two museums. As a result, two societies made contact with one another, a contact that continues to this day. The Netherlands launched a new institutional concept, the museum, and modern Indonesian society took it over and developed it further. The cultural heritage – which according to traditional opinion should screened from excessive public exhibition – is now open to public view in the museums of modern Indonesia and is the object of scrupulous scholarly research.

The Indonesian cultural heritage, whether of an ethnographical, archaeological or cultural historical nature, forms part of the identity of that country. For the most part, these historical phenomena have been produced by specific ethnic groups. But given that so many ethnic groups have become integrated into the new nation, the heritage of this whole ethnic spectrum has become the cultural heritage of the whole country. In order to foster a corresponding sense of community, a more solid awareness of the role of local history in Indonesian society must be promoted. To this end, historical objects can play an important role – both as points of entry and aids to memory – with respect to general history and also to that of cultural and art history. Museums can contribute to the awakening of such consciousness by means of well-organised exhibitions, publications and interactive electronic media.

Our museum objects – derived from the many different cultures existing on Indonesian soil – can play a role in fostering tolerance among the general public. This requires an open mind towards accepting and valuing 'strange' cultural forms of expression. In this respect, Dutch specialists of Indonesian ethnography and archaeology are naturally very proud of their objects of research, the Indonesian cultural heritage thus seeming to them anything but strange. Indonesian specialists have even come to consider their Dutch colleagues as 'members of the family'.

What does this all imply for running a museum? In Indonesia, the most desirable development for museums is largely considered from the perspective of management, and this in turn in terms

Edi Sedyawati

The Importance of Cultural Heritage
An Introduction

of organisational structure and thereafter the management of personnel. The latter largely concerns such matters as a periodic evaluation of the functioning of museum personnel, the recruitment of new specialists, and the internal training of such specialists for their different tasks. Specific skills are always necessary and, given technical developments in the field, they undoubtedly entail a constant renewal of knowledge and skills.

Furthermore, running a museum is concerned with more physical factors. The spaces used for exhibition and storage in a museum must satisfy particular requirements, including the question of climatic control since the material must be properly conserved. Specialists are required for the planning and control of such spaces within the museum. And then there is the question of the public: how can the museum be most effectively and efficiently organised to satisfy a broad range of visitors? Separate strategies might be necessary to reach different sectors of the public, for example particular age groups or those differentiated by criteria such as education and profession.

Last but not least, museums have the task of focusing closely and in detail on particular themes, enabling them to be represented in displays. This aspect of the running of a museum forms the foundation of the cooperative project organised by the museums in Jakarta and Leiden, the 'Shared Cultural Heritage'. In Indonesia, two themes, closely connected with one another, always remain central in the permanent displays of public museums: cultural history and cultural diversity. In temporary exhibitions, a large variety of specific themes are selected, such as sculpture, clothing, bamboo, domestic utensils, and innumerable other possible subject matters.

Two points of entry indicate the directions followed in the present exhibition: the significance of the Singasari period and the importance of collecting, including information about the context in which collections came to be put together. This book provides abundant matter for reflection about these two themes.

The History

Museum of the Batavian Society
of Arts and Sciences
..
The sculpture hall of the museum in the
1930s.

The history of the Indonesian National Museum (Museum Nasional Indonesia, MNI) reaches back to long before the foundation of the Republic of Indonesia: it assumed the role previously played by the Batavian Society of Arts and Sciences (Bataviaasch Genootschap van Kunsten en Wetenschappen), founded more than two centuries ago.

Historical background of the Batavian Society

The intellectual revolution experienced by Europe in the eighteenth century, known as the Age of Enlightenment, eventually reached the Dutch colonies. It was characterised by its application of rational thought to questions of tradition, culture and belief, in the expectation that scientific answers could be found. In the Netherlands, this approach led to the establishment of the Royal Dutch Society of Sciences and Humanities (De Koninklijke Hollandsche Maatschappij der Wetenschappen, HMW) in 1752 in Haarlem. One of the activities it initiated was an essay competition on Dutch trade, especially in the East Indies region, and on how arts and sciences could facilitate the spreading of Christianity in the Dutch colonies. By focusing on such subject matter new ideas were revealed to the colonial officials stationed there.

At the time, the Dutch East India Company (Vereenigde Oostindische Compagnie, VOC) controlled the Netherlands Indies. Members of the higher ranks were rarely interested in intellectual or cultural activities, but one young officer, J.C.M. Radermacher, was keenly supportive of the activities and goals of the Society of Sciences and Humanities. As a member of the Freemasons – an international society based on the principles of brotherhood, charity and mutual aid – Radermacher may be considered an idealist, convinced of the potential for a better future. He proposed the establishment in Batavia of an institution similar to the Society of Sciences and Humanities.

The proposal was not directly accepted, but on the twenty-fifth anniversary of the Society's foundation, the idea of opening a new branch was introduced: a new organisation dealing with the economic aspects of the Netherlands and its colonies. Shortly thereafter, the proposal of J.C.M. Radermacher was accepted. This led ultimately to the establishment of an independent society in Batavia that was not a branch of the Royal Dutch Society of Sciences and Humanities. The Batavian Society of Arts and Sciences was established on 24 April 1778. The Governor General and high-ranking officers of the VOC became its directors, and members included several prominent citizens. Its motto was 'For the Common Good' (Ten Nutte van het Algemeen). It is worth noting that the Batavian Society is considered to be the oldest of such societies in Asia.

The main purpose of the Society was to provide expert scientific research and analysis relating to all aspects of the culture of the East Indies archipelagos. From its foundation, the Batavian Society conducted intensive research, and the results were published in the Batavian Society Reports (Verhandelingen van het Bataviaasch Genootschap van Kunsten en Wetenschappen), which appeared from 1779 to 1950. The reports covered a wide variety of topics: from a new irrigation system to detailed analyses of ancient Javanese inscriptions. The Journal of Indonesian Linguistics, Ethnology and Anthropology (Tijdschrift voor Indische Taal-Land-en Volkenkunde) was established by the Batavian Society in 1853 and continued until 1952, and the Yearbook (Jaarboek), containing research papers, appeared annually from 1926 to 1951. In addition

From Batavian Society to Indonesian National Museum

to the scientific publications, administrative reports in the form of the *Minutes of the Batavian Society* (*Notulen van de Bataviaasch Genootschap*) were also published, from 1813 until 1921.

Unfortunately, most of the researchers only stayed in the East Indies for limited periods and gaps were sometimes left in certain areas of interest when they moved on. Nevertheless, the attention of the Batavian Society maintained its focus of attention on cultural research throughout the archipelago, and members functioned as advisors or consultants concerning cultural issues. As there was no government institution dealing with special cultural issues such as archaeological remains, the role of the Batavian Society was considered very important indeed; the colonial government only established the Archaeological Service (Oudheidkundige Dienst) in 1913. Initially, the activities of the Batavian Society covered broad areas of interest such as the natural sciences, ethnography, history, literary, agriculture and medicine. Although its development fluctuated, it became ever more influential; it was renowned as an international scientific society in the field of culture and related disciplines.

It is noteworthy that although the chief policy makers of the government changed, the Batavian Society continued to exist as an independent society. During the British interregnum in Java from 1811 to 1816, Sir Thomas Stamford Raffles was promoted to Lieutenant Governor of Java. He had a great interest in the history and culture of the East Indies and, therefore, also in the Batavian Society, with its long experience in science and culture. Among other things, Raffles contributed to the Batavian Society a new building for keeping the collections, a meeting room – located in present-day Jalan Majapahit, Jakarta – the use of government printing facilities and the government library. He was also an enthusiastic scholar of the history and the antiquities of Java. In 1813 he became president of the Batavian Society, and changed its name to the Literary Society. Although Raffles only led the Society for a very short time (until 1816), he played a major role in developing it into a scientific institution.

After the British interregnum was over, the Batavian Society returned to the control of Dutch researchers, and several Dutch experts frequently worked for it. So a hundred years after its foundation, the Batavian Society was playing an important role as a credible consultant to the government – particularly regarding the preservation of cultural heritage throughout the archipelago. In fact, the Dutch government was dependent on the Batavian Society for the preservation of local archaeological heritage until the aforementioned Archaeological Institute was established in 1913. From the middle of the nineteenth century, the scope of activities of the Batavian Society decreased: the natural sciences separated and became the preserve of the Society of Physics; the Batavian Society focused on literature and language, archaeology, ethnography and anthropology. The reputation of the Batavian Society increased in significance with regard to these subjects, and it was supported by renowned experts such as Rudolf Frederich, Cohen Stuart, Brumund, Groeneveldt, and Brandes.

Membership of the Batavian Society, which varied between one and three hundred, was not limited to Batavian residents; it included experts who lived in other Dutch colonies or in the Netherlands itself. Membership for Indonesians was introduced in 1860, but was initially reserved for Javanese noblemen. In the 1930s, Indonesians accounted for ten per cent of total membership, and in 1936 one of the Indonesian experts, Prof. Dr. Hoesein Djajadiningrat, became the Society's President.

Professor Hoesein Djajadiningrat

The last President of the Batavian Society of Arts and Sciences, 1936-1960.

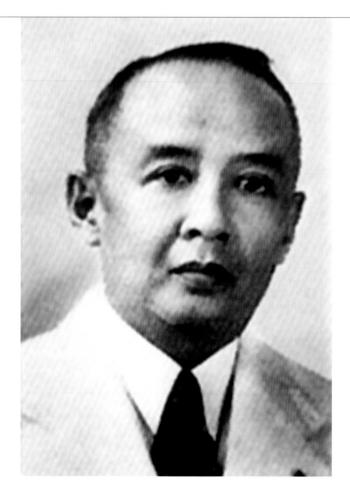

The importance of the Batavian Society as an association for cultural research was officially recognised by the Dutch Government: the Society became 'Royal' (Koninklijk) in 1923. The activities of the Batavian Society continued after the independence of Indonesia, and in 1950 the name was changed to The Indonesian Institute of Culture (Lembaga Kebudayaan Indonesia); it remained under the direction of Prof. Dr. Hoesein Djajadiningrat. The institute was officially dispersed in 1952, leaving only the museum, then known as the Central Museum (Museum Pusat). In 1979, its name was changed to Museum Nasional Indonesia.

Museum

From its inception, the Batavian Society made intensive efforts to collect artefacts donated by its members. J.C.M. Radermacher started by donating his own house, located in Jalan Kali Besar, including his herbarium and all his collections of books, musical instruments, coins and flora specimens. At this time it was fashionable among the upper classes to collect unique items, and the collections of the Batavian Society grew significantly in a very short time. In 1779, it was decided that all collections would be put on public display. This signalled the beginning of activities at the Batavian Society Museum. It was open on Wednesdays from 8.00am to 10.00am, and Society members were permitted to borrow books for a period of three weeks.

During the British occupation the collections grew, and Raffles donated another building located in Harmoni, which was in the area around Jalan Majapahit. Unfortunately, the building has since been demolished and replaced with the State Secretariat building. At the time, though, the increase in available space enabled the collection to grow accordingly, in areas such as zoology, mammals, birds, shells, and so on. The government paid serious attention to the activities of the Batavian Society, and Governor General G.A. Baron van der Capellen – who ruled over the archipelago immediately after the British left Java in 1822 – issued a decree that collections of Javanese antiquities were to be submitted to the Batavian Society. In accordance with the decree, all archaeological artefacts found in the archipelago were submitted to Batavia – even the four-metre high statue of Bhairawa from West Sumatra. During the governorship of General J.C. Baud (1833 – 1836) all officers of the archipelago were instructed to search for antiquities to be added to the Batavian Society Museum.

In 1885, the National Law on Items of Cultural Property was passed. It stipulated that all archaeological finds should be submitted to the government and that the museum could purchase these finds for a price based on an estimated value. However, the growth of the collections created a new problem – the increasing maintenance budget – and a policy was adopted for limiting the collections. Already by 1843, the zoology collection had been removed; some items were sent to Leiden, and the rest was auctioned. In 1850 the geological and mineralogical collections were given to the newly founded Society of Physics; the Batavian Society Museum now narrowed its focus, concentrating on history, archaeology, numismatology and ethnography, and its manuscript collections.

The building in Jalan Majapahit was no longer considered suitable as a museum, and a new building was erected in Merdeka Barat, not far from the old one. In the new building, first opened in 1868 and still in use today, the collections increased. These came not only from government officials; they were also purchased directly from collectors or brought in from military expeditions. Collections were acquired following the Dutch attack on the Royal Palace of Cakranegara in Lombok, and from expeditions to Banten and Banjarmasin, and these were submitted to the Batavian Society Museum. However, not all the collections were kept there. It was policy to divide each collection into two parts; one part was kept in the Batavian Society Museum and the other was submitted to the National Ethnology Museum in Leiden. Nevertheless, on at least one occasion the board of directors of the Batavian Society refused to send the ethnographic collection to the National Ethnology Museum. Following chapters contain more detailed information about how collections were collected and divided.

Thus, the Batavian Society collections came to comprise various types of cultural heritage which were then classified according to their theme (prehistoric, archaeological, numismatic, heraldic, ethnographic, geographical) or their medium (historical relics, ceramic, paintings, and manuscripts). It should be mentioned here that a number of dedicated individuals were responsible for establishing specific collections: Mr. and Mrs. Serrurier-Ten Cate and Van der Hoop for historical relics: Van Stein Callenfels for the prehistoric collections, Orsoy de Flines for the ceramic collections, and Van der Tuuk, Pleyte and Holle for the manuscript collections.

The National Museum

Since independence, the Batavian Society Museum has been managed by the government of the Republic of Indonesia, and, after some changes, it was renamed the Indonesian National Museum. Also, there have been changes involving some National Museum collections during the last twenty years: the manuscript collections and the library were transferred to the National Library, and the painting collections went to the National Gallery.

From the beginning of 1980s, the Indonesian government build museums in every province of the country, and by 1995, each had their own Provincial Museum. Now, any artefacts found in a particular region could be kept in their own museums. Only artefacts of very great significance to Indonesian culture were to be kept in the National Museum. The golden objects found in Wonoboyo, Central Java, in 1990 are just such artefacts (see the article by Pauline Lunsingh Scheurleer elsewhere in this book) This hoard of archaeologically and artistically important tenth-century gold, with a total weight of nearly 32 kilogrammes, was kept in the National Museum. Another example was the bronze statue of Siva, found in Karangnongko, Klaten, Central Java, in 2001.

This headless statue is highly artistic, and can be used as reference for the style of tenth-century statues.

In order to have appropriate display and storage rooms, one of two new buildings located on the north side of the museum building was erected in 1991. It is expected that by erecting the two building units, on the north side of, and behind the existing building, a comprehensive display can be achieved by the National Museum. By 2005, only the first, Building B, had

been completely finished; the re-designing of the displays of the collections will follow. Building C will be constructed thereafter.

The re-designing of the National Museum display is focused on the conceptual basis of the technical display. Formerly, it was object-oriented, whereas the new display strategy will be based on thematic elements of culture. The collections will be used to illustrate the holistic development of Indonesian culture. The themes will be: man and his environment, social organisation and settlement patterns, technology, religion, and the arts. There will also be special exhibitions on ceramics and gold treasures.

From an historical background, the National Museum came into being on the initiative of the colonial government, which based its actions on Dutch interests and needs. Nevertheless, if we cast our minds back to the work conducted by the Batavian Society members in investigating and studying the ancient Indonesian culture, we will appreciate that this was not a display of mere curiosity regarding the culture of the occupied area; it was also scientific research on ancient Indonesian culture – research conducted with great dedication.

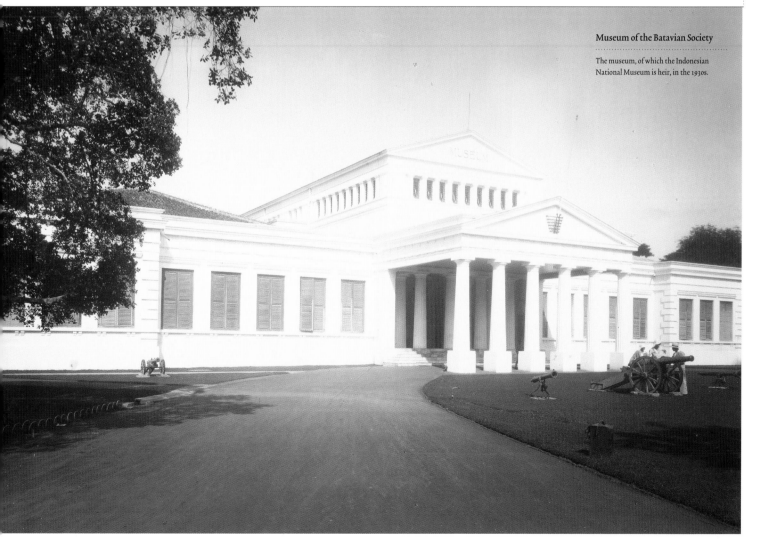

Museum of the Batavian Society

The museum, of which the Indonesian National Museum is heir, in the 1930s.

While the the National Museum of Ethnology in Leiden habitually claims the status of being the oldest ethnology museum in the world, it is however younger than the Batavian Society of of Arts and Sciences (Bataviaasch Genootschap van Kunsten en Wetenschappen). Admittedly, the Batavian Society, established in 1778, was not initially a museum, but even in the early period of its existence, it had brought together sound collections. Not until the nineteenth century was a separate museum established responsible for archaeological and ethnographic collections. The National Museum of Ethnology (RMV) was born in the first decade of the nineteenth century, later than the Batavian Society, but nonetheless earlier than most other ethnology museums. The history of its origins is complex and will not be considered here in detail. A reasonable insight into the background of these origins of the RMV, can be gained from a consideration of three concepts: the Enlightenment, nationalism and colonialism (in that order).

Enlightenment, nationalism and colonialism

The study of non-western peoples, combined with collection of objects, is rooted in the prolongation of eighteenth-century Enlightenment ideals. Two aspects are especially relevant: first, the thought that empirical research must lead to more understanding and control; second, the opinion that non-western peoples differ in no fundamental manner from those of the West. In this respect, the French thinker, Jean Jacques Rousseau, made an important contribution by proposing that our 'primitive', fellow human being – about whom so little was then known – was a 'good savage': someone situated close to nature and, therefore, morally pure. Daily practice hardly conformed with this eighteenth-century

ideal of equality, but, in principle, such notions laid the basis of the twentieth-century Universal Declaration on the Rights of Man. The origin of ethnology museums, and certainly that of the Leiden museum, is hardly independent of this pious principle.

Furthermore, the possibility of acquiring more knowledge about nature and culture by means of empirical research, was considered an investment in the future. As mentioned in the previous chapter, this has already led to the establishment of scientific societies, such as the Batavian Society. Linnaeus had demonstrated that plants and animals could be divided into clearly defined categories. This stimulated the idea, although frequently implicit, that cultures might be similarly classified. Consequently, especially in the early decades of the nineteenth century, fierce controversy occurred over the kind of classification best suited to ethnographical objects. The German physician P.F. von Siebold held a lively debate about this very question with the French researcher Jomard. However, von Siebold would not enter history for path breaking work in taxonomy, but instead as one of the founders of the National Museum of Ethnology.

In *A General View of the History of the National Museum of Ethnology* (published in Dutch as *Overzicht van de geschiedenis van het Rijksmuseum voor Volkenkunde*, in 1937), von Siebold was lauded as the great visionary who laid the basis of the museum by dispensing his own money. Von Siebold certainly played an important role as catalyst, although of processes that had already begun. In 1813, J.F. Royer's collection of Chinese objects was entrusted to those members of the House of Orange who first set foot on Dutch soil following the end of the French occupation. This led in 1816 to the establishment of the Cabinet of Chinese Curiosities. Five years later, after the necessary administrative authorisation, the Royal

Pieter ter Keurs

The National Museum of Ethnology in Leiden

Cabinet of Curiosities in The Hague was set up, the collection of the Stadhouder William v being one of those incorporated into it. Years later, von Siebold pleaded for the addition of his own collection to that of the Royal Cabinet, thereby permitting the founding of a National Museum of Ethnology. He would get his way, but much later than he had wished. Only in 1883, were the larger parts of the two collections joined together. Nonetheless, from 1837 – after certain other collections had been added to von Siebold's (concerning Japan) – one could certainly speak of the existence of a State Ethnography Museum (Rijks Etnografisch Museum) in Leiden, this being later renamed as the National Museum of Ethnology.

In the course of the nineteenth century, strongly unified national states took form, resulting in the aggressive promotion of sentiments of national unity and greatness. Before this time, people had not considered themselves members of particular states, but instead were more likely identify themselves with a particular region (which often possessed its distinctive language). There were indeed loyalties to national leaders, mostly sovereigns, but even this had its limits. This situation would change radically during the nineteenth century. France aggressively fostered the French language as its national language, while its history was re-written from a nationalist point of view. Many French monuments to memorable events of the past derive from the second half of the nineteenth century. Bismarck as Chancellor, unified Germany during the same period. After the period of French occupation, the Netherlands was joined to Belgium, the aim being to form a strongly unified state. In this climate, museums were considered everywhere in Europe as means to display national greatness. This is illustrated by a remark of von Siebold, written in a memorandum in which he pleaded for the setting up of an ethnographic museum:

> The human being, in his many-sided development under foreign climes, is therefore the chief subject matter of an ethnographic museum. It provides an invigorating, instructive and, therefore, useful material enabling the acquisition – whilst remaining on national soil – of knowledge about inhabitants of far away countries and the study of their particular characteristics. Yes, it is even a moral and religious duty to busy ourselves with our fellow men and to learn to detect his good qualities, and thus to become more tolerant of his strange external appearance (which, without us knowing quite why, may even repel us), and help us to become closer to him.

Von Siebold manifested himself here as an inheritor of the Enlightenment, and he allowed no doubt to exist that he had intended all this as an augmentation of the glory of the Dutch state. He had little doubt that the king, William I, would favour it.

This brings us to the third factor leading to the establishment and development of the National Museum of Ethnology: colonialism. The Netherlands was already active in South East Asia from the beginning of the sixteenth century. At the start, in the period of the Dutch East India Company (Verenigde Oost-Indische Compagnie, or VOC), such activity largely concerned trading interests. After 1779, when the VOC had ceased to exist, the 'East Indies' was formally recognised as a colony and the acquisition of political and military influence played an increasingly greater role, although not in the context of international politics. Owing to the rise of

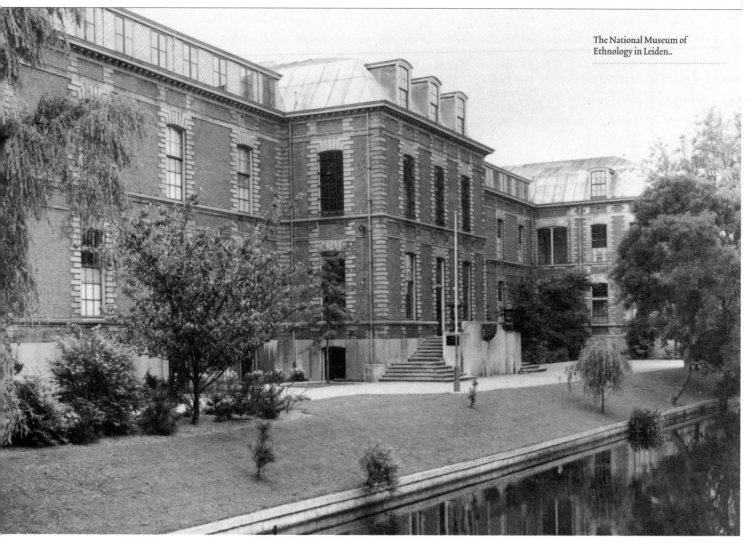

nationalism in Europe, the separation of spheres of influence in non-Western regions became ever more important. Competition between the Netherlands and England played an especially important role in South East Asia.

In the second half of the nineteenth century and first decade of the twentieth, the seizure of new territories snowballed. In fact, many colonial wars were fought in this period and it was largely during this same period that collections grew in European museums of ethnology. Nonetheless, this growth was often not directly connected with military action. This catalogue provides a good perspective upon these questions.

King William I was very interested in the improved mapping of areas that required governance, and, if also for political reasons, he stimulated scientific research in the Dutch colonies. Between 1820 and 1836, the Commission for Physics (Natuurkundige Commissie) organised various journeys in the East Indian archipelago (see the next chapter), much ethnographic material deriving from them finding its way into the RMV. Von Siebold purchased the collection of H. Macklot, one of the participants in the voyages of the Commission for Natural Sciences, while in 1864 the RMV also acquired that of Salomon Müller.

A historical overview

At the start, the National Museum of Ethnology – known at first as the State Ethnography Museum – possessed relatively few objects from Indonesia. In this early period, the emphasis lay rather on Japan and China but, given the aim of creating a museum concerned with general ethnology, acquisition increased from many other parts of the world. In the second half of the nineteenth century, the Dutch East Indies would be the source of an enormous increase. Under the directorship of L. Serrurier, the Indonesian collection increased five-fold. This was largely the consequence of the transfer of objects from the Royal Cabinet of Curiosities (in The Hague) to Leiden and the acquisition in 1883 of the objects displayed at the Colonial Trade Exhibition held in Amsterdam. There came to exist, moreover, an active policy of stimulating government officers and missionaries to acquire collections for the museum (see also the next chapter). Serrurier made a contribution to this by production of guide-lines for such collection.

The first years of the twentieth century were marked by military actions in Aceh, Bali, Bone and Gowa (see the relevant chapters in this catalogue). Those objects collected or seized found their way both to the RMV and the Batavian Society. Collections grew less rapidly after this period. In Leiden, study was devoted to the collections previously assembled, and this led to Juynboll's famous catalogue, appearing in twenty three parts between 1909 and 1932. Moreover, in the 1920s and 1930s, a basis was prepared for structuralism in ethnology. Two curators of the RMV, J.P.B. de Josselin de Jong and W.H. Rassers, evolved into the founders of this tendency of renewal. Rassers was appointed director of the RMV on 1st June 1937. In the same year, the museum obtained its current building in the Steenstraat in Leiden, which temporarily solved its perennial problem of accommodation.

After the Second World War, the RMV rapidly developed. The number of staff members were increased and new methods of work were introduced. In the 1950s, under the direction of G.W. Locher, the basis was laid for an Educational Service in order to devote more attention to relations with the public, a considerable novelty

at this time. Curators, who until then had for the most part been armchair anthropologists, began to do fieldwork in their own right. As a result, field research and collection went hand in hand. A good example of such a method of working, is the fieldwork of A.A. Gerbrands with the Asmat of South-West New Guinea in 1960 – 1961.

The relationship with Indonesia was complex in the period following the war. Indonesia had fought for its independence and cooperation in cultural matters remained low on the agenda for a long time. During the negotiations preceding independence, there was already discussion about the return of cultural objects, but nothing was done about it during the first decades. Only in the 1970s did the question of restitution become an important subject of diplomatic deliberations between the two countries, influenced by international discussion about the matter, for example, in connection with Unesco. Finally, in 1978 it was decided to return to Indonesia the Buddhist sculpture of the Prajnaparamita and a large part of the Lombok Treasure (see the chapter by Wahyu Ernawati). These objects are now to be admired at the Indonesian National Museum in Jakarta.

Since that time, cooperation with Indonesia has slowly resumed. Dr. Van Wengen, of the RMV's Educational Service, has travelled frequently to Indonesia to work on the development of small provincial museums together with Mr. Bambang Sumadio, previous director of the National Museum, and head of the department of Museum Affairs of the then Ministery of Education and Culture of Indonesia. Furthermore, collection, often combined with research, has again become possible in Indonesia. Thus, Leontine Visser on Halmahera and Francine Brinkgreve on Bali have collected for the RMV. Research into museum studies is of much more recent date.

Meanwhile, the RMV has again accomplished an important work of rebuilding: the depots have been renovated and a completely new public display has been put in place. But, in addition, the world outside the museum had changed fundamentally during recent decades. As a result of globalisation, and especially improvements in flight connections, contacts between the Netherlands and the rest of the world have increased in frequency and intensity. The RMV has intensive contacts with countries from which its collections derive. Much effort is spent on further expansion in relationships by means of international networks. The 'Shared Cultural Heritage, Indonesia-Netherlands' project – of which this book and exhibition are results – is not therefore an isolated instance. It forms a part of the growing international interest in the cultural legacy. The National Museum of Ethnology is evolving into an important actor in the world, and this development concerns not least Indonesia.

Dr. L. Serrurier
...
Under his leadership, the Indonesian collection of the museum increased five-fold.

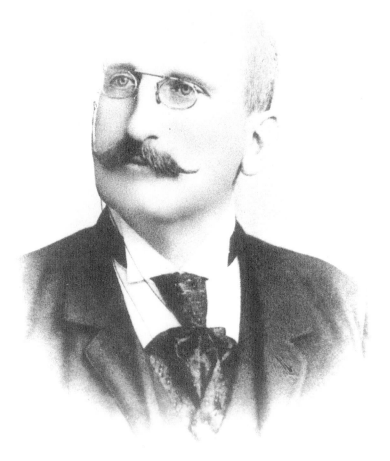

Although the Batavian Society of Arts and Sciences is much older that the National Museum of Ethnology (Rijksmuseum voor Volkenkunde), both these institutes have a great deal in common. Scholarship has always been of paramount importance for both places, and during the course of the nineteenth century their collecting policy also developed along parallel lines. One could say that there was a division of collections between Batavia and Leiden from 1862 on, but even before that date collections were frequently divided up between both these museums.

The starting point for 'Shared Cultural Heritage, Indonesia-Netherlands', a cooperative project between the Indonesian National Museum in Jakarta and the National Museum of Ethnology in Leiden, was the passage (given below) from the notes of the Batavian Society from 1863:

> By government resolution of 24 May 1862 no. 2, an invitation was sent to the heads of regional government in the Dutch East Indies, to create ethnographical collections on behalf of the government, to the best of their ability, with the instruction to send these to the society, the [board of directors] are also requested that, when such objects are received on the strength of this instruction, [they should] notify the government, mentioning [the objects that] they wish to reserve for the society, with the intention of relinquishing them to the society, sending the remainder to The Netherlands for the assembly there of an ethnological collection (NBG 1863: 150-151).

This governmental order resulted partly from a note by Dr. C. Leemans, at that time the Director of both the Ethnography Museum and the Museum of Antiquities in Leiden. Leemans had asked the colonial government to consider allowing collections to be assembled by Dutch colonial officials, and then dividing up these collections between the Batavian Society (Bataviaasch Genootschap) and the National Museum of Ethnology (Rijksmuseum voor Volkenkunde), at that time known as the State Ethnography Museum (Rijks Ethnografisch Museum). This Leiden museum had solid collections from Japan, deriving from Von Siebold (the museum's founder) but there were also several interesting collections from what was then the Dutch East Indies. However, Leemans had really desired a marked increase in the extent of the collections in the Leiden museum, not only from Japan and the East Indies, but also from other parts of the world. The State Ethnography Museum (Rijks Ethnografisch Museum) must become a general ethnology museum, yet the Dutch East Indies served to play a significant role in this extension. Leeman's successor, L. Serrurier, succeeded to a large extent in achieving this (see the foregoing chapter on the RMV).

Not only Leiden benefited from this intensification of collecting activities. The board of the Batavian Society, in a certain sense a competitor of the Leiden Museum, also witnessed an extension of its collection. In the same notes from 1863 we can read:

> The directors hope that, from the scholarly point of view, the heads of the regional governments, who are also nearly all members of the society, will produce results from the invitation, since, however notable the society's ethnographic collection might be called in many respects, it is still far from being complete, and is far from fulfilling the needs of a good ethnography museum, which provides the opportunity of getting to know the people's customs, habits, manufactures, agriculture, etc. etc. (ibid: 151)

Edi Sedyawati and Pieter ter Keurs

Scholarship, curiosity and politics
Collecting in a colonial context

However, The Netherlands was not forgotten by the society's administration:

> Furthermore, it might be considered highly desirable for The Netherlands as well, that the general public there should have the opportunity to obtain, in a good ethnology museum, some idea of the people of the East Indies, who are subject to Dutch power. (ibid: 151)

Officially the Batavian Society was given first choice in deciding which objects should remain in Batavia, and which should be shipped to The Netherlands. In practice, one could say that there was a frequent rivalry between Batavia and Leiden. In November 1889 we read in the notes that the administration of the Batavia Society had registered a fierce reaction to the claims the Leiden Museum was making on ethnological collections in the hands of the Dutch East Indies government. It is clear that, at the instigation of the Leiden museum, doubts were entertained about the Batavia Society's capacity for managing the collection in a sufficiently adequate manner, and people were asking for instructions to be issued in the event that the Society was wound up. What would happen then to the collections? The board's reaction was sharp: 'Our society has succeeded, in difficult circumstances and changes over 111 years, in maintaining its position, and with all due modesty we believe that at the moment there is no cause to expect our demise' (NBG 1889: 143). Conversely, looking at the matter from the viewpoint of observers in the Dutch East Indies, Leiden appeared to be city of academics without a great deal of sensitivity to the field. Most members of the Batavian Society had lived in the colony for many years, while by far the largest number of Leiden curators had never seen the East Indies.

Whatever the situation, to a great extent the Batavian Society and the National Museum of Ethnology were condemned to 'cohabit'. Although consistent collection for both these institutes was not always put into practice, and although many collectors have collected objects for other museums in The Netherlands, even indirectly, one can still talk of a conscious policy in which the Batavian Society and the State Ethnography Museum are the chief participants. As a result a good many collections have actually been divided up between both museums.

Collecting in an historical context

Before we discuss the specific context of collecting in nineteenth-century Indonesia, it is necessary to make a few general remarks on the phenomenon of collecting, and on colonialism, or the power relations within which the collections described here were assembled.

Everyone is familiar with the act of collecting. Even if you have never been a fanatic collector of match boxes, china dolls, empty beer bottles or model aeroplanes, you will certainly know someone who does collect things. People clearly like surrounding themselves with things that give them a good feeling. The fanatic kind of collecting is an extreme expression of this liking, but even in everyday life a similar mechanism is noticeable. We all like to manipulate our surroundings in such a way that we feel pleasure in it. We buy clothes in a particular style, or furnish a house in a particular way. We often have clear ideas about this, and we make a fuss about it when it does not turn out quite how we would like it to be. The psychological aspects of this process undoubtedly constitute an interesting theme for research, but in this book we

shall leave the psychological side of collecting largely outside our attention. This is not to say however, that motives of this kind have had no importance in the situations we are describing here. Individual motives are mentioned now and then in the sources, but in many cases we know nothing about them, and in very many cases the collector disguised them behind considerations that were 'better/fairer' from a political or moral viewpoint.

This book is about the collecting of archeological and ethnological material within a colonial context. For two reasons we are concerned here were a particular form of collecting. Firstly, the material collected could be called unusual. For a long time many objects were regarded as rarities – as strange things deriving from peoples living in far-distant countries. Secondly, this was a situation in which power was unequally divided. However well meaning a researcher or collector might be, in every case he (women play virtually no role in this context) was an exponent of the colonial system.

The first aspect resulted from the fact that most citizens of that time were unable to make long journeys (even if they would have liked to do so). Because of this, much of the material discussed here was viewed as exotic, strange, coming from 'far away'. People knew little about this exotic world, and curiosity about this strangeness would certainly have played its role among the early visitors to ethnographic collections. This apart, there was also an inquisitiveness that would not always have derived from the desire to acquire a better understanding of this 'strange' world. Inquisitiveness may also be the result of the wish to justify one's own world, by definition limited. Quite frequently this led to the negative judgement of other peoples. This aspect would certainly have had some importance in the desire for a better understanding of ethnographic collections.

The same applies to the second characteristic of colonial collections: the unequal distribution of power between the collector and the people with whom the collected objects originated. It is, to say the least, worth noting that for a long time the 'collector' was absent as a character in scholarly studies. A good many studies of museum collections implicitly take as their starting point the idea that the objects present a neutral image of a society, and that these objects lie, passively awaiting the scholars' interpretations. Thus in the stimulating study by Serrurier on the *wayang purwa*, we learn little about the origins of the collections he used as his source material. Serrurier does in fact name the collectors, but shows no interest in the collecting context as a significant factor. Who were the collectors of these *wayang* puppets? What relation did they have to the local society? Were the puppets specially made for collectors? If so, in what way did this datum influence the puppets' appearance? If not, how representative is this collection of puppets? In the study of museum collections, leaving out the collecting context can produce a marked distortion of the reality.

To give another example: Adriani and Kruyt collected a large quantity of decorated tree bark in Central Sulawesi (see the article by Hari Budiarti), for both the Batavian Society and the National Museum of Ethnology. They also wrote a great deal about this fascinating material, and the motifs painted on it. However, what was their relationship with the makers? Did they collect second-hand cloths, or were the cloths made specially for sale? In the Leiden collection we have found tree-bark cloths with the price tickets still on them. Painted tree-bark cloths were very probably a favourite item at annual fairs and similar events. We certainly know that the

material culture of Central Sulawesi contained a great deal more than just decorated tree-bark cloth. Why then are objects made of other materials collected far less often? Does a collection like Adriani and Kruyt's not provide a completely distorted image of the culture from which this collection derived?

Finally, we give the example of E.E.W.G. Schröder, the man who wrote the most important work about the island of Nias (1917). His extremely detailed descriptions of North, Central and South Nias tell us nothing about the context in which his collection was created. When one looks at the actual collection (RMV series 1552, 1620, 1629, 1658, 1691, 1798 and 1895), one could well suspect that the great majority of wooden statues were newly made. They do not give the impression of ever having actually been used. How reliable, then, is the image of Nias produced by Schröder's collection?

The Leiden professor A.A. Gerbrands was one of the first to produce a comprehensive account of the socio-cultural context in which he collected his objects. This description of the collecting context was actually an essential part of his research strategy. Using the example of the Asmat of south-west New Guinea, he hoped to show that individual styles also existed in societies without writing; among the Asmat, the woodcarvers were just as 'recognisable' as Vermeer, Rembrandt or Van Gogh are among the Dutch. He achieved his aim, since his book *Wow ipits* (1967) constitutes – together with his Asmat collection (RMV series 3790) – a unique document on both individual styles among the Asmat and the way in which he carried out his research, and on his relationships with his informants, especially the woodcarvers. The situations described by Gerbrands took the form of anecdotes, something that earned him the criticism of being too journalistic in his writing. In the eyes of some scholars, his writing

Sculpture of an Ancestor
..

Nias
Collected by C.B.H. von Rosenberg
Wood. Height 23.5 cm
RMV 695-5

was 'not sufficiently serious'. However, it is precisely because of his candour and his manner of reporting that Gerbrands could be called a forerunner in the study of the collecting context – a task of cultural anthopology that came to full fruition in the 1990s.

An important book on the interrelationships between museum collections and the historical context within which they were assembled, is *Entangled objects* by Nicolas Thomas (1991). The collection of objects in other cultures cannot be viewed separately from the historical context, yet one must also take account of local ideas about barter, with all the political processes accompanying this. It was never a one-way traffic, although collectors often believed that it was. The local population also had its contribution to make, and also tried to derive an advantage from the relation with the collector. This advantage was often a monetary profit, but it could also be a political one. Undoubtedly contacts with western collectors contributed to the prestige of the people with whom the collectors developed a relationship.

This influence from each side, from both the buyer's and seller's cultures, resulted in a certain degree of hybridization in collections (the term 'hybridization' is used for example by Anthony Shelton, a British anthropologist who has written a great deal on the history of museum collections). Museum objects are never only an expression of the society from which they originally derived. They are also an expression of the process of collecting – the moment of cultural contact that ultimately ensured that these objects, from regions far distant from Europe, were preserved. By far the greatest number of ethnographic collections were collected in a colonial context, therefore in a situation of unequal power relations. Both parties to the transaction tried to derive the greatest advantage from it, yet ultimately it was the ethnographic collections that were the expression of colonial power relations.

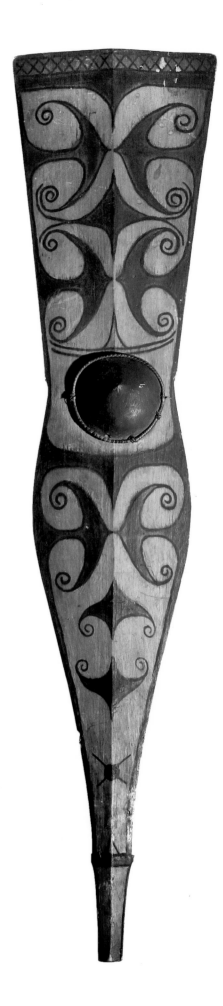

There is an very extensive literature on collecting in an ethnographic context, but this is not the place in which to examine it in detail. We would like to concentrate, here, on the specific situation of Indonesia/The Netherlands. From the end of the sixteenth century the Dutch were sailing to Indonesia, but it was only in the nineteenth century that large-scale collecting began. By modern standards the ships of the United East India Company (Verenigde Oostindische Compagnie – the VOC) were quite small, and the chief aim was to earn money by trade. The cargo holds had to be available for profitable trade, not only between the East Indies and The Netherlands, but especially for trade within the Asiatic region at large. At that period, however, objects from south-east Asia did reach Europe. In Amsterdam, particularly, there was a lively trade in ethnographic objects, but few of these found an eventual shelter in an ethnographic museum. The objects often ended up in private collections belonging to rulers or rich citizens. It was only in the nineteenth century, when the VOC no longer existed, that the ethnographic museums had their beginnings.

After the VOC has been disbanded in 1799, control of VOC possessions in the East was transferred to the Dutch state. Now Dutch military and political power in the entire archipelago began its constant, steady expansion, a process lasting until the beginning of the twentieth century. At the same time, scholarly interest in the East Indies received a huge stimulus, expressed particularly in the activities of the Commission on Physical Sciences (Natuurkundige Commissie) instituted in 1820 by King William I, in order to gather more knowledge of the Dutch overseas possessions. In the next section we shall return to the journeys made by members of this commission, especially those journeys to the furthermost corners of the archipelago. Although the research trips were of a scholarly kind, political considerations were never very far away. In the notes we frequently find remarks about suitable anchorages for ships (also of great military importance) or about the minerals to be found in various places. Everywhere, there was the search for what could profitably be exploited.

Sources of the collections in Leiden and Jakarta

In the context of the project Shared Cultural Heritage we have concentrated on the collecting carried out in the nineteenth century and the beginning of the twentieth. In the following section we outline the sources that have been discovered for collections, and the specific characteristics linked with these.

Scholarly expeditions A respectable number of scientific expeditions were mounted in the former Dutch East Indies. Sometimes the government commissioned the expedition, but organizations such as the Royal Dutch Geographical Society (Koninklijk Nederlandsch Aardrijkskundig Genootschap) and the Society for the Promotion of Research into Physics (Maatschappij ter Bevordering van het Natuurkundig Onderzoek) were also active in this field. In part three of this book we shall be devoting special attention to the Central Sumatra expedition, and the three journeys made through Kalimantan (Borneo) by A.W. Nieuwenhuis. In the context of this introduction, it is nevertheless appropriate to examine the earlier scientific expeditions of the Commission on Natural Sciences.

During the period in which Europe was being torn apart by the Napoleonic Wars, and The Netherlands were occupied by the French, the East Indian archipelago was governed by the British.

Shield
...
Siberut, Mentawai Islands
Collected by C.B.H. von Rosenberg
Wood, rattan and coconut shell.
Length 115 cm
RMV 79-1.

The man whose name is so intimately linked with the history of Singapore, Sir Thomas Stamford Raffles, also left his traces in the East Indies. As the English governor of the East Indian archipelago, he gave a marked stimulus to scholarly research. His own phenomenal book *The history of Java* appeared in 1817. When Napoleon was defeated, and the Dutch state took over the control of the East Indies, the fervent wish was expressed that scholarly research on the country and its cultures should be continued with the greatest possible energy. As early as 1815 Professor C.G.C. Reinwardt was sent out to the East Indies to make recommendations that would stimulate this research. Reinwardt advised the creation of a Botanical Gardens in Buitenzorg (now Bogor), for example – Gardens that are still in existence today. He also devoted considerable attention to the Hindu-Buddhist remains on Java, which still lay, overgrown.

Several years later, in 1820, the Commission on Physical Sciences in the Dutch East Indies (Natuurkundige Commissie in Nederlandsch-Indië) entered its most active period. The reports by the Commissioners frequently mentioned Professor Reinwardt's work, and it is clear that the members of the expeditions organized by the Commission regarded this professor as their forerunner. However, the Commission on Physical Sciences was able to achieve far more that Reinwardt. Between 1820 and 1836 various commission members travelled through large areas of the archipelago, assembling a large number of collections, of a geological, botanical, zoological and ethnological kind.

A good deal of this material was shipped to Leiden. The natural-history component is held in the museum Naturalis in Leiden, but the ethnographic collections are more difficult to trace. Virtually all the European members of these expeditions collected ethnographic

material, yet there appears to have been no custom of sending these collections to a museum, accompanied by good documentation. The European ethnology museums had not yet come into existence, and the objects stored with the Batavian Society can no longer be traced. The Leiden ethnography museum finally acquired two sections of the ethnological collections assembled by members of the Commission on Physical Sciences. The objects collected by H. Macklot were transferred to Philip Franz von Siebold, the German physician who, later on, was to advise King William I to establish a museum of ethnology in The Netherlands, and who became the first Director of the Leiden museum. The Macklot collection now forms part of series 1 in the National Museum of Ethnology in Leiden. Further, Salomon Müller's collection was later to arrive in Leiden. It was only in 1864 that the Müller collection was acquired by the State Ethnography Museum, and registered under the series number 16.

In the years 1839 to 1844 the 'Discourses on the natural history of the Dutch overseas possessions, by the members of the Commission on Physical Sciences in the East Indies, and other writers' (*Verhandelingen over de natuurlijke The History der Nederlandsche overzeesche bezittingen, door de leden der Natuurkundige Commissie in Indië en andere schrijvers*) were published 'by order of the king', by C.J. Temminck. This official reporting on the activities of the Commission on the Physical Sciences gives a good idea of the general aspirations. The ethnographic part of Temminck's publication was reprinted in 1857, but with most of the illustrations left out, under the editorship of Salomon Müller. These texts provide an impression of the way in which ethnographic material was collected. The circumstances that determined whether or not these objects would be collected

were often entirely arbitrary. There was absolutely no question of representative, and well-documented collecting. During a journey in 1828 to the south coast of New Guinea, the region in which the Marind-anim lived, contact was established with the local population. Müller describes the careful manner in which everything was done. There were hours of communication in sign language – the Moluccan interpreters did not understand the local language – which appeared to go well until the expedition members decided to return to their boat because night was falling. The local people tried to prevent the expedition members from leaving in their longboat, and when this failed, they began to throw spears at them. The expedition shot at them, but without killing anyone. The group of local inhabitants ran into the forest in fear, some of them leaving behind their spears, dug into the mud. The members of the expedition returned to the bank to retrieve these abandoned weapons.

By far the largest number of participants in the expeditions mounted by the Commission on the Physical Sciences failed to survive these ventures. At the beginning of the nineteenth century, the tropical climate exacted a heavy toll. Salomon Müller was one of the few who lived to tell the tale.

Archeological discovery sites Some five archeological discovery sites whose collections have been divided up, are discussed fully in part two of this book (see the contributions by Edi Sedyawati, Endang Sri Hardiati, Nandana Chutiwongs, Intan Mardiana and Pauline Lunsingh Scheurleer). Several comments on the collection of archeological finds in the nineteenth century are also appropriate here.

It was not only an interest in ethnography that brought western researchers to Indonesia; there were also the archeological and cultural-historical remains to be found there. In Europe from the sixteenth to the eighteenth centuries, there had been a marked increase in the interest in archeology, and this interest was extended to foreign countries, especially the colonised countries such as the Indonesia of that period. We find an early example, dating from this time, of a description of archeological 'curiosities' in the report by Scippio from 1687 on megalithic remains found in the Bogor area of West Java. Another example is the description of bronze-age and neolithic stone axes written by Rumphius and published in 1705 in his book D'*Amboinsche rariteitkamer* (The cabinet of curiosities of Amboyna). In 1733 C.A. Alons also wrote a report on the ruins of the Prambanan temple complex in Central Java.

It was only half a century later, in 1778, that an organisation was created for people seriously interested in scholarly and artistic fields: the Batavian Society for Arts and Sciences (Bataviaasch Genootschap van Kunsten en Wetenschappen) (see an earlier chapter on this subject). Interest in this Society was focussed on history and archeology; the collections brought under their control were thus concerned with both these disciplines. There was continuing interest in research on the Prambanan temple complex. In 1790 François van Boeckholtz produced a comprehensive description of this, as part of his manuscript *Beschrijving van het eyland Groot Java* (Description of the island of Great Java). Later, in 1805, H.C. Cornelius was given the assignment of making a drawing of the temple ruins by the governor of Java's north-east coast.

During the short-lived British government of Indonesia from 1811 to 1816, directed by Sir Thomas Stamford Raffles, a considerable amount of attention was paid to archeological remains. Raffles'

A village on Timor

From the report by Salomon Müller.

book *The history of Java* (1817) contained drawings of old temples and statues, including the ruins of the Siva temple in the Prambanan complex. As interest in archeological research gained ground in Europe during the nineteenth century, the same interest also increased in the Dutch East Indies. This is clear not only from Raffles' study, but also from the establishment of a commission on archeological investigation in 1822, its ultimate result being the creation of the Archeological Association (Archaeologische Vereeniging) in 1875. A spectacular discovery of prehistoric human remains was made in 1891: the skull of *Pithecanthropus erectus* was found by Eugene Dubois in Trinil, East Java. In 1862 the talented artist and photographer I. Van Kinsbergen accompanied the archeologists in their excavations, and took splendid photographs of the discovery sites and excavated objects, and of the objects sent to museums. From 1913 on his photographs, together with those taken by Cephas, were to form the core of the photographic collection of the Archeological Service (Oudheidkundige Dienst) established at that time.

The beginning of the twentieth century was an eventful period in the history of archeological research in Indonesia. In 1901 the government of the Dutch East Indies established a special institute for archeological research on the islands of Java and Madura: the 'Commission in the Dutch East Indies for archeological research on Java and Madura' ('Commissie in Nederlandsch-Indië voor oudheidkundig onderzoek op Java en Madoera'). The first president of this commission was Dr. J.L.A. Brandes, and the second (from 1910) Dr. N.J. Krom. The commission frequently published Reports of the Archeological Commission (*Rapporten van de Oudheidkundige Commissie*) and also monographs illustrated with a wealth of photographic material over various temples, for example the temples of Jago (1904) and Singasari-Panataran (1909). Brandes himself wrote these latter monographs.

As evidence of the seriousness of the colonial government's intention to stimulate research, in 1913 the Commission was transformed into a government service: the Archeological Service, headed first of all by N.J. Krom. In conformity with its new status as an official governmental organization, the Archeological Service was given a heavier work load. Its tasks included the composition of archeological inventories, the inspection of the current condition of historical remains, and the institution of a programme for documenting monuments and objects, and for preventing their deterioration. The series of regular publications is now called *Rapporten van de Oudheidkundige Dienst* (Reports of the Archeological Service). After his retirement from active service, Krom himself wrote impressive handbooks: *Inleiding tot de Hindoe-Javaansche kunst* (Introduction to Hindu-Javanese art) (three volumes, 1923), and *Hindoe-Javaansche The History* (Hindu-Javanese history) (1931).

From 1915 to 1936 the direction of the Archeological Service was in the hands of Dr. F.D. K. Bosch. In that period the tasks undertaken by the Service were extended with the restoration and conservation of monuments. A set of legal measures were also created to protect archeological and historical remains. In 1931 the government promulgated its Monuments Ordinance (*Monumenten Ordonnantie*), a measure that was to be converted, sixty years later, into Law no.5 of 1992, the *Undang-Undang tentang Benda Cagar Budaya* – the Law for the protection of the material-cultural heritage. Bosch was succeeded by Dr. W.F. Stutterheim, who directed the Service from 1936 to 1939. There were still several activities in the field of restoration and protection to be taken up, before the period of the war followed by the struggle for independence brought the work to

a temporary stop. It was only in 1953 that the Service had an official director once again: R. Soekmono, the first Indonesian to complete his studies in archeology at the University of Indonesia. Later on he was also to direct the restoration of Borobudur (1970 – 1983), carried out with the help of Unesco aid.

The heritage of the Dutch government in the East Indies, in this case the care of archeological and historical remains, was taken over by the Republic of Indonesia. The Indonesians can be grateful that, in the field of scholarship, they are able to continue building on the foundations laid by the Dutch in Indonesia. After Independence in 1945, and especially after the post-war reorganization of social life, in which the Archeological
Service was transferred into Indonesian hands, the Service was given the Indonesian version of its old name: *Dinas Purbakala*. Later on the name was changed to *Lembaga Purbakala dan Peninggalan Nasional* (Institute for Archeology and National Heritage).

In 1975 the Institute was split in two. The branch occupied with archeological research continued under the name *Pusat Penelitian Arkeologi Nasional* (National Research Institute for Archeology) while the other branch directed its efforts to registration, conservation and restoration. Thus it also required chemists and construction engineers. It continued its life as the *Direktorat Sejarah dan Purbakala* (the Directorate for History and Archeology), later called the *Direktorat Sejarah dan Purbakala* (Directorate for the Protection and Management of the Historical and Archeological Heritage). Both these offices were under the control, up to 2000, of the Director General for Culture. However, the continued existence of the directorate general experienced a period of uncertainty with the 'cabinet changes' after Dr. B.J. Habibie's term as chairman. During the following chairmanships the Research Institute and the Directorate were abandoned as independent bodies; they were transferred to the offices of the people known as Deputy Assistants. The provincial departments of both the research institute and the directorate now found themselves in a position of uncertainty, in which it was unclear whether they fell completely under the aegis of the regional government, or were subject to a national coordination.

Individual collectors In Part Three of this book, the central place is occupied by the broad category of individual collectors. Although all the figures under discussion have a colonial context in common, there are great individual differences. The collectors' personal backgrounds varied considerably, as did their methods of collecting. A good deal depends on the period in which the collector was operating. In our opinion, an early nineteenth-century collector operated in a much more superficial way in the ethnographic field; he penetrated less far into the interior, and he gathered less detailed ethnographic information than his counterpart from the late nineteenth century.

In illustration of this point, we would like to use an example of a collector from the mid-nineteenth century, Baron C.B.H. von Rosenberg. This German aristocrat collected objects for both the Leiden and the Batavia museums. Unhappily, there is no certainty about which objects from the collections in the National Museum were acquired by the Baron. Two nineteenth-century re-numberings of the Sumatra collections, in particular, held by the Batavian Society, have given rise to great uncertainty. Further research is needed in order to clarify this situation.

Carl Benjamin Hermann, Baron von Rosenberg, was born in Darmstadt in 1817. He was certainly the descendant of an old, aristocratic line, but he did not possess the financial means for

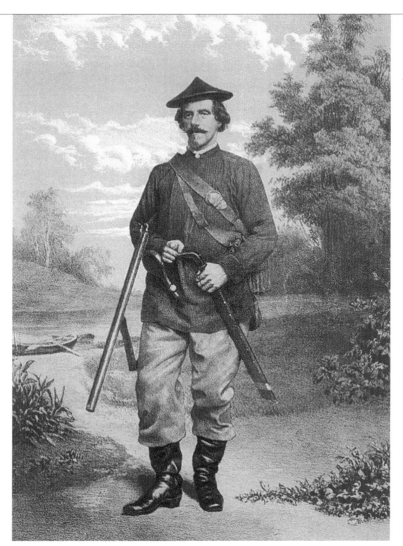

C.B.H. Baron von Rosenberg

Portrait from Der Malayische Archipelago
[The Malayan Archipelago], 1878

independence. As a young man he had already developed the desire to travel to far-distant countries, but a military career was more within his expectations. Consequently his time as a student was more a preparation for military service than for an academic future. After serving for several years in the Hessian army, Von Rosenberg applied to join the Dutch colonial army. Clearly he still needed more money since he had to be content with the rank of Corporal.

In May 1840 Von Rosenberg arrived on Java. He was transferred to Sumatra, where he was made assistant to the geologist Junghuhn, among other functions. He also frequently took part in military expeditions in the Batak region, which up to that moment had not yet been brought completely under Dutch control. In this period Von Rosenberg must have collected various objects from the Batak region. One of the oldest Batak magic staffs (*tunggal panaluan*) (RMV 79-3) must have been collected in c. 1850, yet it is not clear from Von Rosenberg's published and unpublished records where the staff was acquired, or the circumstances under which it came into his hands. He certainly often wrote about abandoned villages found by the soldiers, places where it was very difficult to make any contact with the local population. It seems likely that Von Rosenberg profited from the fact that the local people took to their heels at the approach of an army patrol.

From 1845 on, Von Rosenberg was on the General Staff in Padang (West Sumatra), where he obtained ever greater opportunities for developing his wide range of interests. He carried out a great deal of map work, and travelled the length of the islands off the west coast of Sumatra, among other journeys. In 1847 and 1849 he called in at the Mentawai islands, and in 1852 he visited the island of Enggano. In this period he began to publish his findings, and a steady stream of articles appeared. He was one of the first to publish fairly reliable information on the population of Enggano. This work was still a long way from modern ethnological fieldwork – Von Rosenberg's stay on Enggano lasted only two weeks, and sickness prevented him for pushing into the interior – but it was a beginning.

As mentioned earlier, the quality of the ethnological observations improved during the course of the nineteenth century. Even Von Rosenberg, originally no ethnographer, developed further in this respect. In 1855 he entered the service of the Topographical Office (Topografisch Bureau) in Batavia, whereupon he finally left his military existence behind him in 1859. He entered the service of the colonial government, and was released to devote his time to scholarly research. From that moment on he directed his attention especially to East Indonesia. He has already been in New Guinea, but now he was in a position to visit the Moluccas, the Smaller Sunda Islands, and Sulawesi. His writings continued to appear in print at frequent intervals, but – in common with many of the early researchers – he suffered a great deal from tropical diseases. He left the government service for good in 1871. Back in Europe, Von Rosenberg was awarded various honours by both the Dutch state and various German states, such as his natal Hessen. In 1878 his book *Der Malaysische Archipel* was published, in which he described his adventure in the Dutch East Indies, in an accessible manner. He died in 1888 in The Hague.

Von Rosenberg's very productive life cannot be summarised in a few paragraphs. He wrote a great deal, and as a scholarly government official he journeyed through large areas of the archipelago. In Batavia Von Rosenberg was also involved with the Batavian Society of Arts and Sciences. His name often appears in the notes, especially as a donor of collections, but he was also active in other ways on behalf of the Society. He published in *Tijdschrift voor*

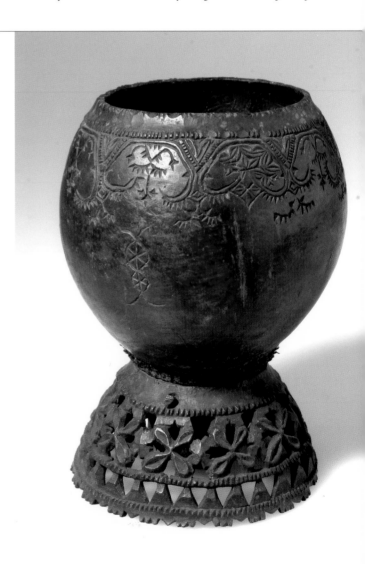

Indische Taal-, Land- en Volkenkunde (Journal of East Indies Language, Geography and Ethnology) brought out by the Batavian Society, and he gave advice on the subject classification to be used for the first catalogue, among other matters. For details of Von Rosenberg's role in the development of the Batavian Society, we recommend the book by the historian Hans Groot due to appear in 2006.

Colonial exhibitions Most of the sources of collections mentioned here, will be discussed at length in this book because, in many cases, there is the question of divided collections. However, this aspect of the division of collections between Batavia and Leiden is not so clearly seen in the category 'colonial exhibitions'. After the large-scale colonial trade exhibition held in Amsterdam in 1883, a great deal of material certainly found its way into the National Museum of Ethnology in Leiden (series 370), thanks to Serrurier, still active as ever, but as far as we know nothing was returned to Batavia. In the case of the exhibitions taking place in the East Indies itself, especially those in Batavia and Surabaya, some material occasionally found its way to Leiden, but the route taken by objects in the Dutch East Indies is harder to trace. Without doubt, a great many objects were sold on the market, and there seems to have been no conscious policy for depositing the objects collected for these exhibitions, in the Museum of the Batavian Society. For a good analysis of the phenomenon 'colonial exhibitions', we recommend the reader to the book by Marieke Bloembergen (2002).

Gifts Various gifts made by Indonesian princes to the Dutch rulers found their way into museums. In a number of cases we can trace the gifts that were divided up between the Batavian Society and the National Museum of Ethnology. Clear examples can be found especially in the context of the complex history of Bali – a history filled with alliances, conquests and violence. This aspect will be examined in greater detail in the chapter on Bali by Francine Brinkgreve.

Military expeditions Finally, we should devote some attention to military expeditions as sources of collections. Especially in the case of the Aceh war, with its key figures Snouck Hurgronje and Van Daalen, the events on Bali and Lombok, and the military activities in South Sulawesi, are examined in some depth in this book (in the chapters written by Harm Stevens, Francine Brinkgreve, Wahyu Ernawati, Hari Budiarti and Nico de Jonge respectively). This collecting context is the most controversial, and is firmly linked to such ethical questions as: by what right did the colonial oppressors carry away objects from Indonesia with military force? Are the European ethnology museums prolongations of out-of-date colonial thinking? If so, what should then be done with these museums?

The subjection of regions by the use of violence is now, quite rightly, viewed as a black page in colonial history. Even at the time of the campaigns in Aceh, Lombok and Bali, there was also criticism, yet generally speaking, few people entertained many fundamental doubts about the colonial venture. Whether it concerned financial gain, or bringing European 'civilization' and the Christian religion to the 'native', only a few people openly expressed their doubts concerning the 'great things being achieved'. Military invention formed part of this. It was seldom difficult to find a justification. Thus when Lombok was invaded, the Dutch emphasised that the local population, the Sasak, was being oppressed by the Balinese princes.

Drinking Beaker

Timor, Lesser Sunda Islands
Collected by S. Müller
Coconut shell
Height 13 cm
RMV 16-219

In this book there is no discussion of the ethical questions that emerged from the military activities in the former colonies. Nonetheless, we hope to provide the background information that will permit a good discussion of this problematic. In this respect we find our way to the questions that occupy central place in the project Shared Cultural Heritage.

Project Shared Cultural Heritage

The English expression 'Shared Cultural Heritage' may be interpreted in two ways: shared cultural heritage or common cultural heritage. In this book, and in the exhibition for which this book forms the catalogue, both these meanings are used. The collections that have been studied in the context of the project are divided up between Batavia and Leiden, yet they derived from the same source: collector, donor, or archeological discovery site. Although the objects in the collections were produced in the various Indonesia regions, the collections constitute a heritage shared by Indonesia and The Netherlands, and this must also be approached in a communal spirit, both scholarly and political. Only if we know more about the collecting context of historic, colonial collections can we look at the past with an open mind. Only then can we evolve models that will make future co-operation possible and fruitful.

For a long time in the museum world, little attention was paid to the collecting contexts. Meanwhile there has been a change in this situation, yet even in 1991/1992, the emphasis in the three large-scale Indonesia exhibitions to be seen in The Netherlands still lay on the esthetic and the ethnological, rather than on the way in which the objects found their way to the west. In 1994 the American researcher Margaret Wiener sharply criticized the exhibition set up

the Asia Gallery in *New York, the Court arts of Indonesia*. This could also be seen in The Netherlands as the opening exhibition in the Kunsthal in Rotterdam. Other big exhibitions from the U.S.A. also reached The Netherlands: *The sculpture of Indonesia*, to be seen in the Nieuwe Kerk in Amsterdam, and *Beyond the Java Sea*, held in the National Museum of Ethnology in Leiden. These were also subjected to the same criticism, that they contained beautiful objects and sometimes exciting archeological-historical or ethnological information, yet they devoted hardly any attention to the collecting context. In both the exhibitions and the accompanying catalogues, the way in which the objects reached the western collections was not mentioned, let alone the way in which this collecting context has influenced the western image of these other cultures.

In this project we cannot do everything at the same time. Many questions remains unanswered in this catalogue. Nonetheless we would like to ask, explicitly, for attention to all the things that have not been mentioned up to the present – from fear of the political-cultural consequences, from ignorance, or because no one saw any importance in the subject. Here we ask you explicitly to turn your attention to the exciting story of the collecting context: a piece of colonial history with the collections as reference point. A great deal can be learned from the history of collecting.

Mukhalingga

Surabaya, Java, 14th century
Stone
Height 62 cm
MNI 352

Today, Singasari is a village in the Malang region of East Java. Its name is probably a survival of that of an old kingdom of Singasari, that flourished in the thirteenth century in what is now the province of East Java. Before we consider the sculpture of the Singasari period in detail, especially the remains discovered at the Singasari temple, it would be useful to give brief consideration to the prehistory of the Singasari period.

The Kadiri period as forerunner

In Java, the Singasari kingdom succeeded the Kadiri kingdom. While the Kadiri period was the golden age of Javanese literature, the Singasari period was more renowned for its sculpture and, in particular, for the execution of stone carvings. The Kadiri kingdom left a heritage of beautifully composed poetic literature in the genre of the kakawin. This genre had been developed from the kavya of Sanscrit literature. Kakawins - written during the rule of the Kadiri - has survived right up to the present; it is found in different theatrical and literary works on Java and Bali alike.

Thus, the Bharatayuddha - which tells of the great war between the Pandavas and the Kauravas - is one of the most popular stories of the Kadiri-kakawins. Other known examples include the Smaradahana (the incineration of the God of Love by Lord Siva's third eye), the Ghatotkacasraya (the help given by Ghatotkaca for the marriage of Abhimanyu with Krishna's daughter, the Bhomakavya (the story of Bhoma, Krishna's son, and the Earth Goddess; an episode of this story concerns the origin of the lingga, or Lord Siva in the form of an immense cosmic fire), the Kresnayana (the story of Krishna), and the Sumanasantaka (death caused by the heavenly flower; the history of Rama's ancestors).

Some scenes, selected from these stories, in relief panels from the walls of East Javanese temples, should be observed together with the kakawin, the Arjunawiwaha, written early during the rule of King Airlangga. Representations from the kakawins are sometimes called atapukan or wayang wang, and might be dramatised, as is the case with comparable stories in the kakwins themselves. This all goes to suggest that artists concerned with literature, and the visual and dramatic arts, possessed a platform for mutual exchange.

The history of the Singasari kingdom

The formation of the Singasari state was the first attempt to form an imperial state in Javanese history. This development culminated in the ensuing Majapahit period. It is interesting to compare this remarkable development in South-East Asian history with other attempts to form states in the region.

The first king of Singasari was the legendary Ken Angrok, as he is known in the later traditional historiography. His official name is Srî Ranggah Râjasa or Srî Girinâtha. These names are mentioned in a source closer in date to his own time, the early Majapahit Nâgarakertâgama. He is considered as the founder of both the Singasari and the Majapahit dynasties. Old Javanese written sources mention this king as responsible for substantial developments in the region 'east of Kawi mountain' in East Java. Singasari kings, such as he and the later Kĕrtanagara took the initiative for the formal recognition of the 'Highest Truth' attributed to Sivism and Buddhism.

The copperplate inscription of Mûla-malurung shows the manner in which the kingdom of Singasari was established. This inscription was made on the orders of Narâryya Sminingrat in

Edi Sedyawati

The Sculpture of the Singasari Period

1177 Saka (or AD 1255). Sminingrat established family members as regents in various regions, and he also appointed them to the chief, fortified towns (nagara or râjya) and 'territories' (bhûmi). Their names and respective territories are as follows:

1 A person who ruled as hajj (= regent or king) in the nagara of Madhura (the name of this person is inscribed upon a missing part of the inscription.)
2 Narâryya Kirana as regent of the nagara of Lamajang.
3 The sainted Srî Kretanagara in the nagara of Daha in the bhûmi of Kadiri.
4 Srî Jayakatyeng,, together with his spouse, the king's daughter, in the nagara of Glang-glang in the bhûmi of Wurawan.
5 Srî Ratnarâja in the râjya of Morono.
6 Srî Narajaya in the nagara of Hring.
7 Srî Sabhâjaya in the nagara of Lwa.

Other inscriptions – what is called the ship charter of 1358 and the Maribong inscription of 1264 – show that Sminingrat is also the name of Wisnuwardhana, the fourth king of Singasari. His full name is expressed in these inscriptions as 'bhatâra Srî Wisnuwardhana ikang Pañji Sminingrat' and 'Srî Jaya Wisnuwardhana sang Mapañji Sminingrat'.

The kings succeeded one another naturally. First came Ranggah Râjasa alias Ken Angrok, who conquered Tunggul Ametung, the akuwu or Tumapel. Afterwards, Angrok changed the status of the akuwu-ship into kingship. By doing this, the relatively small Tumapel appears to have been established as the new centre of an enlarged kingdom. Râjasa's successor was Anusapati, a son deriving from the alliance of his wife with her earlier spouse Tunggul

Ametung. Angrok's son Tohjaya was the next successor, and thereafter Wisnuwardhana, the son of Anusapati, and also known as Ranggawuni. The last of these successive kings of Singasari was king Kĕrtanagara, son of Wisnuwardhana. Kĕrtanagara's daughters would play an important role in the history of the succeeding kingdom of Majapahit.

The Art of the Singasari empire

The building of stone temples appears to have gained momentum during the Singasari period. Some temples were memorial shrines for deceased kings, such as that dedicated to Anusapati in the present village of Kidal. Other examples are temples in the village of Tumpang, known as candi (= temple), one in Jago (called Jahaghu in old Javanese sources, and devoted to Wisnuwardhana), and that in the present village of Singasari (dedicated to Kĕrtanagara). Some temples have not to this day been discovered, such as that of Râjasa in Kagenengan, and a second temple devoted to Wisnuwardhana in Waleri. In the fourteenth-century verse chronicle, the Nâgarakretâgama, one reads that the Singasari kings Râjasa, Wisnuwardhana and Kĕrtanagara were adherents of the Siva-Buddha doctrine.

Buddhist sculpture and iconography developed considerably in this period. Fine carvings of Buddhist saints from the Jago temple are now displayed in the National Museum in Jakarta. Four enormous sculptures from the temple in Singasari can be admired in the National Museum of Ethnology in Leiden. Where dimensions and refinement are concerned, these two temples are the most impressive legacy of the Singasari period. Hindu Sivism and Buddhism flourished alike in this period, and the question

◀◀
Durga slaying the demon Mahisha

Singasari, Java, 13th century
Stone
Height 175 cm
RMV 1403-1622

◀
Mahakala, an avatar of Shiva, as gatekeeper

Singasari, Java, 13th century
Stone
Height 175 cm
RMV 1403-1623

arises as to how they were related to one another. Was there merely a similar identification with the concept of Ultimate Truth? Or can we speak of an integration of concepts and symbols within a new 'system', comparable with that of Hindu Dharma in present day Bali? The fact is that up to the Majapahit period, distinct clergies existed for both Hindu Sivism and Buddhism, these being known respectively as the dharmâdhyaksa ring kasaiwan and the dharmâdhyaksa ring kasogatan. Yet at the same time there was only a single temple structure, exemplified by that of Candi Jago. This had an arrangement of clearly Buddhist gods in the form of upright sculpted figures, while relief murals illustrated both Hindu and Buddhist stories. Written sources mention that the Jago temple was built in 1280, that is to say, in the Singasari period, and renovated during the following Majapahit period in 1343. No other information is known about this renovation.

The art of Singasari, in particular sculpture, may be regarded as the second period of flowering in the history of Indonesian Hindu and Buddhist. The first period occurred during the Borobudur-Prambanan era in Central-Java,, when a remarkable Indonesian (that is, Javanese) style came to characterise sculptural works, both relief and three dimensional. Bodies were no longer represented as in the Indian examples, with sumptuous and sensual forms but instead were more controlled in form, although still characterised by flowing, wavy lines. During the second period of flowering in East Java, sculptural lines became more angular and bodily forms more refined and elegant. The carvings of the Singasari period are the most beautiful to be observed at the Candi Jago and Candi Singasari sites.

Buddhism and Hindu Sivism thus appear to have existed alongside one another, this being shown not only in written sources but also in the artistic remains found in both temple complexes. In the Jago temple, as has already been mentioned, we meet with figures from a Buddhist pantheon while the reliefs contain representations from both Hindu and Buddhist chronicles. In the Singasari temple, important figures of the Siva pantheon are found (most of which are displayed in the exhibition), while in the neighbourhood there is also found the renowned sculpture of the Buddhist divinity Prâjñâparamitâ.

A pointer to what is called the bhairava or tantra cult concerns the sculpture of Cakracakraat at the site of Singasari. Many specialists suspect that the 'integration' of Sivism and Buddhism resulted from their comparable role in the development of the bhairava-tantra cult. This idea is suggested by certain iconographic details that symbolise the site of cremation, the burial place, and worldly lust (that must be endlessly put up with before being finally vanquished), all of which have been figured in a demonic style. The standing figures of Cakracakra in the outer court and that of Ganesha in the main temple, have pedestals consisting of a row of skulls. Cakracakra, being eminently bhairava, has also a row of skulls in the form of an upavita (the cord representing status) and as headdress. He holds a beaker made of a skull and is guarded at his rear by a jackal. This god is carved in the nude and he holds a triśula, or triple-pointed lance, the symbol of Siva, and a damaru drum that symbolises the cosmic rhythm produced by Siva as Natarâja, the god of dance.

Where style is concerned, the Singasari standing sculptures display an elegance of line used to express the physical robustness of the figures. We also observe considerable refinement of ornamental detail, such as that seen in the variety of patterning of loincloths and jewels. However, the standing figure Prâjñâparamitâ appears,

Yoni

Singasari, Java, 13th century
Stone
Height 27
MNI 3549

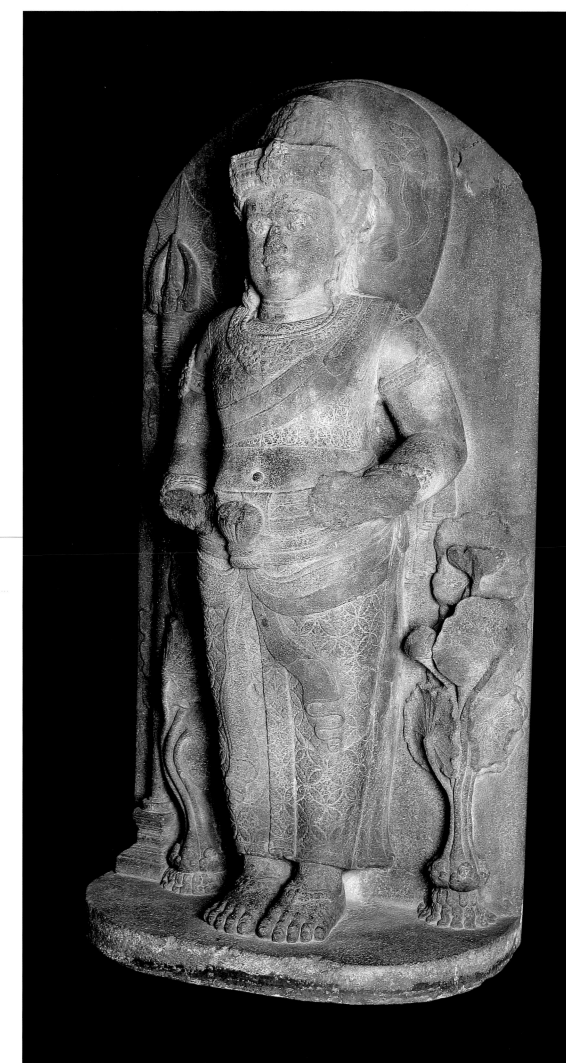

Nandishvara, an avatar of Shiva,
as gatekeeper
..
Singasari, Java, 13th century
Stone
Height 174 cm
RMV 1403-1624

when facing it, deformed due to the fact that her bent legs seem too small in proportion to her body. The explanation for this might be that the carving originally stood in a position placed higher than the observer, so that the perspective from below would act to correct this semblance of deformity.

Another iconometric characteristic of Singasari concerns metrical relationships among a group of Siva gods (Durgâ, Ganesha, and Agastya) that reside in the most important of the temples. These metrical properties are the same as those found at the Gedong Sanga temples of the Central Javanese period, while they differ considerably from those of Rara Jonggrang. Gedong Sanga represents the periphery, and Rara Jonggrang central state worship. At Rara Jonggrang, Durgâ is larger than Agastya, while at Singasari and Gedong Sanga and other peripheral temples of Central Java, Agastya is larger than Durgâ. Moreover, the mutual tâla relationships of the Ganesha at Singasari is similar to that at Gedong Sanga yet different from that of Rara Jonggrang. This leads to the assumption that at Singasari the standing figure – representing the worship of a central state – is a consciously designed work embodying aesthetic and iconographic norms. This might have been a consequence of political, social and cultural developments in the Singasari period.

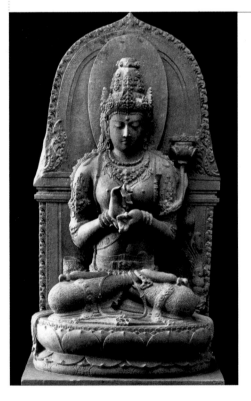

Prajnaparamita, goddess of the highest wisdom

Singasari, Java, 13th century
Stone
Height 126 cm
MNI 1403-1587

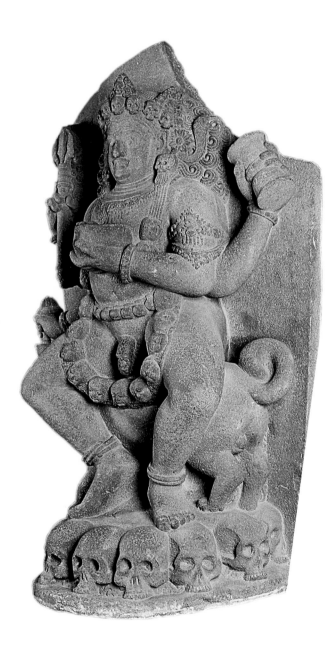

◀
Bhairava, a demonic form of Shiva
..
Singasari, Java, 13th century
Stone
Height 167 cm
RMV 1403-1680

▶
Ganesh, the elephant god
..
Singasari, Java, 13th century
Stone
Height 154 cm
RMV 1403-1681

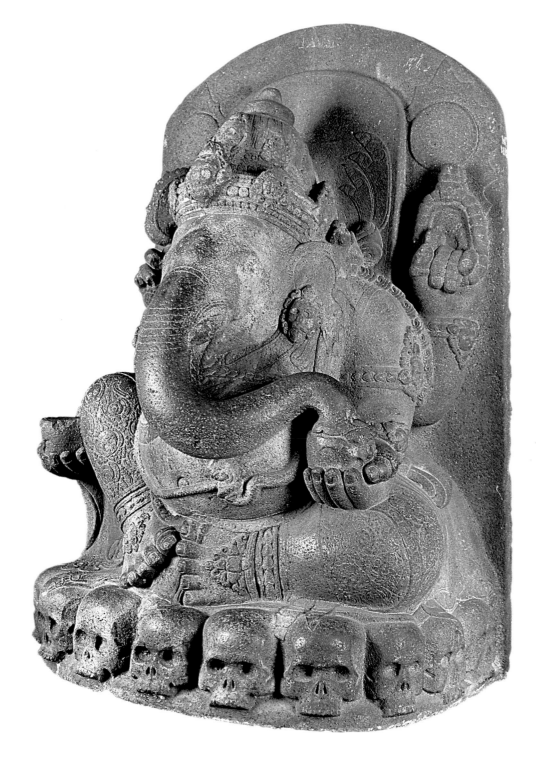

The ancient Indonesians left behind a magnificent heritage in Borobudur. With world-wide help, this monument has been rescued and restored in recent years, and it has regained its former splendour as a pilgrimage site. It is a place for elevating one's thoughts, and a miracle of beauty.

Borobudur arose in the time of the Buddhist Shailendra dynasty, which once ruled an extensive region of South-East Asia. The sanctuary, built in Central Java at the peak of Shailendra power in the eighth to ninth centuries, retained its importance for many decades afterwards. Yet the succeeding dynasty was more attracted by Hinduism, while at the beginning of the tenth century the island's political and cultural centre shifted to East Java. There are indications that many Central Javanese monuments disappeared beneath the lava and dust of volcanic eruptions, while the region became steadily depopulated. After the tenth century, Borobudur gradually fell into a state of neglect, without ever being entirely forgotten. Local chronicles from later centuries occasionally mention the monument, yet in the eighteenth century the place had acquired a bad reputation, and the local population gave it a wide birth through fear.

Europeans discovered Borobudur at the beginning of the nineteenth century, during the brief period when Great Britain ruled Indonesia. In 1814 the Dutch engineer Cornelius and his team, under orders from the English Lieutenant-Governor Raffles, hacked the site free of trees and plants, and made the first map and drawings of the monument. Two decades later Sieburgh, a talented painter, made a large number of lovely drawings and paintings there. In 1873 there was great public interest in, and acknowledgement for Wilsen's large-scale publication with detailed architectural drawings. In the following years the advent of photography permitted the world to see the architectonic miracle recorded in a realistic manner.

Numerous efforts to rescue the sanctuary got into their stride, and the first scholarly restoration of Borobudur was carried out between 1907 and 1911 (Krom and Van Erp, 1920). This project for repairing and restoring the place was accompanied by a stream of scholarly publications, forming the basis of our present knowledge of the monument. Some sixty years later Unesco directed the second restoration, with financial contributions and aid from experts the world over (Bernet Kempers 1976: 189-211). This work was finished in 1982. Borobudur was entered in Unesco's World Heritage list as a site of unusual national and international importance. The monument has now recovered its original grandeur, and attracts ever-increasing numbers of art lovers. The local people are no longer afraid of the sanctuary, and – like the innumerable pilgrims and visitors pouring in from all over the world – have fallen under the powerful influence of the place.

Since the Europeans discovered Borobudur, an enormous amount of research has been carried out on the place. Discussions, conferences and publications have followed hard on each other's heels. By this means an ever-greater quantity of information has become available, yet this in itself has raised new questions that, in turn, have given rise to further study. Recent research and archeological excavations have produced both new data on the monument's history, and new insights into the social functions it once had. Various pieces of the puzzle have fallen into place, but many others have yet to do so. Borobudur continues to fascinate the world. New ideas, exciting theories, complex hypotheses and daring speculations continue to raise their heads, nourishing scholarly research and debate.

Nandana Chutiwongs

Pieces of the Borobudur Puzzle Re-Examined

Our present-day knowledge

In the meanwhile a good many data have come to light on the dating, the stages of construction, the structural design, and the iconology of Borobudur. Taken together, this material allows us to present a general picture with which most researchers would agree.

The architectonic framework The structural design of Borobudur is definitely unique, yet there is nonetheless a probable relation with Indian building traditions. According to some local legends, the chief architect of the monument was called Gunadharma, a name indicating an Indian origin. His profile can be seen on the horizon, in the contours of the Minoreh mountain range forming the setting for the place. The material form of Borobudur is undoubtedly related to the terrace-shaped *stupas* of North India, which have had a long and variable development.

Borobudur however, in its ultimate design, has no parallel. The construction of a building of this type and scale was certainly unknown in Indonesia, both before and after the time of the Shailendras. In ancient Indonesia, Buddhist and Hindu temples were usually fairly small and compact – in architectural treatises and inscriptions they are termed *griha* or *devagriha*. Each of them offered a place for either one or several statues (*arcca*), which either stood alone or were grouped according to a plan. Buildings of this kind had no public function, and they only allowed enough space for several select worshippers. Borobudur in contrast, was an innovation of the Shailendras, the building being designed as a large, long place for worship, open and accessible to large groups of monks and lay people. Similar places do occur even in ancient Buddhist India and Sri Lanka (see De Casparis 1961: 241-248).

The Shailendras' wealth, political power and contacts with the cosmopolitan cultural centres of the time, induced them to construct a large temple for the Buddha close to their own residence. Yet besides this, they also built the great, open site of worship site meant for performance of collective rituals. In this place, visiting scholars and pilgrims could also be accommodated. Many remains of cloisters and guest houses have been excavated in the neighbourhood of Borobudur (Bernet Kempers 1976: 11-21).

International traffic by land and sea reached a high point in the seventh and eighth centuries. This was consequently a period in which Buddhism's impulse to convert people left clear traces in countries outside India, in the regions behind the Himalaya mountain range and in the deserts along the silk route from Central Asia to China. The flourishing sea trade brought wealth to the Shailendras, while culture, art and scholarship flourished under the patronage of these rulers. New cultural contacts were laid between the Shailendras and the Pala dynasty in the Indian regions of Bihar and Bengal, as can be seen from inscriptions, the visual evidence that they shared the same faith and the art styles linked with this. Erudite *pandits* (Hindu religious scholars) from India served at the Shailendra court, and they may well have been the people stimulating the initiative for the new architectonic concept, with the aim of pleasing their lords and masters. They would have stimulated local sculptors to deviate from the familiar tradition and work in the new style and a new religious idiom. In this way a unique artistic expression developed, one that was highly valued throughout the ancient world. Borobudur excites admiration even among present-day connoisseurs, (Diskul 1980; Fontein et al, 1991).

Sketch in the vicinity of Borobudur, by Sieburgh, c 1837–1839

RMV 37-903

The structure and material of Borobudur refer in a symbolic manner to the cosmos, religious concepts, and spiritual metaphysical meanings. Its structural form is described by researchers as *stupa* (the original meaning being 'remains of a burial mound'); *prasada* (sanctuary or temple); or *mandala* (cosmological diagram). In fact, Borobudur bears all three definitions within itself (Krom and Van Erp 1920; Stutterheim 1956; Soekmono 1976; Bernet Kempers 1976; Dumarcay 1978). Various Buddhist literary sources are also used in explaining the meaning and function of this imposing monument (Mus 1935; Fontein 1967; Boeles 1985).

Borobudur is first and foremost a *stupa*: a monument built to honour the Buddha. *Stupas* may have different forms, varying from the simple to the complex. Early *stupas* were sanctuaries sheltering the earthly remains of the Teacher. Later on, they were built for other kinds of 'holy relic' such as 'Word Relics' (the Teaching, written on various kinds of material) venerated as the metaphysical body and the real essence of the Buddha. It is plausible that Borobudur contains not the actual physical body but the 'metaphysical body' (*dharmasharira*) of the Buddha in the form of word inscriptions or texts, and other symbols of a similar kind. The Borobudur stupa has an elaborate and complex form, incorporating many other architectural elements, as well as extravagant sculptural and iconic components. In this form it might have served as a sanctuary or temple (*prasada*) which people entered in order to venerate the Buddha.

The underlying design was undoubtedly a diagram of the universe (*mandala*), ingeniously and symbolically expressed in architectural components and meaningful sculptures. Borobudur shows the cosmological system as a three-dimensional structure, with terraces representing various overlapping levels of consciousness, and the four compass directions reaching out from a centre symbolising the Throne of Creation.

For the Shailendras, Borobudur was a cosmic mountain, the axis of the Universe, the fountain from which the Buddha's teaching poured and the root of their own dynastic vitality. The original and sacred name of the monument was probably *bhumisambharabhudhara*, indicating the many steps the aspirant had to climb in order to reach Enlightenment (De Casparis 1981: 47-83). The layout of the monument provides a clear guideline for spiritual enlightenment, and this guideline can be followed materially as well as spiritually. The guidelines are personified by the terrace structure, the steps, and the passageways that guide the pilgrims in their upwards circumambulation towards their ultimate goal. The incised reliefs on the circuit, particularly, are full of instructive pointers for the throngs of pilgrims on their road to wisdom and spiritual growth. The rising terraces and the reliefs reflect the dynamic and flow of life, governed by the inexorable law of actions and and their consequences. Setting out along the right path, the pilgrims encounter teachers and others able to free them from ignorance and folly. Wisdom and purity, continually increasing, will bring transcendence to the spirit, until it finally rises to a cosmic Space.

The cosmic diagram of Borobudur has a close link with the *mandala* of the Vajradhatu type, as this is known from various northern Buddhist countries (Bosch 1961: 109-118; Chandra 1986). The diagram of the mandala consists of five parts, with the five sacred Buddhas at their heads (*Tathagata/Jin*), which also govern the five elements of the human body and the universe. However, the system in Borobudur is even more elaborate and contains six or even seven Buddhas.

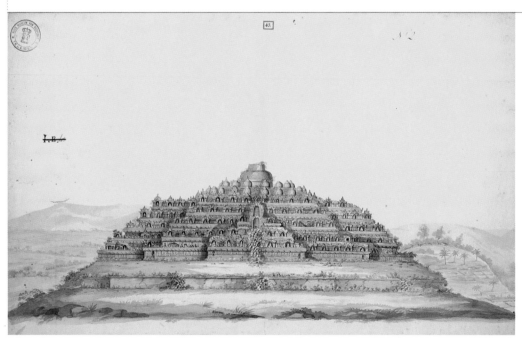

Two further Buddhas have been added to the five sacred Buddhas reigning over the four quarters and the centre. These additional Buddhas are regarded as governing the higher spheres of the Universe at the top of the cosmic mountain: one on the border between the two worlds of Form and Formlessness, and the other over the original invisible world. There are conceptual similarities between Borobudur and the theological systems expounded in the ancient Javanese text *Sang hyang kamahayanikan* (Kats 1910). The oldest part of this probably dates from the beginning of the tenth century. The text emphasises both the relationship between human beings and the Universe, and the essential role played by the teachers on the way to Enlightenment.

The finds in the principal stupa One of the unsolved questions concerns the remains of the biggest *stupa*, standing at the top of the sanctuary, and also in the very heart of Borobudur. According to the sources, this hollow dome remained officially unopened until 1842, although there were traces of several illicit break-ins from earlier dates. Cornelius probably made his sketches of the interior via one of these openings. Yet according to a verbal source from the same period, there was a large well in the floor into which the treasures must have fallen, which is why they had originally escaped notice. Stories were also current that gold Buddha statues could also be found inside the *stupa*.

In the end the *stupa* was opened by Hartmann, governor of the Kedu region. An unfinished stone Buddha statue and a number of small metal objects were found, all of which had to be excavated from under the floor of the innermost room. After a superficial inspection, the small objects were hastily laid aside since they dated from a much later period. However, the unfinished Buddha attracted the attention of the searchers, and turned into the subject of numberless controversies over whether this actually formed part of an original treasure.

The unfinished Buddha The most acceptable idea was either that the statue had been put down there by Hartmann – who still expected the greatest mystery, hidden in the heart of Borobudur, to be solved – or by his subordinates, who wanted to satisfy his longings for a discovery of this kind. Other people believed that the statue was authentic and that it constituted part of the metaphysical content of Borobudur (Stutterheim 1956; van Lohuizen-De Leeuw 1965; Bernet Kempers 1976; Soekmono 1976; De Casparis 1981).

We, too, are inclined to accept this idea, after making several examinations of all the sources. Sieburg's unpublished journal, written before 1842, mentions people's belief that an unfinished Buddha statue was concealed in the stupa, although he had not seen this himself. This reference must therefore have released Hartmann from the accusation that he had faked his evidence. Yet there are other reasons, as well, for clearing him on this count. According to the reports of the first restorers, the hole in the dome existing before 1842 was too small to allow the Buddha statue to be passed through. Even if Hartmann or his subordinates had placed it there, then it could never have been dug so deep into the floor. An even stronger argument is that of why the 'suspect' should have chosen such an imperfect and unappealing Buddha statue as his central find while there were many much finer examples in the immediate surroundings? Moreover, all the sources point to the fact that Hartmann seemed to be rather disappointed and astonished, rather than pleased, with this find. Many people shared his reaction, until

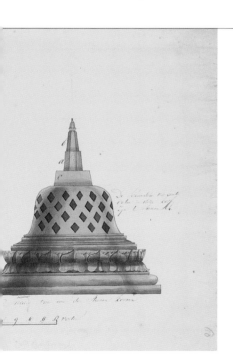

◄◄◄
View of Borobudur. Drawing by the Dutch engineer Cornelius, 1814

RMV 1403-3551

◄◄
Cross-section and interior of one of the perforated stupas. Drawing by Cornelius, c. 1814

RMV 1403-3587

◄
Drawing of the central stupa at Borobudur, probably by Wilsen, c. 1839

RMV 1403-3653

Foucher came forward with several seventh-and-eighth-century reports by pilgrims referring to the unfinished Buddha of Bodh Gaya, the most famous place in the history of Buddhism (Krom and Van Erp 1920: 644-655).

In principle, a phenomenon of this kind is not completely inconceivable in Borobudur. The style of the unfinished statue undoubtedly dates from the same time as the monument itself. The damage to the face was done during the excavations; some parts of the body were still rough stone. The completion of the Bodh Gaya statue would have been prevented by divine intervention, on the principle that a perfect representation of the sacred form could not, and must not, be made by human beings. This view – clearly acknowledged and accepted by Buddhist pilgrims in every age – could have influenced the shaping of the most sacred Buddha figure in Borobudur. Just as Kern had suggested a century ago, this unfinished Buddha was found in the very heart of the monument, removed from human gaze, and this could have been intended as the symbol of the 'embryonic Buddha', the form still undeveloped, partly emerging from the abstract and undefined Buddha principle, yet also remaining in the womb of the Universe, invisible to the eyes of mortal beings.

The incomplete Buddha statue was once moved from the stupa to the top of the monument, where it was left to stand in the open air, protected only by the shade of a tree. It is obvious that the first generation of archeologists and renovators were confused by the statue. The local Muslim population held it in great respect; the Muslims of the locality worshipped it as a stone representation of their ancestral god, smeared it with earth, and paid it honour, despite the Islamic prohibition on idolatry. However, they also referred to it by the irreverent nickname *recho beleg*, 'statue in the

mud' (Scheltema 1912: 260). There continued to be great doubt about the statue even among the later scholars who directed the most recent restoration in the 1970s and 1980s. We are very happy that, in the meantime, the Unfinished Buddha has been released from its 'ancestral mud', and has obtained an honourable place on the museum site close to the monument.

The other finds in the main stupa Besides the Unfinished Buddha in the most important of the stupas, others have also been discovered. The very varying dating of these objects indicates that there has been some bungling in past collecting methods. The objects discovered and recorded in 1842 were probably left behind by treasure hunters, who entered by the hole already existing in the dome.

Krom recorded that the other finds consisted of a bronze statue, a cask containing a number of silver and gold coins, an iron kris, and a bronze dish used in sacrifices (*talam*). He also mentioned a fragment from a smaller Buddha statue, made of an 'inferior' kind of stone, found in the neighbourhood of the monument but probably originating from the innermost area of the main *stupa* (Krom and Van Erp, 1920: 652-654). Other, unconfirmed sources also mention a gold Buddha statue and a pot containing an ash-like substance. Fortunately, three of these objects have been kept safe in the National Museum of Ethnology in Leiden. According to the documentation, these objects were donated by G.J. Heiligers (Master of Law), the former secretary of the Kedu administration. Heiligers had acquired the objects in 1843 from the administrator of Magelang, who had informed him that the items had been discovered 'in a well in the temple of Borobudur'. Nothing is known about where the other objects were found.

The Archeological collections

Statuette of Padmapani/Avalokiteshvara from the main stupa

Borobudur, Java, 8th - 9th century
Bronze
Height 15.4 cm
RMV 1403-1841

The objects discovered appear to derive from two different periods: first, from the time when Borobudur was being built (the eighth and ninth centuries), and second, from the fourteenth and fifteenth centuries. The unfinished Buddha statue could only belong to the first period, like the bronze sculpture representing the Buddhist Bodhisattva Avalokiteshvara in a four-armed variant. The workmanship is extremely delicate, even though the figure is slightly damaged. On the basis of the brief description of several silver and gold coins, we can establish that these are of the *ma* type, used especially in Central Java from the eighth to the tenth centuries.

The bronze *talam* (dish used in a sacrifice) comes from fourteenth and fifteenth-century East Java, as can be seen from the rim spreading outwards and the waving lines of notches in the very stylised linear decorations. The iron *kris* is difficult or even impossible to date. The human figure above the top of the handle derives from the Bronze Age culture governing life in South-east Asia before new waves of culture from India spread over the region. Daggers of this kind were frequently found in Java. They were probably made by people in the locality, while better trained professional artisans produced delicate and luxurious goods for the Court and for people of the higher social classes. No object has been found dating from any time predating the Majapahit period (from the beginning of the fourteenth century), while a great number of items may even date from a much later period, when the term 'Majapahit kris' was used for them in the local language (van Duuren 1996). Regardless of the period in which they might have originated, the objects have a timeless, ritual and talisman-like character, resembling that of the *pusaka*, the ancient and beloved heritage enjoying so much respect within present-day Indonesian culture.

The finds from the stupas with holes in the round terraces In two of the *stupas* with holes in the round terraces encircling their tops, a number of smaller objects have been discovered, including a bronze Buddha statue, and five Chinese coins. The Buddha figure, now held in the National Museum in Jakarta, is of a qualitatively inferior workmanship and probably dates from the fifteenth century or later. The five Chinese coins, used as a medium of exchange, derive from the Tang dynasty (eighth century) up to and including the Ming dynasty (fifteenth century) (Krom and Van Erp 1920: 654-655).

Reconstruction of the history of Borobudur

Through their character and age, these heterogeneous finds can tell us something about the history of Borobudur as a temple, using as a basis the various activities performed in different periods by different kinds of group of worshipper.

Borobudur was never completely finished, but during (or after) an important phase of construction a ritual dedication must have taken place, when Shailendra power was still at its height. The Unfinished Buddha undoubtedly formed part of the original offerings, which also included many other ritual objects such as texts or summaries of important *sutras*. The gold and silver *ma* coins may also have constituted part of these offerings, in view of the fact that coins of this kind are often found in secret hiding places in religious sanctuaries where they were buried as rare offerings and as charismatic objects for attracting success and prosperity. The bronze statue of Avalokiteshvara dates from the same period, yet was probably placed in the main *stupa* only at a later date, together with the offerings from the fourteenth and fifteenth centuries. We will return to this point later.

After the political and economic centre of the island had shifted to East Java in c. 920, Borobudur must to a certain extent have been neglected, yet the sanctuary was never entirely forgotten. Possibly, it no longer fell under the complete protection of the court, but inscriptions and sculptural proofs from East Java show that, despite the dominant Hindu religion in the new capital, there were still influential Buddhist dignitaries at the site. New Buddhist waves arrived from North India, the bulwark of Tantrism – the teaching that neutralised the dogmatic differences between Buddhism and Hinduism – thus uniting the two streams. Borobudur may even have continued to be an important monument for the East Javanese rulers, who prided themselves on their kinship with the old house of Mataram from Central Java. *Nagarakertagama*, the eulogy for the kings of Majapahit written in 1365 by the Buddhist superintendent, points to Borobudur as a registered and acknowledged religious site.

The finds we have attributed to the Majapahit period in the fourteenth and fifteenth centuries have a ritual character. The *talam* is the best known, the priest's dish upon which ritual instruments were placed during the ceremony. The *kris* has a talisman-like character that reinforces the power of the ritual. The presence of these objects suggests that in Borobudur a ceremony, or even a new dedication, took place at some time between the fourteenth century and the year 1526, when the Majapahit kingdom finally surrendered to the power of Islam. This ritual attempt to revive the spirit and charisma of Borobudur may have been initiated by the Bajradhara sect, which had responsibility for supervision of the place. During the ritual a number of new objects were probably deposited in the main *stupa*, and the dome may have been opened for this purpose. In this way the objects originally present there, including one or more Buddha statues, would have been revealed. New objects, relevant to the dedication, were added, and these possibly included the priest's dish, the talisman-like *kris* and the bronze statue of Avalokiteshvara.

This last statue constitutes additional proof of the fact that a ceremony took place in Borobudur during the Majapahit period. Although the object is old, it is not likely to have belonged with the original objects. Despite the great popularity of Avalokiteshvara during the Javanese Shailendra period, this personage, belonging to the theological system of Borobudur, is seen only in several devotional reliefs in the role of one of the many exalted masters for the ideal pilgrim. It may well be that this bronze statue was added during the re-dedication of the monument in the mistaken assumption that it represented Shiva, the great Hindu god. It would not be the first time in history that a mistake of this kind was made.

Those studying the Buddhist and Hindu iconography are aware of the marked external similarity between the Buddhist Avalokiteshvara and the Hindu Shiva. An ascetic character characterises both of these as witnessed in the locks of hair pulled up and tied together on top of the head, the steady gaze, and the rustic tiger skin draped round the figure's hips. The only difference lies in the attributes, and in the presence of a miniature Buddha in Avalokiteshvara's crown, while Shiva carries a skull and a half moon. The worship of the four-armed Avalokiteshvara seems already to have fallen into disuse during the Majapahit period, while the most popular image of Shiva is consistently shown with four arms. The symbol on the front of the hairdo in this bronze figure is very unclear. The attributes in his hand are rather damaged, and thus barely recognisable. This four-armed statue could in this way have been regarded as a representation of Shiva by the priests of the Majapahit period. This would mean a remarkable addition to the *stupa*, as a counterpart to the Buddha statue or statues already

Kris

..

Possibly 14th - 16th century
Found in the central stupa of
Borobudur, Java
Metal
Length 28.3 cm
RMV 1403-1843

present there, obviously in keeping with the religious concepts of the period, when Shiva and the Buddha were worshipped as one deity.

At the end of the Hindu and Buddhist period in the sixteenth century, Borobudur and other ancient Javanese monuments were deserted and avoided by local people, who in the meantime had converted to Islam. The local population had developed a prejudice against such 'idolatrous' locations, and even had a superstitious fear of them. Yet Borobudur never entirely disappeared from local memory. In the Babad Tanah Jawi and

Babad Mataram of the eighteenth century, two extreme cases of adversity and bad luck are mentioned in which a link with Borobudur is established (Osoekmono 1976: 4-5; Bernet Kempers 1976: 183). The last bronze refers to the figure of an unhappy 'knight imprisoned in a cage'. Royal visitors looking at him would suffer misery and bad luck (Scheltema 1912: 268-269). The population thus recognised dormant mystical forces, charismatic power, and even the ability to bring bad luck to the monument.

The only group that probably had no fear would have belonged to the population of Chinese inhabitants of Java, whose cultural background gave them a positive stance to the Buddha statues and to Buddhist matters as a whole. They may have discovered Borobudur and its Buddhist character even before the Europeans. The small 'Buddha statue of inferior quality' and the ancient Chinese coins found on the terraces in the two opened *stupas*, by the restorers of Borobudur, may have been offerings made by such Chinese inhabitants. They could have thrown them inside through the railed-in openings, as visitors still do even today when they seek good luck.

The cutting down of the forest around the site, and the restoration of the mound, would have finally driven out the local population's superstitious fears. Even the Unfinished Buddha, with its sad air, could count on the sympathy of the Muslim community, and the unhappy creature, the 'knight imprisoned in a cage', has now come to be known as a lucky fellow. Local people often affectionately call him 'Grandfather Bima',. He is a guarantee of good luck and ensures that all wishes are granted. Some narrative images emenate a marked feeling of well being concerning the site, even to the extent of being attributed with the power to ensure wealth and a happy family life (Bernet Kempers 1976: 119). It is not only Buddhist pilgrims from Java and the entire world who make their way to Borobudur to honour the Buddha. All the Javanese people, whatever their religion or ethnic origins, often go there to offer flowers and incense.

Buddha Amitabha
..
Derivation Borobudur, Java, 8th/9th centuries
Stone
Height 106 cm
MNI 226

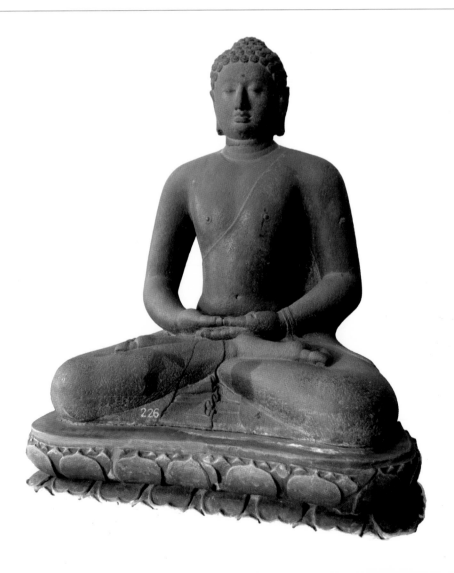

A variety of subjects relating to the temple at Borobudur have been explored in other publications, but few have discussed the archaeological finds in the area surrounding it.

The temple at Borobudur is a series of terraces and *stupas* built on a natural hill above the Kedu plain, 42 kilometres to the west of Yogyakarta. It is 31.5 metres high and 113 metres along each side. The hillsides in this region are steep, so space for building is limited, and a number of hills and mounds were included in the Borobudur site. The western courtyard, the largest, is built atop a mound separate from that of the main temple building. At the south-east corner of the temple is another hilltop, higher than that on which the main structure stands; it is thought to be the location of a nineteenth-century Islamic grave. When Borobudur was actively used as a temple, the south-east and north-east corners were considered suitable for this purpose.

All temple complexes, including Borobudur, had side buildings which functioned as dormitories or monasteries for the monks who looked after the holy site, and as a place of pilgrimage. By observing the morphology, it is possible to deduce that the monastery containing the dormitory was probably located in the north-west corner of the temple. There is some conjecture that it might have been in the south-east corner, but as there is no visible proof this remains open to question.

When Borobudur was rediscovered in the early nineteenth century, it was a ruin, with soil filling many of the terraces and trees growing upon it. In the mid-nineteenth century, many of the stones were cleared and attempts were made to aid drainage, but restoration proper began only in 1907. The work, performed by a team led by Theodor van Erp, continued until 1911. It was intended both to protect the monument from rainwater seepage and to reconstruct a number of damaged areas, including the collapsed *stupas*.

Deterioration of the stone was recognised as a major obstacle to conservation of the monument early in the reconstruction process. The Archaeological Institute (Oudheidkundige Dienst), founded in 1913, conducted research into this matter and made attempts at preservation. They found that stone deterioration was promoted by seepage of water on the main walls, which contained soluble minerals; these made the stone mass damp and encouraged the growth of micro-organisms, such as algae and moss.

Fifty years after the initial restoration, the condition of Borobudur was again causing concern; the floors were sagging and the walls tilting and close to collapse. Rainwater was again seeping through the stones, undermining the natural hill foundation upon which the monument rests. So, in 1969, the Indonesian Government started an intensive restoration effort. International aid assisted in the dismantling of the temple, particularly the galleries. The stones were cleaned and treated, and replaced on a new foundation of reinforced concrete. Restoration was successfully completed in 1983.

The bell and fragments of foundation wall In the nineteenth century, the Dutch colonial government erected a building in the north-west corner of Borobudur for the use of government employees on vacation. The building was demolished in 1951 and in the subsequent excavation, undertaken by the Archaeological Institute, ruins of two foundations and some small artefacts (bronze nails, a bronze bell, and terracotta fragments) were revealed.

The institute concluded that the foundations of a square-roofed building without interior walls had been discovered, and suggested its function was as a meeting hall for Buddhist monks and pilgrims,

Endang Sri Hardiati

49

Borobudur as a Place of Pilgrimage

who would have been called there by the bell built into the wall. This bell (now displayed at the Indonesian National Museum, Inv. 7975) is simply, but beautifully, ornamented with a series of flowers and beads. On the upper part, an ornamental hanger features at each end a *makara* (mythical creature) on a lotus.

Stupikas and votive tablets During the dismantling of the temple, an area in the north-west corner of the temple complex was set aside for the testing of methods of reconstructing the temple after the cleaning and treatment of the blocks. The area was prepared by using the 'cut and refill' technique, and during the preparatory work fragments of pottery and silver were found. Further archaeological excavation revealed a fragment of the lower part of a stone statue, thought to portray Tathagata and Boddhisatwa. Several *stupikas* (miniature *stupas*) and clay tablets were found under this statue, surrounded by earthenware. Terracotta fragments and a silver plate bearing an inscription of an ancient Javanese Buddhist magic formula were also unearthed.

The total number of stupikas and clay tablets found during the archaeological research was 2397 and 252 pieces respectively. They were all made of unbaked clay and, due to the nature of the substance, they were in a fragile condition; most were incomplete. The stupikas range in size from 4 to 13.5 centimetres. There were two varieties: a single stupa with a raised pedestal, and a stupa surrounded at its base by eight smaller stupas. Many of the stupikas were carved or inscribed on the body or base with different characters of the ancient magic Buddhist formula *om ye te svaha*, in Javanese script. It is assumed that the pilgrims were responsible for these inscriptions. In addition, a figure, perhaps representing Tathagata, was found on some tablets.

Stupikas and votive tablets have also been found elsewhere in Indonesia: in Sumatra (Palembang), West Java (Batujaya), Central Java (Semarang, Klaten), East Java (Trowulan, Muncar, Bawean), and Bali (Pejeng, Tatiapi, Tampaksiring, Kalibukbuk). These stupikas differed from those at Borobudur in that each contained one or more tablets inscribed in pre-Nagari script with a Buddhist magic formula, or mantra, such as *ye dharma*. The complete inscription reads:

> *Ye dharmma hetu prabhawa hetuntesan*
> *Tathagato hyawadat – tesan – ca yo nirodha*
> *Ewamwadi mahaçramanah.*

The votive tablets from Borobudur feature no magic formulae. The tablets varied from 6 to 13 centimetres in diameter and from 2 to 4 centimetres in thickness. The relief featured three stupikas, the figures of Buddha in a seated position and a goddess, thought to be Tara. Chemical analysis revealed that the clay used to make the stupikas and tablets, and the soil in the vicinity of the temple complex, are of similar composition; it is reasonable, therefore, to assume that these artefacts were produced locally.

The stupikas are usually simple in form, made up of three parts – base, body and top. The tops are generally broken, and only the lower parts remain. Inscription was achieved by deep carving, carried out when the clay was not yet totally dry. At Klaten, Pejeng, and Palembang, moulds made of bronze for the making of stupikas and tablets were found; at Borobudur none were found.

The traditions and beliefs of Mahayana Buddhism spread through India and eventually to south-east Asia in the second half of the

Bell

..

Found near Borobudur, Java
Height 30.5 cm
MNI 7975

tenth century. Central to its doctrine was the performing of good deeds for others. The fabrication of stupikas and votive tablets was traditional and universal throughout this area.

From various archaeological finds in Indonesia, it has been concluded that the unbaked clay was traditionally put in a special place near to the temple where stupikas and votive tablets were prepared *in situ* by the site keeper – comparable with Borobudur – and that pilgrims received them or bought them, to use as part of religious services dedicated to the Buddha. These clay artefacts were often skilfully crafted. The archaeological finds in Bawean Island, East Java, however, differ from Borobudur. Here, where the pilgrims stopped to collect water, stupikas were made and then taken to other places and temples. Thus, it seems the pilgrims could either collect them *en route* or wait until they arrived at their destination. Further support for this conclusion was found in the hold of the ship *Kapal Intan*. Wrecked in the tenth century, she was rediscovered in 1997. In her cargo was found one iron mould for making stupikas and five copper moulds for making reliefs on tablets. The load of the *Kapal Intan* was thought to have come from eastern India, but it may well have come from Sriwijaya. It is therefore open to question whether bronze moulds were imported to Central Java or made locally.

In conclusion

The discovery of the stupikas and votive tablets in the south-west corner of the Borobudur temple prove provide proof of pilgrimage activity there during the glorious time of Borobudur. Although the remains of a meeting hall have also been found in the north-west corner of the temple, the ruins on the north-east side are too small to house a monastery or dormitory, and no other remains have been found. It is possible, therefore, that due to the constraints imposed by local topography, a much larger monastery was located in the villages near the temple site at Borobudur. However, the local community occupies any possible sites for the monastery and there are few areas available for excavation likely to produce significant archaeological finds.

Stupika

Found near Borobudur, Java
Height 12 cm
MNI 8311C

At the Board meeting held by the Batavian Society on 4 October 1881, the Society was offered the find of 27 Javanese antiquities in gold and silver. They came from a small village, Muteran, in the East Java Residence of Surabaya. This was a memorable moment, not so much because antiquities were being offered, but because that was something that occurred at every monthly meeting. The unusual aspect of this offer lay in the quantity and unusual nature of this discovery. The importance of the Muteran find was only to be exceeded a century later with the discovery of the spectacular treasure of Wonoboyo in 1990 (see below). Despite this importance, the Muteran objects have attracted barely any attention in all the time since discovery. This may be because they were immediately divided up between the museums in Jakarta and Leiden. For this reason the present exhibition gives us the opportunity to view the objects gathered in one place again.

Javanese archeology

During the course of the nineteenth century the Dutch acquired an interest in the ancient, vanished Javanese culture, the ruins and loose fragments of which lay all around. The government brought in many different measures for surveying, documenting, collecting and studying these remains. The Museum of the Batavian Society in Batavia (now the Indonesian National Museum in Jakarta) was the place selected as a centre in which archeology could function could best function on Java. Its counterpart in The Netherlands was the Museum of Antiquities (Museum van Oudheden) in Leiden, and after 1903, when the Asiatic and American antiquities were transferred there, the National Museum of Ethnology.

In 1865 the Director of the Leiden Museum, C. Leemans (1809 – 1893) succeeded in establishing a budget for the purchase of Javanese antiquities. In the Dutch East Indies there had already been, for a long time, the ruling that all antiquities had to be brought to the attention of the Government. Since that time, the archeological policy had functioned in the following way: the finder took the discovery to the local authorities. These drew up an official report, and sent it – together with the antiquities discovered – to the Governor General in Batavia, who then forwarded the whole matter to the Directors of the Batavian Society. At the monthly meetings the Directors of the Society either decided to accept the objects for the museum, or – where duplications were concerned – to reserve them for the Museum of Antiquities in Leiden. If the objects were of no antiquarian interest, they were returned to their finder. A great many things were regarded as having antiquarian importance, even broken objects, parts and fragments of objects. A particularly high value was placed on inscriptions. These were found on rings and other metal objects, on stones, copper plates, and palm leaves.

Archeological discoveries were made very frequently, not as the result of archeological excavations but – like the objects found at Muteran – they were found unexpectedly in the ground. The government policy of encouraging the exploitation of as much land as possible, and of laying open the entire island of Java, unintentionally stimulated the discovery of archeological finds. By extending the area of agriculture, and by construction roads, bridges, railway lines and water works, inhospitable regions were brought under the plough, and the ground was dug up to a greater depth. Engaged in these kind of tasks, local farmers and workpeople frequently encountered ancient objects that had probably been hidden there many generations before, in a quiet place far from the everyday world.

Pauline Lunsingh Scheurleer *

The finds from Muteran and Wonoboyo

* Met dank aan dr. Marijke J. Klokke

The circumstances surrounding the Muteran finds

The notes of the Batavian Society for 4 October 1881 mention that 'while a piece of *tegal* ground [unirrigated land] was being dug to a depth of roughly one-and-a-half [45 cm], a large metal pot containing various silver and gold objects was discovered' (NBG 1881: 4-5). The finder's name was not mentioned; as a rule this was actually given. Yet we can deduce from the description that there was more than one discoverer, none of whom had the right to the entire find, but each of whom had the right to several of the objects. The curator W.P. Groeneveldt (1841 – 1915) suspected that the find had been divided up at the beginning, and had later been brought to the administration of the Society piece by piece. He ascertained 'not all that has been found has been delivered to the administration; some of the ornaments are thus incomplete, and also the contained in which all [the items] were found, offers a proof of this. There is a thick layer of oxide on the inside of this container, on which one can see the clearly defined imprint of a metal band, probably a gold belt or diadem, embossed with flower figures, [an item that is] not among the pieces present'. Groeneveldt considered it desirable to try to find the missing pieces, because he wanted to know what a complete set of small statues of gods deriving from a prosperous family would have been. Nothing came of this attempt.

From Groeneveldt's capacity for sharp observation, we know that more objects formed part of the Muteran find, yet even if we were able to acquire these missing pieces, it would certainly remain dubious if there was ever any question of completion. We do not know who hid these assortment of antiquities in the ground, and even less why they did so. I myself have researched several hundreds of similar archeological finds (I hope to publish a more comprehensive article on these) and it is worth noting that this kind of burial has been carried out with great care. Moreover, it is not always valuable objects that are involved here. The buried articles may be of non-precious metals, and may include damaged pieces, or only mere fragments. Thus it is probable that the objects were always hidden after they had ceased to be used.

The bronze box in which the objects in the Muteran find were concealed (MNI 1243)(Muteran 26) is undecorated, and thus difficult to date. It would be interesting to have a dating for the moment at which the objects were assembled. The box is in a complete state. In this kind of discovery, it often happens that the excavation itself smashes the stone pot or bronze box containing the objects. In these cases it could be thought that the burial took place long before. In the Muteran case nothing can be deduced.

It more often occurs that the entire archeological find is not delivered to the authorities. According to the rules, the finder is given the estimated value of the objects at auction. This process may last months. Valuation does not always take into account the archeological worth of the objects. The long and laborious government procedure in Batavia was certainly no stimulus to stick to the legal rules. Furthermore, there were private collectors and dealers who probably paid faster, and more, for the antiquities. Thus in the finders there must always have been a mixture of feelings struggling for precedence: the threat of the long arm of the colonial authority, the recoil from objects associated with the ancestors, and the attractive prospect of a fast material gain.

Groeneveldt's explanation for the Muteran objects is as follows: 'All the treasures from a Java of earlier days, the jewels and the household gods, that in times of stress he wanted to render safe by burying them, and later on found no opportunity for once again

Hair ornament

Silver and gold
MNI 1540a/3102/A.1020

digging them up'. This was the invariable explanation given for this kind of discovery. In view of the many hundreds of these finds on Java, still being made today, for example that of Wonoboyo, it seems logical to me that there would have been other reasons, as well, for the burial of antiquities. If the behaviour of Javanese in the nineteenth and twentieth centuries is anything to go by, a capricious potential must have been ascribed to the antiquities, one that could bring the finder both good luck and bad.

Contents of the Muteran find

Groeneveldt prepared the way carefully for revealing the Muteran find to the Association meetings. He gave a detailed description of each item, adding a few remarks on each. From the archeological viewpoint, he believed the find to be of great importance, since it included unknown objects and deviant forms of known ones. He also believed that the find was of such significance that it should by rights be taken into the Batavia museum in its entirety, since the archeology of the archipelago could best be studied there. Yet, since he understood perfectly well that this arrangement was unacceptable financially, he also immediately proposed, regretfully, that a division should be made between Batavia and Leiden. In a very literal way he upheld the principle of duplication: where identical pairs of objects were concerned, one of the pair should remain in Batavia, while the other should go to Leiden. Probably he considered, here, that in this way so much would remain in Batavia, that it would be representative of the entire treasure. His proposal was followed in the division of the find.

What is the composition of the Muteran treasure? Groeneveldt described it in 27 numbers, including the bronze container in

which the objects had been concealed. We are concerned here with: (1) small statues of gods; (2) jewellery; (3) a silver dish and two base rests for dishes; and (4) a number of objects, as yet still unidentified.

1 The find includes six small statues of gods: four of the highest Buddha, Wairocana (Muteran 3-6); a statue of the god of wealth, known as Jambhala among Buddhists, and as Kuwera among Hindus; a statue of Locana, the female counterpart of the Buddha Akshobhya (Muteran 2). All the little statues are made of gold, each on a silver throne. With the exception of the last-named, none of them are great works of art. Within a chronology I have suggested for small god statues, they can all be ascribed to Group Four, and thus to the tenth century (Lunsingh Scheurleer and Klokke 1988, nos. 46-47).

2 The jewellery: the most spectacular are the two 'head-dresses', probably an ornament for the hair bun worn on top of the head (MNI 1529, now lost; RMV 1403-2783) (Muteran 7 and 8). One of these was larger and more lavishly decorated than the other. The largest had nine rows of spirals, one above the other, with a groove between the fourth and fifth row from the bottom. The smaller has seven rows of spirals. The spirals on both head-dresses turn to the right. The large head-dress had four set of two small holes in the bottom rim; the small has four small eyes for fastening it. The large one had a complex decoration at the top, consisting of several layers. The lowermost layer consisted of a narrow band with eight small shields, four large alternating with four smaller ones. Emblems were added to these. Groeneveldt recognized some of these, but knew too little to be able to decide whether the emblems represented the four

▶
Buddha Wairocana

Gold statuette on silver thrown
Height 10 cm
RMV 1403-2780

▶▶
Buddha Wairocana

Gold statuette on silver thrown
Height 9.4 cm
RMV 1403-2781

▶▶▶
Buddha Wairocana

Gold statuette on silver thrown
Height 9.4 cm
RMV 1403-2782

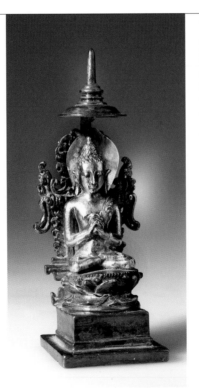
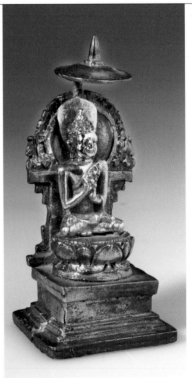
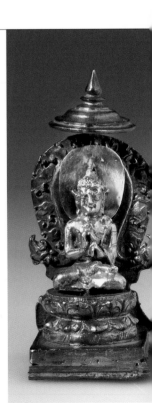

Buddhas, the eight guardians of the compass points, or other deities. The next layer consisted of a lotus cushions on which the four outermost are the crescents of a wajra. A wajra is a Buddhist ritual instrument, symbol of the diamond (the hardest kind of stone in the world), and of spiritual enlightenment. A Javanese wajra has four crescents ranged around a central pin. Between the four crescents on the head-dress, there was a glass ball between the four crescents, placed in such a way that the four points of the crescents met in the middle of the ball. In the middle of the glass ball there was a small wajra on a lotus cushion, linked by a four-pointed motif to the horizontal band and the four crescent points. The smaller example has only the four crescents of a wajra on a lotus cushion as its top. Because of the similarity to the top of the larger example, we can state with confidence that there was once a glass ball between these crescents, as well. The larger example was lost in the fire that destroyed the Dutch pavilion in the World Exhibition in Paris in 1931. Only a photograph remains, made before the object was shipped to Paris (Bosch and Le Roux, 1931, pl. 13a).

These head-dresses are fairly dateable because of the wajra with the four crescent points meeting in the middle, and with which they encircle a glass ball. In bronze wajra, and wajra on hand bells, a distinction can be made between the Central and East Javanese periods of creation, on the basis of the position of the crescent points bending either towards or away from each other (Lunsingh Scheurleer and Klokke 1988, nos. 65-68). In this case the position is Central Javanese, but no one knows at what date the crescent's position changed, and the Central Javanese crescent position can also be found in the early East Javanese period.

The Wonoboyo treasure also included a similar pair of head-dresses, but in this case the glass balls are secured by two small bands, crossing each other (Wonoboyo 1). The wajra render the Muteran head-dresses unmistakably Buddhist. The spirals naturally remind one of the Buddha's curling hair, although it is usually represented more as a kind of snail shell turning rightwards. The same spirals can be seen on the similar, non-identical pair of head-dresses in the Wonoboyo treasure (no.1) which are probably not Buddhist (see below).

Further jewellery includes:

- Upright small leaf-shaped plates (RMV 1403-2784) which can be worn as a diadem by tying it on with a ribbon, and a loose leaf from a diadem (MNI 1495) (Muteran 9 and 10).
- Hair decoration (MNI 3102) (Muteran 11).
- Remnants of two necklaces made of oval elements in gold, with a point facing either left or right (MNI 1486 and RMV 1403-2758) (Muteran 12 and 13). The elements probably represent the stylised bean of the koro pedang (sword bean/canavalia ensiformia (L) D.C.) (Les ors 1995, no.18; Versunkene Königreiche 1995, no. 43) rather than tiger claws (Lunsingh Scheurleer 1994: 47 and 52). One of the two necklaces may have been hung with elements in the shape of long points (MNI 1487).
- Two belts (MNI 1524 and RMV 1403-2786) (Muteran 14 and 15).
- Three bands for the upper arm, two as a pair, and a separate single one(MNI 1482) (Muteran 16).
- A pair of wrist bracelets (MNI 1263 and RMV 1403-2790) (Muteran 17).

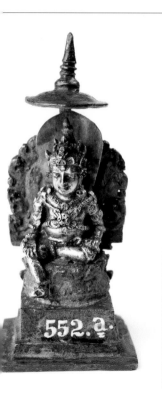

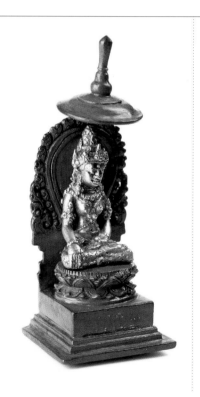

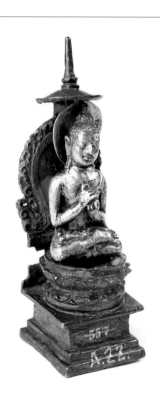

◀◀◀
Kuwera/Jhambala, god of wealth

Gold statuette on silver thrown
Height 8.5 cm
MNI 552a/2997/A.9

◀◀
Locana, female counterpart of the Buddha Akshobhya

Gold statuette on silver thrown
Height 9 cm
MNI 552b/2998/A.49

◀
Buddha Wairocana

Gold statuette on silver thrown
Height 9 cm
MNI 557/A.22

The Muteran find also contains a further two groups of objects, which do not fit into the two categories described above.

3 First of all, group:
- A silver dish, originally with a gold base, to judge by the ring-shaped mark on the bottom (MNI 1738) (Muteran 25). It is possible to decipher from the inscription that the dish was a gift from the Rakryan to the deity of the Abhaya hermitage (Groeneveldt 1887: 326-327; Krom 1923: 185). The writing permits the dish to be dated to between 775 and 825 (Damais 1970, nos. 21-22), or to the end of the nineteenth century (from a personal communication from Dr. Jan Wisseman Christie).
- Two rings decorated with a 'precious-stone-in-a-box motif'; not arm bands, but rather rings from the base of a dish (MNI 1262 and RMV 1403-2789) (Muteran 20).

4 Finally a number of objects that have not yet been identified:
- A little cap made of gold foil, with a small hole, for attaching two pieces of gold foil to the rim, in the shape of a pointed leaf (RMV 1403-2788aa and b) (Muteran 18).
- Three fragments of gold foil from a wide edging in the shape of lotus petals next to each other (RMV 1403-2787) (Muteran 19). If these were complete, they would form a circle. This may have served as a sitting mat in the shape of a lotus leaf, for a large statue or a person, rather like the lotus throne for statues of gods.
- Two purported mirrors covered with gold leaf (MNI 1126 and RMV 1403-2792) (Muteran 23 and 24). In my view these cannot have been mirrors. Although the dimensions and the pointed rise in the middle do indeed occur in mirrors, there cannot

have been any handle attached, since the rim of gold leaf shows no sign of gaps. Furthermore, real mirrors are made of a metal alloy, permitting the smooth side to be polished. Thus the damage would suggest a different kind of fracture, without crumbling as in the case of these little round plates. There can also be no question of lids, either, because in that case the objects would have a knob in the middle (compare Wonoboyo 14 and 15). In my opinion this type of object is as rare as it was in Groeneveldt's time.
- Two puzzling elements: the tops of head-dresses, or spouts for a water container (MNI 1532 and 1533) (Muteran 21).
- A yo-yo-shaped element with four eyes on one edge (RMV 1403-2793) (Muteran 22).
- A gold cover for a *kris* sheath, now vanished (RMV 1403-2791).

The dating of the Muteran find

In Groeneveldt's opinion, the craftsmanship in this objects was not particularly good. On this basis he ascribed the find to the Majapahit period (fourteenth to fifteenth centuries). His obvious starting point here was an art-history evolution of Origin, Hey-day, and Decline, covering the entire Classic period from the eighth to the fifteenth centuries. These days, we know that there more to this period of development. Other archeologists however (Krom 1923: 184; Stutterheim 1937: 9, n. 1), ascribe these antiquities to the Majapahit period, but rather on the basis of their discovery site close to the village of Muteran, in the neighbourhood of Majakerta where the *kraton* (the Princely residence) of the Majapahit dynasty was established. Evidently they believe that the place where the treasure was buried can tell us something about the place in which these

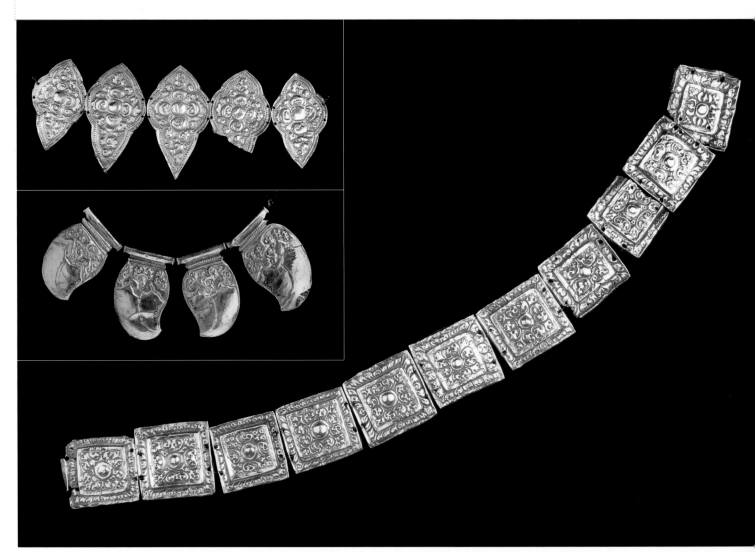

antiquities functioned, and about their manufacture. This is based on the assumption that the Court was situated in Central Java in the Central Javanese period, and in East Java in the East Javanese period. The transition from Central to East Java would have occurred in c. 928. Today this is still accepted, but on the understanding that although the *kraton* did indeed move house, the entire population did not, and that this moving was done gradually rather than suddenly. This is clear from the edicts issued by four successive princes between 900 and 928, in both Central and East Java (Barret-Jones 1984). The inscriptions referring to the succeeding prince, Sindok (929-947) are exclusively from East Java, mostly from the neighbourhood of the village and subdistrict of Turen.

'Our' village of Muteran also lies within the area surrounding Turen, and close to the village of Tembelang, to the south of Ploso. This place may be identical to Tamwlang, the capital of King Sindok (De Casparis 1988a, 1998b: 170). There was once also a temple in Muteran (Krom 1923: 185). Once a relation is established between the discovery site and the dating of the find, this could mean that the Muteran antiquities date from the time of King Sindok, or from the period of transition from Central to East Java (and therefore from the first half of the tenth century). How can this potential dating be confirmed?

Comparison with the Wonoboyo treasure The study of the objects themselves can take us closer to the dating point. When one compares it with the spectacular Wonoboyo treasure, certain features common to both finds become clearer. A more comprehensive description of this particular find from 1990/1991, is given below (a more elaborate version will appear in *Arts Asiatiques*, 2005).

Because we know nothing about why the treasure was buried in the ground, we also know nothing about the link between the objects. Since several similar pieces of jewellery are found in the Wonoboyo treasure, and each find contains two pairs of jewellery, there is a good chance that these belong together, and were made at the same time for the same purpose. We are concerned here with the unequal pairs of head-dresses accompanied by other pieces of body jewellery such as diadems, hair pins, necklaces of *koro pedang* beans, bands for the upper arm, belts, and the sitting cloths in the form of lotus leaves, of which several fragments occur in the Muteran find (Muteran 19) and two complete items in the Wonoboyo treasure (pictured in Mardiana 2003, no. 1) Those from Muteran date from the same period as the head-dresses from Central Java or East Java, thus from the eighth to the twelfth centuries, and those from Wonoboyo from the first half of the tenth century (see the appendix).

Some of the unidentified objects from the Muteran find can nevertheless be dated, because they have a decorative motif in common with their counterparts from Wonoboyo:

- the clove-blossom motif and/or the precious-stone-in-a-box motif (see Wonoboyo 12) on the dish bases from both finds.
- The flower motif with a curl on either side on a small round plate, and on the roof-shaped part from the Muteran find (MNI 1126 and 1533)(Muteran 23 and 21) and on the water scoop (Wonoboyo 15).
- The fish-roe motif on diadem leaves, and the one little bronze plate (Muteran 9 and 24) and a comb and water scoop (*Treasures* 1997, no. 81 and Wonoboyo 15).

◄◄
Pieces of a diadem
..
Gold
Height 13 cm
RMV 1403-2784

◄◄
Pieces of a necklace
..
Gold
Height 7 cm
RMV 1403-2785

◄
Pieces of a belt
..
Gold
Height 4.5-6 cm
RMV 1403-2786

►
Pieces of a necklace
..
Gold
Height 10 cm
MNI 1486

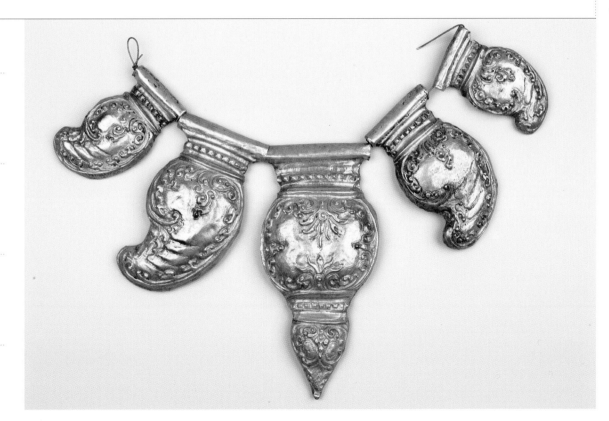

– A flame-like leaf rim on the elements in both belts, one of them a small bronze plate (Muteran 14, 15 and 23) and on the water scoop and the decorative piece on a caste cord (Wonoboyo 15 and *Les ors* 1995, no. 25).

The decorative motifs on the Muteran objects are much more carelessly produced than those of Wonoboyo. This could mean that they were made in a later time, or were made by a less skilled gold/silversmith. Yet the common decorative motifs indicate that they appeared in roughly the same period: in the first half of the tenth century. Apart from the silver dish, there is an overlap in the dates of first appearance for all the objects from the Muteran find, as far as these can be ascertained, i.e., in the first half of the tenth century and even with greater precision, in the transitional period (900-928). The discovery site, Muteran, can also indicate the transitional period, while the discovery site in Central Java of the analogous Wonoboyo treasure also fits this period.

The function of the Muteran objects

What are we able to say about the function of the Muteran objects? Groeneveldt understood the whole as the jewellery and household gods of a high-ranking official who was not a member of the highest social class. He therefore regarded the objects as not sufficiently valuable. Stutterheim called this a Buddhist safe (Stutterheim 1937: 9, n.1). By this he probably meant a safe for storing valuable temple requisites. My interpretation is that they are various groups of objects of which the coherence is still uncertain, or which originally belonged together: (1) statues of gods; (2) ceremonial jewellery; (3) utensils; and (4) a group of objects not yet identified.

1 In my view this is not a 'set of household gods', but rather small statues of gods with no mutual connection; furthermore, astatues of Ashobhya, the consort of Locana is missing. The statues were probably used for private worship, used at home by the devout. Yet they may also have been votive statues, and thus placed in a sanctuary.

2 Jewellery certainly, but very unusual, decidedly not meant for everyday use as Groeneveldt suggested, and moreover originally in pairs. Where the head-dresses are concerned, one of the pieces in the pair in both the Muteran and Wonoboyo finds are larger, and more elaborately worked than the other. It would seem to be logical that one was meant for the man, and the other for the woman in a couple. They are possibly the remnants of a pair of sets, each including a lotus mat meant for a divine, princely or priestly couple. They might have been worn by Buddhist priests, as in Nepal and Tibet, but in these places the priest has no wife (Béguin 1984); or as on Bali, but there the Brahmin priest and his wife wear simple hermits? dress for the initiation (personal communication from Francine Brinkgreve). They might also have been worn by a princely couple for a special occasion, for example a wedding ceremony as in Java today, when the bridal couple are identified with the coupled deities Sri and Sedono (Jessup 1990: 52-59) or as the prince of Kandy had himself portrayed in c. 1600, although without his spouse (Zandvliet 2000, no. 10). Yet another possibility is that the jewellery was presented to a statue of a pair of coupled gods in a temple, by rulers or high-ranking officials. This latter practice was normal in the cultural regions surrounding Indonesia. Unfortunately I know of no temple in which the chief statue represents a Buddhist couple, for

▶
Ring at the base of a bowl

Gold
Diameter 11.2 cm
RMV 1403-2789

▶▶
Round plate

Gold and bronze
Diameter 15 cm
RMV 1403-2792

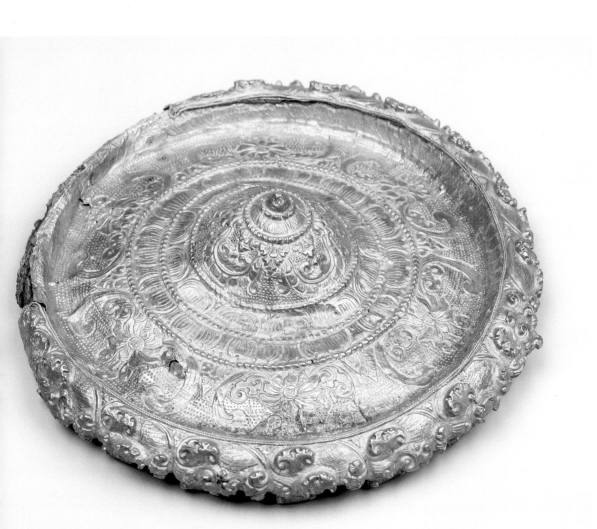

Spout of a cask (?)

Gold
Height 9 cm
MNI 1533/A.136

60

A pair of upper-arm bands
(two of three)

Gold
Height 21.5 and 9.6 cm
MNI 1482/ A.964, A.965 & A.966

▸

Central piece of a diadem

Gold
Height 10.5 cm
MNI 1495

example the Buddha Wairocana and is female counterpart Prajnaparamita, or Ratnasambhava and is partner, as is well known from small statues of gods (Lunsingh Scheurleer and Klokke 1988, no. 47; Moeller 1985: 30-33). Certainly, in ancient Java there was a marked preference for couples, god and goddess.

3 The two ring-shaped bases for bowls, the funnel-shaped spout, and the small round plates covered with gold, may have been items from sets of utensils such as valuable ceramic services for a wealthy official, or perhaps ceremonial service ware used in a temple, like the silver dish, which was a gift made to the Abhaya sanctuary.

4 This still leaves several puzzling objects.

In fact too little is known, not only about the use of the objects from this treasure, but also about the functioning of *kratons* and temples, for instance as banks or safe-deposits. Furthermore, the Princely and the Divine in ancient Java are two sides of the same coin. If these objects were preserved in a *kraton* the owner and the guardian had the reputation for possessing uncommon qualities, and for maintaining contact with the supernatural and/or the ancestors. It goes without saying that such people would have been found in a temple.

In the foregoing text the manufacture of the majority of objects from the Muteran find can be attributed to overlapping periods within the period 900 to 928. Only the silver dish is older. We cannot confirm whether or not the objects functioned within the same context as each other. The small statues of gods, the head-dresses and other pieces of jewellery, if together they do in fact form two sets, are all Buddhist. Yet the local ancestral deity of the Abhaya

sanctuary was most probably not Buddhist, and therefore the silver dish cannot be Buddhist, either.

We may draw the conclusion that the Shaivite silver dish was added to the Buddhist objects after their original function had been forgotten (or when this original function served no further purpose). This conclusion gains support from the fact that even broken objects and fragments were assembled and buried. The reason why this was done by some person unknown, still has a large question mark.

The Wonoboyo treasure

The Wonoboyo treasure is named after the village where it was discovered. The treasure was covered by a layer of lava, beneath a wet rice field in the hamlet of Plosokuning, which falls into the administrative area of Wonoboyo village (subdistrict of Jogonalan, Kebupaten Klaten), c. 20 km. from the Central Javanese city of Jogjakarta, and c. 5 km. to the north of the *candi* (temple) of Prambanan. The woman who owned the rice field had the ground dug up in order to improve the flow of water, thus enabling the treasure to be found. This occurred fairly recently, in 1990 and 1991. This find was a much larger one than that of Muteran; it was concealed in a bronze box, and in five Chinese stoneware pots from the Tang period (618-907) each c. 35 cm high, while yet objects lay loose about the containers (Wahyono 1994). Just as in the case of the Muteran discovery, each of the finders had the right to a certain proportion of all the objects discovered, and these items were handed in to the authorities piece by piece, leaving the uncertainty about how much was actually surrendered. A significant difference from other archeological discoveries on Java is that all the find that

Pieces of a belt

Gold and precious stones
Height 6.6-7.2 cm
MNI 1524/A.1036

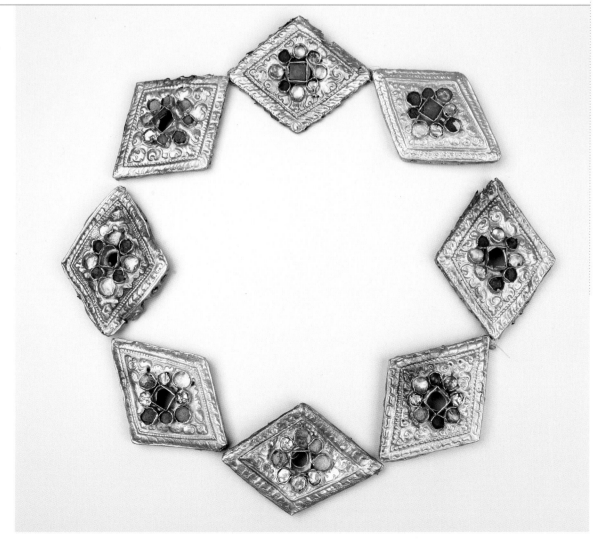

was surrendered was accepted by the National Museum in Jakarta. A selection of several items are being sent temporarily, to the exhibition at the Nieuwe Kerk (New Church) in Amsterdam in the Netherlands.

The Wonoboyo treasure contains almost seven thousand gold and silver coins, but no statues of gods, as in the Muteran find. Neither the Muteran nor the Wonoboyo find includes ceremonial articles such as incense burners, lamps, hand bells, sacrificial knives and so on, which are usually made of bronze. Both of these treasures consist exclusively of gold and silver objects. The Wonoboyo treasure includes several examples of different kinds of body jewellery, a large variety of dishes, water scoops, handles, tops, and parts of weapons, and further consists of other valuables such as water casks, and lotus flowers in different sizes. The gold objects include objects never known until that point.

Similar objects in the Muteran find include, notably, a pair of rare head-dresses and lotus leaves as sitting cloths, as also diadems, hair pin, necklaces, belts, bands for the upper arm, and other things. These are probably (remains of) two sets of jewellery. The Wonoboyo find includes many dishes and combs, while the Muteran objects contain only a single item, and perhaps the remnants of two others, in the form of foot rings. The workmanship of the Wonoboyo objects is noticeably fine, in contrast to that of the Muteran objects which, as Groeneveldt has observed (see above), is much less so.

Another, more important difference from the Muteran discovery, but also from nearly all other archeological finds, is that the entire Wonoboyo treasure can be attributed to the same period. This treasure was covered by a volcanic eruption under a 2.75 metres thickness of lava. In this manner an existing situation was fixed permanently at one blow. This means that the objects were actually in use at that time. Here, we shall set aside the question of whether antique objects were also included in between those found. On the basis of the similarity in the writing of the inscriptions on several casks to that in the Lintakan inscription from 919, the entire treasure could be ascribed to a wide period surrounding this date, from the end of the ninth to the beginning of the tenth centuries (Wahyono 1994).

The dating of the Wonoboyo treasure, based solely on the writing, could be given a broader basis by comparing the figures on the Ramayana dish with Old Javanese figures in other places. The personages on the other dish from the Wonoboyo treasure have the same hair style, their build is just as slender, and they move with the same suppleness as those on the Ramayana dish. The same can be said of the figures on two bronzes, i.e., two crowns added to two unknown objects, one representing a man on horseback, the other a couple of court lovers (Lunsingh Scheurleer and Klokke 1988, nos. 110 and 111). One could say that the pair of lovers had escaped from the Ramayana dish. The two gargoyle-like statues in the form of a standing man with a calabash under his arm, and a woman holding a calabash, have the same hair style and physiognomy as those encountered in the East Javanese village of Mojokerto (Bernet Kempers 1959, pl.s 189 and 19). In time, the discovery site close to Mojokerto may be able to provide the proof of an origin in the first half of the tenth century. The same slim build and agility characterize the figures on the water-spout reliefs in the sacred bathing place of Jolotundo. The princely personages there also wear their hair in the same way. The Garuda bird seen abducting the pregnant princess Mrigawati on the Jolotundo relief

Head piece

Height 11.2 cm., diameter 10.6 cm
MNI 8922

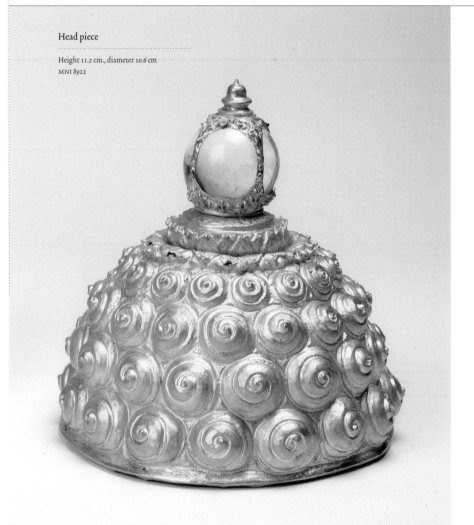

Ear ornaments (pair)

Length 12.5 cm
MNI 8912 A-B

(Fontein 1990, no. 18) is very close to the magic flying chariot in which Ravana carried off Sita on the Ramayana dish (panel 3, scene 2). The bathing place of Jolotundo can be dated from an inscription bearing the (converted) year 977 (Bosch 1961). A stylistic connection has already been registered between a small bronze statue of Sri Devi (Fontein 1990, no. 48) and the Ramayana dish (Levin 1999: 40-41). In view of the fact that Jolotundo is the only building dating from the early East Javanese period, and that the reliefs are also considerably damaged, it is impossible to assemble an exact chronology for the works of art mentioned here. The thing about which we can be certain is that the figures on the Ramayana dish are much closer to those of Jolotundo than to those of the Central Javanese, for example at *candi* Prambanan. An attribution of the Ramayana dish to the tenth century, but earlier than Jolotundo, seems reasonable in my view. The figures on the stone panel showing Ravana's abduction of Sita, held in the Boston Museum of Fine Arts, are more angular and stiffer, and have already been ascribed to a later period, the eleventh century (Fontein 1990, no.19). An interesting consequence of this dating is that the bowls and the pot (Wonoboyo 12 and 13) could pass as Central Javanese, if it were not for the Wonoboyo context in which they were found. The same applies to the *wajra* from the Muteran head-dresses. Certain Central Javanese forms thus carry through to the early East Javanese period.

The question that follows this is, what religion should be attributed to the Wonoboyo treasure: Hindu or Buddhist? Several objects from the Wonoboyo treasure indicate the worship of Vishnu: the Ramayana dish, the amulet holder, and the pair of rings with conch shell and wheel. This is unusual, since on Java the worship of Shiva is by far the most important on Java. No recognizable Buddhist object is included, except perhaps the couple of head-dresses. If all the objects comprising the Wonoboyo treasure were indeed trapped beneath the volcanic lava at exactly the same time, thus belonging to one sanctuary and one worldly establishment, then we may take as our starting point the idea that all the property belonged to the same religion, whether Buddhist or Hindu. In that case the pair of head-dresses would be Hindu.This would imply that the spirals covering them cannot represent the Buddha's hair curls. The direction of their rotation does not seem to conform with this idea: in the largest of the Wonoboyo items these curls turn leftwards, while they turn rightwards in the three others. The spirals thus look different from the Buddha's curls, which are shorter, look more like a snail shell, and always turn rightwards. If the head-dresses were nonetheless Buddhist, then the Ramayana dish would not necessarily form a contrast with it. The Ramayana story is more often absorbed into a Buddhist context.

Owing to the presence of secular, worldly matters, the Wonoboyo treasure has been interpreted as the strong-room contents of the family of Rakryan of Halu, a high-ranking official (Christie 1995: 22). Jewellery perhaps makes one think first of all about worldly vanity and worldly affairs, yet most of the pieces of jewellery from the Wonoboyo and Muteran treasures do not seem to me to be secular. We now know that princely personages of the tenth century did not wear this kind of personal ornament, from the figures on the Ramayana dish and the other objects compared with it. It is the dress worn by deities. If people did wear this kind of jewellery on special occasions, then they were being identified with the gods. Many of the pieces of jewellery such as the bands for the upper arm, the regal necklace, and the belt-made-from-one-piece (*Treasures* 1997, no. 108) are too large for a Javanese person. Were the pieces perhaps meant for the gods themselves, in the form of god

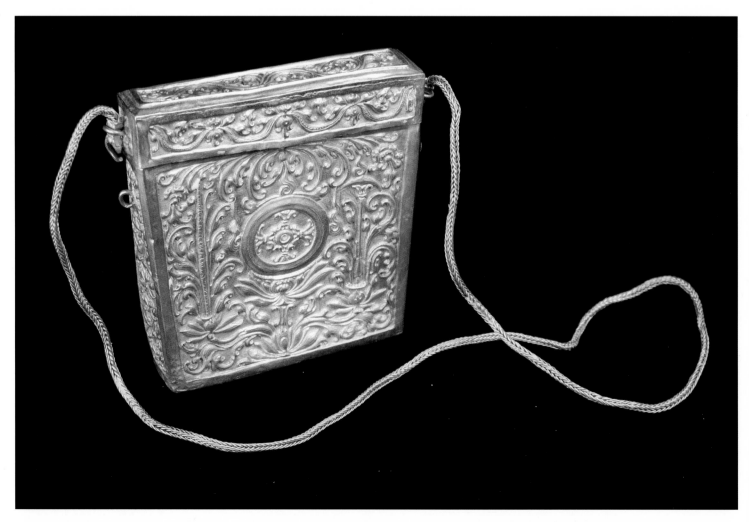

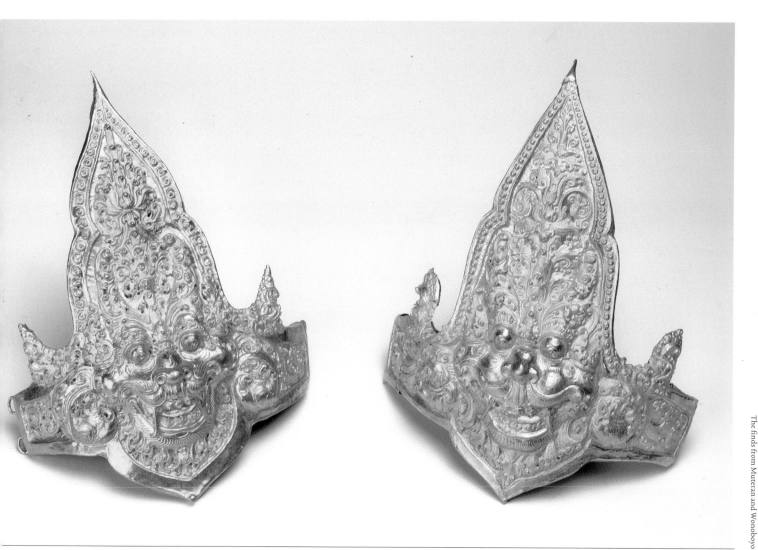

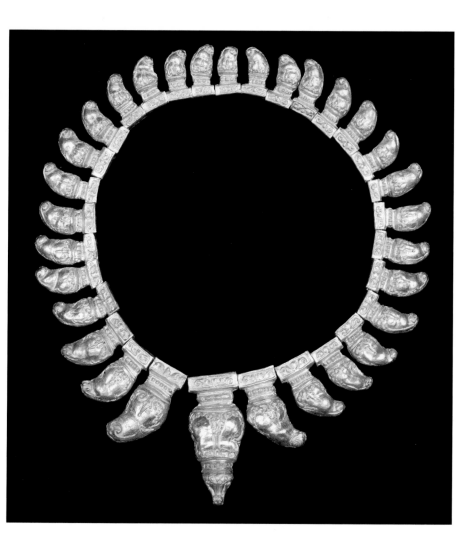

65

Upper-arm bands (pair)

Height 19.5 cm., width 14.4 cm
MNI 9006

◄

Necklace

Length 2.5-5.5 cm., width 2.5 to 1.4 cm
MNI 8874

◄◄

Amulet holder

Height 9.2 cm., width 10 cm., thickness
2.3 cm
MNI 8916

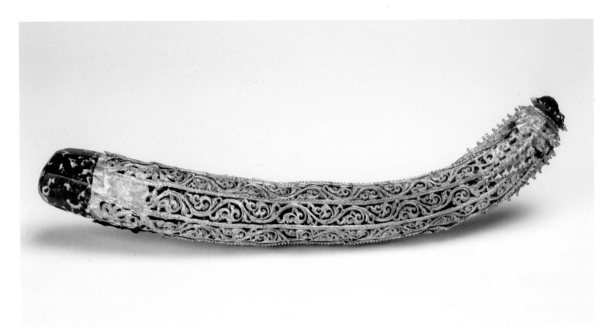

Hand tool

Diameter 2.6 cm., length 20 cm
MNI 8967

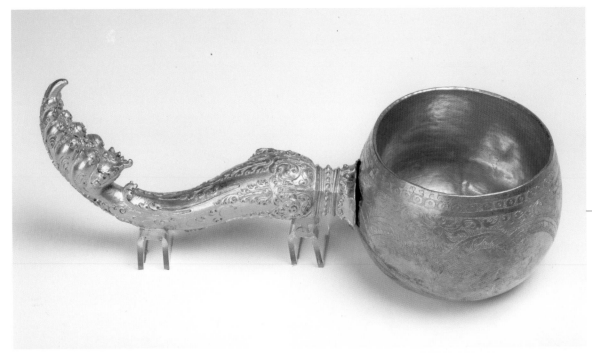

Water ladle

Diameter 10.3 cm., height 3.2 cm
MNI 8990

The Archeological collections

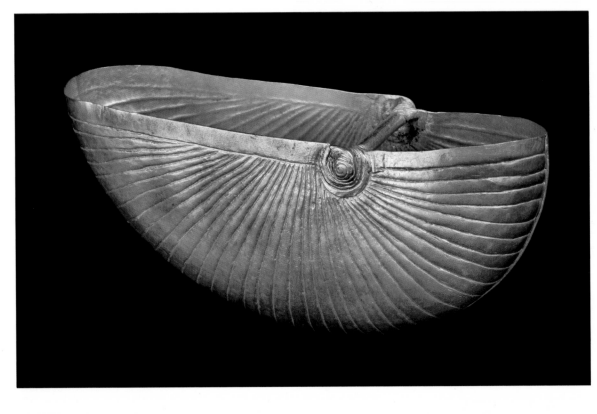

Water pail

Length 15.6 cm., width 5.7 cm., height 6.6 cm
MNI 8997

▶
Bowl or dish depicting scenes from the Ramayana

Length 28.8 cm., width 14.4 cm., height
9.3 cm
MNI 8965

The most spectacular piece from the
Wonoboyo treasure is undoubtedly the
Ramayana bowl (dish). The shape of the
dish - oval and in four lobed sections, and
resting on an equally oval and four-lobed
base - is rarely found in the Java of the past.
It is elaborately ornamented with repoussé
over its whole surface, a technique that in
the older Java was frequently applied with
great skill

 Each panel consists of two scenes from a
story. No beginning or end is represented.,
but it is clear that the scenes follow one
another from right to left. There is no doubt
that they concern the famous Ramayana,
and in particular the episode of the theft of
Sita by the demon lord Rawana

states that were dressed in this jewellery? The possibility has also been suggested that they were worn by State elephants or horses. Whichever of these possibilities might have been true (see also the function of the Muteran objects, above) it seems to me that the religious aspect always predominates.

The Wonoboyo treasure contains more, and lovelier, objects than have even been discovered before. A striking number of shapes are imitations in gold of existing objects. These, and their decorative motifs, are often borrowed from the world of nature. These borrowings would certainly have had a particular meaning, since in a culture like that of ancient Java one expects shape, decoration and function to be linked. For example, there is an imitation of a water pail made for palm leaves woven together (MNI 8997), another of a water butt in the shape of a sawn-off coconut shell with a handle made from a fern bud (MNI 8990). There are miniature imitations of pots made of bronze or stoneware, and lavishly decorated lids and spouts (MNI 8933) that were mounted on stoneware pots.

A slender, curved, open-work handle (MNI 8967) is beautiful in itself, yet its possible function is a puzzle: it may be a tool for smoothing the surface of palm leaves, ready for writing on.

We find here a rich variety of ornaments for every part of the body, including a rare set of decorations for wearing over the hair knot, with a crystal ball at the top (MNI 8922/8923). There are pieces of jewellery in the form of an upright leaf, with a flower worn just above and behind the ear (MNI 8912), of a type still worn today by princes and bridegrooms (sumping ron). The treasure includes more than one complete example of a regal necklace made of imitation koro pedang beans (MNI 8874) of which only fragments had been known before this find. There are bands for wearing on the upper arm with a repulsive monster's head (ill. N), previously known only

from poems. The Chinese influence can be seen in dishes and bowls, as in the case of the most spectacular item from the Wonoboyo treasure, and perhaps from the entire Classical period – what is known as the Ramayana dish (MNI 8965). This item is inspired by a particular type of dish dating from the Tang period (618-907), composed of eight lobes resting on a base, its entire upper surface decorated with repouss(work. Each lobe shows an episode of the famous epic the Ramayana, including the kidnap of the Princess Sita by the demon king Ravana.

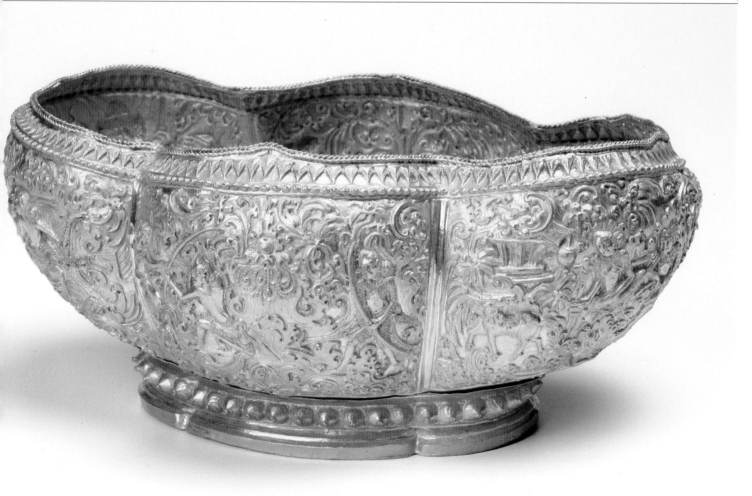

Statues are used in rituals to symbolise the presence of particular deities or, in a more general sense, to represent a particular religious faith. In both Hinduism and Buddhism statues of gods are utilised in these two ways. In other words, statues are manifestations of the deities worshipped, constituting an attempt to present religious concepts in a concrete form. In East Java several small statues of the Buddha have been discovered, both in Combre and Puger Wetan. In this article we shall examine certain noteworthy stylistic, religious and technical aspects of these statues.

The discovery sites

The first discovery site, the village of Combre, lies on the slope of the Wilis mountain in the Residency of Kediri, East Java. Geographically speaking, Combre is situated in the neighbourhood of the Jombret forest close to the hamlet of Turi (Penampihan), belonging to the village of Geger in the subdistrict of Sendang, Tolungagung district in East Java. This area lies on the slope of Wilis Mountain, latitude 111-112 E and longitude 7-8 S. The discovery site was once a tea plantation, and at present is used as farm land by the local people.

Within a radius of a kilometre from the Jombret forest we find archeological antiquities: the Penampihan sanctuary constructed on three terraces; stones bearing inscriptions, located in the neighbourhood, on which the years 898 and 1460 are carved; and a stone statue of the Buddha inscribed with the year 1194. From the Penampihan temple one also sees an alcove, probably serving as a place for praying.

Wilis Mountain lies on the border of Nganjuk, Madium, Ponorogo, Trenggalek, Tulungagung and Kediri districts. Furthermore the Wilis – a mountain 2,169 metres high, which forms part of the Liman-Wilis range – marks the boundary between Madiun and Kediri districts. In the literature Wilis Mountain is mentioned as a place where there was a hermitage. The story Panji Jayakusuma relates how Nila Prabangsa (Brajanata), a child born of the union between the prince of Janggala and Madu Keliku, fulfilled his mother's command to murder Angreni, the first beloved of Panji Semirang. Thereafter Brajanata, under the name of Wasi Curiganata, lived as a hermit on Wilis Mountain. Although the Panji stories are works of literature, written by poets from the Kediri period, one can suspect that they are based on some actual event. At the very least, they reflect the life of that period.

Hermitages are closely linked with places in which religious rituals are performed, often far removed from the inhabited world. Examples of this in Buddhism are *mandala*, *kuti-kuti*, *dharmasala*, *karesyan*, *wanĕsrama*, *patapan* and *kadewaguruan*.

- Kadewaguruan is a place at the foot of a mountain, or on the banks of a river or on a sea shore. It is often inhabited by *dwija* (Brahmins) and pure women. Those people too weak to bridle their lusts receive instruction here.
- Wanĕsrama is another term for *kadewaguruan*. This, too, is consequently a place where one acquires inner purity.
- Patapan is a religious site where the *mpu tapa* and the *sisya* (disciples) separate themselves from the world to live as hermits until they have achieved the desired spiritual state.
- Mandala is a more permanent hermitage consisting of a complex of buildings. Here disciples are instructed at three spiritual levels: *dewarsi*, *siddharsi* and *maharsi*. Besides the hermits – *tapaswi* or *tapa* is a term used for male hermits, and tapi for their female counterparts – the *mandala* is also

Intan Mardiana Napitupulu

Buddha

Gold statuette
Puger-Wetan, 8th-9th centuries
Height 8.7 cm
RMV 1403-2688

Statues of the Buddha from Combre and Puger Wetan

Buddha

Gold statuette
Puger-Wetan, 8th-9th centuries
Height 7.4 cm
RMV 1403-2689

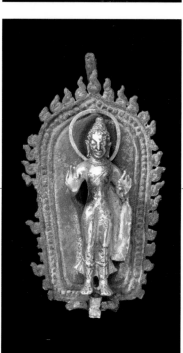

Buddha

Gold statuette
Puger-Wetan, 8th-9th centuries
Height 11.2 cm
RMV 1403-2690

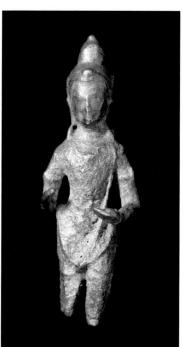

Buddha

Silver statuette
Puger-Wetan, 8th-9th centuries
Height 5.9 cm
RMV 1403-2691

inhabited by the *wiku*, people of aristocratic origins who have become hermits, or monks or nuns. The latter category are disciples (*sisya*) in order to gain a more profound knowledge of spiritual matters under the guidance of the *dewaguru*.

Besides those in the above-mentioned places, statues of the Buddha are also found in the village of Puger Wetan (in Puger in the district of Jember, East Java); these latter have the characteristics that distinguish them from the usual East Java type. Consequently the gold and silver statues of the Buddha found during excavations carried out in 1834 differ from the Combre statues. The region lies on the south coast of East Java at longitude 113-114 E and latitude 8-9 S. At the present time the discovery site is being used for farming by the local people, and no archeological artifacts of any importance are being discovered. However, in the subdistrict of Gumuk Mas, close to the border with the subdistrict of Puger, archeological remains have been found: for instance, Buddhist temples and prehistoric objects. In Kotablater, in Jember district, some twelve kilometres from Puger subdistrict, a copper statue of the Buddha has been excavated. Today the statue forms part of the collection in the National Museum. From the geographical point of view, Puger Wetan, lying as it does in the coastal region of East Java, differs markedly from Combre, which is situated in the highlands of Wilis Mountain.

The discovery of the statues of the Buddha in both Combre and Puger Wetan raises a good many questions about the religious background, the style that diverges from what we usually find in Java, and the materials used – gold and silver. Where these aspects are concerned, the statues reveal wide differences from, for example, the *mandala* statues of the Buddha from Nganjuk, East Java, which

are usually made of copper. Below, we shall examine, in greater detail, the main differences between these statues and the others.

The statues of the Buddha

The National Museum has the custody of six golden statues of the Buddha originating from Combre. Generally speaking, each rests on a pedestal in the shape of a lotus blossom (*padma*) and the Buddha wears his hair in small curls with a bun on top of his head (*usnisa*) and an *urna* on his forehead. Each figure has a broad face and elongated ear lobes; he wears a cloth covering the left shoulder, while the *prabhamandala* lies at the back. Each Buddha is portrayed with his hands in the *abhaya mudra* and *ware mudra* positions. On Java, one seldom finds statues with hands in the *wara mudra* position, and it is thus possible that the statues originally derived from outside Java, or were copied from 'foreign' models, although in East Java there was a definite tendency to adapt statue types that were in current use in India. Besides the National Museum, the National Museum of Ethnology in Leiden also holds five golden statues of the Buddha from Combre, brought to the Netherlands in 1904.

Another group once held in the National Museum in Jakarta consisted of gold and silver statues of the Buddha from Puger Wetan. Some of these were destroyed by fire during the great World Exhibition in Paris in 1931. The National Museum owns two gold statues of the Buddha displaying a mutual similarity. Each Buddha stands on a pedestal in the shape of a *padma*, with a halo surrounding his shoulders decorated with tongues of flame. His robe is pleated over the shoulders to the elbows; an *upawitha* is wound round the left of his chest, while a chattra has been added to

▶
Buddha
...
Bronze statuette
Puger-Wetan, 8th-9th centuries
Height 10.5 cm
MNI 598

▶▶
Buddha
...
Bronze statuette
Puger-Wetan, 8th-9th centuries
Height 15.3 cm
MNI 601
...
The right hand of the figure displays the vitarka-mudra.

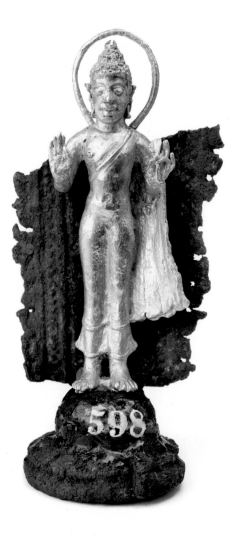

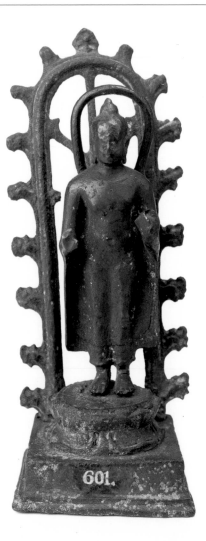

the uppermost part. The National Museum of Ethnology in Leiden also has five gold statues of the Buddha from Puger Wetan. Some of these have haloes made of copper, while in others a part of the foot is missing.

In addition to the gold statues of the Buddha, the National Museum also holds several silver statues from Puger Wetan. These statues represent standing or sitting figures, each on a *padma* pedestal. Each wears a hair knot (*usnisa*), each has long ears (elongated ear lobes), a robe covering the left shoulder to the left wrist, and draped to the right. Apart from the *tataghata* Buddhas, the group also includes a statue of Padmapani, and statues of gods and goddesses. Padmapani is provided with garments, jewels and a Kiritamukuta crown. Each of the three statues of deities stands on a pedestal in the form of a lotus, and wears a *Jatamukuta* or *Kiritamukuta* crown, garments, and jewels. The god statues show varying mudra (hand positions). The statue of the goddess is standing, with a *Jatamukuta* crown, clothing, and jewels.

Style
According to Nandana Chutiwongs, the group of statues of the Buddha from Combre reveal a good deal of variety in style and iconographic detail. One of these styles displays similarities to the classic North Indian style, with a wide face, large hair curls, and a more obtrusive hair knot. The other style is the prototype of the South Indian style, with a finer-drawn face, shorter hair curls, and a smaller *usnisa*. These characteristics indicate that these statues are closer to the statues of the Buddha from the Thai archipelago and Central Thailand from the ninth to the eleventh centuries, than to the statues being produced in Java and Sumatra in that same period.

Supratikno Raharjo believes that the Combre statues dating from the tenth to the eleventh centuries are derivative, yet it is entirely possible that the statues date from an even earlier period, since the context of a temple complex and its religious function are not known. However, if one takes into consideration the year stated on the statue of the Buddha in the Penampihan temple, and the Pandji tales from the literature, in which Wilis Mountain is named as a pilgrimage site of, we may still take the tenth century up to and including the twelfth as our starting point, since the Pandji story is generally accepted as having appeared in the time of the principality of Kediri, in approximately the eleventh-twelfth centuries. Nonetheless, the statues' iconography reveals a similarity to the North Indian and South Indian style of the eighth and ninth centuries.

The statues of the Buddha from Puger Wetan reveal a marked mutual stylistic resemblance. They may have been made in the same workshop, and their makers may have derived their inspiration in statues from Bihar and Bengal in north-eastern India. The influence of Bihar can be discerned from the way in which the body cloth is draped, the rather curly hair, and the shape of the *usnisa*. Features such a wide face, the clear definition of the hairs on the head, and a slim body, indicate the influences from Bengal. The statues may date from the eighth to the ninth centuries.

Religious background
It is not easy to establish with any certainty the precise religious background to the statues of the Buddha from Combre and Puger Wetan. However, this can be deduced from some of the attributes carried by the statues. The *tatagatha* statues of the Buddha to be found in both locations betray a dominant influence of Mahayana Buddhism. Mahayana is a school in which the teaching is centred on the *sunyat* (truth); the faithful consider unselfishness and the concept of *karuné* (compassion,

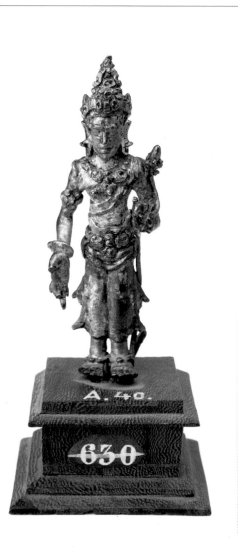

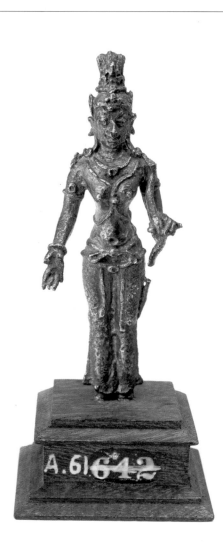

◄◄
Padmapani
..
Silver statuette
Puger-Wetan, 8th-9th centuries
Height 7.9 cm
MNI 630, A.40

The right hand of the figure displays the vara-mudra, while the left hand holds a padma

◄
Devi of Sakti
..
Silver statuette
Puger-Wetan, 8th-9th centuries
Height 8.4 cm
MNI 642, A.61

The right hand of the figure displays the vara-mudra, while the left hand holds a lotus

uprightness) to be of paramount importance, like the positive conviction that when the Buddha state is attained this will benefit all living creatures. Generally speaking, no Buddhist temples dating from the East Java period have been found in which the *tatagatha* appears clearly as the main figure; only groups of statues have been found which can hardly – if ever – be related to a particular temple. It is possible that the *tatagatha* statues belonged among the most important of the statues in a Buddhist *mandala*. Within Buddhism the *mandala* constituted the world of the gods, a representation of ideal circumstances; the *mandala* concept can be summoned up in thought, and can be portrayed on both cloth and stone in our everyday life on earth.

In the Central Javanese period a statue of the Buddha was, generally speaking, regarded as the symbol of belief, and at the same time as a representation of a deity. However, during the East Javanese period, the images of the Buddha also represented a prince or an important figure from the court circles.

Technical aspects In order to produce statues of the Buddha such as those from Combre and Puger Wetan, technical skill in working metal is a prerequisite – a skill that dates back into prehistory. Metals possess mechanical, electric, and magnetic properties. In metal working we can distinguish two kinds of metal: the pure metals, and alloys, the latter being obtained by melting two or more kinds of metal together. For instance, bronze is a mixture of copper and another metal such as tin, while brass is produced by mixing copper with zinc. Both pure metals and alloys were used in the statues of the Buddha of Combre and Puger Wetan.

Gold is universally regarded as the metal with the highest symbolic value. It is seen as 'a part of the divine dawn', or 'the god beneath the metal'. This derives from the beautiful colour (see also the name *su-varna* – 'possessing a beautiful colour'). From the technical point of view, gold has superior properties: it is easy to turn into various kinds of objects, and it is resistant to oxidation, qualities that have given gold the highest status among all the metals. Second place is occupied by silver, also easy to work and also resistant to oxidation. This metal is associated with 'forming part of the divine moon'.

When a statue is being made from gold, this precious metal is often mixed with another metal to make an alloy. A mixture of gold and silver was used in the gold statues of the Buddha from both Puter Wetan and Combre, something that can be seen from the pale colour of the gold. The gold content is expressed in carats. Pure gold has a 24 carat content, while in the gold objects from East Java the gold content varies between 8 carats and 22 carats, meaning that 8 to 22 parts consist of gold, and 16 to 2 parts of other metals. Besides the gold statues from Puger Wetan, statues have also been found made entirely of silver.

The manufacture of gold or silver statues is achieved for example by the 'lost wax' (*cire perdue*) technique, which consists of three stages. First of all a model of the desired object is made from wax. This shape is covered with a layer of clay to a certain thickness, which is then fired. During the firing the wax becomes liquid and flows out through small holes bored into the clay, leaving behind a negative mould. After this, molten metal is poured into the mould, giving the object desired. There is also a soldering technique, in which pieces of a statue are fixed together and subsequently finished with decorative techniques such as engraving. Statues formed from another metal, for example copper or bronze, are sometimes covered with a thin layer of gold or silver.

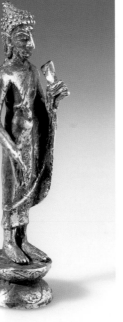
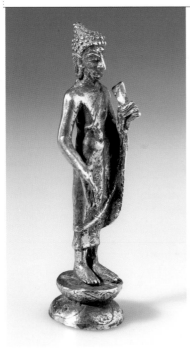
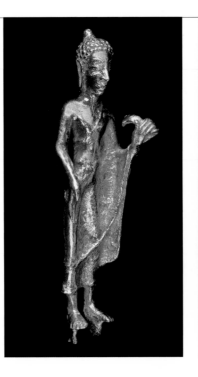
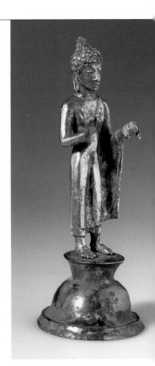

Buddha

Gold statuette
Combre, 11th-12th centuries
Height 8.8 cm
RMV 1463-1

The right hand displays the vara-mudra (of generosity)

Buddha

Gold statuette
Combre, 11th-12th centuries
Height 8.5 cm
RMV 1463-2

Buddha

Gold statuette
Combre, 11th-12th centuries
Height 8.2 cm
RMV 1463-3

The right hand of the figure displays the vitarka-mudra (of reasoning)

Buddha

Gold statuette
Combre, 11th-12th centuries
Height 13 cm
RMV 1463-4

The figure stands on a lotus pedestal
The right hand displays the abhaya-mudra (of protection)

Conclusion

We may conclude that the statues of the Buddha found in Puger Wetan and Combre reveal many features characteristic of Mahayana Buddhism. The statues of the Buddha from both discovery sites probably came from the Buddhist *mandala* in these villages. Where iconography and the method of manufacture are concerned, the finds from both locations differ considerably from the statues found elsewhere in Java. The statues were made by a *cire perdue* method in combination with soldering.

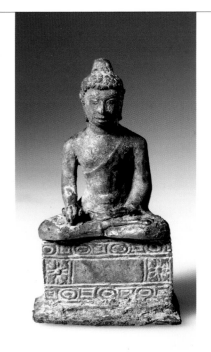

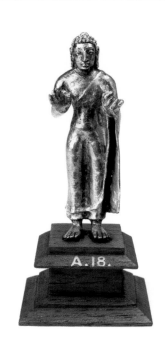

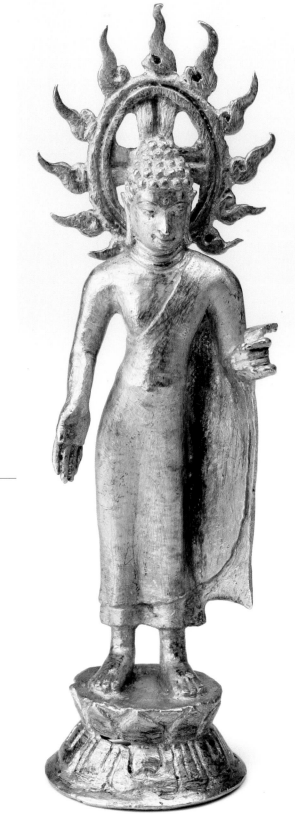

Buddha

Gold (?) statuette
Combre, 11th-12th centuries
Height 5.5 cm
RMV 1463-5

The right hand of the figure displays the bhumisparsa-mudra (the gesture of 'touching the earth' that signifies Enlightenment)

Buddha

Gold statuette
Combre, 11th-12th centuries
Height 7.5 cm
MNI 597c/4634 (A18)

The right hand displays the vitarka-mudra

Buddha

Gold statuette
Combre, 11th-12th centuries
Height 6.7 cm
MNI 596c/4630 (A20)

The figure stands on a double lotus pedestal
The right hand displays the vara-mudra

G.C.E. van Daalen in his hammock
..

Photograph: The Royal Institute for
Language, Geography and Ethnology
(Koninklijk Instituut voor Taal-, Land-
en Volkenkunde)
Code 52074

Mr. Van Daalen has a deeply rooted contempt for everything 'native'. This contempt was expressed in the ridiculous proofs of homage he demanded from both chieftains and subordinates alike. There was no question of social contact with chieftains: after having bent the knee (to him) they then had to stand to receive orders, or to answer questions. Everyone was expected to tremble before the governor. There was no sparing of the cane in impressing the power of the ruling authority (upon the people).

Christiaan Snouck Hurgronje (1857 – 1936), adviser to the government and an Islamic scholar, was not kind in his judgement of Godfried Coenraad Ernst van Daalen (1863 – 1930) who, like Snouck, has come to be regarded a century later as a key personality in the Dutch colonial history of c. 1900. Snouk claimed that he could have filled page after page with examples of Van Daalen's 'inhuman, rough, tactless way of governing and administering the law'. Yet the Governor-General of the Dutch East Indies, to whom the governmental adviser wrote on 2nd October 1903, was spared these examples. Instead, Snouck commended the peerless military abilities of this Aceh officer, hardened in the counter-guerrilla warfare waged by the Dutch East Indies army, c. 1900, against the fanatic resistance encountered in the northern-most part of Sumatra (the region of Aceh, the Atjeh of that time): 'For the rough work of subjecting a Native population offering resistance, I am acquainted with no other officer more suited to the task than the respected Mister Van Daalen.'

Van Daalen's subjugation of the Gajo and Alas country

In 1904 Lieutenant-Colonel Van Daalen made good his henceforth unequivocal reputation when, as commander of a two-hundred-man military police flying column, he spent the time from February to July in laying a well planned military road through the Gajo and Alas territory in the interior of North Sumatra. In this way the Lieutenant Colonel succeeded in smashing the fanatic resistance being offered in this inhospitable mountain region. The enemy had entrenched themselves in a number of *kampongs* turned into forts built of bamboo, which in their turn were stormed and taken by Van Daalen's military police. Inside the fortifications the resistance of the defenders, equipped with primitive weapons and dressed in white garments as a sign of determination to fight to the death, was time and again both fierce and unavailing. Their death sentence was signed when the military police brigades climbed on to the parapet, aided by assault ladders. Rapid fire from the military policemen's modern repeating rifles, aimed at the men, women and children in the *kampong*, quickly put an end to any further resistance. Van Daalen, in a practically on-the-spot report of the capture of Likat on 20 June, wrote:

The population would not consider yielding, and when fathers and mothers continued fighting, we could not spare their children. Here, the people fight in family groups. Attacked by white men's weapons, both men and women alike fell before them. Most of the people had dug their own graves in the place where they were defending themselves, hoping to fall into these, and truthfully they did not yield an inch; compelling respect, yet sad.

Harm Stevens

Collecting, and 'the rough work of subjugation'

Van Daalen, Snouck Hurgronje and the ethnographic development of North Sumatra

Reports written by Van Daalen and his officers, produced during the expedition and published in part after the end of the expedition, provide an astonishingly complex insight into the merciless efficiency with which the military police operated. These journals and reports can be read as a treatise based on colonial warfare practices, in which the finer points of counter-guerrilla and counter-terror tactics are disclosed. The writers linger over the subject of the troops' equipment. The military police were protected, after a fashion, by bamboo helmets with moveable rims, which offered good protection against enemies attacking with 'Lombok water' (water mixed with Spanish – chilli – peppers). Each policeman's personal equipment included a small enamelled pan, enabling him to cook his own food. The column's manoeuvrability was favoured by this personal equipment for cooking, rendering unnecessary the carting of a field kitchen, and improving the troop's mobility. A finely calculated ethnic composition – the troops consisted entirely of 'natives', only the officers being European – was needed to increase the fighting force. One can read about this in a report:

> The combination of Amboinese and Javanese in one brigade is a winning one, and gives a good troop. The mutual jealousy that the Javanese once had, (although) not of the White, as his superior learned to recognise, but merely of the colleague of a similar skin colour, stimulated the less able also to try his hardest to put his best foot forward.

Part of the cheerful domesticity recounted, was a careful stocktaking of the fallen enemies. 'A grim task for the brigades was the counting and identification of the dead', said the report. Thanks to this counting and identification ('it seems that 61 children, unhurt,

could be dragged out from under the pile of bodies') a final tally could be made after the end of the expedition. There were 2,902 dead, including women and children. In the light of a later estimate, this was over a quarter of the total population of the sparsely occupied Gajo and Alas territories.

This large death toll did not leave The Hague politically unmoved. After the expedition was completed, a storm of criticism was unleashed in Parliament over the devastating military actions in the Gajo and Alas country. In the Lower House the Catholic MP, Victor de Stuers, condemned Van Daalen's campaign in the following terms: 'The government called it an excursion, but I call it a history of murder. It is just as though a pack of bloodhounds had been let loose on the natives. It is executioner's work. Let us take them civilization, but not with bloodhounds'. The socialist H.van Kol compared Van Daalen's actions with those perpetrated by Alva during the Eighty Years' War. For that matter the historical comparison did not deter Queen Wilhelmina (who according to rumour entertained until her death a visceral hatred of the 'Iron Duke') from honouring Van Daalen with the Knight Commander's Cross of the Military Order of William I. The Queen would have liked to invest Van Daalen personally with the honour, but this royal accolade was not to take place, since the Lieutenant Colonel relinquished the leave he had planned in the Netherlands, possibly in order to remain safely beyond reach of the fierce criticism in The Hague.

Moreover, in November 1904 Van Daalen expected a new work of pacification to materialise elsewhere in the archipelago. This time his destination was Banjermasin, capital of the Residency for South and East Borneo (now Kalimantan). Van Daalen was member of a commission there that, in a report of 1905, offered a

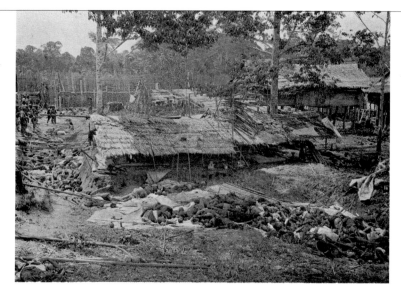

The fortifying of Koetö Reh after the battle, 1904

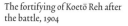

Photograph: from the report of J.C.J. Kempees (1905), Lieutenant of Artillery and Van Daalen's Adjutant

series of recommendations for the installation of an administrative and military occupation. The commission's report presented a blueprint for the entire line of thuggishly aggressive conduct to be pursued as an accompaniment to pacification. On the military level the recommendations were to a large extent grafted on to the discoveries made during the warfare waged in North Sumatra. Snouck Hurgronje also made recommendations (from a distance) on the unrest in Kalimantan. The line of action he recommended unmistakably echoed the remedy for 'native' resistance, which in the meanwhile had been abundantly vindicated in Aceh. In his view this should be: 'Unceasing pursuit of ... leaders of resistance parties, until they have unconditionally accepted subjection to our government, or else have fallen into our hands alive or dead'. A first incitement to this line was given by a detachment of military police arriving from Aceh in Peruk Tjahu on 1 January 1905, whose task it was to provide a good example of the 'offensive spirit' propagated by Commission Member Van Daalen.

The ethnographic exploitation of Aceh

There was another element of importance attached to the military doctrine coming to maturity in Aceh in c. 1900: the active promotion of knowledge of the language, geography and ethnography of the region. This was exactly the point at which Snouck's judgement of Van Daalen became favourable. According to the government adviser, Van Daalen had access to an unequalled 'knowledge of details concerning Atjeh's land, language and people'. The deep-rooted contempt for 'natives' that Snouck imputed to Van Daalen, did nothing to hamper the latter officer's interest in ethnography. Van Daalen was Snouck's best student: a ruthless pacificator and – at the same time – the field agent for ethnographical scholarship.

He was just as driven in the systematic collection of ethnographical evidence as he was is the brutal subjugation of peoples.

The expedition through the Gajo and Alas country had once again added substantial force to this reputation. Van Daalen was also surrounded by officers with similar tastes during the expedition, all of them belonging to the vanguard of the Aceh officers' corps. It is evident from the 'Report on the condition of the officers' kept by Van Daalen during the journey, that the commandant of the column regarded it as a recommendation when his officers showed interest in the language, morals and customs of the local population. Second Lieutenant H. Christofell, who according to the same report 'because of his intransigence, gives the definite impression of being pigheaded', took great pains to learn about the language, morals and customs of the local people (this interest was later to result in an ethnographic collection from the Batak country in particular, donated to the Ethnographic Museum in Antwerp). This interest is also found in First Lieutenant G.F.B.Watrin who, besides his increased knowledge of local morals, took back a horrifying collection of wounds from the expedition. Watrin was, in turn, injured by a 'stone on the right side of his forehead and on the left knee', 'a shot wound to the right side of the chest', 'a bullet graze on the right and left arm(s)', and a wound in the left foot inflicted by a randjoe'. The injuries did not prevent Watrin, as Van Daalen noted approvingly in his report, from 'going to a lot of trouble to perfect his knowledge of the language, morals and customs of the people of Atjeh, Gajo and Alas'.

On 7 November 1904, several months after the conclusion of the expedition, there was a reference during the meeting of the directors of the Batavian Society of Arts and Sciences (Bataviaasch Genootschap van Kunsten en Wetenschappen) to the fact that

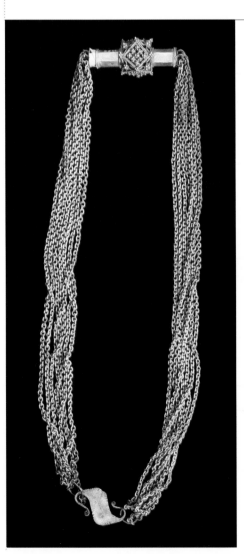

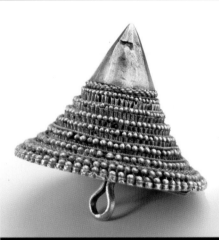

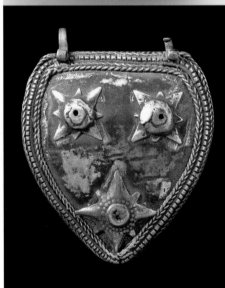

◄◄
Girdle
..
Aceh, North Sumatra
Collected by G.C.E. van Daalen
Length 69 cm
RMV 1429-120

◄
Breast jewel
..
Aceh, North Sumatra
Collected by G.C.E. van Daalen
Diameter 3,5 cm
RMV 1429-116

'Modesty' plate (or covering)
..
Gayo, North Sumatra
Collected by G.C.E. van Daalen
Height 6 cm
RMV 1468-359

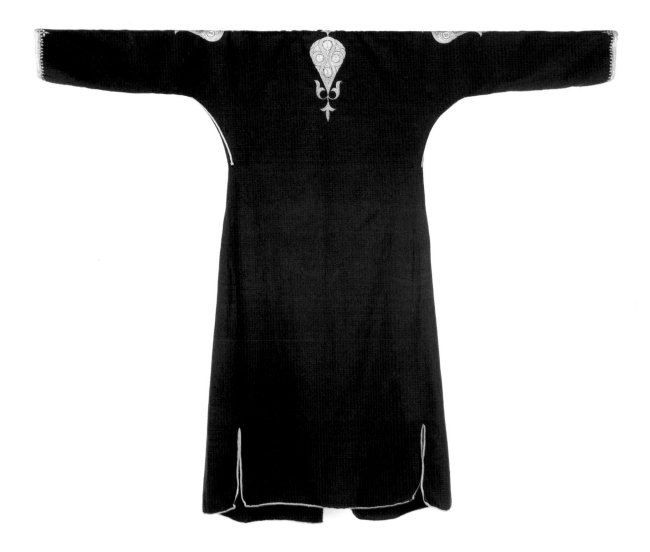

Robe
(and detail of same)

Gayo, North Sumatra
Collected by G.C.E. van Daalen
Length 152 cm
RMV 1468-381

'Lieutenant Colonel G.C.E. van Daalen has sent two chests of ethnographica, as well as photographs dating from his journey to the Gajo and Alas country. As soon as the promised notes concerning the contents have been received, further decisions will be taken'. The chests mentioned, filled with jewellery, items of clothing, ceremonial weapons, toiletry articles and other household objects from the Gajo and Alas country, were the fruit of an unmatched pact between ethnological interest and politico-military repressions. A week after the arrival of the chests in the offices of the scholarly society in Batavia, the decision was made to 'express the directors' sincere thanks to Lieutenant Colonel Van Daalen for this new evidence of interest in the flourishing of the Society'. A little later Van Daalen was promoted to honorary membership 'as evidence of (our) appreciation of (his) vigorous promotion of the interests of the society's scholarly collections'. These good tidings were conveyed to the Lieutenant Colonel, at that period in Banjermasin, in a short letter dated 21st December 1904. The communication was signed by Snouck Hurgronje, president of the Batavian Society.

C. Snouck Hurgronje and the opening of Aceh to ethnographical study

This interchange between ethnography and military action already had a substantial pre-history in Aceh, in which the figure of C. Snouck Hurgronje occupied an inescapably dominant place from the very first. Approximately a decade before Van Daalen's expedition, between 1892 and 1895, Snouck produced (as a government assignment) a series of anthropological studies on Aceh society, part of which were published in his well-known book De Atjehers (The people of Aceh; published in 1893 – 1894). In the secret

'Report on the politico-religious situation in Atjeh' this government adviser exposed the strategy that could be used to combat Aceh fanaticism. The 'very sensitive strike' in order, later, to set the government's 'foot on the enemy's neck', recommended in Snouck's Aceh Report of 1892, indicated the slow but steady transition to active counter-guerrilla warfare waged by the Dutch East Indies army.

In the first years of the new century a new phase in the Aceh war broke out. The guerrillas moved their operations from the coastal regions to the mountainous area further inland, which included the Gajo and Alas country. Before switching to the pursuit and liquidation of the principal Aceh resistance leaders, hiding in these inhospitable areas, Snouck wrote an official note giving a concise survey of the Gajo country. This item, half-way between an ethnographical sketch and a (military) intelligence report, appeared in September 1901, just in time to serve the needs of Lieutenant Colonel Van Daalen in the expedition upon which he embarked through the Gajo country with his 250 military policemen in the autumn of 1901. It was the first Dutch encounter with this region, and the overture to the 1904 expedition. The action of 1901 bore immediate fruit, at all events for the Batavian Society, which was able to refer to a letter from Snouck, in the notes intended for the the meeting of the directors and members held on 24 March 1902:

firm offer of a collection of ethnographica consisting of 159 items, sent with that intention by (Lieutenant Colonel) G.C.E. van Daalen of the general staff. The first 156 numbers include various objects from the Gajo country, assembled by the aforesaid (officer) in the course of his excursion through that region last year. [...] (Lieutenant Colonel) Van Daalen has added a concise inventory to the materials sent, with the names of the

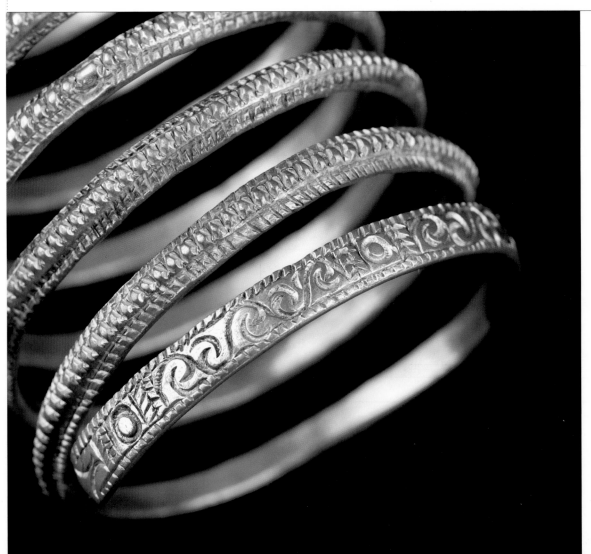

Spiral arm band or bracelet

Gayo, North Sumatra
Brass
Collected by G.C.E. van Daalen
MNI 10193

▸
Bracelet

Gayo, North Sumatra
Silver
Collected by G.C.E. van Daalen
MNI 11045

▸▸
Bracelet

Gayo, North Sumatra
Silver
Collected by G.C.E. van Daalen
MNI 11027

objects and several notes on their use. As far as possible these comments have been improved and expanded by the writer, who has also added several ethnographical details.

A year later the government ordered the publication of Het Gajoland en zijne bewoners (1903) (The Gajo country and its inhabitants), the extensive results of research carried out in Aceh in the preceding years by Snouck, with the aid of two Gajo informants. The foreword shows that, during his investigations, the government adviser had been able to make use of 'the highly important ethnographic collection' assembled by Van Daalen in the course of his journey through the area in 1901. As described above, in 1904 it was once again Van Daalen's turn. In the following five months he and his flying column of military police dealt the ultimate death blow to the rebellious population of the Gajo and Alas country. This was the final step in the carefully worked out relay race on which the Snouck-Van Daalen tandem had embarked in 1901.

The ultimate reward for the unremitting ethnographical work carried out during the previous years was the six-day exhibition of the Van Daalen collection, mounted in February 1905 in the Museum of the Batavian Society. Visitors were able to examine not only the ethnographical objects, but also the large number of photographs taken by the Medical Officer H.M. Neeb in the course of the most recent expedition through the Gajo and Alas country. The expedition journal tells us something, here and there, of the conditions under which the photographs were taken:

The Lieutenant Colonel made it clear that he wanted to attend the marriage feasts. [...] On the 3 May the guest were welcomed, including the commander of the flying column, and all those of his officers who were present on the day. [...] The bridegroom and the entire kedjoeron family make their sembah to the Lieutenant Colonel, who presented them with a wedding present of 100 dollars. After obtaining permission from the respective parents, and from the bridegroom, our indefatigable photographer was naturally present in order to preserve this moment for posterity, although there was a good deal of protest from the bride. [...] The bride was heavily veiled, and when these cloths were drawn back, they revealed a sweetly bashful maiden of perhaps 12 years old.

In addition to the 'ethnographical' photographs, the series also contains several shots of the captured kampongs, showing quite clearly that the military police were trampling over corpses. In several photographs one can see a jumble of dead kampong occupants. The military policemen can be seen in the higher positions. Several photographs show the policemen among dead bodies, always those of young children.

Two years after the exhibition, a new step was taken on the road to the ethnographical development of the Gajo region, this time of a linguistic kind. In 1907 the civil servant concerned with languages, G.A.J. Hazeu, was commissioned by the government to compile the Gajo-Dutch Dictionary (Gajsch-Nederlands woordenboek). In this work Hazeu was aided by two Gajos living in Batavia who, as we can read in the foreword, 'had already been more or less trained by Dr. Snouck to provide information on their language'.

The dictionary constitutes the closing chapter in the scientific/scholarly opening up of the Gajo and Alas territories, which in 1901 had been incorporated into the region under Snouck's authority.

The government adviser, who left the Dutch East Indies in 1906 to take up a professorial Chair in Leiden, had ensured that, as well as the Society in Batavia, the ethnographical establishments in the mother country could also share in the scholarly progress achieved. The Royal Military Academy in Breda, the Museum of Ethnology in Rotterdam (Museum voor Land en Volkenkunde), and the State Ethnography Museum in Leiden, (Rijks Ethnografisch Museum, the current National Museum of Ethnology [Rijksmuseum voor Volkenkunde]) each received a considerable proportion of Van Daalen's donations. The hundreds of ethnographical objects – a cross-section of the Gajo and Alas material cultures – were welcome additions to the respective collections. They enabled the museums to begin once more to colour in a hitherto blank area on the map of 'people' in the Dutch East Indies.

The Van Daalen Collection

1912 saw the publication of the sixth volume of the Catalogue of the State Ethnography Museum (Catalogus van's Rijks Ethnografisch Museum), which included descriptions of objects from Aceh and Gajo. H.W. Fischer, the curator responsible for these objects, noted in his introduction: 'It cannot be otherwise than that the objects shown here had perforce to be collected mainly by (military) officers, who up to the present, owing to circumstances, have been the only people to have come in closer contact with the population (of the region).' This certainly applies to the objects described in the catalogue, deriving from the Gajo and Alas country and forming part of the Van Daalen donation. The curator had been given no further information on the exact nature of the 'circumstances' and 'closer contact' mentioned. which the officiating curator more

than once refers back to Van Daalen's expertise. His donation to the Leiden museum, part of which could be described in the publications in December 1904, was accompanied by several folios with the descriptions that Van Daalen alone had written up. It was a valuable document from which Fischer for example, in his description of a loin cloth, derived the information that in the local language this was known as *oeles tenon pakan megard*. The local inhabitants' name for the motif worked into the edge of the garment could also be given in the catalogue, thanks to 'the donor's statement': *keketang krabong n doekoer*, which can be translated as 'edging like a turtle dove's collar'. Snouck Hurgronje was right: Van Daalen's 'knowledge of details about Atjeh's country, language and people' was unequalled.

There remains one question of interest: how were the objects in Van Daalen's donation actually acquired on the spot? What was the practice used in ethnographical collecting in the field? How did Van Daalen come across these objects during his 'excursions'? It is only occasionally that one can read anything on this subject in the extensive military instructions and reports written up on the military actions. On 17 September 1901 General J.B. van Heutsz, who was Governor of Atjeh and Dependencies at the period, sent the commander of the flying column, Van Daalen, the following instruction during his first trip to the Gajo country: 'Strong measures have to be taken to ensure that no one is guilty of appropriating, or damaging the Gajos' property'. In the Journal of the expedition of 1901 one sees that, on 30 October, several Gajos visited the bivouac 'in order to sell various curiosities to the officers, who had asked for them yesterday'. In the journal of the 1904 expedition one also reads: 'Here, too, the local people had dressed in their festive clothing, and many of the men were

◄
Ear ornament

Aceh, North Sumatra
Collected by G.C.E. van Daalen
Diameter 6.5 cm
RMV 1429-1252

►
Sirih bag

Alas, North Sumatra
The fibres of leaves of the Pandanus
Collected by G.C.E. van Daalen
MNI 11300

wearing costly silk *hadji* garments, with the *al hare* jewellery. The troops were given a strict warning not to rob the bodies of the dead'.

The reports on the expedition were careful to point out that officers purchased the curiosa they wanted from the local population, in the course of the march. Generally speaking it would appear that, as far as possible, steps were taken to avoid the commission of indiscriminate theft by the troops. This was probably also achieved by enabling the officers' cadre to collect the objects they wanted in a more systematic way.

Today, the original objects donated by Van Daalen to the Batavian Society are scattered among various ethnographical institutes and museums in The Netherlands and Indonesia. In Rotterdam, 140 objects originating with Van Daalen form part of the collection held by the World Museum Wereld-museum), successor to the Museum of Ethnology (Museum voor Land-en Volkenkunde). A large proportion of the donation to the Royal Military Academy (Koninklijke Militaire Academie) was returned to the Van Daalen heirs in the 1950s. The National Museum of Ethnology in Leiden, successor to the State Ethnography Museum, holds some five hundred objects deriving from the Van Daalen donation. In a post-war exchange between the Leiden museum and the Rautenstrauch-Joest Museum in Cologne, a number of the objects deriving from Van Daalen found their way into the latter establishment. In the National Museum in Jakarta, successor to the Batavian Society, the origins of hundreds of objects can be traced back to Van Daalen's donation.

One object, a *sirihtas* collected by Van Daalen during the 1904 Gajo and Alas expedition, ended (over a quarter of a century after its description in the Leiden Museum volumes) in the ashes

left on the site of the great International Colonial Exhibition (*Exposition Coloniale Internationale*) held in the Bois de Vincennes, on the eastern border of Paris. There, on the night of 28 June 1931, the entire Dutch colonial pavilion was burnt to the ground. The government declared this event a national disaster, through the mouth of the Minister for Colonial Affairs. It was a dramatic end to an object that, under equally dramatic circumstances in 1904, had formed part of the colonial merry-go-round of ethnographic materials.

Van Daalen was no longer on the scene. About a year before the Paris fire, the General had slipped from his chair one evening in February 1903, in a club in The Hague, and had died of a heart attack. He had spent his last years in the capital, where he occupied his time with growing roses and orchids in the garden of his big house in the Laan van Meerdervoort. Even his passion for collecting had acquired a more domestic tone: from now on, Van Daalen collected postage stamps and coins.

Ethnographical collections from the colonial period present a mirror of the spirit of enterprise that brought the Dutch in contact with foreign cultures, out of scholarly interest in these cultures but also as a complement to the military violence accompanying these encounters overseas. The objects from the Gajo and Alas country donated by Van Daalen to the ethnographical museums in the Netherlands and The Dutch East Indies at the beginning of the twentieth century, reflect this apparent paradox in the Dutch colonial expansion in c. 1900 – a paradox that was formed, one could say, within the dark heart of the colonial adventure, the territory in which Van Daalen enforced 'the rough work of subjecting the rebellious Native population' in the fiercest possible manner.

For the modern viewer, the controversial Lieutenant Colonel may possibly himself seem to represent a 'foreign culture', just as the ethnographical collection from the Gajo and Alas country does. Yet this 'foreign' culture of colonial interference, and the warlike vigour deriving from it, was an important pillar of Dutch civilization in the first decades of the twentieth century. Queen Wilhelmina would not have denied this. In 1908 Van Daalen was summoned to the palace for an audience lasting an hour and a half. Thus the meeting of Queen and Aceh officer came about at last.

Sabre handle

Aceh, North Sumatra
From a corpse slain in battle
Collected by Dr. Snouck Hurgronje
MNI 9159

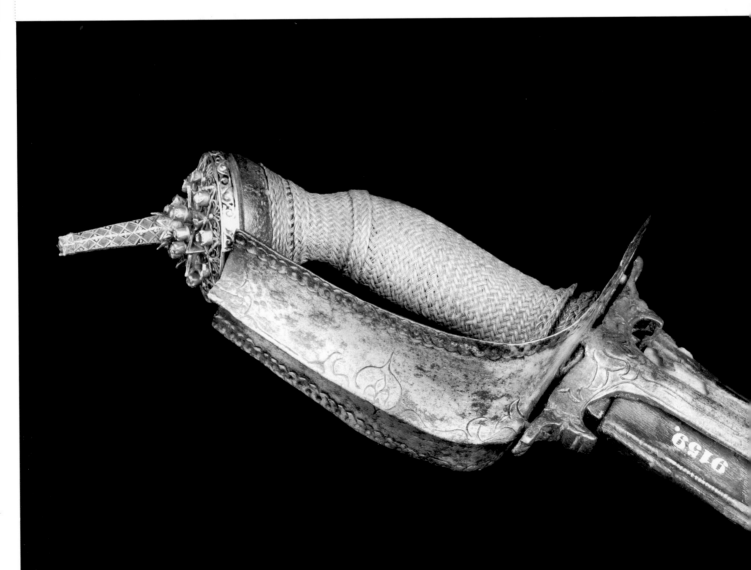

In the middle of the nineteenth century, the map of the large island of Sumatra (now Sumatera) still contained many blank patches. Scholarly expeditions and individual collectors tried to explore the uncharted areas, while collecting ethnographica at the same time.

Central Sumatra expedition: trade and scholarship

In 1873 the Dutch Geographical Society (Nederlandsch Aardrijkskundig Genootschap) was created. It was a private initiative that was nevertheless supported by many notables in Dutch society, and was under the protection of Prince Hendrik. The first chairman was P. J. Veth (1814 – 1895), recently appointed Professor in geography and ethnology at Leiden University. Veth was to play an important role in stimulating the Central Sumatra expedition, and later on by rendering the results publishable.

The new society went energetically to work. From the beginning the intention was to finance, or to stimulate in some other way, researchers, preferably Dutch ones. Partly because, in seeking finance for the venture, the plan was to knock on the doors of private business firms, it was clear from the beginning that trade and scholarship could, and must, be in line with each other. Further, it was not long before the suggestion was made that Sumatra ought to be the objective of the first expedition. The secretary of the committee appointed to prepare and accompany the Central Sumatra expedition, Lieutenant Colonel W. Versteeg, wrote in 1881 about the motives for going to Central Sumatra:

The research [...] would not only take geographical knowledge a good stride forwards, but at the same time would open up the prospect, that suitable natural roads would be indicated for the products of the highlands lying behind it, known as being very fertile and rich. The chance of establishing something of value, for tracking down new sources of prosperity for the Colonies and Motherland, were regarded as greater [in this region] than in other parts of the island.

The economic objectives of the expedition appealed especially to trading companies in the great cities, and by the end of 1876 thirty thousand guilders had been collected. Following this, four objectives were formulated: (1) to map the region to be travelled through' (2) to institute an investigation of the 'productivity' of the soil; (3) to establish a linguistic and ethnographic investigation; (4) to institute research on the region's natural history. The naval Lieutenant J. Schouw Santvoort was appointed head of the expedition, but the conclusion was quickly reached that the journey ought to be split into two parts, and that a second expedition leader was therefore needed. A. L. van Hasselt (1848 – 1909) was approached, a *Controleur* with the colonial administration on Sumatra, and because of his function, someone who was very familiar with the local conditions. Van Hasselt would take responsibility for the ethnographic documentation, including the collecting of an ethnological collection. D. D. Veth (engineer and photographer) and J. F. Snelleman (zoologist) were also appointed to serve under Van Hasselt.

Besides the promotion of economic interests, the filling in of the white blanks on the map of Sumatra was also a major motive for the entire enterprise. The Dutch economic and political interest was never far away, yet it was made quite clear that this was not a government expedition. This fact was often stressed, particularly in negotiations with local leaders. It was emphasised that members of the expedition should not go armed, and that it was not the

Collecting in Central and South Sumatra

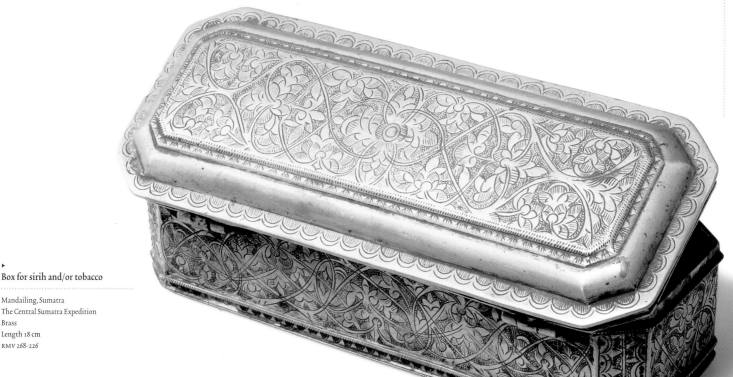

▶
Box for sirih and/or tobacco

Mandailing, Sumatra
The Central Sumatra Expedition
Brass
Length 18 cm
RMV 268-226

intention to take possession of the regions visited. Perhaps we ought to add 'not the intention yet' since the information furnished by the expedition leaders was naturally very useful to the colonial government.

That government also maintained ambivalent relations with the expedition. The Society's first appeal to local administrators for information received very enthusiastic and positive replies. The region for which the expedition was heading, Jambi, was peaceful, and the intentions of the Geographical Society met with approval. The expedition leaders were actually asked to refrain from doing anything to disturb the peace of the area. Later the government's position was less positive. Some regions were placed under an interdiction, and with increasing frequency government servants queried the aims of the expedition. However, by that time a great many things had gone wrong.

Soon after the beginning of the undertaking, Lieutenant Schouw Santvoort died, wholly unexpectedly. Although this leader is most emphatically praised in the sources, his decease does not appear to have had any great influence on the plans. A successor was rapidly appointed, and it then seemed that the expedition would be able to go ahead. However, the expedition members Van Hasselt and Veth (Snelleman had already fallen out because of a wound to his foot) were confronted with problems when they were approximately a hundred kilometres to the east of Padang. They were on their way to the area round Singuntur to study the stone statues there, before travelling on to Jambi. In order to request access from the local leader, Van Hasselt and Veth has sent ahead a Malay assistant, and a relative of another local leader, with letters of introduction. The report of the two emissaries leave us in no doubt as to what occurred. When they mentioned to the Raja the expedition's plans

for the journey, and wanted to hand over the letters and gifts, the ruler turned his back on them.

For some time they remained there sitting, until at last they were asked, in the Raja's name, what the gentlemen's real intentions were in his kingdom; had they come to investigate the country, in order to take possession of it later. 'Our gentlemen' was the reply 'are simple travellers who want to pay a visit to the princes, and to view the stones that lie in the vicinity of Sigoentoer'.

There were a few painful moments of silence, then several hours later the visitors were told that they were not welcome. At about one o?clock in the morning both the representatives received a visit from one of the Raja's sons. The Malay assistant had to go to the ruler. The latter appeared to be very angry, and asked irritably why they were still in the village. If they had not left by early the next morning the Raja would give the order to kill them. The Raja gave the assistant to understand the following:

You can take these letters back with you, and tell the gentlemen that I do not wish to receive them; yes, I don't even want to hear anything more about them; because according to the oath that I, like my predecessors, have sworn, I shall never permit a white man to enter the Rantau, and [I shall] have every European murdered who dares to penetrate my kingdom!

With this message, two things immediately became clear. Firstly, it was obvious that earlier reports from administrative officials had presented a far too rosy view of the local political situation. Secondly, one of the chief objectives of the expedition, the

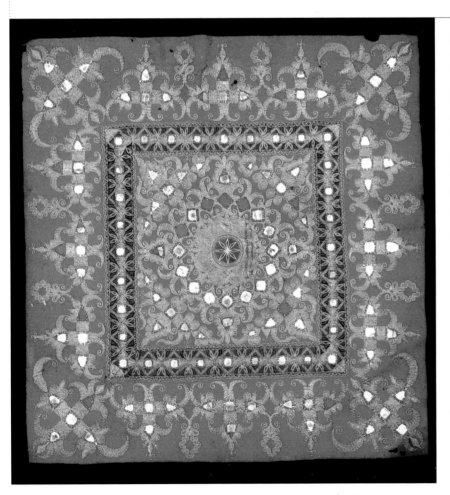

The Batang Hari River

The Central Sumatra Expedition did not proceed beyond this point
Photograph: D.D. Veth, from the report of the Central Sumatra Expedition

◀
Cloth

Mandailing, Sumatra
The Central Sumatra Expedition
Cotton, mica and gold thread
Width 60 cm
RMV 268-118

discovery of routes for transporting the raw materials found in Jambi (particularly coal) immediately seemed to be very far off. Van Hasselt and Veth understood that there was little to be done about the situation. They did sail further up the river, in order to sail via a tributary back to Silago, a village they had visited earlier on, and where they had been given a friendly reception, but even this led to great tension. They were threatened, and when the news arrived that a large group of warriors was on its way to murder the Dutchmen, the Dutch men packed their belongings at breakneck speed and withdrew to safer regions.

The region to the north east of Siguntur remained a painfully white blank spot on the map, even after the end of the expedition. The members decided to travel to other areas, thereafter concentrating fully on scholarly activities. In the introduction to the imposing four-volume report of the Central Sumatra expedition, Professor Veth went to great trouble to explain that the expedition had not been in any sense a failure. A good many things had gone wrong, but a great deal of new information had become available on the regions in which the expedition members had been permitted to stay. The reporting was indeed extremely impressive.

A. L. van Hasselt mentioned in his *Ethnografische atlas*, forming part of the report of the expedition, that all the objects collected under his leadership had been handed over to the State Ethnography Museum in Leiden (Rijks Ethnografisch Museum, the current National Museum of Ethnology, or Rijksmuseum voor Volkenkunde). This appeared to be inconsistent with government's intention of splitting up collections between Batavia and Leiden, but we should not forget that the Central Sumatra expedition was not a government undertaking. Van

Hasselt was certainly a government official, but for the duration of the expedition he had been 'loaned' to the Geographical Society, and the collection belonged to that society and not to the state. Nevertheless, the Indonesian National Museum in Jakarta holds a collection from the Central Sumatra region that is very similar to that in Leiden. Moreover, the model houses were collected in the same period, and resemble each other stylistically. According to our hypothesis, although hard proof for this is lacking at the moment, this was connected with the manner in which the objects were collected. The *Ethnografische atlas* does indeed give a good deal of information on the objects illustrated (they now belong to the Leiden collection, RMV series 268) but nothing can be discovered about their collection context. Van Hasselt often mentions the prices that were paid, but he says nothing about the circumstances in which their objects were purchased. It is very possible that he obtained many of these objects from other Europeans. He may have asked government-official colleagues to gather things for the expedition, and these collectors may in their turn have given a thought to the Batavian Society. This could be the explanation for the similarities between the Leiden and Jakarta collections.

Van Hasselt himself was promoted to the post of Secretary of State for the Dutch East Indies, after which he was appointed Resident of Tapanuli and Riouw. In 1898, after his official retirement and return to The Netherlands, he was appointed Professor in the geography and ethnology of the Dutch East Indies in Delft. He died in Oosterbeek in 1909.

Depiction of a Besemahse habitation

Commissioned by O. Helfrich. He has numbered and named all the parts of the house
RMV 886-1

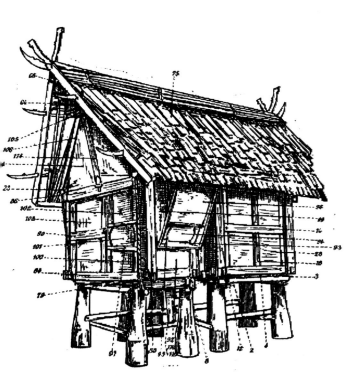

Oscar Louis Helfrich (1860 – 1958)

Otto Helfrich: administration and scholarship

Apart from members of large-scale scholarly expeditions, many individual collectors were also active on Sumatra. During the board meeting of the Batavian Society held on 19 September 1885 there was a reference to a visit by O. L. Helfrich, candidate for the post of *Controleur* in Kroë, with the aim of being made a member of the Society. 'This fact will be recorded' said the notes.

Otto Louis Helfrich was born in 1860 in Serang. His father, Conrad Helfrich, was a Bavarian Medical Officer; his mother was Jeannette Caroline Couvrier. The young Otto was sent to The Netherlands at a young age, where he attended both primary and secondary school in Leiden. At the same time he attended the lectures given as part of the training for the Dutch East Indies government service. Helfrich returned to the East Indies, and in 1883 (now married) he set out for the Residence of Benkulen. In 1886 he was to write:

> In the conviction that it is of the greatest value for a government official to know the customs, morals, habits and language of the country which he will govern, I am making haste to put [all this] into practice on my appointment to the Kroë Department, and, to the best of my ability, to let no time go by before learning as much as I can about the country and its people.

The young Helfrich was certainly very energetic. After Helfrich's death P. Voorhoeve was to write that this youthful energy did not always produce good results. His contribution on the flora and fauna of Kroë, intended for *Bijdragen tot de Taal-, Land- en Volkenkunde van Nederlandsch-Indië* (Contributions to the Language, Geography and Ethnology of the Dutch East Indies) was rejected, although his ethnographic notes were actually accepted. In 1888 Helfrich published an article on the island of Enggano, to which Von Rosenberg (see the chapter 'Knowledge, curiosity and politics?) had also devoted an article thirty years before. Although Helfrich was still young and relatively inexperienced, the difference between his and Von Rosenberg's observations is patently obvious. Helfrich is clearly a good observer, very thorough, thereby greatly extending the knowledge of the regions he visited.

In c. 1890 the government official, still young in years, received tokens of appreciation from great scholars such as Snouck Hurgronje and Van der Tuuk, a gesture that gave him an enormous stimulus. Between 1888 and 1892 he was in Pasemah (South Sumatra) and carried out extremely detailed linguistic and ethnological research there. The collections he assembled at that time were divided up between Batavia and Leiden. A large part of Helfrich's Leiden collection (RMV series 820, 886, 939, 2456 and 2528) is documented with great thoroughness, and to this day the original labels, with numbers referring to his notes, are still attached to the objects. In the case of the model houses, for example, this has resulted in a very valuable documentation of house building in Pasemah. Unfortunately the documentation belonging to the Jakarta collection has not yet been traced.

As a good example, we reproduce here part of the description that Helfrich provided for one of the model houses he collected (RMV 886-1). This description was absorbed in its entirety by H. W. Fischer in his catalogue of the South Sumatra collection in the National Museum of Ethnology (Fischer 1918: 76-80).

Jacket

Jambi, South Sumatra
The Central Sumatra Expedition
Cotton, fibers
Breadth 137.5 cm
RMV 268-65

Model of a Besemah dwelling (Department of Manna, Benkoelen)
 Groemah beberoege or beroege (B) belonging to a prosperous person, consisting of a larger and a smaller building, each on four piles, linked over half their width by a walking plank and under one roof. The smallest building is called beroege and is the sleeping place of the unmarried males (boedjang). If one of the sons has just married, and if he still has no home of his own, then the parents move temporarily into the beroege, while the newly married couple move into the house. The beroege also contains a hearth. The young girls sleep in the attic, unless a small room is divided off for them.

Helfrich then gives a long description of the house's arrangement and measurements, but only after this do we find the really detailed work. Accompanied by two drawings of the model house (one of which is illustrated below) there is a list containing some 119 components of the house, each provided with the local name. To this date we know of no other collector who provided such detailed documentation.

 In his foreword to his catalogue, Fischer writes that he received good support in the composition of his book from Helfrich 'who, tireless as ever, very willingly placed his inexhaustible knowledge of the country and people at my disposal, and to whom we are indebted for many invaluable pointers in the linguistic and ethnographic field'. In 1906 Helfrich became the first Resident of Jambi, returning to Bengkulen at the end of his successful and productive career. In 1912 he retired, and returned to The Netherlands, where he continued to lead a long and active life. He played a great part in the establishment of the South Sumatra Institute in 1916, and in the compilation of the volumes on *adat* law (especially with his contributions on South Sumatra). He also served

for three years as Governor of Curaçao. Otto Helfrich died in 1958 in the Voorburg nursing home.

 Concerning his behaviour in the regions in which he worked, we could mention that the local people in South Sumatra knew him under the name of *toean tjabe rawit,* meaning 'small but fierce'. At that time this was probably no superfluous luxury for a Dutch government official. Sumatra was still far from being tranquil, and in view of the many honours Helfrich received during his life time, he was very active in the various 'war enterprises'. He was awarded honours for his actions in Aceh (1898), Jambi and Kerinci (1906) and Central Sumatra (1908). In 1903 he was rewarded for his courage and political policies with the appointment to the position of Officer in the Order of Orange Nassau.

Indonesia may be proud of the extent of its territories and of the cultural diversity of its population. This cultural diversity characterising the archipelago operates like a handbook guiding the inhabitants in their various daily activities. One region, the island of Kalimantan (previously called Borneo), covers an enormous area and has considerable potential with respect to its natural resources. The Malay province of Sarawak and the independent state of Brunei Darussalam, also form parts of this island.

The word Borneo derives from the local word 'Burni' that refers to an Islamic trading town in north-west Kalimantan. The term Burni or Borneo came later to be used to name the whole island (Low 1948: 2). The name Kalimantan derives from 'kalamantan', signifying *lamanta* island or 'the island of uncooked sago'. However, others consider that Kalimantan is a corruption of 'kalimanten', which signifies a 'river of precious stones', or 'precious stone river'. This explanation seems to be confirmed by the fact that in many areas of Kalimantan precious stones are indeed found, as in Martapura (South Kalimantan).

Kalimantan

Position and nature Kalimantan is situated between the latitudes of seven degrees north and four degrees south. It is one of the largest islands in the world, standing only after Greenland and Irian (New Guinea). The equator divides the island into northern and southern segments of roughly equal area, so that thermo-ecologically the island can be described as an intertropical, equatorial, transitional region. There is virtually no dry area to be found, a large part of the surface being intersected by rivers such as the 1143 kilometre long Kapuas River. This river flows from the foot of Cemaru Mountain westwards through a large part of West Kalimantan, thereafter meandering through low-lying areas and flowing into the sea at the marshy coast. The Banto River is another example: it rises in the Muller hills and thereafter flows southwards, to finally empty into the sea near Banjarmasin.

Kalimantan extends for a length of roughly 1300 kilometres and covers 540,000 km2 of Indonesian soil. This means that it includes almost 28 percent of the total territory of Indonesia. The rest of the island consists of 201,000 km2 belonging to Malaya and almost 6000 km2 to the state of Brunei Darussalam.

The most important variety of tree on Kalimantan is that of the *Dipterocarpus*, a species that grows beneath the 500 meter contour. These trees may grow up to 60 meters in height, and are adorned with lianas under which hardly any scrub is able to grow and which, besides, obtains little or no sunlight. The laterite soil – a yellow or red acid soil – is less fertile that that of Java since lacking the volcanic content of the latter. The Kalimantan flora includes bamboo and rattan, and trees such as the kapok (ceiba pentandra) and palm, and besides a resinous tree. The fauna includes the orang utan, the bekantan ape, deer, pigs, wild cattle, panthers, the kukang, bear, crocodile, turtle, snakes and the hornbill. This last has become the symbol of Kalimantan.

The natural environment of Kalimantan thus consists of its forest and water-based resources, and these have inspired many kinds of cultural expression. In each culture, people need to develop their skills in order to satisfy their basic needs, and also secondary needs that depend directly upon the former. According to the English anthropologist, Radcliffe Brown, however, certain aspects of social behaviour are independent of such pressures to

Irwan Zulkarnain

Kalimantan and the Expeditions of Nieuwenhuis and Van Walchren

fulfil individual wants, instead expressing the desire to manage the social structure of the community (Ihromi 1992: 60-61).

The Inhabitants

Although Kalimantan is very extensive, the population consists of no more than 9.1 million inhabitants (according to the census of 1990), with a population density of 17 persons per km2. At the present time, the population consists of a mixture of different groups, of which the two largest are the Malays and Dayaks. The oldest evidence of a human presence in Kalimantan has been discovered by Tom Harrisson. A skeleton of *Homo sapiens* was encountered at the entrance of West Gua Niah (the western cave of Niah) in Sarawak during his excavations. Kalimantan has been inhabited by human beings for at least forty thousand years. It was always a meeting point for flows of human migration and this has led to the current distribution pattern of the population (see the diagram showing the distribution of ethnic groups in Kalimantan). Some groups of Dayak and Punan have been considered to be the original inhabitants of Kalimantan (Avé en King 1986).

The Dayak population consists of hundreds of tribes, but J. Vredenbregt (1981: 33) has classed them into five main groups: South Kalimantan is occupied by the Ot-Danum Dayak and the Ngaju; the west is inhabited by the Kendayan Dayak and Iban; in East and Central Kalimantan there are Kenyah-Kayan Dayak and the Bahau; finally the Murut Dayak inhabit the north west of Kalimantan and Sabah, which is part of Malaya. However, Dr. H.J. Malinkoodt distinguishes six Dayak groups: the Kenya Kayan Bahau, the Ot-Danum, the Iban, the Murut, the Klemantan and the Punan.

Even if outsiders see the Dayak as the original inhabitants of Kalimantan, only a few sub-groups of the Iban of Sarawak and West Kalimantan recognise the appellation Dayak as their original name. The term Dayak is also used to signify *orang darat* ('countryman') and *orang hulu* ('rural inhabitant').

Dayak tradition and daily life

Some Dayak communities live in 'long houses' or *rumah betang*. The community has an egalitarian structure but individuals enjoy competing with one another. This rivalry is expressed by the enthusiasm with which they ornament themselves with jewellery and tattoos. Such tattoos express religious belief, social status, stage of initiation, and descent, and they are a form of inspired magical art. The Dayak believe that a tattoo possesses intrinsic meaning, manifesting a significant religious sentiment, and that it acts as means to communicate with the gods. They thus believe that tattoos can keep evil spirits, illnesses and death at bay. Kayan and Kenyah women consider tattooing a means of displaying their beauty and social position, while Iban and Murut males use it as a sign of masculinity and success in battle. The animal signs on the shoulders of a Murut male show the number of heads he has severed.

Differences in tattoo design are an important mark of distinction between the various Dayak tribes. The Bahau and Punan use dark striped patterns. Women have their tattoos on their forearms, thighs and feet, while the men tattoo their shoulders, chest and arms. A tattoo on the left hand and left thumb is reserved for the most courageous men. Bukat and Beketan males ornament virtually their whole bodies between the lower jaw and knee. The Dayak of Barito and Melawi are known for globe-shaped tattoos, both large

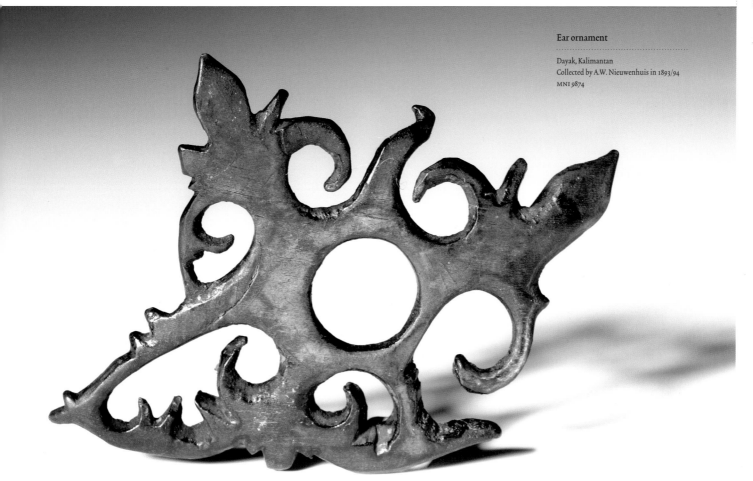

Ear ornament

Dayak, Kalimantan
Collected by A.W. Nieuwenhuis in 1893/94
MNI 9874

and small, placed on the calf below the hollow of the knee. Bodily ornamentation forms part of many ceremonies. When a male Kenyah Dayak is tattooed, all his male kin must clad themselves in loincloths. They are not permitted to leave the house and must refrain from certain activities in order to avoid endangering the life of the man being tattooed. This ceremony is called *mela malam*: it signifies a request for help from ancestors, enabling the tattoo to be safely accomplished.

Customary law (*adat*) is applied to life in society. Decapitation used to be solidly entrenched among the Dayak, but this custom, an example of *adat*, did not result from a persistent inclination to kill. Decapitation was not considered as something negative or sadistic because it did not result from a desire to kill someone. Moreover, not everyone was permitted to do it. In principle, a head was severed only in order to transfer the spirit of the deceased to a specified other person, this leading to pacification of the situation. In the case of the Kayan, head cutting was a symbol for the expansion of their sphere of control through the subjugation of an enemy, and in no sense did it arise from the mere desire to 'take heads'. Before the head of the losing party was actually severed, there would be an undertaking to fulfil the victim's final request to care for his descendents up to and including the seventh generation. This custom, known as *notong*, was intended to show honour to the losing party, and it served as a moral constraint on the victorious party to hold a ceremony, a duty affecting each of the next seven generations but after which the head could be buried.

When a Kayan child is born it is washed, and immediately afterwards the ear lobes are pierced with small pieces of bamboo which must remain in place until the wounds are healed. Afterwards, they are replaced by lead earrings which, because of their weight, result in the elongation of the lobes.

Dayak livelihood is mainly based on hunting, fishing and 'slash and burn' cultivation (the latter consisting of the burning down of areas of forest in order to cultivate crops in the resulting clearings; upon exhaustion of the soil, a fresh area of forest must be burned down). Each morning the men, women and children leave with baskets on their backs and cutting knives in their hands, the men with bows and arrows and accompanied by one or two dogs. In the evening the group returns with fire wood and the spoils of the hunt, while the women return bearing fruit.

Life depends wholly on nature and the Dayak believe in the necessity of a natural balance. If this balance is disturbed an accident might occur. For this reason, daily life is continually punctuated by adat ceremonies. The Kendayan thus perform the ceremony of *naik dango* to express gratitude for a good harvest. During this ceremony, a mask shaped like a bird's head is used; it is the symbol of divinity that has descended to earth to offer protection and bestow fertility on the soil. In the case of the Taman Dayak and Kayan Dayak one finds the *hudo* mask with its large and wide-open eyes, and also, as one of its more remarkable features, its large open mouth and huge teeth. This mask is used to frighten off bad spirits responsible for misfortune and to keep away sickness.

Next to food, clothing represents another primary need that must be satisfied. Originally, use was made of the ubiquitous tree bark. This bark was soaked in water, laid out, and then evened out by beating with hammers and other tools, until it became a piece of cloth from which a skirt, jacket or other piece of clothing could be made. Later, men acquired a knowledge of weaving, for example the Iban with their *ikat* fabric and the Benuaq society that made a thread from *doyo* fibre (which derives from the leaves of a variety of orchid).

Dish
...
Kayan, Kalimantan
Collected by A.W. Nieuwenhuis in 1896/97
Wood, bone
Length 39.5 cm
RMV 1219-44

Dish
...
Dayak, Kalimantan
Collected by A.W. Nieuwenhuis in 1893/94
Wood
MNI 10870

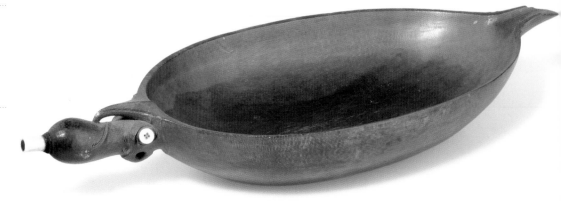

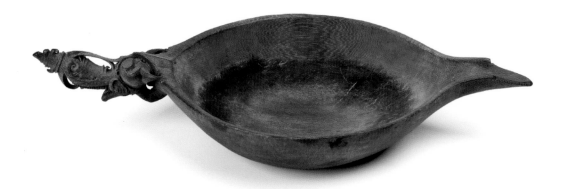

Seat

Kayan, Kalimantan
Collected by A.W. Nieuwenhuis in 1893/94
Wood
Height 8 cm
RMV 1219-51

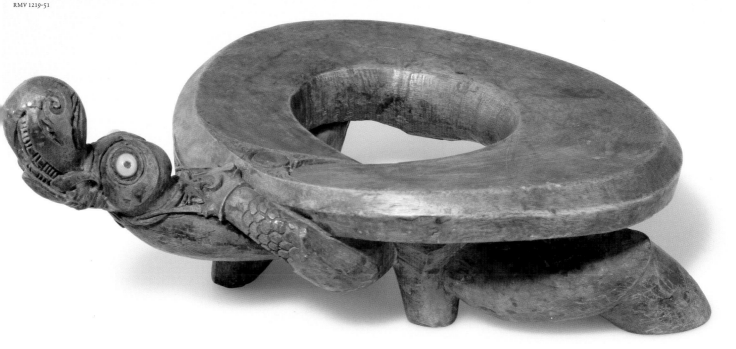

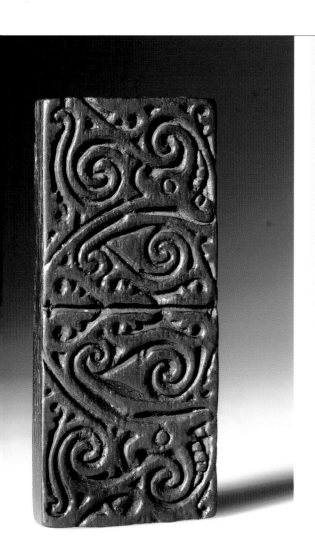

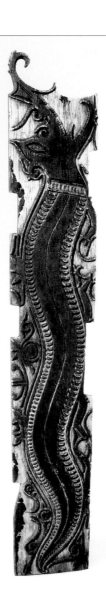

◄◄
Tattooer's design

Kayan, Kalimantan
Collected by A.W. Nieuwenhuis in 1896/97
Wood
Length 8.5 cm
RMV 1219-35

◄
Tattooer's design

Kayan/ Kenya, Kalimantan
Collected by A.W. Nieuwenhuis in 1898
– 1900
Wood
Length 24.5 cm
RMV 1308-321

Basketry needle

Kayan, Kalimantan
Collected by A.W. Nieuwenhuis in 1896/97
Wood, iron
Length 15.5 cm
RMV 1219-95

◄

Woman's jacket

Dayak (Taman), Kalimantan
Collected by A.W. Nieuwenhuis in 1898-1900
Textile, fibers, beads
Height 49 cm
RMV 1308-44

The European exploration of Kalimantan

As the first Europeans to arrive in Indonesian waters, the Portuguese and Spaniards established themselves in the archipelago from around the fifteenth century, extending their presence under the motto of *gold, gospel and glory*. Ever since, there have been contacts between European countries and South East Asia., but it was not until the nineteenth century that European influence and trade reached Kalimantan.

In 1817, the first Dutch commissioner in Kalimantan, Jacob d'Arnaud van Bockholtz, established contact with the Sultan of Banjarmasin, following which relations were also established with the Sultans of Pontianak and Sambas in 1818. A further phase of colonial history occurred in the middle of the nineteenth century when the English and Dutch used intimidation to occupy sites on Kalimantan. A number of adventurers strived to create their own areas of control, as, for example, Alexander Hare in Banjarmasin (1812), James Erskine Murray in Kutai (1844), and James Brooke (1842) and Robert Burns (1848) in Sarawak. In the 1840s, the Dutch forced the sultans of the coastal areas to sign trading agreements, following which they were then pressured to recognise Dutch authority. Thereafter, the exploration of the hinterland could effectively begin: Schwarner in Barito, Van Lijnden, Veth and Von Kessel in Kapuas, and Weddik in Mahakam.

By the middle of the nineteenth century the Netherlands had succeeded in gaining control over the whole coastal area of Kalimantan, and over the trades to be found at the estuaries of the larger rivers. The army was regularly called into action, not only against resistant sultans - exemplified by the Banjarmasin war of 1859 – 1863, and that of Wangkang after 1870 - but also against hostile tribes in the upper reaches of the rivers, as for example the Ot-Danum and the Tebidah (from 1890). Brooke saw an opportunity to extend the area of control by subduing the Sultan of Brunei., the Kayan people (during the Kayan expedition of 1863), and several Ibna tribal groups (between 1868 and 1919). The discovery of petroleum oil and rock coal in the 1880s stimulated a still greater interest from outside Kalimantan. Now, control of trade was regarded as insufficient, the interest lying in an active territorial conquest based upon administrative and military structures. In this respect, the last quarter of the nineteenth century was characterised by the organisation of large expeditions: by Hugh Low in the region of Rejang Hulu (from 1880), by Tromp in Mahakam, and by Nieuwenhuis in Kapuas Hulu at the beginning of 1893.

All armed conflict appears to have ended during the last decade of the nineteenth century. In 1894, a general peace was agreed in Tanjung Anoi, situated on the upper reaches of the Kayahan River, where between May and July representatives of thirty Dayak tribes assembled together. In the following century the exploration of Kalimantan was carried out by Knappert's expedition into the Mahakam region, that of Enthoven to Kapuas Hulu, Stolk to the Busang drainage region, and Van Walchren to Apokayan. Finally, in the 1930s, the whole hinterland was brought under colonial rule, with the exception of the Brunei Sultanate.

The Origins of the Kalimantan Collection at the National Museum

The material culture of the Dayak is rooted in their perception of life and death, and in the sources of fertility and its safeguard. Many patterns and motifs ornamenting their objects, derive

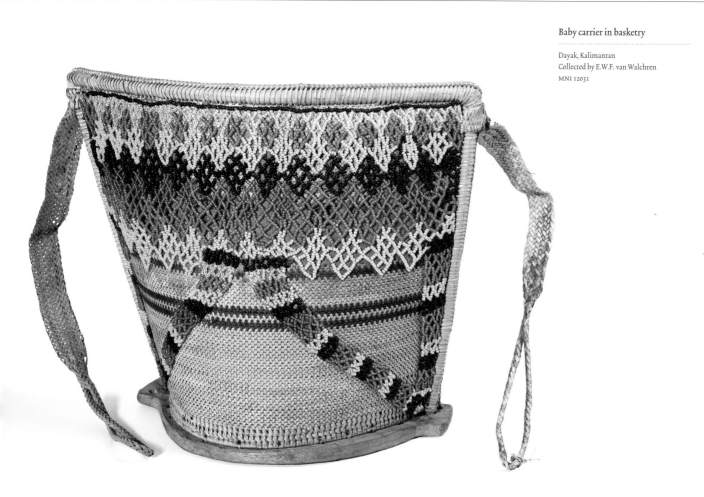

Baby carrier in basketry
...
Dayak, Kalimantan
Collected by E.W.F. van Walchren
MNI 12031

from elements of the cosmos, the animal world and the spiritual realm of the dead. In addition, some designs express social status. The National Museum's collection of the cultural legacy is not arbitrarily derived from an abundance of contributions made by collectors; instead, collection was systematically and intentionally organised so that all aspects of the social life of the concerned populations would be documented. At the end of the nineteenth century, the collection of objects of cultural value by colonial officers became current, a development that in turn influenced the indigenous way of life. When the English temporarily gained control over Indonesia – prompted above all by Governor General Raffles – missionaries, administrators, specialists and artists took an increasing part in contributing to the documentation of the cultural past.

Collectors of ethnographic objects in Kalimantan

Two Dutchmen made especially important contributions to the collection of those ethnographic objects from Kalimantan, that at the present moment can be found in the National Museum in Jakarta. They are the physician A.W. Nieuwenhuis and the administrator E.W.F. van Walchren.

A physician who at the same time was expert in ethnography and anthropology was not unusual in the nineteenth century. Dr. Anton W. Nieuwenhuis, born in Papendrecht on 22nd May of 1864, successfully combined both disciplines, considering there to a narrow relationship between cultural development and natural environment. Nieuwenhuis believed that accurate observation and description of the living conditions of indigenous peoples were important for ethnography. Between 1883 and 1889, he studied

medicine at Leiden University. In 1890 he qualified in medicine at Albert Ludwigs University in Freiburg-im-Breisgau, Germany, with a thesis entitled *Über haematoma scroti*. During the same year Nieuwenhuis joined the army, and in 1892 was posted to Sambas in West Kalimantan, serving as a physician to the Dutch East Indian army.

One of Nieuwenhuis' tasks in Kalimantan, was that of explaining the death of Muller in Nanga Bangun. Besides Nieuwenhuis, the first interdisciplinary expedition (1893 – 1894) included the zoologist Johann Buttikofer, curator at the National Museum of Natural History in Leiden, the botanist H. Hallier, assistant at the herbarium of the Botanical Gardens in Buitenzorg (now Bogor), and the geologist G.A.F. Moelengraaff. Between March and May of 1894, Nieuwenhuis resided with Buttikofer in the *long house* (*betang*) of the village of Nanga Raun, on the headwaters of the Mandau River. This long house was known as the longest *betang* of the Ulu-Air Dayak in West Kalimantan. On 14th July, 1894, he succeeded in crossing the Muller Mountains and thereby traversing the boundary between West and East Kalimantan. All these activities occurred under the umbrella of the Society for the Promotion of Research in the Natural Sciences in the Dutch Colonies (Maatschappij ter Bevordering van het Natuurkundig Onderzoek der Nederlandsche Koloniën). In 1894, warfare broke out in Lombok and Nieuwenhuis was posted there as physician. In the following year he returned to Batavia, from which he sailed for Pontianak in Kalimantan in February 1896.

A second Kalimantan expedition took place in 1896 – 1897. It was led by Nieuwenhuis himself, and included the zoologist F. van Berchtold, the renowned photographer Jean Demmeni, Nieuwenhuis' personal assistant, Midan, together with Jaheri

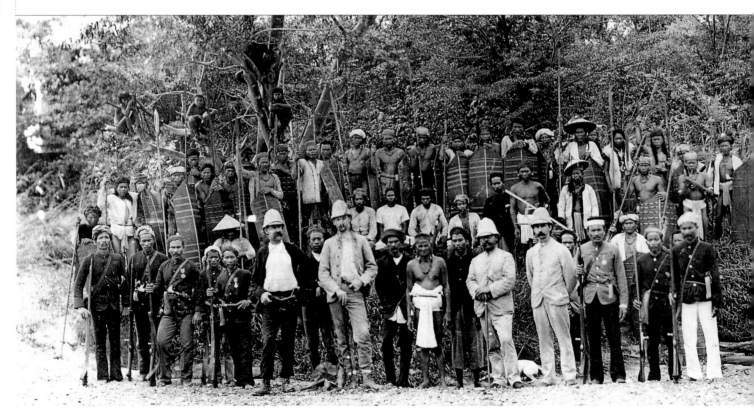

A.W. Nieuwenhuis

A.W. Nieuwenhuis (in the first row, second from left) with members of the second expedition. It was the first expedition led by him.
Photograph: Demmeni, RMV Archive

and Lahadin, responsible for the collection and for the botanical specimens. The expedition left Putussibau on 3rd July 1896, with twelve *sampans* (small coastal vessels) and fifty prows belonging to the Kayan tribe, and accompanied by their tribal chief Akam Igau. The boat journey ended downstream on the Mahakam River, on 5th June 1897, when in Samarinda six of the expedition members took leave for Surabaya and Batavia.

Nieuwenhuis had negotiations with government officials to persuade them to finance a third expedition, the purpose of which was the extension of Dutch influence to the headwaters of the Mahakam and Kayan Rivers. This third expedition (1898 – 1900) thus had a mainly political purpose, but it included ethno-sociological and medical missions. The group, once more led by Nieuwenhuis, included the photographer, Jean Demmeni, the collector (first class) J.P.J. Barth, the topographer H.W. Bier, and a taxidermist, Doris, from Java, in charge of the zoological aspects. The expedition left Pontianak for Putussibau on 24th May 1898, arriving in June of the same year. Nieuwenhuis and his group remained eight months in the region of the Mahakam headwaters, studying the languages and cultures of the local inhabitants, and putting together a collection of local artefacts and art objects. Finally, the expedition journeyed downstream and reached the town of Samarinda on 9th July 1899. In the following year, 1900, another expedition was sent to Apokayan where they remained for two months, and collected considerable information about the Kenyah and their history. Since these tribes suffered repeated attack by Iban tribes from Sarawak, the Kenyah accepted Nieuwenhuis' offer of Dutch protection. The return journey upstream, on the Boh River, took place on 4th November 1900. Nieuwenhuis passed Long Iram on 3rd December and finally arrived in Batavia on 31st of the same month.

Shield

Oema Alim, Kalimantan
Collected by E.W.F. van Walchern
Wood
Height 114 cm
RMV 1573-12

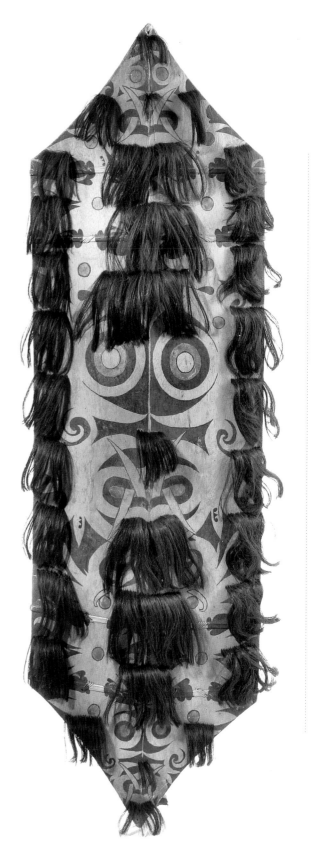

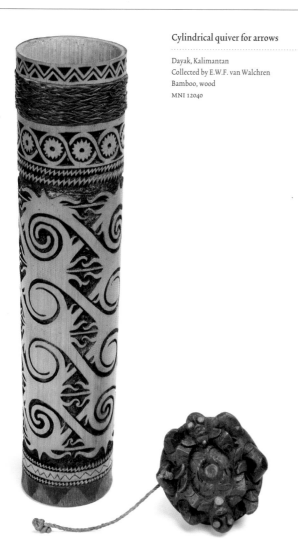

Cylindrical quiver for arrows

Dayak, Kalimantan
Collected by E.W.F. van Walchren
Bamboo, wood
MNI 12040

Once there, he was appointed as government advisor for matters concerning Kailimantan. In 1904, he was appointed Professor of Geography and Ethnology of the Dutch East Indies in the Faculty of Letters of the National University of Leiden. Nieuwenhuis returned for good to the Netherlands. He retired in May of 1934, after a long academic career as a specialist in Indonesian studies. He was succeeded by J.P.B. de Josselin de Jong as professor in 1935. He passed away in Leiden on 21st September 1953. His pioneering work in anthropology obtained considerable recognition, and he was described as the 'Dr. Livingstone of Borneo'. It is Nieuwenhuis who made the Dayak known in international, scientific circles (Sellato 1989; Schefold and Vermeulen 2002: 64).

Not long after Nieuwenhuis had left Kalimantan, a Dutch administrator, E.W.F. van Walchren, took over the baton. In 1903, as collector, van Walchren travelled up the Berau River to Apokayan, where he stayed for twelve months. In 1906, he returned to this region in order to settle enmities between Kenyah tribes. In the beginning, he was not concerned with cultural matters, not least because of his lack of contact with them owing to his military activities. His interest grew and he began to collect cultural objects connected with the Dayak way of life. His collection is interesting because well conserved and annotated (Schefold and Vermeulen 2002: 58).

The artefacts collected by Nieuwenhuis and van Walchren allow us to see the extent of their interest in Dayak culture. In the National Museum of Ethnology in Leiden, the collection of Nieuwenhuis is catalogued according to his three expeditionary journeys, in three series (RMV 1060, 1219 and 1308). Van Walchren's objects are catalogued under the serial number 1573.

A Nji Lohong

A Nji Lohong was one of the hosts of the Controleur, E.W.F. van Walchren, during his second journey, 12 november 1905 – 11 april 1906
Photograph: from the report of this journey

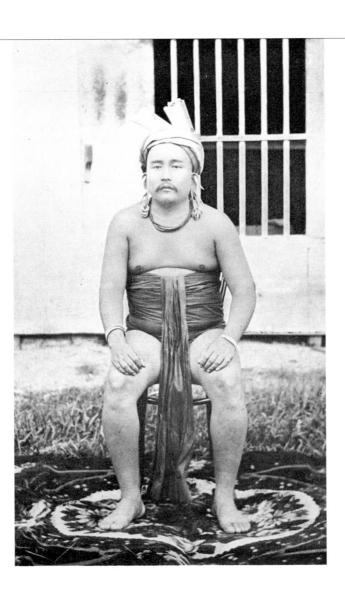

Dayak, Kalimantan
Collected by E.W.F. van Walchren
MNI 12057

Fewer collections shared by the Museum of the Batavian Society in Batavia (Jakarta) and the National Ethnography Museum in Leiden (the older names of the Indonesian National Museum and the National Museum of Ethnology) derive from Java than from any other region of Indonesia. Since Dutch power had firmly established itself at an early date on Java, there were no large-scale military campaigns in the second half of the nineteenth century that would have led to divisions of the spoils of war. During the heyday of ethnographic collecting, the last great campaign, the Java War (1825 – 1830), was already far in the past. Furthermore, after Sir Thomas Stamford Raffles' and F.W. Junghuhn's path breaking scientific work on Java, scholarly expeditions were concentrated on the still unknown regions of Kalimantan, Sumatra and East Indonesia.

In the second half of the nineteenth century where Java was concerned, the Batavian Society (Bataviaasch Genootschap) laid its stress on research into Hindu-Javanese antiquities. The Society also attached great value to the study of the large collections of Javanese manuscripts, appointing special officials responsible for linguistic matters, such as the old Javanese scholar Dr. J.L.A. Brandes. Yet, similarities can still be found in the early histories of collections of both museums. In 1864 for example, a *Controleur* (Inspector), W.L.H.A. Harloff, together with *Controleur* E.D. Levyssohn Norman, donated a major collection of 279 objects from Central Java to the then recently instituted Museum of the Batavian Society. Somewhat remarkably he referred in notes accompanying the collection to:

... a carefully compiled 'catalogue raisonné' of the collection which added considerably to the value of the donated objects. [...] The main headings are: *agriculture, manufacture of oil, fishing, bird catching, working in horn, the manufacture of wayang puppets, the making of mats, spinning, weaving, the production of batik cloths, the preparation of aren sugar, coppersmithing, goldsmithing, brass founding, blacksmithing, preparation of leather, saddle making, mason's work, the manufacture of kris handles, carpentry' tools, forms of transport, the preparation of medicines, mats, household goods, permitted and prohibited games, weapons, thieves' tools, and other objects.*

This catalogue was absorbed in its entirety into the Museum's first catalogue published in 1868. In the same year, 1864, the Leiden National Ethnography Museum acquired a collection of Javanese objects collected by the same government official, Harloff. However, Harloff had assembled this collection – which consisted of a large number of *wayang kulit* figures and *gamelan* instruments – some years earlier for use in training candidates at the Royal Academy (Koninklijke Academie) in Delft for Dutch East Indies government service. When this training scheme was wound up, these Javanese objects found a home in the Leiden Museum (as part of series 37). Thirty years later, the *wayang kulit* figures of this collection were studied by the then Director of the National Ethnography Museum, Dr. L. Serrurier. Since he also included in his investigation the *wayang* collection of the Museum of the Batavian Society, where, moreover, he later became a curator, his study *Wajang poerwa* forms one of the subjects of this chapter.

Besides objects collected by *Controleur* Harloff, objects acquired by several other individual collectors were housed in both museums. Examples include collections made by members of the

Francine Brinkgreve & Itie van Hout

Java: Gifts, Scholarship and Colonial Rule

Jacobson family, who had a trading company in Semarang, and by Baron L.A.W.J. Sloet van de Beele. The collection of this Governor General – mainly consisting of ceremonial weapons received from Javanese rulers – will be discussed in the section on *kraton gifts*. Moreover, we shall pay attention in this chapter to two collector-researchers having considerable significance for the development of Javanese art and crafts, and who maintained relationships with the museums in Leiden and Batavia, namely J.E. Jasper and G.P. Rouffaer. The portrait of Rouffaer has been written by Itie van Hout, while the rest of the chapter is by Francine Brinkgreve.

Kraton gifts to Governors General

The collections assembled by *Controleur Harloff* include above all ethnographic objects concerned with the culture and society of the ordinary Javanese inhabitant. However, Java was also known for its very refined and rich court culture. On various occasions, instances of the latter reached the museums through gifts made to officials of the Dutch colonial government by rulers of Javanese princely courts. Examples are found in both Leiden and Batavia.

Although the colonial government had established itself principally on Java in the first half of the nineteenth century, the four princely houses of Central Java remained relatively independent. In 1755 the ancient Javanese kingdom of Mataram was divided into the princedoms of Jogjakarta and Surakarta, while in 1757 and 1812 further divisions were created, those of the Mangjunegaran in Surakarta and of the Paku Alaman in Jogjakarta. The princes ruling over these mini-kingdoms maintained their positions relative to the colonial government by offering gifts to the Governors General. The latter could either

keep the gifts, or sell them at a later date. However , according to the notes of the Batavian Society, the government made the following important proposal in 1858:

> Such weapons, items of clothing, and so forth, whether received as gifts or as tokens of homage from native rulers, and not kept by the governor-general, but to which some historical value can be attributed, [should] from this time on not be sold publicly but retained, in order to compose a special section of the Society's collection.

The Society 'declared itself completely ready to take over the care of the objects concerned'. The first to put this proposal into practice was Charles Ferdinand Pahud, who filled the post of Governor General from 1856 to 1861, after having acted as Minister for the Colonies in the period 1849 – 1855. For example, ceremonial lances were presented to him (MNI E636 and E637 [1660 a and b]) by the Sultan of Jogjakarta, Hamengkubuwana VI, and also a sabre (MNI E632 [1671]), this time given by Mangkunegara IV. The Governor General, who since the year 1867 had been entitled to call himself Pahud de Mortanges, donated these objects to the Museum of the Batavian Society in 1860.

The Leiden museum also holds gifts from the same donors, since between 1861 and 1865 Hamengkubuwana VI and Mangkunegara IV offered a number of marvellous presents to Pahud's successor as Governor General, Baron L.A.W.J. Sloet van de Beele. However, the latter did not give these to the Batavia museum, but took them home to the Netherlands as part of a beautiful collection. In 1888, the curator of the

Hamengkubuwana VI, Sultan of Jogjakarta, in court dress, c. 1865

This photograph comes from the collection of Governor General L.A.W.J. baron Sloet van de Beele, who had received a number of gifts from this sultan.

Photograph: KITLV, Collection, no. 4708

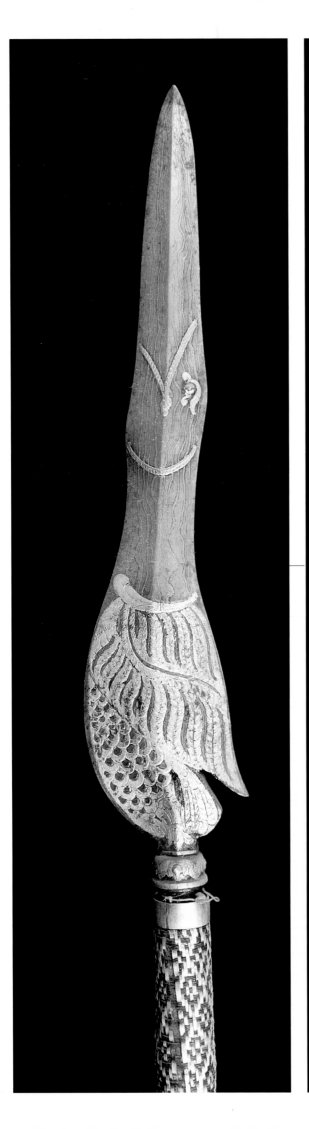

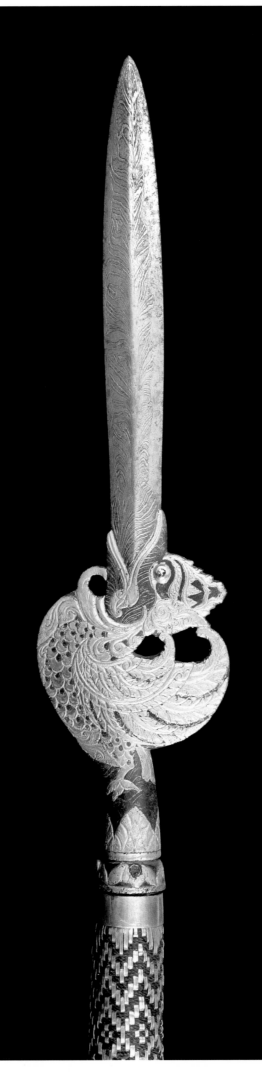

◀◀

Ceremonial lance, *Tombak ligan*

...

Jogjakarta, Central Java
Donated between 1856 and 1860 to Governor
General Pahud, by Hamengkubuwana VI
Iron, nickel, gold, wood, precious stones
Length 207 cm
MNI E 636 (1660a)

...

The blade of the lance is in the form of a
bird's head with a long beak, and is called
banyak angrem (brooding goose)

◀

Ceremonial lance, *Tombak ligan*

...

Jogjakarta, Central Java
Donated between 1856 and 1860 to Governor
General Pahud, by Hamengkubuwana VI
Iron, nickel, gold, wood, precious stones
Length 206 cm
MNI E 637 (1660b)

...

The blade of the lance is in the form of a
crowned Garuda, with the blade of the
weapon in the shape of his beak. The pamor
pattern on the blade is called pamor miring
(inclined pamor)

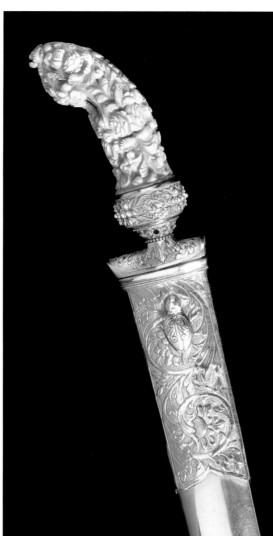

Surakarta, Central Java
Donated between 1856 and 1860 to Governor
General Pahud, by Mangkunegara IV
Iron with nickel (pamor), gold, silver, precious
stones, wood
Length 67.5 cm
MNI e 632 (1671)

Ceremonial sabre with gold handle, the steel ring
being set with diamonds. The blade has pamor
of the Beras Wutah type. There is a beautiful
crowned snake (naga) on it, crowned in gold, and
set with precious stones on the crown and tongue.
The ornament on the gold handle and sheath are
embossed with floral and leaf motifs

b Short sheathed kris or dagger
 Patrem

Surakarta, Central Java
Donated between 1861 and 1865 to Governor
General Sloet van de Beele, by Mangkunegara IV
Iron with nickel (pamor), gold, copper, ivory,
diamonds
Length of sheath 30.5 cm
RMV 982-1

The patrem is usually worn by women. The stem
ring is gold, set with diamonds. The ivory handle
is decorated with a Garuda bird and with floral
and leaf motifs. The wooden sheath is inlaid with
copper and gold, and decorated with embossed
flower and leaf tendrils. A gold belt-hook in the
shape of a beetle has been added

(a) and (b)

Two ceremonial weapons, presented to the
Governors General C.F. Pahud (1856 – 1861) and
Baron L.A.W.J. Sloet van de Beele (1861 – 1865) by
Pangeran Adipati Arya Mangkunegara IV

Sheathed kris or dagger

Donated between 1856 and 1860 to
Governor General Sloet van de Beele, by
Mangkunegara IV
Gold, iron, nickel, diamonds
Length 46.7 cm
RMV 1089-2

The blade has three curves (luk) and heads
of monsters on both sides. The gold sheath
is decorated with peacocks in green enamel
and inset diamonds

National Ethnography Museum, Dr. J.D.E. Schmeltz, viewed with admiration. Sloet van de Beele's collection of Indonesian ceremonial weapons, and wrote descriptions of them at the latter's request. Several years later, after the collector's death in 1890, his heir sold these weapons to this museum for hundreds of guilders a piece. Examples of these include a *kris* (RMV 1089-2) and a dagger (RMV 982-1), both received from Mangkunegara IV, while a *wedung* or chopper (RMV 963-5) derives from the Sultan of Jogjakarta. Baron Sloet van de Beele also received gifts from outside the Javanese princely territories. Consequently the collection contains a number of presents (including a richly decorated sacrificial knife, RMV 1050-2) given to him in 1864, during a state visit to Batavia, by Gusti Ngurah Ketut Jelantik, Regent of Buleleng in North Bali.

Ceremonial or state weapons were a favourite princely gift, but the Indonesian princes themselves owned the best collections in this field. Lances were tokens of rank, carried in processions and preserved as valuable heirlooms, *pusaka*, which brought good luck. The unusual and splendid forms of the heads of the blades, inlaid with gold, were frequently designed by relatives of the princely ruler himself, each having its own significance (for example, a head in the form of a bird, designated *banyak angrem* or brooding goose, MNI 636 [1660a]). Special daggers and *kris* formed part of the prince's state regalia. They were magical-religious objects representing the prince's power, each of which frequently bore its own name.

Baron Sloet van de Beele may have owed his lovely collection partly to the fact that, in the years of his governor-generalship, he was at the same time a deputy grand master of the freemasons. Although in that period there were no Indonesian members yet affiliated to the lodges, there was certainly a mutual sympathy between the Javanese courts and freemasonry.

Members of the Javanese aristocracy were joined to the Batavian Society at quite an early period. Mangkunegara IV was appointed an honorary member, and he made a particularly fine gift to the museum in 1871. According to the Society notes, he donated 'a complete set of figures for the *wajang poerwa*, this being what may be described as a particularly magnificent (gift)' (MNI 1852 to 1968). These figures were mentioned in the large-scale study of *wayang purwa* published by L. Serrurier in 1896.

L. Serrurier's research on Wayang

Wayang purwa is the Javanese form of the shadow play (*wayang kulit*), the repertoire of which is based on the oldest myths and legends, and upon the great Indian epics, the Mahabharata and Ramayana. The oldest set of *wayang kulit* figures in the National Museum of Ethnology forms part of the collection that *Controleur Harloff* had assembled for the Delft Academy, and which was moved to Leiden in 1864. In the 1890s this collection was studied by Dr. Lindor Serrurier who at that time was director of the Leiden museum and also reader in general ethnology at Leiden University. He wrote his book, *Wajang poerwa; een ethnologische studie*, published in 1896 by the National Museum of Ethnology, on the basis of this and other collections, and upon a survey of the *wayang kulit* figures held at the Batavia Museum. Two of these latter figures had also been collected by Harloff, but the majority belonged to the princely gift donated by Mangkunegara IV, an example of which was a *gunungan* (MNI 1925). In his introduction Serrurier wrote the following:

◂◂
The *wayang kulit* (shadow play) figure Batara Guru, standing upon a bull, Nandi

Central Java
Collected prior to 1864 by W.L.H.A. Harloff
Painted leather and horn
Length 70 cm
RMV 37-726

◂◂
The *wayang kulit* (shadow play) figure Yamadipati

Purwadipura, Central Java
Collected by W.L.H.A. Harloff, 1856
Painted leather and horn
Length 68 cm
RMV 37-734

▸
The *wayang kulit* (shadow play) figure Batara Brama

Purwadipura, Central Java
Collected by W.L.H.A. Harloff, 1856
Painted leather and horn
Length 59 cm
RMV 37-729

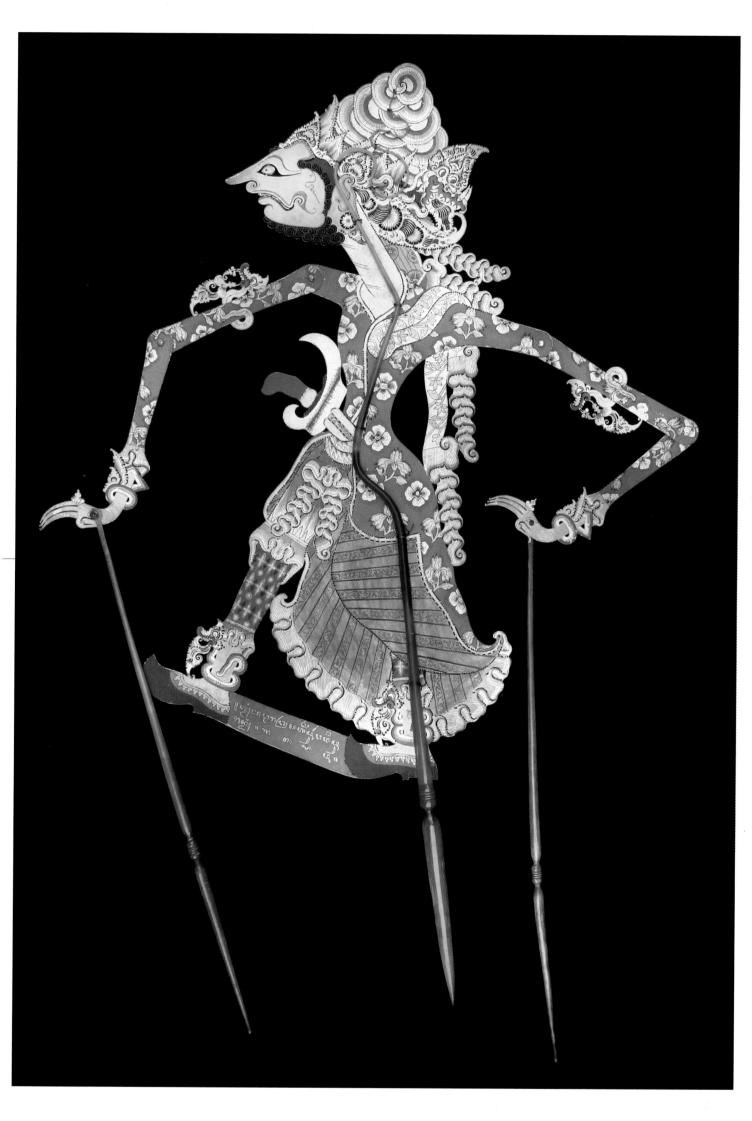

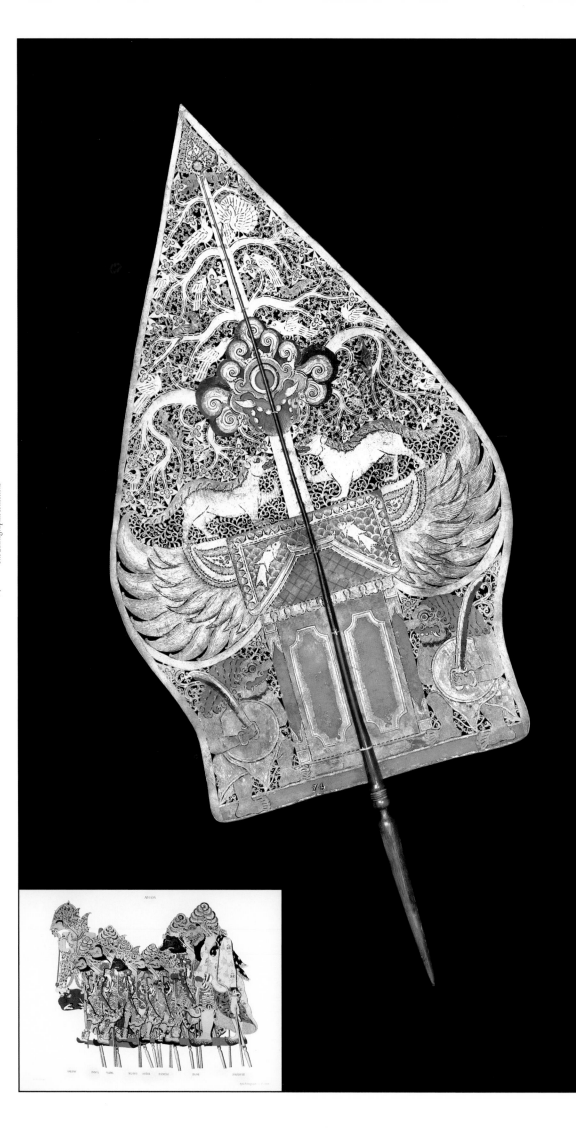

The wayang kulit (shadow play) figure Gunungan or Kayonan

Surakarta, Central Java
Donated in 1871 by Mangkunagara IV
Painted buffalo leather and horn
Length 91.5 cm
MNI 1925

The puppets of the wayang kulit theatre are set up behind the gunungan (mountain) or kayonan (tree) before the beginning of a performance, after it ends, and to signal intervals. On the winged roof of a small gateway building, flanked by guards, there is a pond with fish, symbolizing the source of life. A Tree of Life emerges from this pond, with birds and monkeys in the branches, and two tigers facing each other close to the trunk. The gunungan is the symbol of the totality and unity of the Universe

▸
The wayang kulit (shadow play) figure Batara Bayu

Central Java
Donated in 1871 to the Batavian Society by Mangkunegara IV
Painted leather and horn
Length 66 cm
MNI 1856

▸▸
The wayang kulit (shadow play) figure Batara Surya

Central Java
Donated in 1871 to the Batavian Society by Mangkunegara IV
Painted leather and horn
Length 65 cm
MNI 1859

◂
RMV Bibliotheek, folio 553

Plate 11b from the volume of plates connected with the book Wajang poerwa, written by L. Serrurier (1896).

The wayang kulit figures shown here represent eight gods who play a role in the story 'Abiasa', one of the oldest myths and legends of Java. In the tale the chief god Batara Guru (on the left front of the picture) and the gods (from left to right) Indra, Brahma, Vishnu, Surya, Basuki and Bayu, aid the main character Raden Abiasa in his bid to retain the throne of the kingdom of Astina. During a duel, the faithful servant Semar, in Abiasa's name, appeals to Batara Guru, to intervene. Batara Guru 'accompanied by a host of lesser Gods from the Abode of the Gods swooped down in order to settle the matter himself.' He first requests the help of Batara Yamadipati or Kala, god of the underworld pictured directly behind the crowd of gods

The reason for writing this work has been my desire to render [...] one of the major collections in my care, better known and more accessible for study even outside the museum, by means of good reproductions. I can therefore find no better choice than the puppets of the wajang poerwa, of which a good representation has so far never been published. The fine scholar, His Honour the Resident H.L.C. te Mechelen, [...] has been good enough to assemble some 12 plays from among the enormous stock of our puppets, such as is generally assembled for display by the dalang.

These puppets plays, with their groups of wayang figures, are beautifully portrayed by means of chromolithographic plates in folio format, a very expensive and labour-intensive process.

In the meantime the wajang puppets had awakened my interest; I asked myself what the link could be between the character of the ancient heroes and the distorted manner in which they were represented; in this manner I gradually came to develop a focused project of research on these puppets.

Serrurier himself regarded this ethnological monograph (also published in a cheaper, smaller edition as well as in its more restricted quarto publication) as his best work. He not only discusses in it the sources, background and diffusion of the wayang; he also links the wayang with other ethnological phenomena on Java and even expresses opinions on the origins of Javanese society as a whole. Following in the footsteps of C. Poensen – Professor of Javanese and one of the first to raise the subject of the origin, history and meaning of the wayang – Serrurier took as his starting point the influence of what he called 'the Hindu colonists' upon the birth of the Javanese wayang. However,

years later, in the scholarly debate concerning this subject, the ethnologist Serrurier would be criticised from a linguistic point of view. In 1897 G.A.J. Hazeu (who later was also a Board member of the Batavian Society) defended his thesis 'for the title of doctor in the language and literature of the East Indian Archipelago'. The thesis was entitled Bijdrage tot de kennis van het Javaansche toneel (Contribution to the understanding of the Javanese theatre). In various places he expressed a harsh judgement of Serrurier's work.

The explanation [...] appears to me – like, for that matter, those complete hypotheses produced by writers concerning the probable origins of the Javanese civilization – too fantastic to be explored any further: lakon (story) is a specifically Javanese word [...]; no one with any knowledge of Javanese could doubt it.

Imitating Brandes, Hazeu posited that wayang was a purely Javanese phenomenon, and, ultimately, his doctoral thesis appears to have had more influence than Serrurier's study. Although Serrurier provided no convincing answer to the question of the origins of the Javanese wayang, the unusual portfolio, with plates in folio, that preceded his own study, continues to be remarkably valuable.

Serrurier had no opportunity to investigate the meaning of wayang on Java itself. Consequently he based his work on the knowledge possessed by people who had actually been there, such as Te Mechelen and Poensen. From Leiden, he wrote in gratitude:

to gain an insight into the geographical diffusion of the wayang poerwa over the various residencies of Java, the shortest way was to appeal to the well-known kindness, and the enthusiasm for scholarly enquiry, found

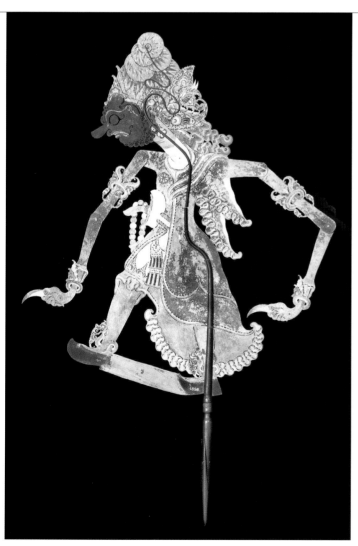
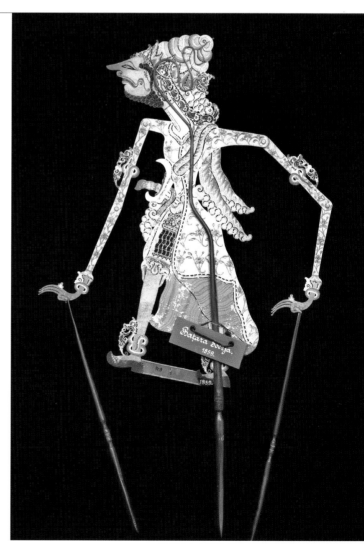

among officials of the BB. Questionnaires to be filled in were sent to all the Honourable Residents and Assistant Residents on Java and Madoera. My expectations were far exceeded by the receipt of a bulky dossier!

To Serrurier's displeasure, the writer appointed as the *Controleur* of Bandar, R.M. Oetoyo, personally went so far as to publish an 'Answer to the questions posed by Mr. L. Serrurier', in the *Tijdschrift voor het Binnenlandsch Bestuur* (Journal of the Internal Administration). At all events, this written enquiry provided a good survey of the various forms of *wayang* encountered on Java and Madura at the end of the nineteenth century. Another of Serrurier's important contributions was his treatment, in his book, of the origins and development of the *wayang* theatre. In this way he devoted attention to indigenous Javanese ideas in an age when this was still unusual.

When Serrurier, after having been director of the Leiden museum since 1881, resigned his post in 1896, because of serious conflicts over the housing problems of 'his' museum, he became Curator at the Museum of the Batavian Society. Now, at last, he had the opportunity to see the *wayang* about which he had written. As we can read in the obituary written by his brother-in-law, H. ten Kate:

> When in 1899, at the court of Jogjakarta, there took place the decennial performance of the *wajang wong*, Serrurier was guest at the Sultan's invitation. A rare pleasure had been prepared for him there, a great satisfaction afforded him. How it must have raised his spirits, he, the man with the ethnologist's soul, [so] subtle in feeling, so full of knowledge, to observe there and understand! He saw embodied there, in the most beautiful form – the flower of Jogja's aristocracy – which he had so often regarded in his mind's eye. […] Then at last something of 'that unreality' that his heart had so longed for must have wafted over him.

At the end of 1896, Serrurier left Leiden for Batavia. First, he gave lectures in geography and ethnology in department B of the Willem III Gymnasium, where people from the Dutch East Indies were trained for a career in the internal administration. As member of the Society, Serrurier immediately sought the right to borrow 'objects that might serve as means of educational elucidation.'

From August 1897 he was appointed to the Board of the Batavian Society, and from 1899 he was its secretary and also curator for the museum's ethnology department. Under his editorship, in 1901, the extensive second supplement to the catalogue was published, and Serrurier drew up plans for the reorganisation of the museum. After his premature death in July 1901, his work for the museum was continued for a number of years by his wife, Mrs. M. Serrurier-Ten Kate. In recognition of her work, she was made a Knight of the Order of Orange-Nassau in 1908.

The masks and musical instruments of E. Jacobson

The collections of *wayang kulit* puppets held in the Batavia and Leiden museums directed by Serrurier, are among the oldest museum collections in the field of Javanese performing arts. The collection of Javanese masks (*Topeng*), donated by E. Jacobson to the Museum of the Batavian Society, is another of these old collections. Although, in the second half of the nineteenth century, not much

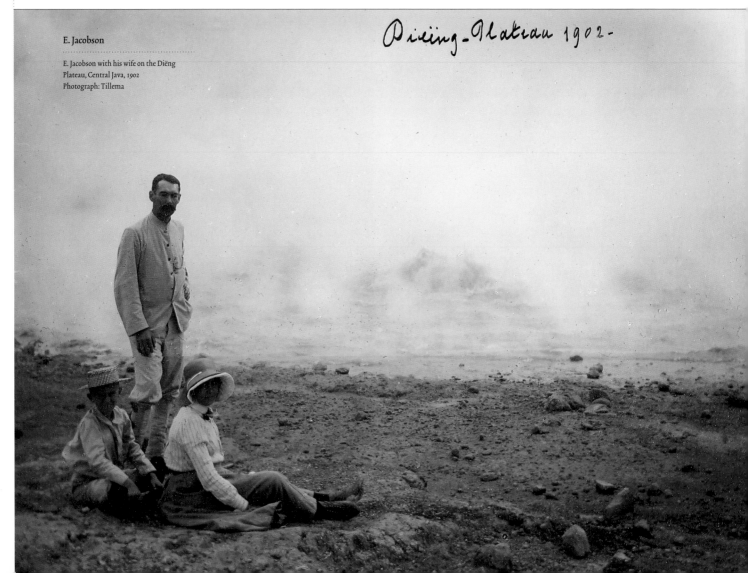

E. Jacobson
..
E. Jacobson with his wife on the Diëng Plateau, Central Java, 1902
Photograph: Tillema

was jointly collected in the field of Javanese ethnographica, the individual collections in both museums grew considerably in size, thanks to gifts from (amateur) collectors or objects purchased from them. However, the members of the Jacobson family, who were not professional collectors but mercantile agents, assembled collections for both museums.

The notes inform us that an important collection of 113 Javanese masks, *Topeng*, was donated to the Museum of the Batavian Society even before 1868 by E. Jacobson, who worked for the import/export firm of Jacobson & Co. at Semarang. The same firm had sent a crate of *wayang* puppets to the museum (probably the gift, already mentioned, from Mangkunegara IV).

In 1907 a relative of E. Jacobson, likewise called E. Jacobson and 'member of the Firm Jacobson, van den Berg & Co., of Rotterdam', donated a collection of objects connected with the construction of Javanese gongs (RMV series 1564). However, he also gave the museum other objects such as a beautifully decorated Jew's harp or *gringdingan* (RMV 1565-7) which, to judge from the annotations attached to these in 1880 – 1882, were collected in Buitenzorg (now called Bogor) in West Java. Some of the objects in this series had been collected as early as 1868, probably by the older E. Jacobson, first mentioned.

The collection of tools for making gongs has acquired additional significance from a study of the gong industry of Semarang, published by E. Jacobson together with J.H. van Hasselt in 1907. For this book, published by the National Ethnography Museum, these two men carried out extensive field work in Semarang, where the business offices of the Jacobson family were located. Yet, we do not know the extent to which the older E. Jacobson had himself examined in depth the significance or the origins of the

masks given him. They were catalogued in the Batavia museum by the Javanese Raden Pandji Soerja Widjaja, and they form part of the oldest recorded collections in the field of Javanese *wayang* theatre. However, the conditions under which they were kept were far from ideal. For example, the notes for 1871 mention that : 'The manner of conserving the objects is limited, as formerly, to the frequent ventilation of the display cases in which they are kept. Some of the *Topeng* masks, despite repeated treatments with petrol, are riddled with boeboek (a parasitic worm) and partly destroyed.' In the second edition of the Batavian Society's catalogue (1877) the collection of masks had been reduced from 113 to 93 as a result.

The oldest collection of Javanese masks in Leiden also dates from this early period. It was donated by the Professor of Javanese studies, T. Roorda, to the Royal Academy in Delft, being transferred into the possession of the Leiden museum (as part of series 37) in 1864. In that same year, Roorda published a first translation of a story that forms part of the repertoire for the Javanese mask theatre, *wayang Topeng*. The chief character in the stories from the *wayang Topeng* is Raden Panji, a young prince from the East Javanese kingdom of Jenggala. These stories are partly historical (the prince of Jenggala would have reigned at the end of the twelfth century in the region of the present-day Surabaya) and partly legendary. In the tales, the prince's beloved Candrakirana, and his adversary Klana, a foreign prince, usually play leading roles. Panji is supported by the servant and clown Pentul, and by Sembu Langu, while Klana is backed by Togog. An example of a Panji story is the *lakon* Kuda Narawangsa, while tells of Panji's wife who is changed into a man, only regaining her proper form when struck by one of Panji's arrows (MNI 1772, 1808, 1809, 1810, 1825).

Batik cloth portraying figures in the wayang style

Pekalongan, north coast of Java
Purchased in 1906 from the Firm, Jacobson & Van den Berg & Co.
Cotton and gold leaf
Length 139 cm
RMV 1575-2

These figures, from the Mahabarata, are in the wayang style. The figure on the right is Bhima, together with his servants or panakawan, Semar, Petruk and Nala Gareng. The cloth, probably intended as a tablecloth, was devised by Major Haighton

Topeng (mask) of Putra Jenggala,
Panji

Central Java
Donated before 1868 by E. Jacobson
Wood, polychrome
Length 15.5 cm
MNI 1825

These five masks were used in a mask-
theatre, and form part of the story, Kuda
Narawangsa, in which Panji plays the
central role.

Topeng Klana Tunjung Seta, the
adversary of Panji

Central Java
Donated before 1868 by E. Jacobson
Wood, polychrome
Length 15 cm
MNI 1808

▸▸
Topeng Pentul, Panji's servant

Central Java
Donated before 1868 by E. Jacobson
Wood, polychrome
Length 15.5 cm
MNI 1772

▸
Topeng Kuda Narawangsa,
Panji's wife

Central Java
Donated before 1868 by E. Jacobson
Wood, polychrome
Length 12.5 cm
MNI 1809

▸▸
Topeng Sembu Langu,
Panji's servant

Central Java
Donated before 1868 by E. Jacobson
Wood, polychrome
Length 17 cm
MNI 1810

J.E. Jasper, Mas Pirngadi and the development of arts and crafts

The book by Jacobson and Van Hasselt on the gong industry in Semarang fits into a series of studies appearing at the turn of the nineteenth/twentieth century, dealing with various aspects of Javanese arts and crafts. From around 1900, there was greater interest in this subject because more attention was being paid to improving the economic position of the indigenous population, under the influence of what was known as the 'ethical policy' (see below). One of the people mainly involved in the development of arts and crafts was the government official J.E. Jasper (1874-1945), who worked on Java together with the Javanese, Mas Pirngadi (1875 – 1936)

Johan Ernst Jasper was born at Surabaya in 1874. He came from an Indies family that had lived for generations in the Dutch East Indies. His father had a photographic studio in Surabaya, and at an early age his son had become familiar with the world of the indigenous population in the city with its many *kampongs*. He chose a career with the internal administration, for which he was trained in department B of the King Willem II Gymnasium in Batavia. In his thirty-year career he climbed the professional ladder from candidate *Controleur* in 1898 to Governor of Jogjakarta in 1928. He died towards the end of the Japanese occupation in an internment camp in Tjimahi.

Jasper was a very versatile man, with a very wide range of interests. He wrote novels and short stories and published innumerable articles on the most diverse subjects. Above all, he wrote contributions for the *Tijdschrift voor het Binnenlandsch Bestuur* (Journal of the Internal Administration), and cooperated in producing one of the first cultural journals in the colony, the *Weekblad voor Indië* (Dutch East Indies Weekly). After the end of his official career, he still fulfilled a number of other important functions, such as that of deputy grand master of the freemasons, and chief editor of the *Java-bode* (The Java Courier), the biggest newspaper in the Dutch East Indies in that period.

The development of the indigenous arts and crafts was one of the themes that particularly interested Jasper. As early as 1900 he wrote his first article on this field (after which nearly fifty others were to follow). This article concerned the Javanese potters' craft. Further, as he later wrote, 'it was on the basis of the exhibition of arts and crafts of the Dutch East Indies, held at The Hague in 1901, that I extended my investigations on the field of Javanese weaving'.

It was G.P. Rouffaer (see below for more on this individual) who attracted Jasper's attention to the '*tjindé*, so unusual and so beautiful', referring thus to silk cloths from India which had become rare on Java. Jasper then conducted research in Gresik, since this was the only place on Java where *tjinden* were still being produced; these cloths, related to *tjindé*, were silk *ikat* fabrics. In this kind of fabric production, patterns were outlined by winding the threads before immersing them in the dye baths. Jasper studied and described 'the secret of the ancient Javanese procedure of dyeing before the weaving together of the threads' in his article entitled 'Inlandsche kleurmethoden' (Indigenous dying methods, published in 1902) in which he waxed enthusiastic over the 'vivid merging of dyes, so characteristic of the *tjinden*'. In this article he showed his appreciation for this form of craftsmanship: 'We have to admire the highly practical talent of the Javanese, his ingenious art, his simple yet beautiful methods, [...] and above all, his liking for pretty and gay colours, wonderfully glowing'. In 1907, Jasper

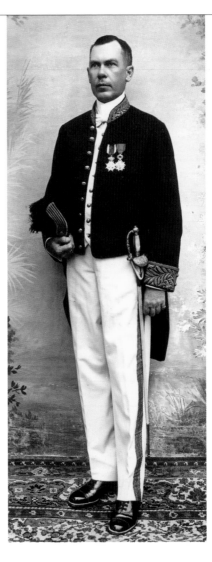

◄
J.E. Jasper

Portrait of J.E. Jasper as Governor of Jogjakarta, c. 1930
Photograph: B.T
Ligthart Collection

◄◄
Mas Pirngadi

Photograph: 'Koloniaal Weekblad 1910'

◄◄◄

Portraits of Indonesians belonging to different ethnic groups, painted by Mas Pirngadi, who worked together with J.E. Jasper. Mas Pirngadi received this commission from the Batavian Society, to which he was in service during the 1930s

sold a number of the silk ikat fabrics he had collected in Gresik to the Leiden museum; an example is a cummerbund sash, *sabuk setagen*, of purple silk (RMV 1593-3).

Jasper based his investigation not only on his own field work and collections. He wrote to many colleagues who were government officials, throughout the entire archipelago, and they sent back answers to the innumerable questions he had posed on the arts and crafts of the region. He also requested the loan of certain things from the Museum of the Batavian Society in pursuit of his research. According to the notes for 1902:

> it has been decided to inform Mr. Jasper, although satisfying his request would be completely contrary to the regulations drawn up at Society meetings [...], that the Directors consider that is this exceptional case, and especially with an eye to the importance of his studies into Native Arts and Crafts, [we should] deviate from the usual rule and agree to the wish he has expressed.

In government circles as well, Jasper's interests did not go unnoticed. When in 1902 he was given the assignment, as *Controleur*, of examining the educational programme in schools for Javanese children in Surabaya, he argued in his conclusions that special technical schools should be created in which ample space for craft training could be given. This assignment fitted in with the new line of thinking the government had adopted since the turn of the century, and which was known as the 'ethical policy'. This was a reaction to the nineteenth-century policy in which the Netherlands (both the State, and Dutch individuals) exploited the Dutch East Indies during the system of 'compulsory farming', and during the liberal period following this. In 1899, C. T. van Deventer

published his article 'a debt of honour' in *De Gids* (The Guide), in which he argued that The Netherlands had a moral obligation to combat the great poverty found especially on Java among the indigenous population. These ideas were taken up in the speech from the throne in 1901, and there was a discussion of the 'moral mission' of The Netherlands to 'uplift' the indigenous population of the Dutch East Indies to a higher level of prosperity. Education in the *desas* must be improved, and the economic position of the indigenous people must be reinforced, by improving the level of 'home (or 'cottage') industry', among other means. Partly because of this, the development of home industry attracted special attention at the beginning of the twentieth century. In order to implement this policy of stimulating the crafts, the Government first required a great deal of information.

Consequently, in 1906 Jasper was asked to undertake a technical-artistic investigation into indigenous arts and crafts, and in 1912 he was specially 'charged with tasks concerned with Native (arts and) crafts'. In 1914 he was appointed Assistant Resident for this purpose. In the fulfillment of his new functions, Jasper was principally occupied with organizing large-scale exhibitions-cum-annual fairs in Javanese cities, and compiling reports on them. In his introduction to the report on the first annual fair at Surabaya, published in 1906, Jasper discussed the aim of these fairs:

> The three-fold aim, the intention of holding a pasar malem or annual fair, is to provide a good outlet for various products of Native arts and crafts, still largely unknown even to the East Indian public, in order to encourage industrious workers to regular labour and provide them with the opportunity to dispose of their wares through the mediation of others.

Woven pattern, *Poleng gambir saketi*

Singaparna, West Java
Collected before 1908 by J.E. Jasper
Strips of coloured and uncoloured bamboo
Length 29 cm
RMV 1647-515

This basketwork pattern is woven from dyed and undyed strips of bamboo. This check pattern (poleng) is known as '100.000 (saketi) small blocks of plant extract (gambir)'. It is one of the many patterns Jasper had made during his study of basketwork.

At the end of his report, Jasper formulates his ideal:

Yet things are slowly gaining ground. First the Native acquires a little of the merchant spirit; he no longer waits for orders, he seeks them out; he no longer has the need of officials as intermediaries, he offers his products for sale, which win prizes at exhibitions; his children, who enjoy a better education and are gaining a more logical way of thinking, perceive the usefulness of doing business on a larger scale, and finally a little of the ideal is realised to the extent that the artisan deals directly with trading companies, without the mediation of third parties.

In 1909, the fourth annual fair was held at Surabaya, and in his report Jasper observed that these aims were slowly being achieved:

The benefit that the annual fairs held up to now, have had for Native craftsmanship can be seen from the fact that the artisans' work is improving. [...] The tjinden weaving at Gresik, for example, has progressed and an outlet has been provided for the women weavers involved in it, inciting them to invent new motifs that differ from the traditional ones and that nonetheless are original.

Furthermore, the annual fairs that followed, and which later were to be held in other cities on Java, such as Pekalongan (1923), and Jogjakarta (from 1928 on), were increasingly successful.

However hard Jasper, as Government representive and active Freemason, laboured for 'the the uplift of Native craftsmanship' and for providing 'the very necessary goad to work in the Native crafts', he still had before his eye the enormous beauty, opulence and variation in designs of the arts and crafts produced in the archipelago. Jasper's best-known publication in this field is a series of five books entitled *De Inlandsche kunstnijverheid in Nederlandsch Indië* (The Native arts and crafts of the Dutch East Indies). The five volumes – I Basketwork; II Weaving; III Batik; IV Gold and silver smithing; and V The working of non-precious metals – were published between 1912 and 1930. In the introduction to the first part, on basketwork, Jasper emphasized the artistic aspects, even though he maintained his interest in its economic significance, not least for the workers themselves:

This hand work, originally very easy and simple, slowly developed into a characteristic art, the practice of which offered a welcome opportunity for adapting the geometric surface decoration into its most graceful complexity. [...] Simply to encourage the qualities found in great abundance here, sound materials have a great economic importance for basketwork in the Dutch East Indies. [...] Greater attention [must] be given to the vigorous development of this kind of home craftwork, rather than to the industry already existing in Japan, where large-scale production of basketwork is already being carried out.

According to its minutes for 1909, the Batavian Society administration's judgement concerning the manuscript of the first volume, was that 'similar Government publications of standard works are useful, in order that the Government might have in hand plentiful material for judging whether or not the task being dealt with (arts and crafts) has a future, [and] what measures should be taken by Her [the Government] for the maintenance and furthering of the Native population'. The administration of the Society therefore suggested that Jasper should add a separate chapter on the economic significance of basketwork. Jasper complied with his proposal, but: 'After having

Head cloth

Pamekasan, Madura
Purchased from the International
Colonial and Export Exhibition of
1883 (Internationale Koloniale- en
Uitvoerhandelstentoonstelling)
Cotton and gold leaf
Length 93 cm
RMV 370-604

The indigo coloured motifs include brown
birds, plants, leaves and flowers on a white
background, and are made by means of
the batik technique. The parts that remain
visible after folding the head cloth, are
covered with gold leaf (prada)

looked at this addition, our Directors as well as the members see fit to record that it certainly does not comply with the demands posed, so that [their] judgment is that the official concerned has missed the mark.' The administration felt that 'there must be serious doubts about the usefulness of the expensive measures suggested by Jasper, by way of conclusion, that should be taken for improving Indigenous basketwork'. According to the Administration 'the book can be offered, not as a standard work, but as a valuable contribution to the knowledge of basketwork in the Dutch East Indies'.

The Batavian Society could never have suspected that this study (like the four other volumes) would, nearly a century later, still be regarded not only as a valuable contribution, but even more especially as a standard work, despite the absence of a treatment of the economic aspects. Recently, volume I, on basketwork, was reprinted. It contains very extensive and detailed descriptions of basketwork materials and methods, dyeing and fixatives, all kinds of objects made of basketwork, and an enormous variety of weaving patterns (RMV 1647-515). Jasper was also well informed on the technical aspects; this is evident, for example, in his description of a household box 'for storing and transporting food and snacks' from Cirebon (RMV 1647-242):

More work is being spent on the Cheribon tenong or tetenong. The lid is often woven with black and red weft-strip figures, while the tenong is also worked with soesoen (i.e., with layers), and has a spherically shaped lid. The ball-shaped lid is achieved in the same way as a hat, viz. by making warp and weft strips, in pairs, longer than the foregoing ones, while each strip is also wider in the middle than at the ends (fig. 152).

It is worth noting that in 1908 Jasper donated his great collection of basketwork, containing at least 1300 objects and assembled during his study of this subject, not to the Batavia museum but to the museum in Leiden (RMV series 1647). Earlier in 1908, however, he had given a woven fabric to the Museum of the Batavian Society.

The range of books on arts and crafts under the name not only of J.E. Jasper but also Mas Pirngadi, is witness to the fact that Jasper regarded his Javanese colleague's contribution as of equal value to his own. The innumerable, very precise and detailed illustrations contained in these books, were produced by this Javanese artist who, born in 1875, came from an aristocratic family of Banyumas, in Central Java. As early as 1905, he was 'appended' to Jasper in order to assist him with the exhibition at the first annual fair in Surabaya. For this he made decorations of batik motifs for the covers of the programmes, and for the diplomas handed out to prize winners. At the beginning of 1910, Jasper himself wrote about this 'Javanese painter-draughtsman' in Het Koloniaal Weekblad (The Colonial Weekly):

It is now some five years since I first got to know Mas Pirngadi's work. At that time, he was draughtsman for a cadastral office, making security maps for certificates of tonnage and the like, and naturally he was provided with a brush and several pans of watercolour for washing in border lines, rivers, lakes and seas in a neat and scholarly manner. [...] Yet Mas Pirngadi had higher aspirations than the colouring-in of lines and giving blue washes to areas of water. [...] In my service he had the opportunity to study the motifs found in various specimens of Native arts and crafts. [...] Mas Pirngadi has no peer in the representation of Eastern surface decoration. In this he is the finest and

best in the country. He shows the same ease in overcoming technical difficulties, whether in colour or in drawing, resulting from the application of special procedures. The patience he has in representation is immense, admirable. [...] He has returned to his original pleasure of working in watercolours. Having abandoned his box of oil paints, he now draws Native surface decoration and paints in watercolours. Does he own a studio? In a tiny room in his modest, plainly furnished domicile, he paints on a sheet of paper stretched upon his drawing board or painter's easel.

According to Jasper, Mas Pirngadi worked alone. When his former teacher came to look at his work, the teacher cried 'I can see it, he has grown taller than me!' Mas Pirngadi also sought advice from the Dutch painter F.J. van Rossum du Chattel, who lived in Indonesia from 1908 to 1914, and again in 1916, painting especially in watercolours and producing graphic work. At the end of 1909 Mas Pirngadi had an exhibition of watercolours in Surabaya. In 1928 he was even one of the teachers of the well-known Javanese painter Sudjojono.

Because of the great success of the illustrations in the series of books that Mas Pirngadi published together with Jasper, in 1929 he was 'appointed to rest at the disposal of the Society. His first task is to provide oil paintings of ethnic types for the great ethnographic map now in preparation'. This map still hangs, together with its accompanying portraits, at the entrance to the ethnographic department of the National Museum in Jakarta. He probably also made, after 1930, the drawings visible in the margins of the museum's old inventory books. Mas Pirngadi died in 1936.

G.P. Rouffaer: autodidact and expert on batik

Jasper derived inspiration from another enthusiast and expert on Indonesian arts and crafts, G.P. Rouffaer, with whom he also occasionally worked. Together they purchased a collection of objects at the fifth annual fair and exhibition in Surabaya that would be shown at the World Exhibition in Brussels.

Rouffaer played a special role in the dissemination of knowledge on the cultural heritage of Indonesia. This is extraordinary since, in a certain sense, he was an outsider. He occupied no official position either in the Netherlands or in the Dutch East Indies. It was with his own energy and percipience that he developed into a recognized scholar. He regarded it as his special task to collect as much knowledge as possible of the Dutch East Indies, in order to describe and catalogue them. He wanted not only to serve scholarship and disseminate his knowledge; he also hoped to improve the condition of the craftsmen of the archipelago and make the arts and crafts of the Dutch East Indies known to the Dutch public at large. He achieved this by means of publishing his own work and by organizing exhibitions. Both from the symbolic and from the esthetic point of view, Rouffaer was drawn to the material culture of the East Indies. He hoped by studying this material culture to arrive at an historical and systematic investigation of Indonesian cultures.

Gerret Pieter Rouffaer was born in Kampen in 1860. After leaving secondary school he enrolled as student at the Delft Polytechic. At the age of nineteen he abandoned his training as mining engineer, having decided to pursue his artistic interests. Since his recently deceased parents had not been without means, he had at an early age, already made the acquaintance of a number of European

G.P. Rouffaer

Gerret Pieter Rouffaer (1860 – 1928) in 1890
Photograph: KITLV Collection, no. 5786

countries. A journey to Italy in 1879 was for him a decisive experience. He had already greatly value the Dutch masters, but in Italy his interest in art developed still further. A second journey followed in 1884.

Rouffaer made two trips to the Dutch East Indies: from 1885 to 1890, and from 1909 to 1911. Between these two journeys he went to Spain for his health. His curiosity about the Dutch East Indies was stimulated by Multatuli's work. When he left for the east for the first time, in 1885, his plan was to make 'a pleasure trip of eight months', but this turned into a five-year study trip, during which he laid the basis for his later scholarly work. He covered a great deal of the East Indies archipelago: Java, Bali and parts of Sumatra, Sumba, Flores, Timor, Sulawesi and the group of islands including Roti, Lomblen, Alor and Adonara. From 1909 to 1911, Rouffaer traveled once more, this time not just to the East Indies, but also to the Philippines, British Borneo, Portuguese Timor, and Malacca.

In the Dutch East Indies his interest in other cultures developed into an impassioned 'desire to know everything': over the structure of society, the culture and colonial politics. He summarised, described, and catalogued his findings. With the greatest precision he observed and recorded in a staccato style in his note book everything that attracted his attention: 'Batavia is a kind of Naples, [with its] peripatetic Chinese barber, its Zoo, its Museum of the Bat. Soc. [Batavian Society], its *sarong-air* [i.e. place for waxing *batik*], *kampong air*, frogs and crickets, singing birds, beautifully scented flowers'. He also drew up lists in which, in his minute handwriting, he kept up to date with his spending: 'Hair cut French hairdresser *f.* 1, 00; 1 soda water with ice in Concordia *f.* 0, 40 and 1 soda water with ice in restaurant *f.* 0, 50'; and '1 small bottle of ink *f.* 0, 75'.

In the East Indies, Rouffaers began by examining the economic conditions of Java, and its colonial politics. During his first stay in Surakarta, he began his large-scale study of the Princely Territories. He undertook research on the subject in the archives of the Princely Territories, and studied in the libraries of the Batavia Society for Arts and Sciences, in the National Archives, and in the Topographical Institute.

In 1890, poor health took Rouffaer back to the Netherlands, and he stayed in Spain from 1893 to 1897 in order to recover. It was from Spain that he first touched upon the theme of art. He expressed the opinion that the bad treatment of 'East Indies art' in the first *Reisgids voor Nederlandsch-Indië* (Travel Guide to the Dutch East Indies) was based on the 'ubiquitous national error'. The idea that the colony might actually possess its own art was virtually absent among the Dutch. Rouffaer believed that if this idea were to change, both the ancient art from the Hindu period and the lively art of Bali, would come to be valued. However, in that period, he also spoke in less approving terms of the 'ethnologically interesting, yet weak [...] arts and crafts of the archipelago'.

Once back in The Netherlands, this attitude changed and Rouffaer became absorbed in the subject of arts and crafts. This was done mainly in the library of the Royal Institute for the Language, Geography and Ethnology of the Dutch East Indies (Koninklijk Instituut voor de Taal-, Land- en Volkenkunde van Nederlandsch-Indië, the current KITLV), when he settled in The Hague, and the library of the East Indies Society (Indisch Genootschap). While in Spain, he also maintained contact with the KITLV, asking the Institute to furnish him with a number of books in Spanish and Portuguese indispensable for researchers concerned with the colonial history of the Dutch East Indies.

Batik design, Semèn tokol
(sprouting semen)

Jogjakarta, Central Java
Collected before 1891 by I. Groneman
Cotton
Length 52.8 cm
RMV 847-8

Rouffaer was not only a passionate researcher but also someone who loved ordering and cataloguing. Back in The Netherlands, he offered to bring order into the KITLV's stock of books and maps. When he was made deputy secretary of the KITLV in 1898, he set to work on this project, also taking on the task of acquisition. He was entirely committed to the task and succeeded in extending the library's stock with a number of important works. He considered not only objects of material culture, books and maps as important; he also busied himself with the creation of a photographic collection for the KITLV. He was ahead of his time in recognizing the value of collecting pictorial material from all over the Dutch East Indies. He appealed to the administration of the Batavian Society to encourage amateur photographers living in the Dutch East Indies to collect pictures of subjects unknown or little known at that time.

During the course of the following years, Rouffaer became involved in editing the journal *Bijdragen tot de Taal-, Land- en Volkenkunde van Nederlandsch-Indië* (Contributions to the Language, Geography and Ethnology of the Dutch East Indies) and in work for a number of commissions dealing with his areas of concern in that region. Thus he was appointed secretary of the Board of Management of NV Boeatan, the commercial offshoot of the East and West Society (Vereeniging Oost en West), and which was involved in the sale of East Indian arts and crafts in the Netherlands. He was also appointed editor-secretary to the Royal Dutch Geographical Society (Koninklijk Nederlandsch Aardrijkskundig Genootschap) with special responsibility for Asiatic Art. Besides writing the standard work on *batik*, still to be discussed, his scholarly work included a large number of articles on a wide variety of topics: thus from political-economic topics

and theoretical contributions in ethnology to articles on the art and crafts of the Dutch East Indies. He published articles in *Bijdragen tot de Taal,- Land- en Volkenkunde van Nederlandsch-Indië*, in the *Encyclopaedie van Nederlandsch-Indië* (The Dutch East Indies Encylcopedia) and the *Tijdschrift van het Koninklijk Aardrijkskundig Genootschap* (Journal of the Royal Geographical Society). His interests were so many-sided that some of his manuscripts remained unfinished, for instance a study of Multatuli, and a piece of research into the situation concerning agrarian law in Central Java. On 14th October 1921 Rouffaer received an honorary Doctorate in Letters and Philosophy in Leiden.

The ethical policy Rouffaer was occupied with the Dutch East Indies during a period in which the 'ethical policy' formed the foundations of colonial-government policy. Taking the cue from C.T. van Deventer, who in 1899 asserted that the Netherlands had an economic debt of honour towards the Dutch East Indies, Rouffaer wrote of an 'artistic debt of honour'. Besides the scholarly aspect, he considered, especially, that in giving greater value in the West to East Indian arts and crafts, the economic conditions of East Indies artisans would improve. Hence his involvement with the East and West Society and with NV Boeatan, which exhibited and sold Indonesian arts-and-craft products.

Where Rouffaer's scholarly aims were concerned, he revealed on several occasions that he was irritated by the fact that it was mainly foreigners, like T.S. Raffles and J. Crawfurd who were the first to show an interest in East Indian art. He spoke of the '*gloomy indolence*' of the Dutch. Yet he also placed great value on the work of such Dutchmen as F.A. Liefrinck, A.W. Nieuwenhuis and J.A. Loebèr, besides many others. In referring to this

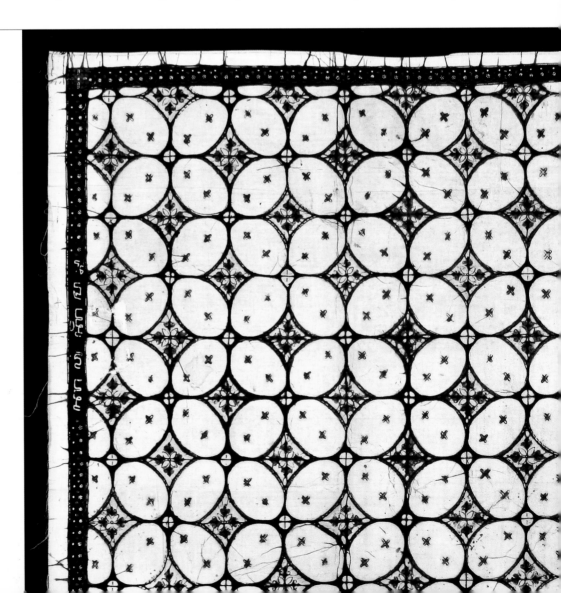

'artistic debt of honour', he observed that a great deal had been achieved in the area of East Indies studies, and that the Batavian Society formed the pivot of research in the linguistic, historical and anthropological fields, but that as yet nothing had been undertaken in the realm of Indonesian decorative arts. According to Rouffaer, this was because there was no interest in the Netherlands in an artistic comprehension and appreciation of the Dutch East Indies, this deriving from the fact that the Dutch had no 'natural artistic feeling'. In company with Loebèr, he expressed amazement that science showed such concern for flora and fauna, geology and ethnography, 'but the highest human expression of these islands, the decorative arts, are the most often forgotten. There seems to be greater interest shown in the shapes of skulls than in the fruits of the human brain; greater attention is paid to the colour and length of brown hands than to the artistic products wrought by those hands.' In the footsteps of the research initiated by H.D. Levyssohn Norman in 1872, into Javanese hand-production of cotton goods, Rouffaer thought that the time had come for the colonial government to provide an impulse favouring a broader-based, technical cum artistic investigation of arts and crafts. In his view, major interests, both colonial and national, practical and scientific, were implicated by this research. As we have seen earlier in this chapter, J.E. Jasper had been asked in 1906 to carry out a similar investigation, resulting in a series of a standard works produced together with Mas Pirngadi.

In the exhibitions organized by the East and West Society, Rouffaer observed opportunities for what he considered to be the threatened arts and crafts of the East Indies. By attracting the attention of the general public, he hoped to aid in the survival of existing arts and crafts. His way of writing the catalogues for these exhibitions also showed that he was ahead of his time. In his surveys, he introduced a kind of evaluative stratification by awarding a small star to the most exceptional cloths; 'an aid that has made things easier for many people who have no time or desire to examine everything very closely.' Although Rouffaer had such a positive attitude towards these exhibitions, he was correspondingly negative about several of the Dutch museums. He complained to the Leiden museum about the way in which they had stored the 'ethnological treasures of the East Indies', and he was evidently not very happy with the Rijksmuseum (National Museum). Only the Colonial Museum in Haarlem provided evidence of 'at least a small beginning towards what an art department should be'. Furthermore, in his view, museums were required to pursue simultaneously scholarly ends and the public interest. Thus he complained that the Leiden collection had no inventory that might provide the public with a survey of its contents.

The art of batik

Rouffaer was a versatile and erudite scholar. No effort was too much for him in tracking down all the available literature, and in studying the many objects with which he was occupied. In c. 1899, his major work *De batikkunst in Nederlandsch-Indië en haar geschiedenis* (The art of batik in the Dutch East Indies and its history) began to acquire its definitive form. This work was produced in collaboration with H.H. Juynboll. According to Rouffaer, the art of *batik* had a double importance for Indonesia: for both the culture and economy of the country. The work's subtitle reads: 'On the basis of materials available in the National Ethnography Museum and other public and private collections in the Netherlands'. The work contains some five hundred pages of

Batik design, *Kawung kemplang*
(sun-dried leaves of the sugar palm)
..
Jogjakarta, Central Java
Collected before 1891 by I. Groneman
Cotton
Length 54.5 cm
RMV 847-84

text, published in five installments between 1901 and 1905 by the National Ethnography Museum. The text appeared in book form in two parts, between 1900 and 1914.

The occasion for this investigation into batik art was the collection of 118 batik patterns donated by Dr. I. Groneman to the National Ethnography Museum in Leiden in c. 1892; Groneman was the East Indian personal physician to the Sultan of Jogjakarta,. Rouffaer was quick to realise that private collections and collections held at other museums must be brought into the research, including the collection of the Museum of the Batavian Society. The investigation by Rouffaer and Juynboll was a study in depth of the technique and history of Javanese batik, its relation to the Indian art of wax-resist printing, batik designs (their names, meanings and history), the significance of batik for Indonesia, and finally the mutual artistic influences between East and West. In this work, Rouffaer's enormous breadth of reading, his understanding of business matters, his passion and precision, came convincingly to the fore. He wanted to write for a wide public, thus setting himself the task of 'never losing sight of the scholarly nature of our work; yet at the same time writing a text that – leaving out all erudition – will yet be readable for those who are deeply interested, who are looking for clarification, who are unbiassed art lovers'. In his attractive and expressive writing style, he praised the work of the Indonesian craftsman, and especially that of the craftswoman. He particularly regarded textiles as being of great beauty: 'what strength and beauty of colours'. He compared the Javanese woman producer of batik – with her *canting* (wax pen) and her waxing pan – to a painter with his palette and brushes, and he compared the *gawangan* (the batik rack) with a painter's easel.

The last chapter of the book was devoted to the artistic exchange between East and West. Rouffaer believed that it was dangerous for Javanese batik art to come into contact with western civilization. Thus, he also wanted, before it was too late, to investigate 'genuine Javanese' patterns and dyeing methods. In this he directed his attention to the batik art of the Princely Territories of Central Java. He was critical of the batiks produced on the north coast of Java, – the 'beach regencies' as he named this region. In certain cases he could admire the high quality of the batik work and what he called the exotic play of colours, but in comparison with the batiks of the Princely Territories, they lacked one thing: style. He issued a particular warning against the 'Europeanisation' of the art of batik, such as one saw in the batik workshops directed by Eurasian women. Rouffaer shared this opinion with the women working for the National Exhibition of Women's Work in 1898 in The Hague, including G.A.N. van Zuylen-Tromp and B. Levyssohn Norman. Rouffaer wrote in his book that the private collections of textiles owned by these women had been of great value in his research

While he accused Eurasian batik entrepreneurs of a 'Europeanization' that constituted a danger for the original style, Rouffaer believed that Dutch artists such as Chris Lebeau and Gerrit Willem Dijsselhof, who had begun to investigate the art of batik in c. 1900, actually possessed an artistic sensitivity to the authentic batik and that they could thus provide support for Javanese batik art. Rouffaer made a great contribution to this development of batik art in the Netherlands (Wronska – Friend 2001: 111). His exhaustive writing on batik technique allowed H.A.J. Baanders to perform experiments with different kinds of waxes and dyes in the Laboratory of the Colonial Museum in Haarlem. This investigation produced results that benefited the

Sorasari gumyur (beautiful sorasari flowers)

Jogjakarta, Central Java
Collected before 1891 by I. Groneman
Cotton
Length 52 cm
RMV 847-116

work of Dutch artists. In Rouffaer's view, these artists would, in turn, be of service to Indonesian arts and crafts and thereby aid in preventing the disappearance of this living art.

Gerrit Rouffaer, who died in 1928 in The Hague, laboured his whole life long for the benefit of Indonesian arts and crafts. With his publications on *batik* art, he inspired scholars the world over during the twentieth century, and even now continues to inspire ongoing research into Indonesian textile art.

At the beginning of the twentieth century the Bali collections from the museums in Batavia and Leiden were significantly enlarged with precious objects deriving from the principalities of South Bali. There was a reflection here, in two ways, of the relations between Balinese princes and the colonial government. On the one hand the princes already operating under Dutch rule endorsed their relation with the colonial government by sending gifts that often ended up in one of the two museums. On the other hand, to a certain extent a number of principalities were subjugated by military force, in which case a great many precious objects from the palaces were looted. After the 'pacification' of Bali, art lovers and government officials were able to build up magnificent collections, undisturbed.

The first Dutch to visit Bali arrived in 1597. In the three centuries after that date the island was left in relative peace by the colonial government since, apart from the slave trade, no other interests were at stake. The island was divided into mini-states, small in area, in which the ruling princes, who themselves profited from the slave trade, were principally occupied with fighting each other. After Sir Thomas Stamford Raffles put an end to the export of slaves during the English interim rule, the Balinese rulers developed an interest in other forms of trade. On the Dutch side, from 1840 onwards the stress lay on trading agreements and on contracts aimed at preventing the customary plundering that took place after the all too frequent shipwrecks. The Balinese princes, afraid of losing their independence, did not keep to these contracts, the result being a long series of hostile relations.

The war in Buleleng, the northern part of Bali, lasted from 1846 to 1849. In 1854 a Dutch *Controleur* was appointed to the area, as well as a Balinese regent from the princely line of Buleleng,

I Gusti Ngurah Ketut Djelantik. He presented some beautiful ornamental weapons to the Governor General in Batavia. Nonetheless, two further military expeditions were needed before North Bali could be brought directly under Dutch rule in 1882, in the person of the Resident.

The princely ruler of Karangasem in East Bali, involved in warfare against his own brother the prince of Buleleng, committed suicide. The ruler of Lombok, I Gusti Ngurah Ketut Karangasem, may have been a relation, but was nonetheless a rival to the house of Karangasem. He had given assistance to the Dutch, and was rewarded with the throne of Karangasem as an independent ruler. The gifts presented to the Dutch government between 1865 and 1889 bear witness to the friendly relations existing in that period.

However, the political situation changed in 1894. The Balinese prince of Lombok (not the same as the person ruling in 1849) exploited the original inhabitants, the Sasak, and was further, more interested in trading with the English than with the Dutch. The result was the notorious Lombok war of 1894 (see the article by Wahyu Ernawati). After the Dutch victory this ruler was exiled to Batavia. In Karangasem the title of Viceroy was awarded to I Gusti Gede Djelantik, another descendent of the princely family, loyal to the Dutch. In 1908 this ruler handed over his power to his nephew, I Gusti Bagus Djelantik. On this occasion princely gifts were sent to the Dutch government, both in Batavia and in the Netherlands.

The South Balinese mini-states of Badung, Tabanan, Klungkung and Gianyar still remained independent, yet there was a great deal of internecine strife. The relatively small Gianyar state therefore sought the protection of the Dutch; in 1899 the

Francine Brinkgreve

Balinese rulers and Colonial rule

The creation of collections, and politics

Dutch appointed the prince – Dewa Gede Raka – to the same position (Vice Regent) as the prince of Karangasem. This relation was confirmed by a large gift to the colonial government in 1903.

The other small South Balinese states were ultimately brought to heel by military action: Badung and Tabanan in 1906, and Klungkung in 1908. In the course of all these campaigns a great number of precious objects were looted from the palaces. In the Museum of the Batavian Society (Bataviaasch Genootschap) these collections were described at a later date by the retired government official and deputy curator, H.J.E.F. Schwartz. From 1897 onwards he had been appointed as *Controleur* on Bali, and in the period of military actions he was temporarily promoted to the position of Assistant Resident, and placed at the disposal of the government Commissioner, and of the military officer commanding the expedition. In this way he gained greater familiarity than anyone else in the museum with the history of these objects, some of which he had searched for himself, in the field.

Part of the ethnographic collection that the art collector W.O.J. Nieuwenkamp assembled on Bali in 1906 and 1907 for the National Ethnology Museum in Leiden also has – as will be seen from this chapter – a direct connection with the military actions mounted against Badung and Tabanan. A good deal has been published on the subject of Nieuwenkamp's ethnographic work on Bali. Here, however, we shall restrict our interest to his collecting work in the aftermath of both these military operations.

After the final establishment of Dutch authority on Bali, various people working for the Department of the Interior, Resident

F.A. Liefrinck for example, assembled important collections. These however were not divided up between the museums in Batavia and Leiden. Sometimes several items from a collection did find homes in both museums, for instance pieces from the collections assembled by Resident H.T. Damsté (, and the official with special responsibility for languages, H. Neubronner van der Tuuk. Both museums each housed a significant proportion of the collection created by Engineer T.A. Resink, who lived and worked in South Bali during the 1930s. Resink maintained good relations with the Balinese aristocracy in the little town of Ubud, and was also involved in the establishment of the Bali Museum in Denpasar. After World War Two his collection was housed in both Leiden and Jakarta. For this reason we shall be examining his collecting work in greater detail, in this chapter.

Gifts from friendly rulers

As described in the chapter on Java, after the end of 1858 the Batavian Society was given the opportunity to house, in the Museum, those gifts from indigenous rulers to the Governor General which he had no wish to keep for himself. Consequently in 1865 some of the items forming a gift from the prince of Lombok and Karangasem to Governor General L.A.W.J. Baron Sloet van de Beele, consisting of valuable cloths and golden presentation trays among other things, were placed in the Museum of the Batavian Society. This Governor General was himself a collector of Indonesian weapons for ceremonial and display use (see the chapter on Java), which he therefore did not donate to the Museum in Batavia. For instance, in 1864 the Regent of Buleleng, I Gusti Ngurah Ketut Djelantik presented him with

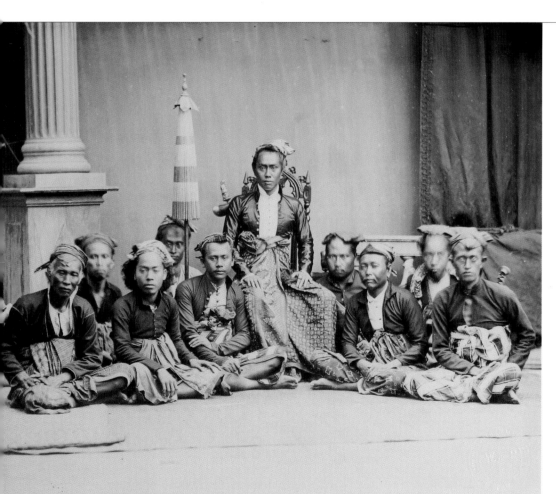

I Gusti Ngurah Ketut Djelantik, ruler of Buleleng

The ruler was on a visit to Governor General L.A.W.J. baron Sloet van de Beele, in Buitenzorg in 1864
Photograph: Studio Woodbury & Page, KITLV Collection, no. 3512

Sacrificial knife and its sheath

Buleleng, Noord-Bali
Donated to Governor General Baron Sloet
van de Beele, in 1864, by I Gusti Ngurah
Ketut Djelantik, ruler of Buleleng
Silver, horn, wood, polychrome
Length 50 cm
RMV 1050-2

This knife was presumably used for ritual
purposes. he sheath is painted with floral
motifs and decorated with a wood carving
in the shape of the small head of a monster,
karang Boma.

a pair of especially fine weapons, and a sacrificial knife in its beautifully carved sheath (RMV 1050-2) which was purchased by the State Ethnography Museum only after his death.

In 1878 four *sirih* boxes and eight water pitchers with golden lids, presented by the ruler of Lombok and Karangasem, were donated to the museum in Batavia. They formed part of a gift intended as a tribute to the Governor General. We do not know what the Governor General kept for himself out of the entire gift, but in the notes of the Batavian Society it is recorded that in 1889 a deputation from the same prince to the Governor General presented the following gifts: 'Two pikes with gold mountings; four earthenware *kendies* with golden spouts and corresponding baskets; two bamboo *sirih* boxes and two wooden puppets'. The Society decided that 'in response to this, in token of gratitude, (they) would advise that only the pikes and the wooden puppets are really appreciated, since the other things are already represented in the Museum, and furthermore (they) have decided to relinquish the other objects to the State Ethnography Museum in Leiden'. These other objects – two *sirih* boxes and four water jugs with golden spouts (including for example RMV 770-2 and 2a) – were indeed offered to the Leiden museum.

In December 1908 the Governor General once again received a sizeable gift from the Vice Regent of Karangasem, I Gusti Gede Djelantik, this time 'on the occasion of the dewa festival, held recently', or large-scale sacrificial rituals for the gods *(dewa)* at the time of handing over his office to his nephew I Gusti Bagus Djelantik. 'The gift received consists of: 1a. a piece of yellow silk, intended to hold up the upper sarong; 1b. a silk upper sarong; 1c. a piece of chintz for a belt; 1d. a silken under sarong; 1e. an embroidered floor cloth; a golden presentation dish, in which the

gift is presented; a small gold box with lid, containing a piece of *tjendana* wood; 2 small gold boxes with lids, filled with *kemanjan* (incense in a solid mass) and *setangi* (incense in fine powder form); 1 cushion for sitting on; 2 gilded *pajongs* (umbrellas); 4 wax candles made in Bali; 20 English gold coins each worth 62.50 florins; 200 Dutch rijks-dollars.' These objects were placed in the museum, while – as the notes record – the coins were 'deposited in the Governmant treasury, for the benefit of the Land'.

At the same time not only the Governor General, but also Queen Wilhelmina were presented with a similar sumptuous mark of honour, which Rita Wassing has described in her book *Royal Gifts*. It is worth noting here that the gifts presented to the Queen were rather more valuable that the set of presents given to the Governor General. He was given two golden incense boxes (MNI 13990, E838, and 13991, E838), while although identical little boxes were presented to the Queen, hers had rubies fixed into the lids. The Queen retained most of the objects in this gift, which are kept in the Royal collection housed in the East Indies Room in the royal palace at Noordeinde. The two gilded umbrellas and the wax candles were donated to the Leiden Museum (RMV series 1689). In return, the Queen gave the old Prince a fountain for his garden. After his death in 1916 there was a huge cremation ceremony in Karangasem. On behalf of the Batavian Society H.J.E.F. Schwartz attended this ritual, in order at the same time to collect two thousand guilders' worth of objects for the museum, of which he was Deputy Curator at that period. As we shall see later in this chapter, Schwartz had played a role earlier on, in acquiring Balinese objects for the Batavian Society's museum.

Dewa Gede Raka, Viceroy of Gianyar appointed in 1899, also cemented his relationship with the Dutch government through the presentation of gifts. In 1903 he sent the government a triple gift. 'These goods, destined for three authorities of different rank, consist of three entirely similar collections, differing only in that some of these objects 'are decorated with silver and gold, in place of gold alone', the notes inform us. Each collection consisted of twenty objects. Apart from the set intended for the Governor General, the other two sets of gifts were meant for the Resident of Bali and Lombok, and for the '*Controleur* for Political Affairs in that place', i.e., H.J.E.F. Schwartz. The notes record that 'His Excellency the Governor General has kept a pair of *pinang* shears with gold handles from one collection (of gifts), and also the gold ring from each of the three sets. The Directors of the BG (Batavian Society) counsel the government to pass on one of the three collections as a loan to the Museum, and to pass on both the others to the State Ethnography Museum in Leiden, and the Prins Hendrik Museum in Rotterdam'.

On 22 February 1904, two complete sets of gifts certainly arrived in Leiden, except for the second pair of *pinang* shears already removed by the Governor General. However, the gifts were not divided equally between Leiden and Rotterdam, as the Society had proposed. From the annual report of 1904 it is clear that both examples of the most valuable objects were retained in Leiden. Thus articles in RMV series 1436 included the small gold boxes for holding tobacco and *gambir* (1436-5a and b), and the silver boxes with gold lids (1436-6a and b), originally intended for the Resident of Bali and Lombok, and *Controleur* Schwartz respectively, while the Batavia museum kept the gold boxes destined for the Governor General. The series also includes two cigar cases, one with gold fittings and one with silver bands, and two silk cloths with lovely decorations in gold leaf (1436-15). This series contains

Water pitcher (*Caratan*) with a gold spout, and its woven carrying basket

Karangasem, Bali
Donated in 1899 to Governor General Pijnacker Hordijk, by the ruler of Karangasem
Earthenware, coloured rattan, gold
Height of basket 45 cm
RMV 770-2 and 2a

Part of a larger donation, including woven sirih boxes

Boxes with solid incense (*menyan*) and crushed powdered incense (*setanggi*)

Karangasem, Bali
Donated in 1908 to Governor General Van Heutsz, by I Gusti Gede Djelantik, vice-regent of Karangasem
Gold
Diameter 7 cm
MNI E 837 (13990) and MNI 838 (13991)

These boxes were part of a donation that the vice-regent of Karangasem offered to the Governor General, on the occasion of the transfer of the post to his nephew. Wishes are communicated by means of the scent of the incense

a Two boxes for tobacco and *gambir* (a plant extract), Klopok

Gianyar, Bali
Donated in 1903 to the Resident of Bali and Lombok, by Dewa Gede Raka, vice-regent of Gianyar
Gold
Diameter 6.6 cm
RMV 1436-5a and 5b

The boxes were part of a sirih set. On the base of each box is a punched eleven-leafed flower, and on the lid the flower of a pomegranate, surrounded by leaves

b Two boxes for tobacco and *gambir* (a plant extract), Klopok

Gianyar, Bali
Donated in 1903 to Inspector H.J.E.F. Schwartz, by Dewa Gede Raka, vice-regent of Gianyar
Gold, silver
Diameter 7.6 cm
RMV 1436-6a and 6b

The boxes were part of a sirih set
On the base of each box is a punched eight-leafed flower, and on the lid the flower with fourteen petals

a and b

The difference in material composing the two boxes (1436-5 en 6) indicates the differences in rank of the two recipients

only one of the less valuable objects, for instance the woven *sirih* boxes; in this case the gifts were in fact divided up equally.

In every case the first choice was made by the actual recipients of the gifts, the Queen and the Governor General as holders of the highest authority in the Dutch East Indies. Thereafter it was the Society's administration that decided which gifts the Government could donate to the museum in Batavia, while the excess items were subsequently destined for the Leiden museum.

The gifts described above always constitute a whole, a set. The various objects complement and enhance each other, thus giving the whole a special significance. These presents, meant for someone of higher status than the giver, seem in certain respects to resemble the gifts presented to the gods and ancestors on Bali, in the form of sacrifices. The intention in both cases was both to confirm the relationship with a higher power or higher authority, and to ensure the 'blessing' of that power or authority. Hierarchical relations were expressed in the content and form of the sacrifices: higher deities were offered ingredients of a quantitatively and qualitatively better kind. The same thing was seen in the presentation of gifts: there were more rubies on the little gold boxes presented to the Queen, while the *Controleur* had to be content with silver in place of gold. Moreover, every gift always contained included both incense, as a means of transmitting the essence of the sacrifice, and elements of the *sirih* quid to confirm the relationship between giver and recipient. The *sirih* quid, consisting of a small piece of the nut from the *pinang* palm, the leaf of the betel plant – with a little lime – were used not only in Bali but also elsewhere in Indonesia as a stimulant. Although there has been a marked decrease in the daily use of

this, the offering of *sirih* is still regarded as a sign of hospitality, and of the confirming of relationships, especially in a ritual context.

The gifts mentioned in the records also usually include objects connected with incense and the offering of *sirih*, for example the small boxes for *menyan* and *setangi*, i.e., incense in both solid and powder form (MNI 13990, E838 and 13991, E839), and the gold, or gold-with-silver boxes for holding tobacco and *gambir* (RMV 1436-5a and b and 6a and b). Tobacco and *gambir* (a plant extract) are both potential additions to the basic elements of *sirih*, in order to render the whole more fragrant. Anyone who chewed *sirih* had the basic ingredients to hand in a simple case made of bamboo or, among people of higher social status, in all kinds of little trays, boxes, and bowls, together in a beautiful dish. Sirih sets of this kind made of gold, silver or copper, were often beautifully decorated, and constituted valuable inherited items – *pusaka*. In their portraits, rulers often had themselves shown with a fine *sirih* set close at hand.

The campaigns against Badung and Tabanan, and the Nieuwenkamp collection

The direct cause for the first military actions in South Bali was the wreck of the Chinese cargo ship Sri Kumala in May 1904, on the coral reef off the coast of Sanur in Badung. The ship was immediately plundered, the ruler of Badung – Gusti Gede Ngurah Den Pasar – being held responsible for the looting by the Dutch East Indies government. When he refused to pay compensation, a large-scale military expedition from Batavia was set in motion, under Major General M.B. Rost van Tonningen.

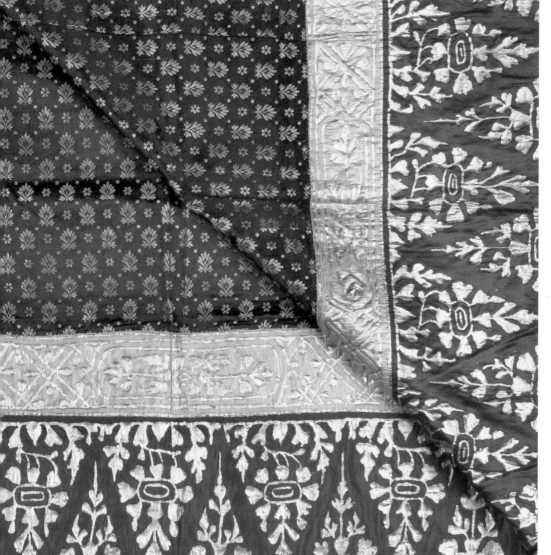

Upper garment, *Kampuh*
...
Gianyar, Bali
Donated in 1903 to the Resident of Bali and Lombok, by Dewa Gede Raka, vice-regent of Gianyar
Silk, gold leaf
Length 154 cm
RMV 1436-15
...
Gold leaf was used to make the triangular motifs along the edges, tumpal

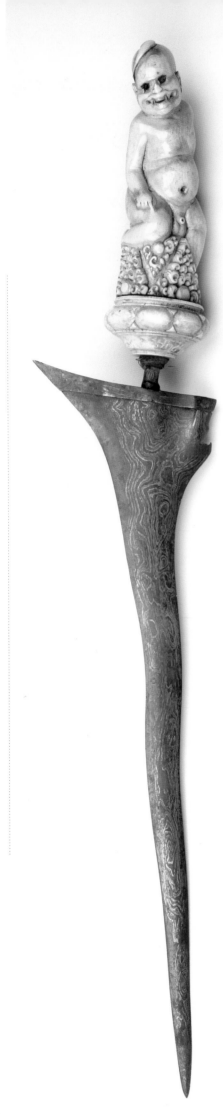

The first troops landed in Sanur on 14 September 1906, and on 20 September the palace of the ruler of Badung was taken after a dramatic *puputan* (suicide action) by the prince and his family and followers. Before this the Dutch had mounted a blockade, broken however on the inland side by the allies of Badung in Tabanan. Consequently military action was also taken against Tabanan. The ruler surrendered, but committed suicide in captivity.

As the result of these campaigns the annual report of the National Ethnology Museum for 1908 states the following information:

> Bali. The Dutch East Indies Government has received, through the mediation of His Excellency the Minister for the Colonies, a large collection of foreign-made objects from Bali, including the most noteworthy krisses, the handle partly in the form of a God, and also a sheath covered in gold, decorated with engraving and precious stones; in addition body ornaments, ceremonial equipment including a gold dish, a great many cloths, partly from silk and in remarkable patterns (series 1602).

In the spring of 1907 a total of 410 objects, packed in three crates with a volume of approximately two cubic metres and weighing 375 kilos, arrived in the Netherlands. They had been selected by a special committee of the Batavian Society, headed by C.M. Pleyte, from among the hundreds of objects looted by the army and handed over to the Government. In the museum at Batavia 241 objects had been 'ceded for safekeeping' and given the inventory numbers 12939 to 13180.

◄

Kris

Badung, Bali
Looted during the puputan Badung in 1906
Iron, nickel, wood, ivory
Length 36.5 cm
MNI 12965

The ivory handle of the kris has the shape of a small demonic figure, the protector of the owner of the kris.

▶

Crown, Gelung

Badung, Bali
Looted during the puputan Badung in 1906
Gold, precious stones, rubies, rattan
Height 35 cm
MNI E 899 (13065)

This fine crown was used during rituals of transition, such as marriages, of members of the ruler's family. The head of an elephant, karang asti - for warding off evil - is to be found on the back of the gold crown, on which 175 small precious stones have been set.

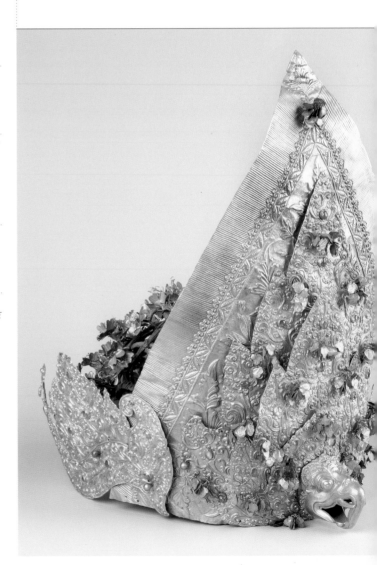

On 4 November 1906 eight crates containing 'preciosa looted on Bali' arrived at Tanjung Priok on the 'H.M. Koningin Wilhelmina'; the cargo included an inventory compiled by 'Infantry Major J.Bryan'. After Pleyte had accepted the goods on board, these were conducted under military escort to the Society, and stored in the treasury. The Committee sorted the objects, and proposed dividing them up between the Museum of the Batavian Society, the National Ethnology Museum, and other museums in the Netherlands. The chairman of the Batavian Society, however, disagreed with the division suggested, because 'the greatest proportion (of the objects) destined for the Netherlands has been allotted to the National Ethnology Museum in Leiden, while the other museums in the Netherlands, for example the Prins Hendrik Museum in Rotterdam and the Colonial Museum in Haarlem, have been badly treated'. It was consequently proposed that the Minister in the Netherlands should decide on the museums to which the objects should be given. They were sent 'at the country's cost' to the Department of the Colonies, after which 186 objects finally found a home in Leiden. Lastly, 'a number of ethnographically valueless pieces and fragments' were 'recommended for sale'.

The 241 objects loaned to the Batavian Society Museum included 60 weapons, chiefly *krisses* but also lances and a number of 'gunstocks with gold fittings'. It was also clear from the inventory that the collection included some 95 textiles, both imported and indigenous Balinese cloths, intended mostly for wearing apparel. The remaining objects consisted largely of body ornaments, including a marvellous dancer's crown (MNI 13065, E899), a great many parts of *sirih* sets such as finely decorated *pinang* shears (MNI 13008, E 943), and ritual objects including temple decorations (MNI 13160a and b).

The 186 objects registered in the Leiden museum also included a large number of weapons (43 items), especially a good many 'highly remarkable' *krisses*. Here, too, over a third of the collection consisted of textiles, in fact 'a large number of fabrics' (67 items). The remaining objects consisted chiefly of jewellery, parts of *sirih* sets, and ritual objects, just as in Batavia. With this, the collections of Balinese court art in both museums, which until that point had owned only a small collection of Balinese objects, were extended and rounded off in a significant manner.

After the collective suicide of the ruler and his followers in Badung, the State Ethnography Museum in Leiden not only received Balinese court objects via the Government. As fate would have it that the painter Wijnand Otto Jan Nieuwenkamp (1874 – 1950) journeyed to Bali and Lombok in precisely this period of political unrest, in order (among other things) to collect objects for the Leiden museum. Two years earlier he had already made a journey to Bali and Lombok, and he had been very impressed by everything he saw. In a letter dated 9 February 1906, he wrote the following message to the Director of the State Ethnography Museum at that time, Dr. J.D.E. Schmeltz:

In 1904, as you know, I spent time on Bali and Lombok in order to study the country and its people, its art and crafts, and as a consequence of this visit I began [writing] a large work. [...] To collect the further details I need I plan to leave once again for these islands before the close of the season, yet since I still lack the financial means, I would like to ask you if you could assist me with a subsidy. On my part I should be happy to collect ethnographic objects for the Museum on Bali and Lombok, on the condition that, for one year after my return, I shall

Pinang (areca or betel nut) cutters, *Kacip*

..

Badung, Bali
Looted during the puputan Badung in 1906
Iron, gold
Length 26.5 cm
MNI E 943 (13008)

..

These areca nut, given the shape of a horse's head and decorated with swastika (banji) motifs and other symbols of the sun, are inlaid with gold, and are part of a sirih set.

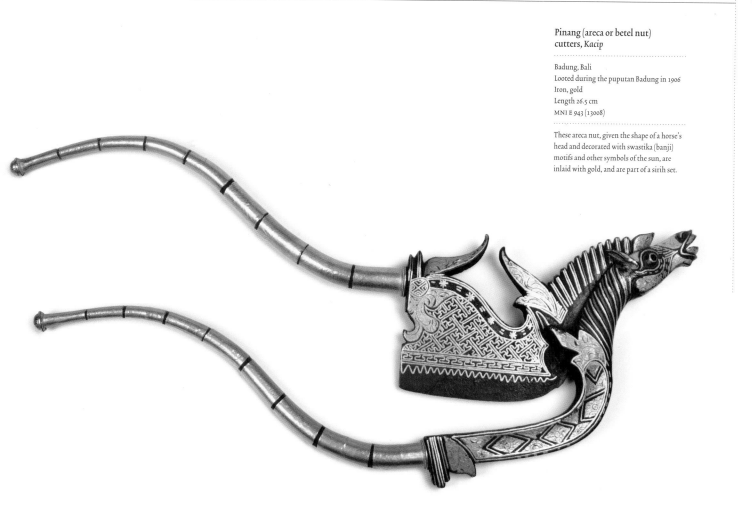

have the exclusive right to describe all the objects I have collected, and to produce illustrations for them in the above-mentioned work. Since I am quite well aware of what the Museum possesses from both islands, I believe I am in a good position to be able to complete this collection, and turn it into a splendid whole.

Although all the subsidies had not yet arrived, Nieuwenkamp decided to set out in the spring of 1906. For months the Museum heard nothing from him, although Schmeltz carried on a copious correspondence with the painter's wife, Anna Wilbrink. She wrote to him on 11 August: 'Only yesterday I received another letter from him. He had obtained permission from the Governor to accompany the expedition against the hostile kingdoms, but because the expedition had not set out immediately, he left for Singaradja, where he hoped to arrive on 24 July'.

Nieuwenkamp arrived back in Batavia on 11 June. After visiting his sister-in-law in Pekalongan, he planned to leave for Bali as quickly as possible at the end of June. Because of the tense political situation, he therefore had to request permission from the Governor General Van Heutsz. He left for Bali, and as soon as the war fleet appeared off the coast of Sanur in South Bali, Nieuwenkamp was able to move on to one of the ships. On 14 September a landing was made on Sanur. While Nieuwenkamp sat sketching a temple on the beach in Sanur on 20 September, the capital of Badung, Denpasar, was taken, followed by the notorious *puputan* of the ruler and his family. In a letter to his wife Anna, dated 23 September, Nieuwenkamp described this event (cited in a book written by his grandson, with the same name).

I have not yet made up my mind whether or not to write letters to the Handelsblad about the war. I am quite certain that anything I write will differ radically from the (news given in) the officially embellished telegrams; and such a letter would make me a lot of enemies. I am very curious to know what the newspapers will have to say about the taking of Den Pasar, the capital, or will they turn it into an heroic feat. Nonetheless, there was absolutely no question of a battle. Our troops stood with canons in front of the entrance to the place; some hundred or so Balinese came outside, men and women and children. The men knifed the women and children to death, then allowed themselves to be shot dead by the soldiers. Absolute hordes of Balinese kept on coming, and in the same way 1800 died (I wonder what the official numbers will turn out to be?) The ruler himself came out in a palanquin in all his splendour, and allowed himself to be killed. In the entire campaign, we lost only four men, a clear proof that there was no real battle. [...] In a couple of days I shall be going to Den Pasar, it is still in a dreadful mess; they are still busy burying the dead.

Nieuwenkamp went to Denpasar on foot, on 26 September. The army bivouac had been set up in the *puri* (palace), but the painter had a small hut built for himself in the space outside the palace, which the Balinese had burned to the ground. Later on, Assistant Resident Schwartz was to have a house built for himself on that spot. According to the painter: 'It is a terrible shambles here; in one of the courtyards the soldiers were occupied heating up their meal on firewood consisting of pieces of a gamelan, covered in beautiful carving. I had all [...] that had not been burned dragged to my hut. I have rescued other objects, as well'. Nieuwenkamp wrote later (on 24 December) in the *Algemeen Handelsblad*:

◄ W.O.J. Nieuwenkamp
..
W.O.J. Nieuwenkamp on the beach at Sanur during the puputan Badung, September 1906
Photograph: Van Weede, KITLV Collection, no. 10058

►
..
After the puputan, the corpse of the ruler of Badung was carried to the palace at Denpasar.
Photograph: Van Weede, KITLV Collection, no.10107

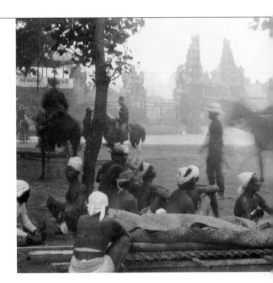

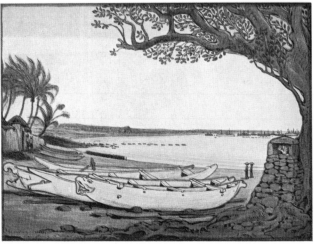

'Sanoer, landing 14 September 1906'
..
Ink drawing by W.O.J. Nieuwenkamp.
The war fleet is visible in the background.
Published in 'Bali en Lombok', p. 168

As little as the prince and his followers wanted to fall into our hands, they were just as reluctant to hand over their possessions; thus they set fire to the many palaces and houses belonging to their chiefs and great men, and a city of ruins some square kilometres in area grew up around the poeri. It was a pitiful sight: nothing but blackened fragments of wall, with a chaos of charred wood between them, broken statues, collapsed god-houses, pottery shards etc. etc. What a treasury of fine carving and household goods has been lost! [...] A great deal has been stolen by the population, I even witnessed myself how, for days on end, little gangs of Balinese emptied the prince's poeri, where the troops were camped, right under our eyes.

Originally Nieuwenkamp was only granted the opportunity to measure the vast puri of Denpasar, and to make a map of it. In his book *Bali en Lombok* he writes:

The whole, 171 metres long and 158 metres wide, consists of twenty-three right-angled spaces, and with the exception of the first courtyard was surrounded by a massive wall, six metres high and one-and-a-half metres thick. [...] On the eastern side of the forecourt there was a huge, massive doorway with two beautifully worked wooden doors, flanked by two smaller doors, which allowed entry to a courtyard intended for guests.

In the chapter covering the expedition against Badung in the same book, the painter shows his concern for the fate of the cultural wealth of the palace:

When the poeri was taken, it contained masses of lovely wooden carving and statuary, such as finely made doors, windows, pillars and frameworks, a large number of wooden statues in the houses and beside the wells, and stone statues in the house temple, ignoring all the household goods, weapons, clothing and musical instruments belonging to the many occupants, yet everything rapidly disappeared (stolen by the people) or else (was) wilfully hacked into pieces by the soldiers or burned in the field kitchens. I was able only with great difficulty to save two beautiful doors from the great doorway, which led from the forecourt to the space meant for guests. The men had wanted to use them for making a bridge over a water channel, for the soldiers; happily, they are now safely housed in the Ethnography Museum in Leiden, and find themselves among the most beautiful of the very extensive Bali collection. These massive pieces, each carved out of one enormous piece of djati (teak), are 4.37 metres high, 1.46 metres wide taken together, and 6 cm thick, and on one side are entirely covered with finely executed ornamental foliage, with for instance a representation from the Old Indian epic Ramayana in between; Jatayu is portrayed, who vainly tried to release Rama's kidnapped consort Sita from the hands of the giant Ravana.

However, as his correspondence reveals, he was unable to secure these famous doors from the Nieuwenkamp collection (RMV 1586-31) in a direct way. On 29 November he wrote to Schmeltz from Buleleng:

He [the Resident of Bali and Lombok] has allowed me to read what you have written to the government of this place. What a pity that the letter was not sent a couple of months earlier; had it been so, then I would have been able to assemble a unique collection for Leiden here in Den Pasar. I have just spent several extremely unpleasant days there, where I am continually hindered from collecting, and where an immense

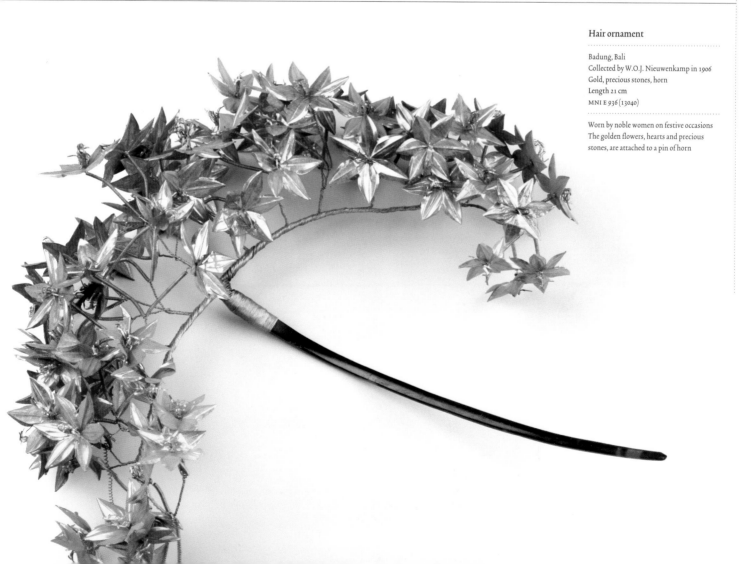

Hair ornament

131

Badung, Bali
Collected by W.O.J. Nieuwenkamp in 1906
Gold, precious stones, horn
Length 21 cm
MNI E 936 (13040)

Worn by noble women on festive occasions
The golden flowers, hearts and precious
stones, are attached to a pin of horn

amount has been destroyed or stolen. Thus your letter has not had the effect it promised, to allow me to collect what strikes me as important in the Poeri. At the beginning of January I shall therefore go to Den Pasar again; I still know of a few fine doors, some pillars, a wooden lion and some carving, which I hope I can acquire for the museum. I also expect to receive some money soon; otherwise I cannot last out much longer, if my pocket is empty.

On 18 January Nieuwenkamp once again found himself in Denpasar. He wrote;

At the moment I am sitting in Den Pasar, and have finally managed to gain something out of the poeri, one of the few things that have not been stolen, for the simple reason that this was too heavy and too big, a fine set of wooden doors, carved all over, of roughly 41/2 metres in length. I had great difficulty in obtaining them, but in the end I succeeded. This morning I took them to Sanoer, together with a set of very fine, smaller doors from the poeri of Tabanan, two pieces of painted bed compartments, and 4 ceremonial weapons carried in front of the ruler of Tabanan when he went walking.

The attached survey of costs shows that the palace doors from Denpasar and Tabanan cost nothing, except that a large number of porters were needed to transport the objects to the ship in Sanur. The objects from Tabanan about which Nieuwenkamp was writing, also form part of the RMV series 1586, and are directly connected with the events taking place around the Badung *puputan*. One week after the dramatic events in Denpasar the Dutch East Indies army began its march on the neighbouring state of Tabanan which had, as an ally of Badung, refused to cut

◄

Palace doors

Denpasar, Badung, Bali
Collected by W.O.J. Nieuwenkamp in 1906
Wood
Height 437 cm
RMV 1586-31

These doors, from the palace at Denpasar, are decorated with finely carved wood reliefs, including many floral and leaf motifs. A bird can be seen at the top of the carvings on each of the two doors, while at the bottoms there are mythological animals. The body of this animal consists of a winged lion (singa), while its head seems to be that of a karang asti (elephant's head)

off the land side during the Badung blockade. However, the old ruler Gusti Ngurah and his son and heir to the throne, Gusti Ngurah Anom, were compelled to surrender to the Dutch when they arrived in Badung to attempt negotiations. In his book *Bali en Lombok* Nieuwenkamp wrote:

He therefore left for Den-Pasar, accompanied by Assistant Resident Schwartz. I saw him arrive in a palanquin, which he left a little outside the poeri in order to proceed further on foot, this tiny, thin man with his beaky bird's face, looking all the smaller next to the giant height of Mister Schwartz, who approached him with large, slow steps. His son, a fine young fellow with a pleasant appearance, walked behind him. In the poeri where he had so often visited as a guest, the prince, together with his people, was now imprisoned in one of the areas with high walls.

Here, Nieuwenkamp was able to make secret night-time visits to the prince, before the latter also put an end to his own life. The princely palace of Tabanan was also organized into an army camp, and a *Controleur* was installed to enforce Dutch authority. Before Nieuwenkamp left Buleleng for Denpasar for the second time, in order to commandeer the doors from the *puri*, he first visited Tabanan, arriving there on 6 January 1907.

For five days there I was the guest of the Controleur A.M. Sandveld, who had taken over a small bamboo house opposite the poeri . The unhappy prince's poeri, which had been completely demolished, was not as large, and was much less finely arranged that [that of] Den-Pasar, only the front door being impressive. A public sale was held of the numerous movables from the poeri, because it was simpler to divide up a particular sum of money between the dead prince's

Kris holder

Tabanan, Bali
Collected by W.O.J. Nieuwenkamp in 1906
Wood, polychrome, gilding
Height 77 cm
RMV 1586-142

The sculpture has the form of a demonic ruler (evident in the crown and fangs), possibly Wibisana, the brother of Rawana, in the Mahabarata. His right hand acts as the hole into which the kris is put. The belt worn round his abdomen is decorated with a large gilded monster's head. The front centre of the pedestal has a gilded floral design and monkey

Painted panelling from a sleeping pavilion, *Parba*

Tabanan, Bali
Collected by W.O.J. Nieuwenkamp in 1906
Wood, painted
Length 159 cm
RMV 1586-33

The painting shows episodes from the Ramayana. On the lowest panel, Laksmana fights with Indrajit, who stands upon a wagon. In the centre, Rama is fighting with Rawana, who has already lost five of his ten heads. Above left, Sita cremates herself, showing that she has remained faithful to Rama

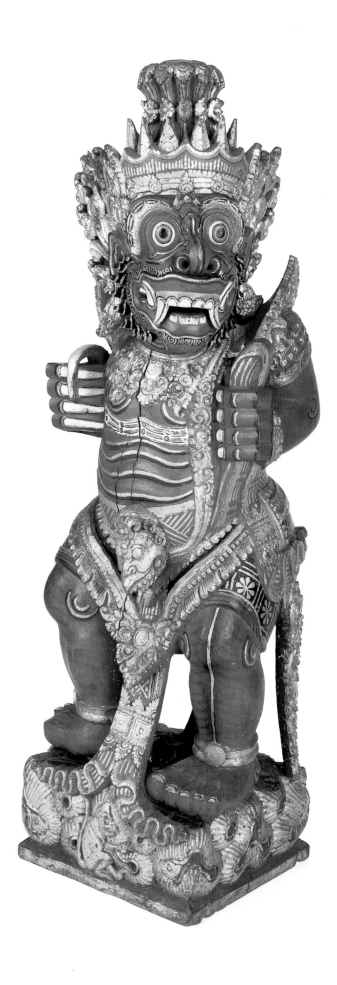

heirs than a huge number of different objects. Here I was able to purchase a good many important items on behalf of the R.E.M. [the State Ethnography Museum) in Leiden. I also succeeded in acquiring a fine set of wooden doors with gilded carving, and some painted bed-compartments for this museum.

In addition to the palace doors (RMV 1586-32) and the painted bed compartments (1586-33) there is also a large kris dagger (1586 – 142), as well as a number of ear ornaments (1586-112 and 113) and ritual objects from the Tabanan palace in the Leiden Museum collection. Later on it was clear that 'the sale of the poeri possessions of Tabanan served to create a capital sum to offset the costs of maintaining Tabanese exiles on Lombok'. Only a few of the items from the prince of Tabanan's estate found their way to the Batavia museum. From a 'Description of some of the princely poesaka weapons looted during the South Bali Expeditions (1906 – 1908)' the following shows us:

> Likewise the poesaka belonging to the prince, who killed himself, were put up for auction; the most important of these objects were 2 krisses, 3 lances (toembok), a gold sirih box (lantjang) and two gold bowls (bokor). Afterwards at least a proportion of the poesaka from the locality were once more bought up, and sent to Batavia (it is stated that [the following] were sent: 1 kris, 2 bokors and 1 lantjang). This is apart from the kris called I Gandja Iras. At the sale the kris was purchased by I Koromas, a smith and representative of the family of pandés who frequented the poeri. I Koromas however believed that he had seen a gleam of light emanating in the dark from the kris, which made him too scared to keep his prince's kawitan any longer in his home.

After the Inspector's attention had been drawn to the 'significance the kris possessed in the people's beliefs, this weapon was re-purchased', according to the notes. This was done in July 1908, costing the Government a thousand guilders. The Assistant Resident of South Bali, Schwartz, advised the government to 'donate the kris mentioned to the Society'.

Shortly after his visit to Tabanan, Nieuwenkamp left Bali. Just before his departure he received a letter dated 19 February from the Resident of Bali and Lombok, G.F. de Bruyn Kops, who expressed his appreciation for the painter's work: 'May I take advantage of this opportunity to inform you, on your departure from Bali, that I entertain the highest admiration for the enormous energy and dedication with which you have fulfilled the task imposed upon you'. At a later date Nieuwenkamp made a number of other visits to Bali, during which he collected a great deal, but he had nothing further to do with the political developments there.

War loot after the capture of Klungkung

Originally, Klungkung had kept out of the military actions against Badung and Tabanan, but in 1908 here, too, warfare broke out. The cause was a conflict with the Dutch over the monopoly of the opium trade, which was flourishing in that period. Ultimately a puputan took place on 28 April 1908 in the capital Klungkung, in which the ruler, Déwa Agung Djambé, and hundreds of other Balinese met their deaths. A correspondent for the daily newspaper De Locomotief wrote on 9 and 22 May 1908:

Ear ornaments (a pair), Rumbing

..

Tabanan, Bali
Collected by W.O.J. Nieuwenkamp in 1906
Gold, rubies
Length 6.1 cm
RMV 1586-113

..

Worn by male nobles

Box containing cockspurs

Badung, Bali
Looted during the puputan Badung in 1906
Wood, polychrome, metal
Length 18.8 cm
RMV 1602-169

The box is painted with figures from the
Ramayana, including Hanuman, the
monkey

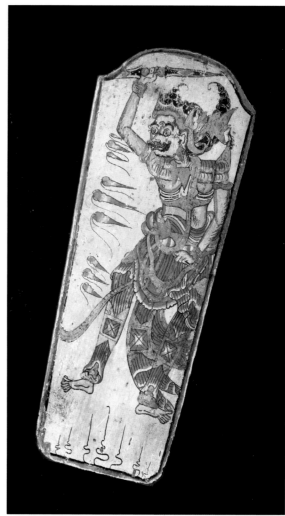

Bracelet, *Gelang*

Badung, Bali
Looted during the puputan Badung in 1906
Gold, rubies, precious stones, tortoise shell
Diameter 6 cm
RMV 1602-53

This bracelet is shaped like a snake and set
with precious stones

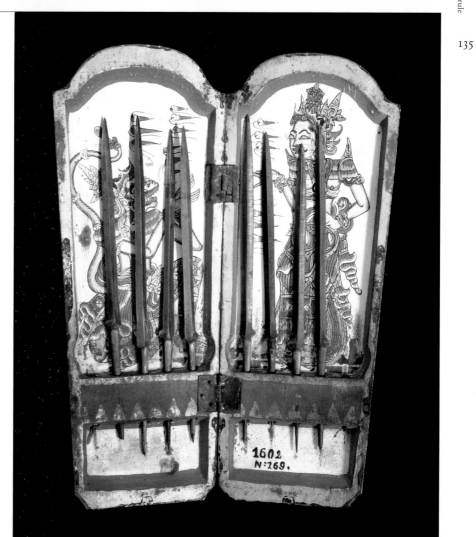

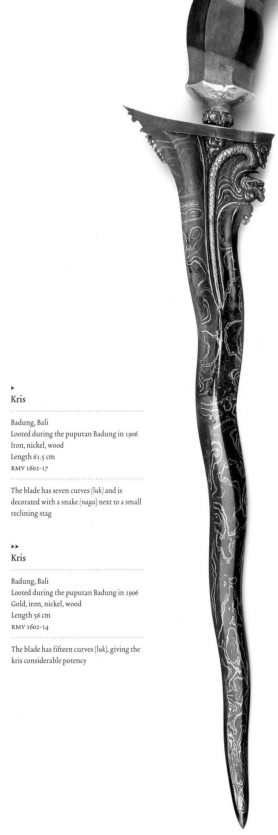

136

▸
Kris

Badung, Bali
Looted during the puputan Badung in 1906
Iron, nickel, wood
Length 61.5 cm
RMV 1602-17

The blade has seven curves (*luk*) and is
decorated with a snake (*naga*) next to a small
reclining stag

▸▸
Kris

Badung, Bali
Looted during the puputan Badung in 1906
Gold, iron, nickel, wood
Length 56 cm
RMV 1602-14

The blade has fifteen curves (*luk*), giving the
kris considerable potency

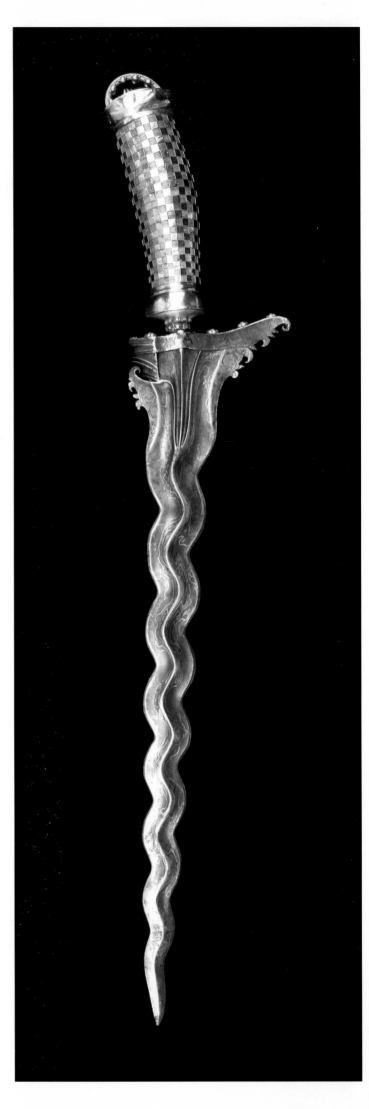

When I visited the ruler's residence the day after the poepoetan, this presented a miserable view of fallen greatness [...]. In the personal residence of the dewa agoeng the greatest destruction had been done by the mining of the outer wall which, made of stone more or less 1/2 M thick, could not be brought down in any other way. Now everything lay tumbled together in chaotic disorder. [...] Huge mirrors partly cracked, wajang puppets, etc. etc. In the women's quarters, doenoengan, one saw piles of European-made perfumery, chests full of kepengs, sarongs, carpets, etc.etc.

The resident and the assistant resident [still Schwartz – FB] are very busy looking for the valuable krisses worn by the dewa agoeng and other chiefs during the poepoetan, or found in the poeri; these include very costly krisses, some of which are worth 10,000 florins. The handle consists of an image covered in a thick layer of gold, ornamented with precious stones, while the scabbard bears lovely figures. Some of these are still blood-stained. The krisses will be sent to the museums. Some of them were stolen by the dewa agoeng during the war with neighbouring small states. [...]

The krisses belonging to the dewa agoeng must include some that, in the eyes of the Balinese, possess magical powers. Thus one of them is attributed with the power of causing earthquakes if the point is dug into the earth; a second has the power to kill someone immediately if its point is directed towards him. It is said that the dewa agoeng had this kris in his hand when he faced us in the poepoetan, we all know with what result; the Balinese belief in this magic power will undoubtedly have suffered a blow. A third kris caused anyone to freeze motionless in the position he held at the moment when the kris was used to trace a spiral figure in the air.

After Assistant Resident Schwartz, together with Resident De Bruyn Kops, had sought out all the treasures, these were packed in nine crates and handed for safekeeping to the National Treasury in Batavia. Two other crates containing Balinese manuscripts were also sent.

In a letter from the Resident to Governor General Van Heutsz dated 19 May 1908, the five hundred or so objects were valued at sixty thousand guilders. Responding to the Governor General's question of whether all these objects could truthfully be considered as spoils of war, and whether any of the objects should be handed over to the dead prince's heirs, the Resident wrote back that on Bali, no distinction was made between the personal possessions of a ruler and those of the state over which he ruled, and that the booty was thus perfectly legal. Moreover, all the ruler's heirs had been exiled to Lombok, and it would thus be sensible to sell everything that had no ethnographic, antiquarian or artistic value in order to finance these exiles' keep (as had already been done in the case of Tabanan).

The members of the Batavian Society occupied themselves with the division of the treasures. On 13 June the Director of the Leiden Museum had already written a letter to the Government, 'reiterating the request that since, as the newspapers have reported, krisses and other objects have been looted on Bali, the National Museum of Ethnology should also benefit from the division of these'. The Minister for the Colonies replied that 'His Excellency is delighted to be able to fulfil the above request'. The division of the objects took place in accordance with the proposal made by Administration of the Batavian Society. Four crates holding approximately 225 objects were shipped to

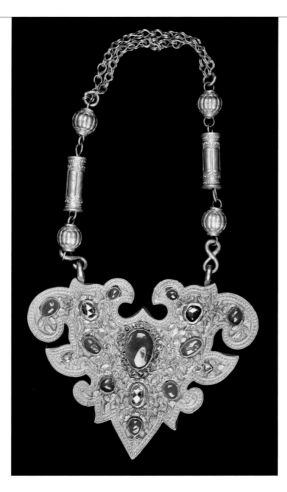

Pendant

Klungkung, Bali
Possession of the crown prince, Déwa Agung Gedé Agung, and looted during the puputan in 1908.
Gold, diamonds, rubies
Length of the pendant piece 12,8 cm
MNI e 821 (14891)

This heart-shaped piece of jewellery is decorated with a floral and leaf pattern and inset with rubies and diamonds
The chain includes gold balls

From left to right, Déwa Agung Gedé Agung, crown-prince of Klungkung, wearing the pendant [E821 (14891), above], Cokorda Raka Jodog, Déwa Agung Jambé, ruler of Klungkung, and Cokorda Putu Plodot with a sirih set
About 1908
Photograph: Puri Klungkung Collection

Dish for offerings, Bokor

Klungkung, Bali
Looted during the puputan in 1908
Gold
Diameter 25 cm
RMV 3600-98

The upright rim is decorated with the heads of monsters, and floral and leaf motifs

Dish for a sirih set, Lelancang

Klungkung, Bali
Looted during the puputan in 1908
Gold, wood, painted and gilded
Length 44 cm
MNI E 749 (14830)

This lavishly worked oval gold dish, on a wooden base, was meant to hold the parts of a sirih set. Besides flowers, the motifs portray various beasts such as birds, deer, tigers and snakes

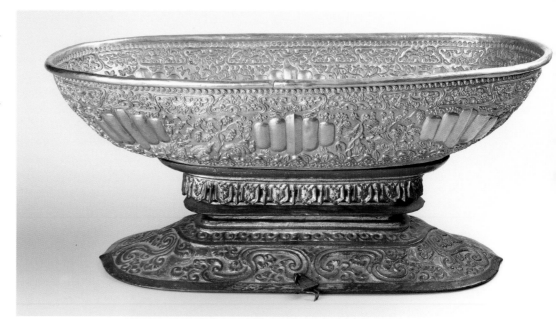

Small tobacco box

Klungkung, Bali
Looted during the puputan in 1908
Gold, precious stones
Length 15 cm
MNI E 786 (14837)

This unusual little box, shaped like a winged fish, forms part of a sirih set. The head of the fish is decorated with rubies, while the wing serves as a lid

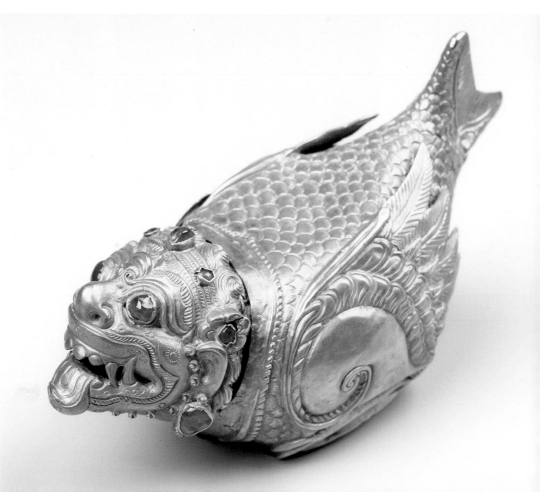

The Ethnographic collections

Holy watervessel, *Siwamba*

Klungkung, Bali
Looted during the puputan in 1908
Gold
Height 25.5 cm
MNI E 811 (14866)

The tripod is a double lotus blossom, covered
with gold, resting on curled feet each ending
in a small crouching lion. Priests use this
kind of vessel for preparing holy water, tirta

Lamp for priestly ritual *Padamaran*

Klungkung, Bali
Looted during the puputan in 1908
Silver
Length 20.5 cm
MNI E 810 (14867)

The calyx-shaped oil reservoir is borne on
the head of a mythical bird, while the bull,
Nandi, the god Siva's mount, sits on the back
of the lamp

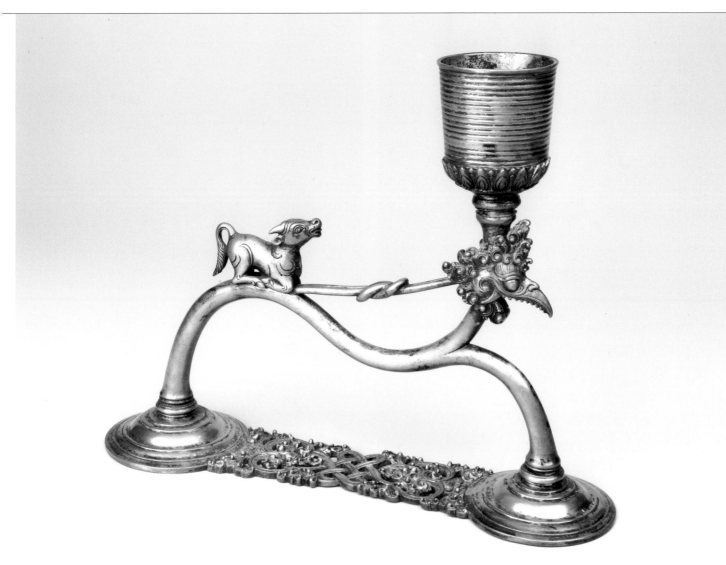

the Netherlands, where the contents were registered under series number 1684. Via the Leiden museum, the museums in Rotterdam and Breda (the Ethnographic Museum of the Royal Military Academy) were also given objects from the Klungkung booty. In 1959 the share allotted to Breda was returned to Leiden (under RMV 3600-98, for example).

At the Museum of the Batavian Society, 157 objects were taken into storage, largely of the same kind as those sent to the Leiden museum. However, various unique items, such as beautiful gilded instruments, (MNI 14892, E829 and MNI 14896, E833) and a small tobacco box with an unusual shape (MNI 14837, E786) were assigned exclusively to the museum in Batavia. The item registered under the number 14891 was described as a 'pectoral jewel, gold, heart-shaped, with scalloped edges, finely done with flower and bird ornamentation; the rim edged with bead motifs. Inlaid with rubies and diamonds; fixed to a chain, decorated with 4 round and 2 barrel-shaped golden beads'. In Margaret Wiener's doctoral thesis we find the photograph of a number of members from the princely family of Klungkung, a short time before the *puputan*. In this photograph the young crown prince, Dewa Agung Gedé Agung, shortly to die, is wearing this jewel round his neck (MNI 14891, E821). According to Margaret Wiener, who interviewed Balinese eye witnesses to the *puputan*, this twelve-year-old boy was one of the most courageous fighters against Dutch power. A third group of 123 objects of less value (largely, silver in place of gold) were sold publicly in Batavia. This auction was organized by the Director of the Ministry for Internal Affairs, the proceeds of the sale finding their way into the treasury.

Thirty years after the military campaigns, the question of possibly returning several of the looted *krisses* was again raised. During the preparations for the institution of Home Administration for the small Balinese states in 1938, the Resident of Bali at that time pondered whether he found it desirable to loan several of the *krisses* to the new administrators, heirs to the former rulers, as a symbol of their greater independence. R.Goris, official with responsibility for languages and an authority on Bali, was asked for his advice. In connection with this, prominent Balinese belonging to the princely families of Badung, Klungkung, Tabanan and Gianyar were invited to the museum in Batavia in order to identify their ancestors' heirlooms (especially *krisses*), to relate their origins, to describe the rituals surrounding them, and to talk about the legendary powers ascribed to them. In this way an important *kris* called Durga Dingkul was recognized by an emissary from the Klungkung, while the representative for Tabanan identified the *kris* – mentioned above – called to I Gandjah Iras. Ultimately, however, none of the *krisses* were given back at the institution of Home Administration. According to Goris, these weapons certainly belonged among the sacred heirlooms (*pusaka*) of the relevant families, but they could not be viewed as 'ornaments', genuine state jewels without which a prince would not have been able to rule.

The collection of an art lover; Engineer T.A. Resink

Thomas Anne Resink was born on 15 March 1902 in Jogjakarta. He inherited his penchant for Indonesian art and crafts from his mother, Anna Jacoba Resink-Wilkens, who had herself been

Kris in its sheath

Klungkung, Bali
Looted during the puputan in 1908
Gold, iron, nickel, silver, ivory, precious stones
Length 70 cm
MNI E 794 (14909)

The handle of the kris is decorated with a rakshasa or demon. The sheath is made of burnished wood (*kayu pèlèt*) overlaid with gold, decorated with floral motifs in chased work

Kris in its sheath

Klungkung, Bali
Looted during the puputan in 1908
Gold, iron, nickel, silver, ivory, precious stones
Length 74 cm
MNI E 795 (14912)

The blade has 13 curves (*luk*). The handle of the kris is decorated with a rakshasa or demonic figure. The sheath with its ivory top piece is overlaid with gold and silver, and is decorated with engraved floral motifs

Stringed instrument, *Rebab*

Klungkung, Bali
Looted during the puputan in 1908
Gold, emeralds, crystal
Length 91 cm
MNI E 829 (14892)

Particularly fine, lavishly decorated stringed instrument, forming part of the orchestra that accompanied the princely dance-drama *Gambuh*. The fingerboard and bow are lacquered red and are covered with gold

collecting Hindu-Javanese antiquities since the beginning of the twentieth century. Her collection was described by W.F. Stutterheim, an authority on Hindu-Javanese art. Madam Resink's collection of antiquities contained at that time at least 283 objects, mostly articles of use made of bronze, such as lamps, priests' dishes and bells, hanging bells, incense burners, containers for consecrated water, jewellery and Buddhist attributes. There were also bronzes and stone statues, and fragments of stone from buildings. Most of the items were collected in Central Java. At the time this was one of the largest private collections in Indonesia. According to Stutterheim, Madam Resink's intention had been:

by collecting Ancient Javanese articles of use, to set an example to the present-day Javanese coppersmiths and silversmiths, thereby combating the increasing deterioration in Javanese craftsmanship, by means of both exhibitions and publications. The collection consequently formed only part of a larger collection, relevant to Javanese craftsmanship. The collection housed at the moment in the owner's home is an outstanding example of what the Central Javanese artists of the period 800 – 1000 A.D. could achieve.

The collector had yet another aim in throwing open the museum housed in her own home:

Those who, after viewing the collection, found the opportunity to show their interest in the cultural development of the Javanese People, could – with the aim of expressing this interest in Djokjakarta – give voice to their sympathy by making a financial contribution to the Benefit Fund 'Darmo Sedjati', on behalf of the Associations:

Krido Bekso Wiromo (a Javanese school for music and dance), Wanito Oetomo (a Javanese women's association for the promotion of native cottage industries), Mardi Habirando (a dalang course) and Taman Siswo Art Fund.

Madam Resink was President of this benefit fund. Her husband, T.G.J. Resink who, as a Freemason also had an interest in it, acted as its secretary. Madam Resink gave lectures, and published works not only on a wide range of subjects connected with Javanese art, but also for example on 'the development of education at home for the village girls'. 'By this means a great step forward will have been taken to improve the position of the woman in the village' she argued.

The Resink couple had five children of their own who, according to the stories told by the grandchildren, grew up in Jogjakarta in an atmosphere of great interest in, and respect for the ancient and modern Javanese culture. The children were taught to play the gamelan, they learnt Javanese, and with their parents they visited *wayang* performances, which helped them to become familiar with the Hindu-Javanese world of ideas. During the restoration of Borobudur, T. van Erp stayed with them, and there was frequent contact with archaeologists he knew such as Stein Callenfels, Stutterheim, and Koperberg. Madam Resink also maintained a good relationship with the Sultan of Jogjakarta, Hamengku Buwono VIII. During the Japanese occupation a large part of Madam Resink's collection found its way via the Sultan to the Sonobudoyo Museum in Jogjakarta.

The son, Thom Resink, also had a great interest in art and archaeology. Like his mother, he collected ancient Javanese bronzes, sixteen of which he was to sell to the Antiquities Service

Engineer T.A. Resink (left)

C. 1960
Photograph: collection P. Terwen

in Jakarta in 1955. Shortly afterwards these bronzes, which came from Central and East Java, were donated to the museum (they included a little statue of a goddess, MNI 8272, and a small figure of a ram, MNI 8276). He incorporated his familiarity with ancient Hindu-Javanese shrines into articles on, for example, Belahan and Candi Kedaton.

Resink had qualified as a civil engineer at Delft, and was employed by the Department of Communications; at the end of the 1920s he was sent to South Bali to lay a system of water pipes. Here he settled down in the artists' village of Ubud, and became friendly with the painters Walter Spies and Rudolf Bonnet, who both played a part in the development of modern Balinese painting. Through these friends, Resink also developed an admiration for the classic expression of the art of painting on Bali, in which the motifs and the stories represented were already familiar to him through his knowledge of Hindu-Javanese culture. 'The Old Balinese art was dominated by the collective feeling for style among an extremely artistic people, who gave to all their artistic expression an extremely individual character, of rich and exuberant beauty', Resink wrote in 1961 in *De kunst van Bali* (The art of Bali).

As an enthusiastic amateur, Resink collected a great many painted cloths, showing scenes and characters from the Ramayana Mahabharata, Arjuna Wiwaha, and the Malat cycle for example. Almost all these cloths had a function to fulfil in temples and palaces, often as decoration for a *bale* (open building) or shrines. A *langsé* or curtain for example (RMV 4491-81) was used to close off the long walls of a bale, while the ceiling of this area might also be decorated with a painted cloth (RMV 4491-65). We do not know whether Resink purchased the paintings (often old ones) from

dealers, or directly from friendly aristocratic families in Ubud. For instance, he had a good deal of contact with Cokorda Gede Agung Sukawati, who together with Spies and Bonnet, was occupied with the preservation of Balinese painting.

Since Resink was friendly with Walter Spies, he also became involved with the Bali Museum in Denpasar, of which Spies was the curator. He himself was temporarily appointed a curator in this museum. As early as 1910 there were plans for a similar museum, for which the buildings were ready in 1925. It was only at the beginning of the 1930s that a serious start was made on assembling a collection, which by 1937 contained some two thousand objects. Work was also begun on a 'sales department for modern art, with the aim of raising the level of Balinese craftsmanship and of disseminating its products'.

During his time in Bali, Resink also acquired three very unusual Balinese fabrics, as well as the paintings. These fabrics are known as *lamak*: long cloths serving as decorations for altars and shrines in temples, and also as the basis for offerings placed on the uppermost, undecorated space. The *lamak*, often found on Bali, is made of a variety of materials, but Resink's woven fabrics are extremely rare. They show a unique manner of decoration (a kind of embroidery of the warp during the weaving process), and they were attributed to a woman weaver, Men Nis, who lived in the Denpasar area in the 1920s, dying in 1927. In 1941 Resink sold these three rare *lamak* to the museum in Jakarta (MNI 23936, 23937 and 23938). The National Museum is thus the only institute to possess three different versions of these woven textiles. Only ten examples are known, in six museum collections world-wide, besides a number of private collections, while a single woven *lamak* is still being used in South Bali.

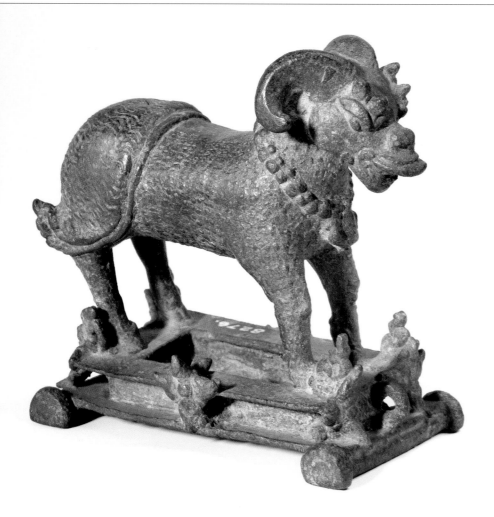

Statuette of a ram

East Java, 14th-15th centuries
Collected before 1955 by Engineer
T.A. Resink
Bronze, manufactured by the lost wax method
Height 11.5 cm
MNI 8276

The ram, probably used as a child's toy during the Hindu-Javanese period, stands on a base with four small, fixed wheels, and a hole for a pulling string

Resink, as a soldier, was interned during the Japanese occupation. After the war he lived in Jakarta, where he organized an exhibition in 1946, on the old and new styles in Balinese plastic arts. In 1957 he once more returned to The Netherlands, where a large number of the painted cloths from the Resink collection were exhibited in 1961 in the City Museum in The Hague: 'The art of Bali; past and present'. Resink wrote a comprehensive introduction to, and extensive descriptions of his paintings for the exhibition catalogue. In 1962 the beautiful collection was loaned to Leiden's National Museum of Ethnology(series 4491) and after Thom Resink's death in 1971 the collection was donated to that museum.

Thus the communal collecting history of Balinese objects is based not only on the violence of military expeditions, but also – through the gifts of princes and the collections made by individuals – on friendship and respect for Bali's rich culture.

Painted cloth, used as a covering for the ceiling of a sleeping pavilion

Kamasan, Klungkung, Bali
Collected by Engineer T.A. Resink in the 1930s
Cotton, painted
Length 270 cm
RMV 4491-65

The painting shows the epic Garudeya, part of the Adiparwa. After Garuda obtains the elixir of life, in order to release his mother from a curse, he is attacked by the gods, who want to prevent this happening. Surrounding Garuda, who holds in his right hand the vase containing the elixir of life (amerta), we see the gods of the north, east, west and south: Kuwera, Indra, Varuna, and Yama. The gods of the Zenith and the Nadir stand to the left and right of the gods. Bottom left: Twalèn, servant/clown figure

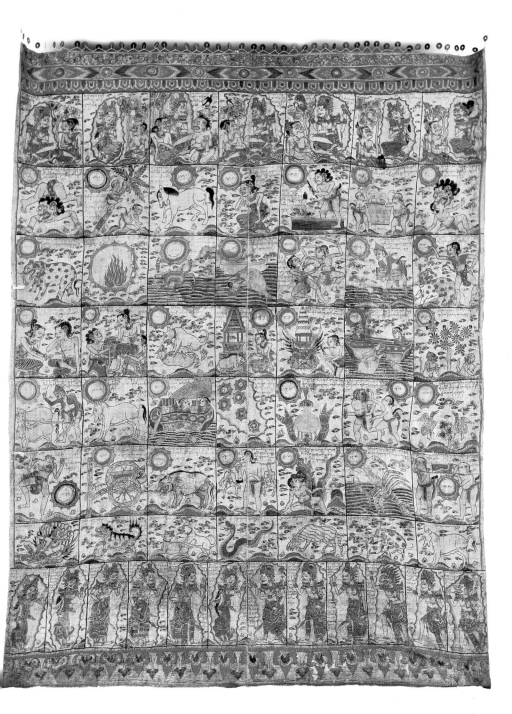

Painted cloth, used as a curtain, *Langsé*

Kamasan, Klungkung, Bali
Collected by Engineer T.A. Resink in the
1930s
Cotton, painted
Length 240 cm
RMV 4491-81

An astrological calendar, palelintangan., is
portrayed. The top-most row of seven panels
show, from Sunday to Saturday, the deity,
the wayang figure, the tree and the bird, that
influence the five-day week shown beneath.
The next five rows of seven panels reproduce
the star signs for the 35-day month, based
on the pawukon calendar. The seventh
row contains seven beasts that, with their
properties, influence the lives of the people
born under these star signs. On the bottom
row are twelve gods who influence the lives
of those people born in the month concerned

Temple decoration, *lamak*

Badung, Bali
Collected by Engineer T.A. Resink in the
1930s
Cotton, tissue, decorated with additional
motifs in the warp
Length 154 cm
MNI 23937

The *lamak* serves to decorate places of
sacrifice, and on which to place the offerings.
The top edge consists of five small female
figures, *cili*. The hour-glass motif beneath
this is called *ibu* (mother), indicating
the fertility of Ibu Pertiwi, Mother Earth.
The chequered motif below this is called
masmasan (jewel) and is repeated in the
geometric motif in the lowest half of the
lamak. The rows of triangular motifs on
the sides and at the bottom of the cloth
are known as *gigin barong*, the teeth of a
mythical, protective animal

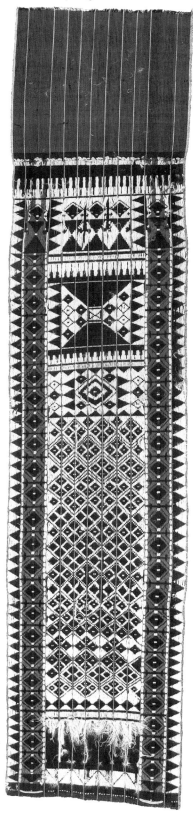

On Lombok, it was not Dutch scholars or missionaries who succeeded in creating ethnographic collections, out of interest in the local culture. Instead, there was a direct link between the amassing of what came to be known as the Lombok treasure, and the military subjugation of the island. When Dutch troops defeated the Mataram-Cakranegara kingdom in 1894, the riches contained in the palace were taken away as war booty. The Dutch stole 230 kilos of gold, 7,000 kilos of silver, together with jewellery and precious stones. Part of the collection was returned to Indonesia in 1977.

Lombok

The island of Lombok forms part of the province of Nusa Tenggara Barat, situated between the province of Bali to the west, and that of Nusa Tenggara Timur to the east. Besides Lombok, the island of Sumbawa also belongs to the same province. To the west, Lombok borders on the Lombok Strait separating Bali and Lombok, to the north it borders the Java sea, and to the south the Atlantic Ocean. To the east the Alas Strait forms the division between Lombok and Sumbawa.

Lombok, with a surface area of some five thousand square kilometres, can be divided into three ecological regions: North Lombok with its mountains, including the Rinjani, 3,726 metres high; Central Lombok with its fertile lowlands and rice fields flooded by means of irrigation works; and South Lombok with its arid plains and rain-fed rice fields. Domestic animals on this island include cattle, water buffalo, goats, sheep and poultry.

The name 'Lombok' is mentioned is the ancient manuscript Nagarakertagama (Desawarnana) and other written sources, which include chronicles written on *lontar* leaves. The name is also known from oral tradition. Sources written on *lontar* leaves mention Lombok Mirah for West Lombok, and Sasak for East Lombok. According to oral tradition the island is called Sasak because in earlier times it included impenetrable jungles, so that the term *seksek* or *sesak* came into use (Melalatoa 1994: 741).

In the chronicle Sungapati, Lombok is called *Pulau Meneng* (the silent island), perhaps because there were still very few people living there. Until the end of the nineteenth century the island was also known as Selaparang, a name for a kingdom situated in East Lombok that flourished up to the mid-fourteenth century. In the records of the United, or Dutch, East India Company (Vereenigde Oostindische Compagnie, or voc), Lombok was first named in 1603 by Steven van der Hagen. According to his report, Lombok produced large quantities of cheap rice, which was transported to Bali every day in small boats. It is thus hardly any wonder that the name Lombok was known to outsiders.

However, the original inhabitants of the island named their home region *gumi Sasak* or *gumi Selaparang*. One of the chronicles mentions that ancestors of the ruler of Lombok had come from the kingdom of Majapahit, referring to the fact that the names of various places on Lombok resemble those found on Java: Kediri and Mataram for example, among others. In oral sources the Sasak came from Riau, reaching the shore of the south coast of Central Lombok (Melalatoa 1994: 741). There they saw enormous forests containing trees with straight trunks. They called the place Seksek-Lombo, because the trees stood so close together (*seksek*) and had straight trunks (*lombo*). This, then, is the pre-history of the naming of Sasak and Lombok.

Wahyu Ernawati

The Lombok treasure

Population

The original inhabitants of Lombok are known as Sasak. They are spread out over three districts: West Lombok, East Lombok and Central Lombok. In addition to Lombok, these people are also found in the west of Sumbawa and in the northern part of Bali. Sasak have also migrated to other regions of Indonesia. Others who settled on Lombok were Balinese, Javanese, Buginese and Makassarese, people from Banjar, and also people of Arabic and Chinese origins.

Sasak society consists of social levels based on descent. The main distinction is that between the aristocracy and non-aristocratic people. The highest social level is known as the *raden*; the men are addressed as *raden*, and the women as denda. The middle class form part of the *triwangsa*, in which the men are addressed as lalu and the women as baiq. The third social level is formed by the *jajar karang*, in which the title *log* is used for men, and *le* for women. Today, this division is subject to heavy pressure, now that factors such as power, education and wealth are regarded as the most important elements in the acquisition of high social status. Nonetheless, descent still plays a significant role. The farmers grow rice on both wet and dry fields, with maize, sweet potatoes, groundnuts, coconuts, and tobacco. A second source of income is provided by cattle. Additional income is obtained by the sale of basketwork, pottery and textiles, while the inhabitants of the coastal regions can earn their living as fishermen.

Over the centuries the Sasak have absorbed Buddhist, Hindu and Muslim influences. In the sixteenth century the Sasak converted to Islam, which arrived via Java. The adherents of Islam also include followers of the Wetu Telu, a mingling of animist, Hindu and Islamic influences. In their performance of the basic principles of Islam, these believers adhere to only four out of the five pillars of the faith: the *syahadat* (confession of faith), *shalat* (ritual prayer), *zakat* (religious taxation) and the *puasa* (fasting during the prescribed months). The *kyai*, the religious teacher, is obliged to adhere to these rules, while those who are not kyai are not strictly bound by the rules since they are already represented by the *kyai*. Nowadays this teaching is no longer popular, because young people, especially, want to follow the purer form of Islam.

The history of Lombok

According to the annals of Lombok, the site of the oldest kingdom lay in the village of Lae'; the kingdom itself was therefore called Lae'. When the Rinjani volcano exploded, the inhabitants spread out over the little islands surrounding Lombok, and a new kingdom, Suwung, came into being. According to the Suwung annals, it was the ruler Betara Indra who established the kingdom. After the decline of Suwung the kingdom of Lombok came to power. Other sources relate how, after the ruler of Suwung was defeated by Majapahit, *Raden* Maspahit fled to the forest, returning after the Majapahit attacks ended to establish a new kingdom, called Selaparang. In 1357 Majapahit sent out a military expedition to subjugate Lombok. This expedition arrived only after Majapahit has conquered Bali in 1343.

Between 1500 and 1800 small, independent kingdoms arose on Lombok, for instance Lombok, Langko, Pejanggik, Bayan, Sokong, Tempit, Pujut and others. The best known and most outstanding kingdom was that of Lombok, with its capital in the port of Lombok. This city was built on the shore of the beautiful Lombok Bay, with its abundant supply of fresh water, and was often visited by merchants from Palembang, Banten, Gresik and Sulawesi.

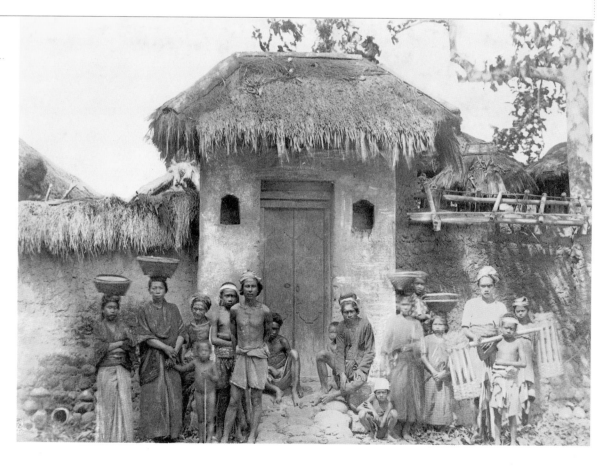

Sasak people of Lombok

1894
Photograph: RMV Collection 11671-10/8

Selaparang was frequently involved in disputes with the kingdom of Gelgel on Bali, especially since the rulers of Gelgel feared that the religious developments on Lombok constituted a danger to their kingdom. In 1520 Gelgel mounted an unsuccessful attempt to reduce Selaparang to submission.

The arrival of the Dutch in the archipelago, hoping to control the northern trade routes, resulted in a bad relationship between the Dutch East India Company (the VOC) and the kingdom of Gowa. The consequence was that Gowa attempted to block the southern sailing routes by occupying Sumbawa and Selaparang. In 1618 Gowa annexed the smaller kingdoms in West Sumbawa, followed by Selaparang in 1640. With this the other small kingdoms acknowledged the power of Gowa. In encouraging marriages between the aristocracy on both sides, Gowa tried to increase its influence on Lombok by peaceful means.

Towards the end of the seventeenth century Pejanggik, in Central Lombok, and Selaparang in East Lombok, were the most prominent kingdoms in the region. According to a note from Macassar, dated 30 November 1648, Mas Pamayan, the son of the ruler of Selaparang, became ruler of Sumbawa, meaning that the kingdom was regarded as forming part of Lombok. Meanwhile the kingdom of Pejanggik, under the rule of Pemban Mas Meraja Sakti, continued to flourish. Selaparang, under its ruler Prabu Rangkesari, who had the hegemony over Lombok, achieved its peak as the propagator of Islam.

The year 1720 witnessed a stream of incoming migrants from Karangasem (Bali), led by the court of the ruler of Karangasem. This wave of immigrants resulted in the creation of small kingdoms on Lombok, including those of Pagesangan, Kediri, Pagutan, Sengkoro, Singasari and Mataram, led by relations and

trusted friends of the ruler of Karangasem. As a result, it was the kingdom of Karangasem on Bali that actually gained the dominance over the Lombok region. The kingdom of Singasari was granted the right to establish a number of small kingdoms on Lombok. Because of this their palaces and other buildings were called Puri Karangasem-Sasak Singasari. In 1744, under the leadership of Singasari, an agreement was reached between the kingdoms of Karangasem on Lombok and other, smaller kingdoms, to construct the Pura Meru (Meru Temple) as a symbol of unity. All those allied to Karangasem and to the Hindu community in general, were henceforth permitted to use this building as their main temple, a situation continuing to the present day.

The little kingdoms attempted to extend their boundaries as rapidly as possible. This resulted in disputes between the ruling princes; in 1837 bloody fighting broke out between Mataram and Singasari. It was Singasari that lost the war, and the ruler and his following committed mass suicide (puputan) at Sweta. A prince and princess survived, and were then taken into custody in Karangasem, Bali. Mataram had virtually won the war, but the ruler lost his life. He was succeeded by the rightful heir to the throne, Anak Agung Gde Ngurah Karangasem and his younger brother Anak Agung Ketut Ngurah Karangasem. In 1839 Mataram succeeded in finally wiping out Singasari.

Towards the middle of the nineteenth century the ruler of Mataram, following upon this fratricidal struggle, built a temple over the devastated ruins of the palace of the Singasari kingdom. This temple complex was constructed in an elegant style. It included a pool first known as taman Kelepung, and later as taman Mayura. The temple complex was completed in 1856 and the

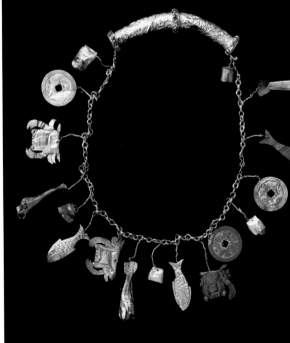

Ring

Lombok
Looted during the military expedition
of 1894
Gold, precious stone, rubies
Diameter 3 cm
RMV 2364-0-15

Chain with amulets

Lombok
Looted during the military expedition
of 1894
Gold, silver, copper
Length 21.5 cm
RMV 2364-145

Hanging from the chain, secured by a small
golden tube, are 14 amulets, with shapes
including those of marine animals, and
three Chinese coins (kepeng)

building, now the power centre of the kingdom, was renamed *puri* (princely palace) Cakranegara.

The kingdom of Mataram-Cakranegara

The ruler of Lombok, Anak Agung Gde Ngurah Karangasem, as the successor to the throne, built this temple and palace complex with stylistic features clearly derived from the styles fo the Singasari, Karangasem and Mataram periods on Lombok. Cakranegara, signifying 'the circular kingdom', became the new power centre of the kingdom of Mataram on Lombok. The building method used in *Puri* Cakranegara is based on the concept of the *Puri Ageng* (Great Palace) of Karangasem on Bali, constructed by I Gusti Anglurah Made Karangasem Sakti.

Anak Agung Gde Ngurah Karangasem reigned from 1872 to 1894, the year in which the Dutch attacked Mataram with their Lombok expedition. This ruler was married to a Sasak woman, Denda Aminah (alias Nawangsasih), daughter of Dea Guru, a man who played a major role in the spread of Islam. Since this union, there had been peace in the kingdom. Denda Aminah adhered strictly to the religious rules, and exercised a great influence over her husband. During this period Muslims were able to practice their religion in tranquillity, with no further need for clandestine worship. Through the good offices of Denda Aminah a well known Islamic teacher was even allowed into the Hindu temple: he was Baok, or Hadji Mohammed Yasin.

By order of the ruler, a large mosque was built in Ampenan, like that in Cakranegara. One of the ruler's grandchildren, Gopul alias Iman Sumantri, converted to Islam, being known thereafter as Datu Pangeran. The ruler also married another Sasak woman, Denda Fatimah, a niece of Denda Nawangsasih, who bore two sons: Anak Agung Made Jelantik Barayangwangsa and Anak Agung Ktut Oka. The marriages with Sasak women had a political objective, that of promoting tolerance between the religions. In this period life was peaceful on Lombok, and there was an increase in trading activities between the islands.

Following the victory gained by Mataram over Singasari in 1839, the kingdom had the wind in its sails. This was also partly owing to the English businessman G.P. King; all trading contacts with other countries, and the regulation of shipping, were handed over to him. The Lombok Strait was very busy with both foreign shipping and ships from the region itself. In return for his trouble, the ruler gave G.P. King the monopoly on everything to do with shipping and trade with foreign lands. Through King's mediation Mataram purchased two British ships, the Sri Mataram and the Sri Cakra. The Dutch were nervous about this development, fearing that Lombok would fall under British influence. On 7 June 1843 they succeeded in concluding a treaty with Mataram, establishing that Mataram acknowledge its submission to the Netherlands, and agreeing that it would not submit to any other party, that the kingdom would send a delegation to Batavia, and that Dutch interests would be protected. In exchange for these concessions, the Dutch promised that they would refrain from interfering with the internal affairs of Mataram.

The treaty was signed on behalf of Mataram by Raja I Gusti Anglurah Ktut Karangasaem, I Gusti Anom, Gusti Gde Rai, Gusti Peguyangan and Gusti Nyoman Tangkeban. For the Netherlands, H.I. Huskus Koopman, Commissioner of the Dutch East Indies, signed the agreement. The Dutch, through their efforts to bind the rulers of Lombok to their side, at

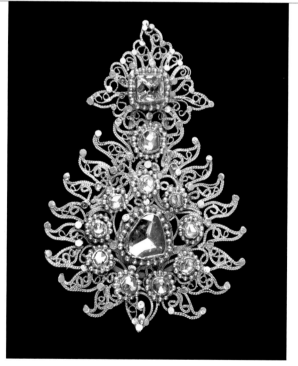

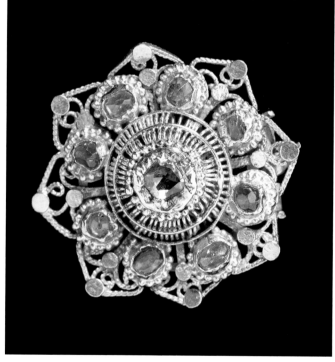

Brooch

Lombok
Looted during the military expedition
of 1894
Gold filigree, diamonds
Length 7.5 cm
RMV 2364-320

The flame motifs on this brooch symbolize a
magical power

Brooch (one of six)

Lombok
Looted during the military expedition
of 1894
Gold, rubies
Diameter 2.3 cm
RMV 2364-345 a-f

first operated carefully, trying to limit the use of violence to a minimum. The aim behind the treaty of Mataram was to keep other western powers out of the region, in order to consolidate Dutch control. For the Dutch, the treaties were simply a formality which they did not honour, while as for Mataram, the kingdom was certainly expected to keep to the contract. This was one of the tactics used by the Dutch to gain the mastery of Lombok, and the influence of the British gradually declined. We can deduce from the events that took place when the Dutch attacked Klungkung and Karangasem on Bali in 1849 (when both rulers died) that Mataram was a faithful ally. The Dutch entrusted the territory of Karangasem to Mataram as token of appreciation for its support from Lombok, and Anak Agung Gde Oka was appointed the replacement ruler of Mataram in Karangasem on Bali.

The aged ruler Anak Agung Gde Ngurah Karangasem refused to hand over power to his two sons, Anak Agung Made and Anak Agung Ktut Karangasem, resulting in the decline of the kingdom of Mataram. On 7 August 1891 war broke out with Praya, a war supported by the population of Sasak villages, hostile to the Mataram regime. On 8 September the ruler gave his son Anak Agung Made Karangasem the order to call Praya to order with the aid of three thousand soldiers. On 25 August he had already sent the Crown Prince Anak Agung Ktut Karangasem there, with eight thousand troops. In mid-September the region heard the news that a great many Sasak people had been killed or taken prisoner in East Timor. The Sasak population was enraged, and it looked as though the ruler's army would be worsted in the fight. Consequently the ruler asked the help of the ruler of Karangasem in Bali, Anak

Agung Gde Jelantik, who sent him 1,200 elite troops. Because of the never-ceasing threats and attacks, the Sasak leaders decided to place the kingdom of Selaparang under the authority of the Dutch government.

Dannenbargh, Resident at Buleleng on Bali, left for Lombok for an audience with the ruler of Lombok, and a meeting with Sasak notables. From that moment on it was clear that the Dutch were preparing to interfere in the internal affairs of Lombok. Several Sasak spies were sent out, to report back to the Dutch about the development of the popular uprising. Mataram built up an army with the aim of attacking the Sasak community. After a three-year war (1891 – 1894) the rebellious villages were occupied. Mataram disposed of the most modern weapons, and of two ships purchased in Singapore, and auxiliary troops from Karangasem (Bali) were available to give their assistance. The Mataram army was deployed on both eastern and southern fronts, forcing the Sasak to defend their territory on two sides, and the resulting neglect of agricultural work on the land produced a famine. The Dutch sent several Buginese to sound out the feelings of the Sasak population, as well as those of their leaders. On 20 February 1894 the Sasak sought the help of the Dutch East Indies government, following which a delegation led by Liefrinck arrived with food supplies on 3 March in the roadsteads of Tanjung Luar, intending to resist Mataram, whether peacefully or violently, in consultation with the Sasak leaders. Liefrinck and the Sasak leaders travelled to Ampenan, and for a brief while the war between Mataram and the Sasak ceased.

150

Ear plug

Lombok
Looted during the military expedition of 1894
Gold, precious stones
Length 4.9 cm
MNI E 1086b (7955b)

This leaf-shaped ear plug, set with rubies and diamonds, is fastened at the back by a gold flower with a ruby at its centre

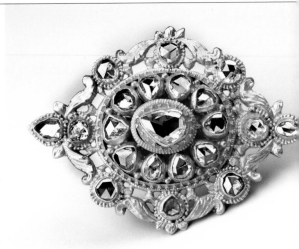

Ring

Lombok
Looted during the military expedition of 1894
Gold, precious stone
Diameter 2.5 cm
MNI E 1046 (8045)

This richly decorated ring is called 'Sritaman'

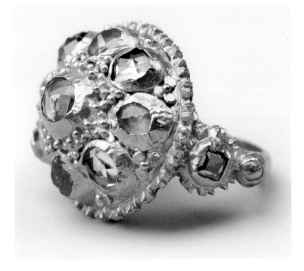

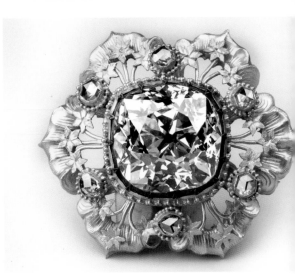

The military expedition to Lombok

Because Lombok, with its rich fertility, had been exporting rice to Australia, Manila and China since the eighteenth century, it had attracted the attention of the Dutch. However, in view of the fact that the ruler of Mataram maintained close contacts with the British, to begin with the Dutch operated with some caution. Originally the colonial government had considered the war between Mataram and the Sasak to be of minor importance. The Dutch realized that Mataram could never win it, because almost all the Sasak had converted to Islam, and Muslims permit themselves neither to be dominated easily, nor to be forced to change to another religion. At that time the Dutch were unaware that the princes of Balinese descent on Lombok, for instance the rulers of Mataram, Singasari, Pagutan and Pagesangan, had in the past pursued a policy directed against the Sasak community, with a great deal of violence and cruelty. For this reason first one then other Sasak village communities decided to take up arms to resist these rulers, many prominent Sasak men thereby finding their deaths or imprisonment as a result. The Mataram kingdom was torn apart through all the mutual quarrels and enmities, thereby playing into Dutch hands. With their resolute behaviour, the Dutch succeeded in concluding a treaty in 1843 with the ruler of Mataram, after which the British influence declined to a marked degree.

From that time on, the Dutch interfered openly in the disputes between the Sasak and Mataram. They attempted to calm both warring parties. In 1891 Governor General M.C. Pijnacker Hordijk was asked by the Sasak leaders to intervene, but he was bound by the 1843 treaty with Mataram, and could do nothing. The Dutch ignored violations of the agreement by Mataram, for instance the aid given by Karangasem in the assault on Klungkung, the importation of weapons, the refusal by the ruler of Mataram to receive delegations from the Dutch East Indies government, an attempt to attract the British back.

In 1893 the Dutch, with Hordijk as intermediary, tried to promote a peace treaty between the Sasak and Mataram. The ruler of Mataram refused the proposal, causing a good deal of wrath in the Council of the Dutch East Indies. The Governor General gave Liefrinck and the Sasak leadership the task of reporting back on the situation in Lombok. These reports revealed that the people of Lombok were suffering hunger, that Sasak enmity towards Mataram was diminishing but that the Sasak community would never surrender to Mataram, and that Mataram was planning to murder all the Sasak leaders.

On the basis of this report the Governor General decided that an intervention could no longer be delayed. On 22 May 1894 he wrote a letter to the Minister for the Colonies, Bergsma, that the government of the Dutch East Indies would take steps to improve the condition of the population of Lombok. Governor General Van der Wijck, who followed Hordijk, ordered the Resident of Bali and Lombok to inform the ruler of Mataram that he must apologize to the government of the Dutch East Indies, that he must swear an oath of fidelity to the Governor General, that he must abdicate as ruler, and that he must permit the Resident to intervene in the internal affairs of Lombok.

The ruler rejected these demands, consequently Resident Dannenbargh and *Controleur* Liefrinck landed at Ampenan on 3 June 1894, for a meeting with the ruler. However, the ruler was then in East Lombok, and was unable to attend the meeting

Brooch

Lombok
Looted during the military expedition
of 1894
Gold filigree, diamonds
Length 6.2 cm
INI 4905-119 (LB 296)

Brooch

Lombok
Looted during the military expedition
of 1894
Gold filigree, precious stones
Diameter 4 cm
INI 4905-133 (LB 315)

Lombok expedition 1894

In the front row, left to right; Anak Agung Ketut Karangasem, Major General P.P.H. van Ham, Major General J.A. Vetter, Resident M.C. Dannenbargh and Gusti Djelantik
Photograph: RMV Collection 11671-30

because he was ill. He sent his two sons. At eight o'clock in the morning on 9 June 1894 the two sons and the Resident met in the *puri* Cakranegara. During the interview Resident Dannenbargh outlined the four Dutch conditions to the sons, Anak Agung Made Karangasem and Anak Agung Ktut Ngurah Karangasem, who were obliged to give their answers within three days. Should no answer arrive, the Dutch would consider themselves obliged to resort to force.

Governor General Van der Wijck then decided to send a military expedition to Lombok. Major General J.A. Vetter was appointed commander, Major General P.P.H. van Ham was made his representative, and Resident Dannenbargh was to be the political adviser. On 30 June 1894 the military force left Batavia in three ships: the Prins Hendrik, the Koningin Emma, and the Tromp, with 107 officers, 1,320 European soldiers, 948 indigenous troops, 386 horses, 216 servants, 64 (indigenous) supervisors, and 1,718 convicts, and several government officials on board. They arrived at Ampenan on 5 July 1894. The ultimatum was extended, and the ruler was given until daybreak on 6 July 1894 to respond. Extra conditions were added to the ultimatum, i.e. that the ruler must hand over power to his son, that the costs of the expedition to Lombok must be reimbursed with gold and silver, and that the treaty of 1843 must be adapted to the wishes of the Governor General.

The ruler of Mataram accepted these demands unconditionally, except for that concerning the transfer of the throne to his son Anak Agung Made Karangasem, whom the ruler executed with his own hands for committing incest with his niece, Anak Agung Ayu Made Rai the daughter of his brother, something regarded as scandalous. Both young people were killed, and their bodies thrown into the sea. At the same time the Crown Prince Anak Agung Ktut Karangasem was in East Lombok, to suppress a rebellion. The Dutch grasped this chance to send their army to Mataram and Cakranegara, and to occupy strategic positions in the temples. This action provoked anxiety among both Sasak and Cakranegara communities.

On 12 July 1894 the Crown Prince was requested by letter to return to Mataram. *Controleur* Liefrinck was sent out to bring him back, together with the rebellious Sasak of East Lombok, to Cakranegara. During this meeting Vetter, in order to emphasise the power of the Dutch East Indies government, mentioned the fact that the Dutch would appoint Crown Prince Anak Agung Ktut Karangasem as ruler, and that all the Sasak leaders must obey the new prince. However, the ruler and his son saw through this Dutch political ruse to swindle them out of power over their kingdom. To defend the kingdom and their own dignity, the ruler and Crown Prince agreed together to find a way out of every Dutch proposal.

In the early hours of 26 August, violence broke out. A princess, the offspring of the marriage with Denda Nawangsash, ran *amok* with her attendants, killing every Dutchman they encountered. During this attack General Van Ham also died. In Dutch books this is regarded as 'the Treachery of Lombok' (Vanvugt 1995: 30).

Vetter recounted the failure of the first military expedition to Governor General Van der Wijck in Batavia. They agreed to take a harsh line on this question; more arms and cannons would be sent, and the army force would be increased. After the arrival of these additional troops and weapons from Batavia, Vetter and Dannenbargh decided to attack Mataram first of all, then to travel to Cakranegara via Pegesangan. In the meanwhile the ruler

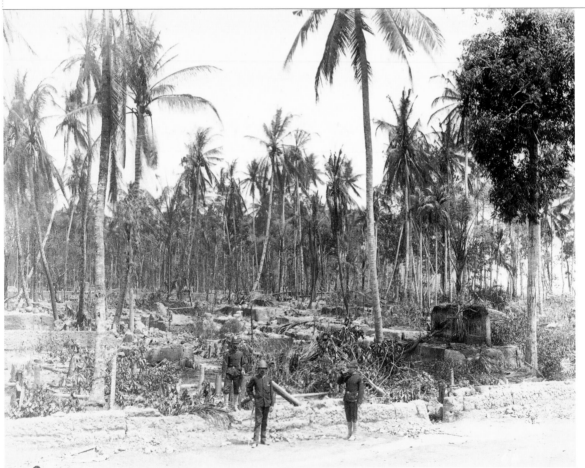

Destruction of Pagesangan East

'In the same way, the whole of Mataram and the western half of Cakranegara was laid waste.'
Photograph: collection RMV Collection 11671-10/26

of Lombok had vacated his fort, and had transferred the Balinese troops to Cakranegara and Mataram. The Sasak of East Lombok grasped this opportunity to attack the Balinese houses, burning them to the ground. This was connected with the fact that on 9 September 1894, the Dutch had attempted to surround West Lombok from both the north and the south. On 29 September General Vetter gave the order to begin the attack on Mataram, encountering fierce resistance from its population. On 30 September the attack finished, and the Dutch occupied the *puri* of Mataram.

From 11 October on, the Dutch mounted unrelenting, ferocious attacks on Cakranegara, the fighting being heavier than that experienced in the attack on Mataram. In a report, General Vetter wrote to the Governor General in Batavia that, in the space of a month, from 19 October to 19 November, thousands of bullets had been used in the attempt to break the resistance of this last Lombok kingdom. To give the expedition a breathing space, the Governor General decided to dispatch new troops from Batavia and Semarang. He sent 8,200 heavily armed soldiers, in the hope that General Vetter would then be in a position to occupy the *puri* of Cakranegara.

Resident Dannenbargh sent a delegation to the ruler, with a peace proposal. However, the ruler made a determined reference to the 1843 treaty, which included the clause that the ruler of Lombok would acknowledge Dutch dominion over the Dutch East Indies, provided that the Dutch East Indies government refrained from meddling in the internal affairs of Lombok. The prince therefore demanded that the Dutch should leave Lombok immediately. This demand was rejected totally by the Dutch, and General Vetter immediately prepared his troops for the attack on Cakranegara.

Pinang (areca or betel nut) cutter, Kacip

Lombok
Looted during the military expedition of 1894
Gold, iron
Length 19 cm
MNI 4905-57 (Lb 65c)

This pinang cutter has the shape of Togog or Sangut, a servant (penasar) to princes in the wayang theatre. He carries a kris. The cutter form part of a sirih set, and is used to cut the pinang nuts into fine slices

On 18 November 1894 over five thousand soldiers, divided in four units, were sent in to the attack, and the fort of Mataram was rapidly overcome. Towards late evening, other units penetrated the area round the *puri* Cakranegara. At this stage the Dutch encountered heavy resistance, and many soldiers were killed, leading to the decision to retreat. The next day, 19 November, the Dutch found the *puri* deserted. Scattered about, the treasures of the *puri* were plundered by both Dutch soldiers and Sasak people. These same Sasak were later to be executed by the Dutch. On this occasion the Dutch looted 230 kilos of gold and 7,000 kilos of silver, which was sent to Batavia. On 20 November a Dutch ship left for Batavia, with gold objects such as *krisses*, eleven *sirih* sets, and hundreds of other valuable items. During this expedition the manuscript written on palm leaves, *Negarakertagama*, relating the history of the Kingdom of Majapahit, was 'secured' by the Dutch scholar Brandes.

After the Dutch troops had withdrawn, the ruler decided on 19 November to leave his palace and move to Saksari, where all the Balinese, the entire court, the aristocrats, and the Brahmins, had assembled. On that day the ultimatum to the ruler expired, and General Vetter gave the order to attack Saksari. During heavy fighting, in which the Crown Prince was killed, the ruler received a written communication from Resident Dannenbargh promising that the prince could go to Batavia to explain his side of the affair to the Governor General. For this reason the ruler, together with his sons Anak Agung Made Jelantik and Anak Agung Ketut Oka, were invited to Ampenan for a discussion with Resident Dannenbargh and *Controleur* Liefrinck, aboard the ship Prins Hendrik. They would be able to talk over all the points that the prince wanted to lay before the Governor General. Without

his realizing it, however, the ship was slowly approaching Batavia on 23 November 1894. In this way the ruler of Lombok was carried off, to be imprisoned in a house in the suburb of Tanah Aband in Batavia. It was only in 1943 that his body was cremated on Lombok. Because the ruler died in Batavia, he is known under the name of *Dewata di Betawi*.

After Colonel Swart and General Segov had directed the mopping-up operations the Lombok Expedition, which had overthrown the *puri* Cakranegara on 1 December 1895, was brought to an end. The subjugation of the kingdom of Mataram by the colonial government had exacted a great many victims on both sides, Mataram counting ten thousand dead and wounded, while the Dutch lost 175 men, with 503 wounded. When the war had finished all the defence bulwarks were broken up, and part of the army force led by Commandant Swart was sent back. On Lombok the construction of a new governmental apparatus was begun, under the guidance of the commanding officer Vetter, assisted by the Director of Internal Affairs G.A. Scheren, and in consultation with the Sasak leaders. Lombok was placed under the immediate direction of the Dutch East Indies government, becoming a department of the Residency of Bali and Lombok, with Ampenan as its capital.

The collection of the kingdom of Mataram-Cakranegara

After Dutch troops defeated Cakranegara, thay took the treasures of the palace of Cakranegara as war booty. The treasures were not just dragged from the palace: even the bodies of those killed in the attack were stripped of their valuables. The objects stolen by the Dutch, including 230 kilos of gold, 7,000 kilos of silver, and

jewellery and precious stones, were all sent to Batavia. The first person to examine this Lombok treasure was Van der Chijs, the chairman of the Batavian Society. He was the first to make his selection from among the extremely valuable objects, to give them into the safekeeping of the Society, and its was this man who suggested sending a certain proportion of the objects to museums in the Netherlands.

The notes recorded by the Batavian Society on 1 October 1895 contain a list of the objects included in the treasure taken from the kingdom of Cakranegara. The lists mentions 34 rings, 9 spear heads, 4 gold tobacco boxes, 2 gold opium pipes, and head-dresses. At first these items were not sent to the Netherlands, but were transferred to the society that was later to become the National Museum of Indonesia. A year after the expedition had ended, several chests filled with gold, silver and precious stones arrived on 8 November 1895 at the Nederlandsche Bank in Amsterdam (Vanvugt 1995: 61). In 1896 the Dutch government official Victor de Stuers, head of the art and sciences department of the Ministery of Inland Affairs, encountered a problem when he had to list and make inventories of the Lombok treasure kept in the Nederlandsche Bank. There was such an immense quantity of objects! The list also included less fine items such as simple objects that had not been decorated with any particular aim in mind, which could be sold. Further, he was given permission to sell duplicate identical objects, and some of the objects out of the pairs. The money these fetched was deposited in a fund to defray the cost of the Lombok war. This fund also provided financial aid for the widows of the men killed in the war.

At the end of 1896 the Dutch government requested that the Lombok treasure deposited for safekeeping with the Batavian Society should be sent to the Netherlands. At first no notice was taken of this request, but since it was an order from the Minister for the Colonies, the collection kept in Batavia was in fact shipped to the Netherlands. In 1897 – 1898 the Lombok treasure, together with all the other riches from Lombok that were already in the Netherlands, were exhibited in the Rijksmuseum (National Museum) in Amsterdam. This exhibition was exceptionally well attended. It attracted 23,000 visitors, including the Queen of the Netherlands. Consequently plans for selling off part of the collection had to be abandoned. This decision was owing to the intensive efforts of Victor de Stuers, with the Director of what later became the National Museum of Ethnology in Leiden, J.D.E. Schmeltz, and the Director of the National Museum in Amsterdam, B.W.F. van Riemsdijk, none of whom agreed with the idea of selling any of the Lombok treasure.

In July 1898, after lengthy consultation with the Minister for the Colonies, the Batavian Society was given back a large part of the Lombok treasure. The Minister had planned to have the precious stones removed from the objects in the treasure, in order to sell them. Naturally, the Batavian Society was not in favour of this measure, as can be seen from the notes recorded on 2 February 1897. In the Netherlands the Lombok collection was kept in the National Museum in Amsterdam, from where part of the collection was transferred in 1937 to the National Museum of Ethnology in Leiden (RMV series 2364). In 1977 the rest of the collection was also transferred to Leiden (RMV series 4905), so that its projected return to Indonesia could be properly organized.

In the same year an agreement was reached between the Indonesian and Dutch governments to return part of the Lombok treasure still remaining in the Netherlands to the National

◄
Head-dress
..

Lombok
Looted during the military expedition
of 1894
Gold, diamonds, rubies, velvet
Length 91.5 cm
MNI E 1101 (8013)
..

Floral and leaf motifs in gold filigree are
fastened to a background of red velvet

►
Ring
..

Lombok
Looted during the military expedition
of 1894
Gold, black crystal
Length 2.2 cm
MNI 4905-103 (Lb 262)

Museum in Jakarta. On 1 July 1977 the return of 243 gold and silver objects was agreed upon, deriving from both series of the Lombok treasure. The Dutch government was represented by Prof. P.H. Pott, Director of the National Museum of Ethnology in Leiden, who acted on behalf of the Minister for Culture, Recreation and Social Work. Amir Sutaarga, Director of the National Museum, represented the Indonesian Minister for Education and Culture. The objects given back to Indonesia included jewellery and ornamental objects such as diamond rings, hip cloths, ankle rings, bracelets, brooches, tobacco pipes, *sirih* articles (including little boxes for holding tobacco, tongs for betel nut, and *sirih* holders), all in gold or silver. All these objects would fit in with the collection held by the National Museum in Jakarta, and some of them were exhibited in the ethnographic Treasure Hall, to show the wealth of the Lombok Cakranegara kingdom. It also permitted the Indonesian public to see that the manufacture of objects in precious metals (gold and silver) was at a peak in this kingdom in the eighteenth century. Meanwhile 220 objects from the collection remain in the possession of the National Museum of Ethnology in Leiden, where they are on display.

The descendants of the prince of Lombok, Anak Agung Gde Ngurah Karangasem

The actual palace of Cakranegara no longer exists. Today there is a shopping centre in the place where it once stood. Buildings still in existence in the area are the Pura Mayura and the Pura Meru. The descendants of the princely rulers of Mataram live behind the Pura Mayura, in the palace of Pamotan, encircled by lotus pools in the centre of a beautiful area with large gardens containing *mangosteen* and *rambutan* trees.

As we have seen above, Anak Agung Gde Ngurah Karangasem, ruler of Mataram, was sent to Batavia, where he died in 1895. He had six sons and four daughters. One of his sons, Anak Agung Made Djelantik Barayangwangsa, was born in 1875 in the palace of Cakranegara, and died in 1957 at the age of eighty-three. During his father's reign he was the *Panglima Perang*, the army commander; he was taken prisoner, ending in prison in Batavia. He went through the war untouched, a fact that only increased his self-confidence and courage. He was approximately nineteen to twenty years old during the struggle against the Dutch, and he witnessed the destruction of the palaces of Mataram and Cakranegara.

After his father's death, the Dutch exiled Anak Agung Made Djelantik Barayangwangsa to Sulawesi, Bogor and Palembang, among other places. During the Japanese occupation he returned once more to Cakranegara in 1943, where he lived in the Pamotan palace behind the Mayura gardens of Cakranegara. In his seventy-ninth year he married Mekele Prabalanga of the Lombokse Karangsiluman Lombok, who gave him two daughters and a son, Anak Agung Biarsah Huruju Amlanegantun, who married a relation, Anak Agung Istri Sudewi. Today these two live close to the lovely palace with its lotus pools, and large gardens full of fruit trees, together with their daughter Anak Agung Ayu Agung Subiantari Dewi and two sons, Anak Agung Made Djelantik Agung Barayangwangsa and Anak Agung Ketut Agung Oka Kartawirya, a trainee engineer.

Anak Agung Biarsah was an official in local government, but these days he is occupied almost entirely with social and religious

Tobacco box

Lombok
Looted during the military expedition of 1894
Gold, silver
Length 8.5 cm
MNI E 1032 (7968)

The motifs engraved on the lid of this tobacco box represent a scene in which a priest talks with his disciple, illuminated by the sun shaped like a flower

affairs. He still enjoys a high status among the people living in the area round the palace, particularly among the somewhat older people who still know what happened in the past. When he was asked about the 1894 Lombok expedition, and about his views on the events, he related his memories enthusiastically. He could still remember a story his father told him about that expedition, when he was a small child. It concerned his grandfather's magnificence when he was a young prince, and his own father, who had commanded the army. His father, Anak Agung Made Djelantik Barayangwangsa, died when the story teller was only six years old. Consequently he had heard the many tales about his grandfather and father from the people living in the neighbourhood of the palace, among whom many people had also died.

He asked himself why the Dutch had initiated the attack on the kingdom of Mataram, which had been a very peace-loving little state, with a population among whom many different ethnic groups and religions lived together in harmony. The kingdom of Mataram had never done anything to offend the Dutch, and where trade was concerned, an agreement could always be reached, and thus no war had ever been necessary. In his view the Dutch had behaved in a very underhand fashion during the peace discussions with the kingdom of Mataram. These discussions were held on board a ship lying in the harbour of Ampenan, and the ruler was unaware that the ship was secretly sailing to Batavia, where he would be taken prisoner, and placed under house arrest in Tanah Abang, where he died in 1895.

When questioned about whether he knew of any special family heirlooms, or other objects from the palace of Cakranegara, Anak Agung Biarsah replied that he knew nothing about these. At that particular moment, the only thing he himself owned was a gold ring with two rubies, and a head-dress that, according to what he had been told, had been worn by the ruler when meditating.

He was shown photographs of the collection from the palace of Cakranegara, upon which he became silent; he was amazed and moved, happy, proud and even a little saddened. He was also told about the size of the collection, and where it was kept. Clearly, he had never known that such jewels were the most notable remains of the heirlooms of the Cakranegara kingdom. After viewing the photographs, it was obvious that he did not want the objects shown in them. He would never have felt secure if he had been obliged to guard such extraordinary things himself, in a situation where he could not have kept them safe, and he therefore gave them to the government, to be kept in the National Museum. In that way the precious objects would become the country's property, allowing the people of Indonesia to see how great and rich the kingdom of Cakranegara had been in times past. He wanted to borrow the manuscripts taken from the palace, to be returned after he had used them; he wanted to translate them into Indonesian so that his grandchildren would have knowledge of them later on. As grandson of the ruler of Mataram, he also wanted his grandfather to be given the status of national hero, because of the determination with which he had resisted the Dutch during the first and second Lombok expeditions in 1894, until he was taken prisoner and exiled to Batavia.

One day Anak Agung Biarsah Huruju Amlanegantun was traced by a descendant of Major General Van Ham, who wanted to have his grandfather's grave restored; the grandfather had died on Lombok and was buried there. P.P.H. van Ham was acting commander of the army during the Lombok war. At

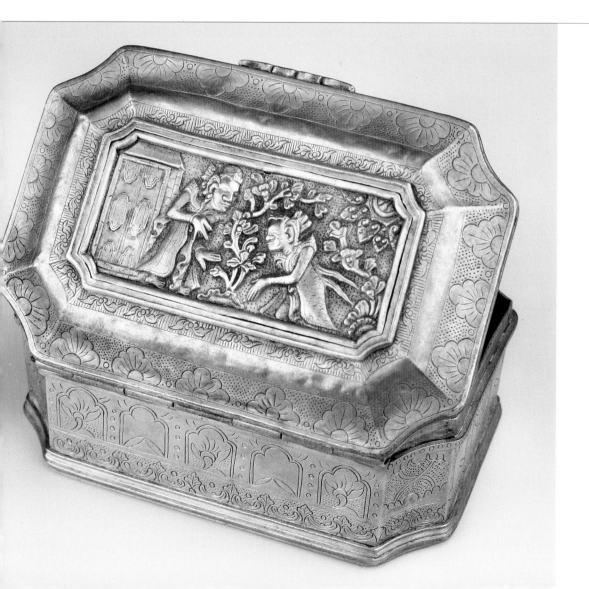

present the local government administration is negotiating this matter with Van Ham's descendants. Partly through this channel, the request by the descendants of the ruler of Cakranegara that he should be made a National Hero, reached government levels.

Remains of the kingdom of Mataram-Cakranegara

The remains of the earlier kingdom of Mataram- Cakranegara on Lombok, that can still be visited, include the following:

- The *Taman Mayura* earlier known as the Kelepung Gardens. Before these gardens were tidied up, there was a house surrounded by pools, which the ruler had ordered to be built as a prison for the ruler of Singasari. When the gardens were enclosed in 1896, and the palace of Cakranegara was completed, the ruler of Mataram used the gardens to store the palace treasure derived from taxation. It was not only a place for the storage of the kingdom's *lontar*-leaf manuscripts and heirlooms; it was also a place in which to rest.
- The *Taman Narmada* which has a spring, a sacred bathing place of the gods. This place is named after the Narmada River in India, regarded as holy. In this complex, close to the spring, there is a temple with the *kiblat* (direction for prayer) towards the mountain Rinjani and its Segera Anakan. The temple is called the Kelasa, after the mountain of the same name in India.
- The history of the temple *Pura Lingsar* is longer than that of the Taman Mayura or the Narmada. It was built in c. 1847 by I Gusti Anglurah Made Karangasem, and restored in 1860 in its present form by I Gusti Anglurah Ketut Karangasem,

the Mataramese ruler. Next to this Pura Lingsar stands the Kemali shrine, where the Islamic group Waktu Telu worships. During *Pujawali*, celebrated every year in the sixth month of the Posiamasa period (i.e. in October or November), the *perang ketupat* (literally, the war with the little baskets woven from palm leaves, containing steamed rice) is fought between Hindus and the Muslim Waktu Telu people. This bears witness to a common bond, and it is believed that this *perang ketupat* makes the sawas fertile.
- The *Pura Suranadi* is closely linked with the golden Balinese era under the ruler Dalem Watu Renggong in Gelgel. The power of the Gelgel kingdom extended to Lombok in that period, which leads to the strong suspicion that many Hindus lived on Lombok in c. 1500. This gave Hinduism the form it has retained on the island up to the present day. Under the regime of the ruler of Mataram, the temple was restored and extended.
- The *Pura Batubolong* is a sacred place used by the Lombok ruler I Gusti Ktut Karangasem for his meditation. This temple was constructed in c. 1746 by a younger brother of the ruler, I Gusti Made Jelantik.
- The *Pura Gubung Sari* was also built by I Gusti Made Jelantik. During the perang suadara (fratricidal war) between Mataram and Singasari in 1838, this place functioned as the logistical centre for the Mataram kingdom. I Gusti Ketut Karangasem also often used this temple for his meditation. When the Dutch began their military expedition in September 1894, it is said that the Crown Prince of Lombok, Anak Agung Ktut Karangasem, visited this temple in the evening.

Gateway by the pool in the puri of Cakranegara

1894
Photograph: RMV Collection 11671-10

The descendants of AA Gde Ngurah Karangasem

The son of Anak Agung Made Djelantik Barayangwangsa, with his family, who live today in Puri Pamotan, Cakranegara. From left to right: AA Biarsah Huruju Amla Negantun SH (the grandson of AA Gde Ngurah Karangasem, the ruler of Mataram), AA AAgung Subiantari Dewi (first child), AA Kt. Agung Oka Kartha Wirya (third child), AA Made Jelantik Agung Barayang Wangsa (second child), AA Istri Sudewi Djelantik

The Sulawesi collections, in the National Museum in Jakarta (MNI) and the National Museum of Ethnology in Leiden (Rijksmuseum voor Volkenkunde, RMV), were for the most part assembled in the colonial period, that is to say, in the second half of the nineteenth century and beginning of the twentieth century. The ethnographic objects to be discussed in this contribution, can be divided into three groups according to their origins:

 I Objects collected by missionaries and translators of the Bible, especially B.F. Matthes, working in South Sulawesi, and A.C. Kruyt and N. Adriani, who worked in the interior of Central Sulawesi.
 II Objects obtained by the military expedition to South Sulawesi in 1905 – 1906.
III Objects that functioned as royal gifts, originating from the royal houses of Bone and Gowa

The research into these important collections has been carried out partly by reconstructing the social life of this period, to enable us to know the societies in question in their historical and cultural aspects.

Sulawesi

Sulawesi, known as Celebes during the colonial period, is one of the five largest islands in Indonesia, and the eleventh largest in the world. The Sulawesi region, encircled by islands, covers 190,000 square metres. The shape of the island has been compared to an orchid, a starfish, or a scorpion. It is surrounded by deep ocean basins and troughs. It consists of four centrally connected peninsulars separated by four enormous bays. Sulawesi has various lakes: the Towuti Lake (the largest) in the southeast; the Tempe and Sideng Lake in the south; the Poso Lake in Central Sulawesi, and the Limboto and Tondano Lake in North Sulawesi.

Virtually the whole island is mountainous, and there are eleven active volcanoes in the vicinity of Minahasa. Deep valleys and clefts, with rivers rushing through them, accentuate the landscape, while vast plains add to the difficulties of reaching certain parts of Sulawesi. Generally speaking the land is infertile owing to the high content of magnesium and other heavy metals. Raw materials exported from this region included copper, nickel, iron, gold, silver, coal, and mica, with copra, coffee and hard woods. The main trade items are coconut, sago, *bamboo* and various kinds of palms, maize, cotton and resin.

Culturally speaking, the island is inhabited by ethnic groups showing considerable mutual variation: the Sangir Talaud, the Minahasa, the Bolaang-Mongondow, the Gorontalo, the Tomini (Toli-Toli), the Toraja, the Loinang, the Bungku-Laki, the Macassarese and Buginese, the Muna-Butung, the Toala and the Bajau sea nomads. Every ethnic group has its own language belonging to the Malay-Polynesian language group. In the colonial period the inhabitants of Central Sulawesi were given the name of Toraja, with an occasional distinction being made between the West Toraja and the East Toraja. These days the name Toraja is used only for the ethnic group Sa'dan in South Sulawesi. The other ethnic communities use local names. The administration of Sulawesi is now divided into six provinces: Gorontalo, North Sulawesi, Central Sulawesi, Southeast Sulawesi, South Sulawesi, and a new province, created in 2004, named West Sulawesi.

Hari Budiarti

The Sulawesi collections
Missionaries, rulers, and military expeditions

Sulawesi has a long cultural history, going back to prehistoric times. In later ages major influences derived from Islam, and later still from European culture during the colonial period. In contrast, the region has been little influenced by Hinduism and Buddhism; the remains of a statue of the Buddha have only been found at one location.

The origins of the Sulawesi collections in Jakarta and Leiden

The ethnographic collections of the National Museum in Jakarta and the National Ethnology Museum in Leiden have a variety of sources. Primary among these are the collections made by missionaries and Bible translators in the Dutch East Indies period. Objects were also collected during military expeditions in colonial times. Other items were originally gifts exchanged between members of Indonesian royalty and members of the Dutch Indies government. See the article by Nico de Jonge for more details on the fourth source: colonial government officials.

Even before the mid-nineteenth century, Dutch missionaries had begun the labour of spreading the Christian faith on *Ambon* in the Moluccas, and in the Minahasa in North Sulawesi. Thereafter, other regions in the Moluccas, North Sumatra (Batak) and East Java became their area of operations. Their activities were performed under the aegis of the Nederlandsch Zendeling Genootschap (Dutch Missionary Society), an organisation established in 1797 in Rotterdam, to spread the Christian gospel. Besides their religious work, the missionaries also took an interest in collecting objects in the areas in which they worked. Their motives for doing this were various, and not always completely clear. In general, one might reasonably assume they

were interested in the cultures of the peoples among whom they were working. Many objects collected by missionaries were sent to museums.

Towards the end of the nineteenth century, and at the beginning of the twentieth, the Dutch East Indies government had brought most of Indonesia under Dutch rule. In this period the government dispatched various military expeditions to establish colonial power outside Java and Madura: they were sent to Aceh (1874 – 1914), Lombok (1894), Bali (1906 – 1908) and South Sulawesi (1905 – 1906). In conquering these small kingdoms, the Dutch gathered valuable objects, which later found their way into museum collections. The relationships between the kingdoms in the archipelago and the Dutch colonial government were not always characterised by wars and disputes. Cooperative links were frequently developed between both parties. These links were expressed in the exchange of gifts, which would later become part of museum collections.

In the following section, we will examine how significant portions of the Sulawesi collections were actually created. We will first discuss objects originating from the military expedition to South Sulawesi in 1905 – 1906, and then objects presented by the royal houses of Bone and Gowa.,

Missionaries and translators of the Bible

B.F. Matthes: specialist in the Macassar and Buginese language

Benjamin Frederik Matthes (1818 – 1908) was connected as linguist with the Nederlandsch Bijbelgenootschap (Dutch Bible Society), an organization established in 1814 in Amsterdam. He was born in Amsterdam, the son of a Lutheran minister. The young

Container with lid, Baku
..
Ujung Pandang (Macassar), Sulawesi
Collected by B.F. Matthes; to Leiden in 1864
Lontar leaf
Diameter 30 cm
Ceremonial dish for food
RMV 37-93

Benjamin studied literature and religion at Leiden University, then at the Lutheran Seminary in Amsterdam from 1838 to 1841. After a short period of service in Rotterdam, he continued his higher education at Heidelberg, in Germany. In 1844 he returned to Rotterdam as assistant director of the Kweekschool voor Zendelingen (Missionary Training School). It was here, three years later, that he was offered the opportunity to work in South Sulawesi as a 'representative'. His mission was to learn the Macassar and Buginese languages and, when his knowledge was sufficiently extensive, to 'forthwith embark upon the translation into Buginese of the Holy Scriptures.'

After a voyage lasting 112 days, Matthes, together with his wife, arrived on 28 October 1848 in Batavia, where he made immediate contact with the Batavian Society. Two months later the couple reached South Sulawesi, where Matthes was able to begin his task. His first investigation was carried out in Bulukumba and Bonthain, where he was addressed as the *Tuan Pendeta* (the Minister Sir) or the *Tuan Panrita* (the Spiritual Sir). As a linguist it was his task to assemble a grammar, followed by a dictionary, on the basis of which he could begin his translation of the Bible. However, for a reliable translation he first needed some knowledge of each population group's cultural background.

With this aim in mind Matthes engaged in further research in South Sulawesi. In 1852 he visited a region north of Macassar, where he collected ancient manuscripts written on *lontar* leaves (from the *lontar* palm), transcribing all these texts.

In 1854, a Macassar grammar and a Macassar-Dutch dictionary were completed. The manuscripts for these were sent, together with an anthology of manuscripts, to the Netherlands. That same year, the Matthes family moved to Maros, north of Macassar, and

it was here that Matthes wife died in 1855. This was an enormous blow for Matthes, and the linguist requested early leave. He wanted to take his children to the Netherlands, and he would also be able to oversee the printing of his Macassar-language publications.

Prior to his departure in 1858, Matthes had an inspired idea: in order to make his dictionary, which was full of indigenous concepts, more accessible to Westerners, he built a collection of indigenously crafted objects and arranged the manufacture of models of local houses, boats and tools. This he did in order to have illustrations made in the Netherlands of these objects for inclusion at the end of the dictionary. The result was an 'Ethnographic Atlas provided for clarification' (1859). The objects that accompanied him soon found their way to the Royal Academy in Delft. The Academy was a technological institute to which a faculty for the training of East Indies government officials was added in 1842.

In 1861 Matthes returned to South Sulawesi. Among the places he visited was the Bone kingdom, where he studied the Buginese language. He brought with him his newly printed books as gifts for the indigenous elite. The publications were received with enthusiasm, and in exchange he obtained a wealth of linguistic information. Matthes became friends with Arung Pancana, a Buginese woman of noble descent from Bone, who helped him collect and interpret *lontars*, and to establish contacts within the Buginese population. She also put him into contact with a number of *bissu* (transvestite priests) who assisted Matthes in the translation of ancient manuscripts. The *bissu* possessed extensive knowledge regarding customary law and played an important role in ceremonies, such as the inauguration of a monarch. At the end

▶

B.F. Matthes

...

After repatriation in 1879

▶▶

War cuirass

...

South Sulawesi
Collected by B.F. Matthes; to Leiden in 188)
Copper
Height 65 cm
RMV 522-1

of the 1860s, the manuscripts were completed of a three-volume anthology, a number of ethnological articles, and a Buginese-Dutch dictionary.

From 1870, Matthes stayed in the Netherlands for some years. During this period of leave, he realised all his planned publications. The new dictionary also appeared with an 'Ethnographic Atlas', which included an illustration of a model of a house that had been specially brought from South Sulawesi. After it had been drawn, the model, together with an interesting *bissu* collection, found its way to the National Ethnology Museum in Leiden (series 131).

Those objects brought to the Netherlands by Matthes that had originally been housed in Delft, had by then also been moved to Leiden. From 1864, the training of East Indies officials took place in Leiden, and for this reason the educational ethnographic collection was also transferred there.

After an extremely active life, Matthes died in 1908 at the age of 90. He completed his life's work – the translation of the Bible into Macassar and Buginese – a few years earlier. By means of his publications and ethnological collections, Matthes was the first person to communicate an impression of the lives of the indigenous inhabitants of South Sulawesi. Anyone hoping to give a description of the Macassar and Buginese culture cannot ignore Matthes' contributions. He also left behind an extensive library, housed now in the Yayasan Kebudayaan Sulawesi Selatan (Cultural Foundation of South Sulawesi) originating in the Matthes Foundation.

A.C. Kruyt and N. Adriani, missionary and linguist

Albertus Christian Kruyt (1869 – 1949) and Nicholas Adriani (1865 – 1962)

worked together as a team mainly in the interior of Central Sulawesi. Dr. Kruyt was the first missionary to work in Central Sulawesi (Poso), playing a major role in the attempts to covert the local population of this region from their ancestor worship to the Protestant Christian faith. Later on Dr. Adriani, who worked for the Dutch Bible Society, arrived in Poso to assist Kruyt in translating the Bible into the local language (Bare'e).

As a duo, Kruyt, who was well grounded in ethnology, and who knew the interior, and Adriani, trained in linguistics and theology, were extremely effective in spreading the Christian belief. Kruyt, as missionary, had been given the task of working in the region round Poso, which had been *terra incognita* up to that time. In 1891 he began his work in Gorontalo, and only arrived in Poso, together with his wife, at the end of 1893. He tried in various ways to make contact with the local people, often visiting small villages, maintaining good relations with the local village heads, attending ceremonies, and attempting to learn the local customs. In March 1895 Adriani and his wife reached Poso, to assist Kruyt in his labours.

Kruyt had a great interest in the cultures of the peoples of Central and South Sulawesi, producing detailed descriptions of these. The ethnographic objects he collected constitute only a small proportion of the results of the research issuing from his visits to various areas of Sulawesi. He wrote over a hundred articles for scholarly journals, and two large books on ethnography. Apart from his trips to remote areas of East and West Toraja, and to other areas in Toraja, he also visited the islands of Sumba, Rote, Timor, and the Mentawai islands in the period 1921 – 1924.

Together, Kruyt and Adriani published *DeBare'e sprekende Toraja's van Midden-Celebes* (The Bare'e-speaking Torajas of Central

▶
A.C. Kruyt

In his official regalia, c. 1925

▶▶
N. Adriani

And his wife, M.L. Gunning in 1916

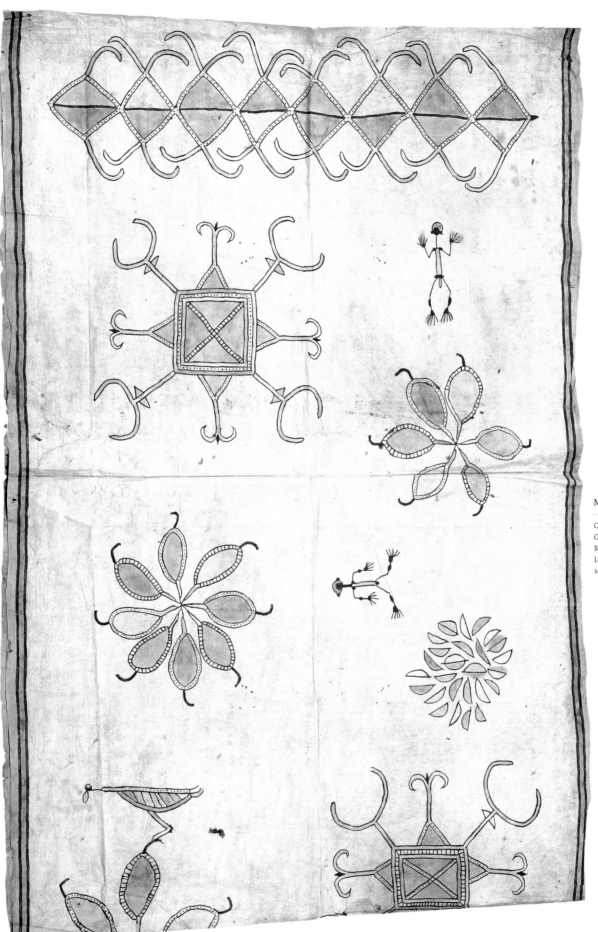

Male garment, *Pauba*

Central Sulawesi
Collected by N. Adriani; to Batavia in 1900
Barkcloth
Length 210 cm
MNI 9203

Celebes). It was a three-volume standard work on the Toraja Bare'e of East Toraja, as it was called at the time. The first two volumes, which were written by Kruyt and dealt with the country and its people, were published in 1912 and 1913; volume three, which was written by Adriani and addressed local language and literature, was published in 1914. Among other things, the authors examine the ancestral religion of the inhabitants of Poso, the presence of Islam in the south of the Bay of Tomini, and the social activities resulting from the expansion of Christianity. Furthermore, attention was given to local arts and crafts, such as the making of bast fibre clothing, copper working and the making of household implements. After retirement, Kruyt published another monumental work, *De West-Toraja's op Midden-Celebes* (The West Torajas in Central Celebes), in 1938. The four volumes describe many artworks, and may therefore be considered a catalogue, according to Koentjaraningrat (1961).

Besides the research Kruyt and Adriani conducted on the peoples they visited, they also collected ethnographic objects. The items Kruyt collected have found their way into various museums all over the world, including the National Museum of Ethnology in Leiden and the National Museum in Jakarta. The former holds approximately 170 objects from Kruyt's collection. The National Museum in Jakarta acquired a part of Adriani's collection, as can be seen from the notes recorded by the Batavian Society in February 1905 (MNI 9203-9215), as well as a number of items made from tree bark fibre (MNI 20705-20710). In 1901 this museum also acquired part of Kruyt's collection (MNI 9719-9729). These collections contain objects for both everyday and ceremonial use. The items for daily use include household articles such as a dish for holding lime, and storage boxes made of *bamboo*; useful items such as objects for fastening up chickens, filaments, objects for transporting things, and so on; toys (*gasing*, a spinning top); and weapons, including the perisai (shield), and the *sumpit* (blowpipe). Besides these, there are ceremonial objects made from tree bark, such as a cloth (*pauba*) and head ornaments (*siga*).

Collected objects made from tree bark fibre Clothing made from tree-bark cloth was characteristic of Central Sulawesi in earlier times. Because these objects were easy to transport, and because missionaries and researchers found their colours attractive, many of them were collected by Westerners. This is the reason why both the Jakarta and Leiden museums hold a considerable number of items made from tree bark. Those described in this catalogue came from the Bare'e in the east of Central Sulawesi, where Kruyt and Adriani collected them.

Until the beginning of the twentieth century, clothing made from tree bark played a major role in Central Sulawesi life. The tree producing bark of a quality suitable for this clothing, was the *ambo* (*Broussonetia papyrifera*, the paper mulberry). Tree bark of a good quality is easier to process, or to stamp with paint. The preparation of the tree bark is done in four stages: the tree is felled; the bark is prepared for treatment; it is beaten; and it receives its final processing. The bark is beaten with a wooden stick (*totua*) taken from the wolasi tree (*Lagerstroemia ovalifolia*). Several stones (*ike*) are also used. The bark is beaten until it has acquired the desired thickness; thin bark is used exclusively for ceremonial purposes.

The processing of tree bark is not universally permitted. There are certain prohibitions, taboos and conditions attached to it, connected with the agrarian cycle. In the harvest season no one may carry out this work. Further, no one is allowed to beat the bark in his or her

Head cloth, *Siga*

Central Sulawesi
Collected by A.C. Kruyt (1899)
Tree bark
Length 100 cm
MNI 8840

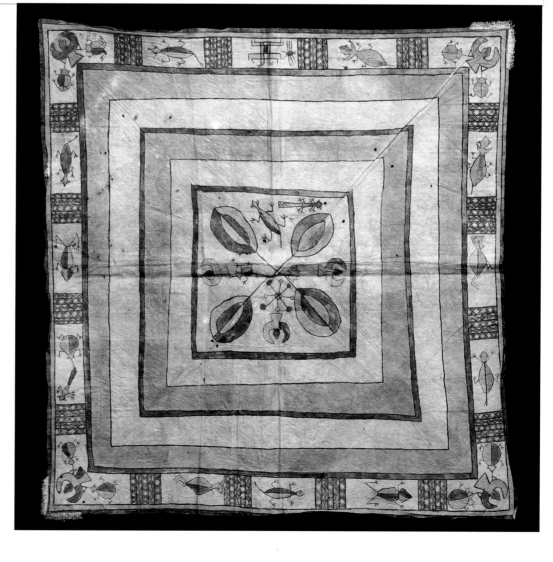

own home, and a special hut is constructed for this purpose. The processing of the bark lasts between two and nine days, depending on the basic material used. The colours employed come from the forest. Traditionally, in Central Sulawesi five colours were used: red, yellow, purple, green and black. Besides this natural colouring matter, imported aniline dyes were introduced at the end of the nineteenth century. The painting of bark cloths can be achieved in three different ways: with a small brush made from a little piece of bamboo and the leaf-vein of the *Jatropha cucas*; with a stamp; or with a bamboo pen (*pontula*) for drawing straight lines. The entire processing of beaten tree bark is carried out by women from the To Bada, To Besoa, and To Napu. According to Adriani and Kruyt, male priests dressed as women also perform these tasks. Men conform to certain conditions when felling the large trees from which bark is to be extracted.

The processed beaten tree bark is used for making garments as well as for manufacturing articles for everyday use, and also for ceremonial purposes. According to the rules, the ceremonial robes must differ visibly from clothing for daily use. The ceremonial clothing is decorated with motifs, while everyday garments are undecorated. There are various kinds of clothing made from bark cloth:

1 *Sarung* (cloth or garment) with its variant the *pauba* (man's cloth), *kumu pasua* (cloth for sleeping wear), and *topi* (woman's cloth).
2 Head cloths: the *tali* for women, and the *siga* for men.
3 Skirts (*bauga*).
4 Clothing for ceremonies connected with sickness and health: *ambulea* (a kind of uncoloured poncho worn by woman)

and *abe* (smaller than the *ambulea*, worn by men but also by women, who wear it over their ordinary clothes).
5 A close-fitting blouse worn by women (*lemba* or *karaba*).
6 Bark-cloth garments for funerals (*sompu*).

The bark-cloth *Sarung* is an important piece of clothing, white or brown for daily use, while motifs are added to garments worn on ceremonial occasions. The National Museum in Jakarta and the National Museum of Ethnology in Leiden have a variety of garments made of bark cloth, donated by Adriani and Kruyt. The item of clothing numbered MNI 9203 is decorated with motifs such as that known as petonda-oiale (buffalo horn-flying bird), a snake, a flower with seven bracts, and a human figure. The *pauba* MNI 20709 is coloured a striking purple, and also has a *petondu-oiale* motif, together with sun and star motifs.

The *siga*, a head cloth worn by men, is square. Three of its corners are folded, the bottom of the cloth covers the neck, the point rises above the head, and the other ends cover the front of the head. The *siga*, coloured and decorated with motifs, reveals the wearer's social status, and is linked closely with head hunting. According to Adriani and Kruyt, the *siga* worn during a head-hunting ceremony bore a special motif. The *siga* shown here (MNI 8840), collected by Kruyt, is predominantly coloured brown, with an unusual motif. The middle is decorated with four flower bracts, the edge with animal motifs, while the *petondu* or *petono* motif is also shown.

The *tali* is a cylindrical head ornament, made of *pandan* leaf or bamboo, and covered with a thin layer of tree bark. The object completed a woman's clothing, ensuring that her hair did not fall over her forehead. The women's head bands from the Ondae and Lage region, South Sulawesi, are called *tali bonto*. The *tali bonto*

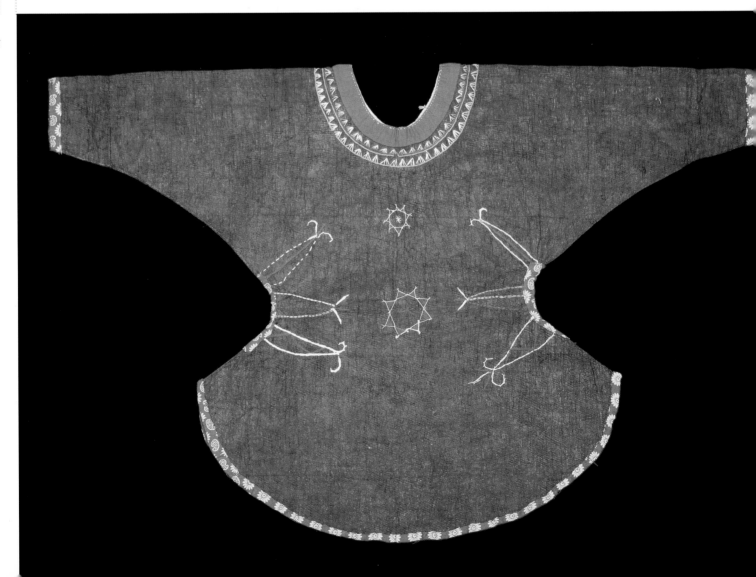

collection donated by Kruyt shows the decorative motifs of narrow lines, tumpal, triangles and flower sheaths in red, black and yellow.

The *Abe* or *ambulea* (RMV 1759-47) is an article of clothing in the shape of a tabard or toga, with open sides and a hole in the middle for the head. According to Kaudern (1937) these garments were worn by young men during their initiation rites. The *abe* were also worn during commemoration feasts in honour of the dead, and the bones of the deceased were wrapped in them. Some researchers have indicated that the *abe* and *ambulea* are not in fact the same; in their view the *abe* is smaller than the *ambulea*. In their three-volume work (1912 – 1914) Adriani and Kruyt indicate that the *abe* is worn by both men and women, and that its function is more that of decoration than of a garment, while the *ambulea* is worn next to the body. In the opinion of Kooijman (1963) the *abe* is worn by both men and women as an everyday item of clothing, in contrast to the *ambulea*, which is worn only by women. The *ambulea* or the *abe* is worn in healing rituals for a man or woman. According to Kotilainen (1992) the difference between these two items is of no importance: both are worn by sick people during the healing ritual, or by participants in a head-hunting feast.

Women's skirts made of bark cloth are usually coloured dark brown or black. Kruyt writes that women's skirts from Poso were never decorated with motifs, but the *lemba* or *karaba* (women's smocks) certainly were. Most smocks are decorated with various motifs applied in embroidery using tree bark, cotton, or mica. Kruyt's collection of *lemba* (RMV 1232-99) contain examples of objects worked in cotton with appliqué and embroidery. The bottom edge, the neck opening, and the sleeves are trimmed with cotton appliqué work. The waist, and the central panels of the smocks, have embroidered motifs.

Other objects collected Besides bark cloth garments, Adriani also collected other objects such as a dish made from a calabash, meant to hold lime, from the Poso region (MNI 92131). In Central Sulawesi, calabashes were used for making little boxes in which *air nira* (a sweet drink made from the palm *mayang enau*), salt and lime for the *sirih* plums, were stored. According to Kaudern (1937) the Bada were known for their beautifully decorated calabash items, which were traded in Kulawi, Pipikoro and the mountainous area to the north of Bada. The lovely calabash dish from Poso might not, in fact, be a local product. Its decorative motifs are similar to those on a *bamboo* box. The calabash, in the shape of a cucumber or pear, is divided into smaller fields by black, cross-hatched lines. The largest fields are usually found on the thinnest sides of the calabash. These fields, and the second-largest one, are divided into smaller units by small horizontal black lines. On top and below, triangles form the border. A common among the motifs encountered on calabash items are the heads of water buffaloes, which are traditionally very valuable. The heads are engraved into the calabash with a small piece of iron heated red hot.

The calabash dish for holding lime was part of a *sirih* set. This shows that the *sirih* quids, occurring everywhere in Indonesia in this period, were also in fashion in Central Sulawesi. They constituted an important part of the ceremonies and social activities. In view of the fact that *sirih* was a stimulant, besides possessing antiseptic qualities used in medicine, the offering of *sirih* (together with the *pinang* or betel nut) was regarded as a gesture of politesse and sociability.

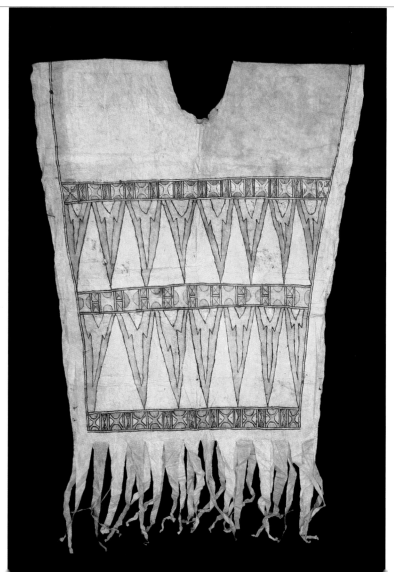

Smock, Lemba

Central Sulawesi
Collected by A.C. Kruyt; to Batavia in 1899
Barkcloth
Tree bark, cotton
Length 57 cm
RMV 1232-99

Worn at festivals

Poncho, Ambulea

Pebato, Sulawesi
Collected by A.C. Kryt; to Leiden in 1911
Barkcloth
Length 140 cm
RMV 1759-47

Ritual garment

II The military expedition to South Sulawesi

The aim of the Dutch military expedition to South Sulawesi (the South Celebes Expedition) in 1905 – 1906, was the pacification of all the kingdoms in this region, and to increase the extent of Dutch rule to regions outside Java and Madura. The Dutch chose the port city of Macassar as the centre from which to extend their colonial power. A series of conflicts broke out, with Bone, Gowa and Luwu, followed by a second phase of wars with smaller kingdoms. Finally the Dutch attacked the most influential kingdoms.

The primary objective of the expedition was the subjection of the kingdom of Bone, regarded as one of the principal opponents to Dutch authority. The kingdoms of the Buginese (Bone) and the Macassars (Gowa) were conquered by the Dutch army, and reconstituted into the Self-Governing Regions (Zelfbesturende Landschappen). The administrative system of the ruler was maintained in these administrative units, but under the supervision of Dutch government officials, for instance an Assistant Resident, or an *Controleur*. Today, these former kingdoms are ordinary districts.

During the military expeditions, objects were looted that were later donated to various museums. The National Ethnographic Museum in Leiden was given a number of objects, mainly weapons and ornaments. The major part of the war booty found its way directly to the Museum of the Batavian Society. The objects obtained via these military expeditions were usually of great cultural value in their form, the materials used (valuable metals and precious stones, for example) and in their functional content. These valuable objects came from palaces and other royal buildings overrun by the Dutch. In earlier times a palace

functioned not only as a site of royal power, but also as a cultural centre. Quite apart from the attention paid by the ruler, the arts could flourish in the area surrounding the palace. The palace itself was where artists assembled, and were able to create excellent works of art. Partly because of this the arts and crafts produced in the palace were of high quality.

The notes of the Batavian Society for December 1905, and a Governor's resolution (17 July 1906) record that the objects obtained in the course of the military expedition to South Sulawesi had been transferred to the Museum of the Batavian Society. Nine objects (MNI 12456-12464) were transferred from the collection taken from the kingdom of Bone, and the museum was given a considerable number of objects (MNI 12465-12611) from the Gowa collection.

Nevertheless, at the present moment the National Museum in Jakarta contains no objects from Bone, because the original nine objects were returned to the descendants of the ruler of Bone. According to the 'Inventory of the state ornaments of Bone' (1931) kept in the Museum La Pawawoi, this Bone collection consists of a *kris*, *pasangtimpo* (inv. no. MNI 12459) which, according to a handwritten note in the register, was transferred to Mrs. A. Pabetang, and a small dagger, *kawali* (inv. no. 12460) which was given to Arru Melle. Those members of aristocratic families receiving the other objects are not identified. These other objects included a tobacco box *japingjaping* (inv.no.12461), a *sirih* bag, *paopao dengan pasimbing* (inv. no.12463), an amulet *mustika* (inv.nos. 12463 and 12464), and three silver presentation trays (inv. nos. 12456 tot 12458).

The same inventory indicates that the Batavian Society also gave back to the Governor of Macassar and his subordinates the collection made by an earlier military expedition to Bone, in 1860. This collection was shipped on 24 March 1931 on the

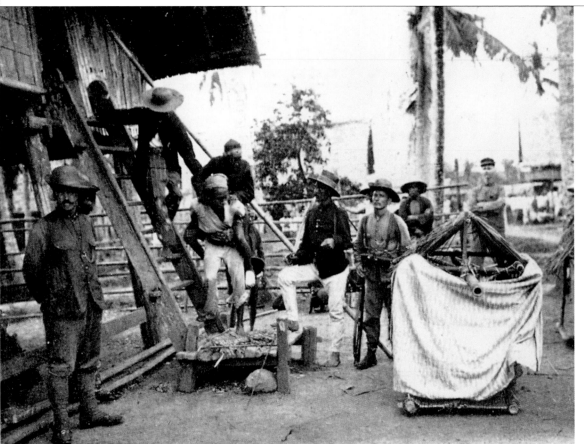

La Pawawoi

Under the watchful eyes of soldiers of the Royal Dutch East Indies Army in 1906, the last Buginese ruler of Bone, is carried to the palanquin that will take him to his place of exile at Bandung

Girl's apron, *Jempang*

Gowa, Sulawesi
Looted in Gowa in 1906
Silver, gold
Height 6 cm
MNI 12594/E 530

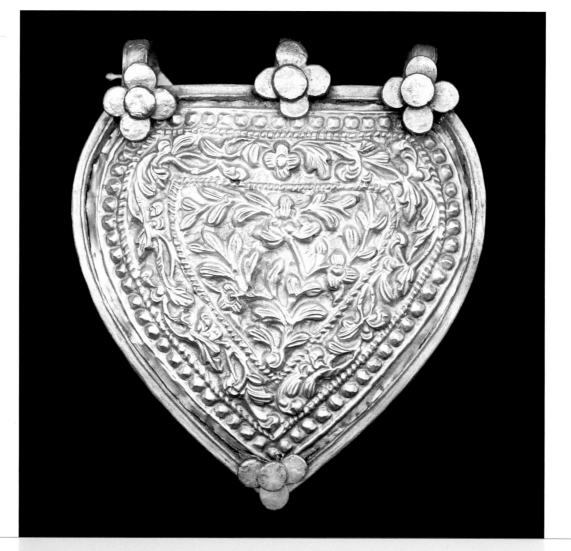

Ornamental pot

Gowa, Sulawesi
Looted in Gowa in 1906
Vietnamese pottery, gold, silver
Height 12.5 cm
MNI 12532/E 550

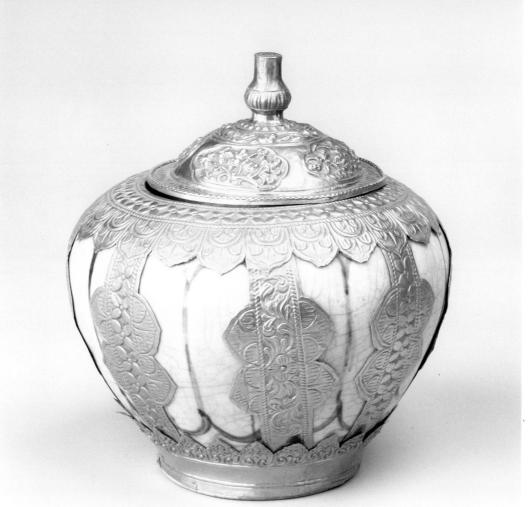

'Treub', a boat belonging to the Royal Packet Boat Company. The collection returned to the Governor comprised 61 items (inv. nos. 17231-17285), objects given into the safekeeping of the Batavian Society, according to a Governor's Resolution of 10 December 1913. The collection consists partly of heirlooms from the kingdom of Bone (Buginese: *arajang*, Macassar: *akarajang* or *kolompowan*). Without these objects, the rulers of Bone and Arumpone cannot be acknowledged as such. At the present time the majority of these objects are being kept in the office of the Regent of Bone, while a smaller number, including the lances and a scabbard cover, are in the custody of H. Andi Mapasissie, director of the Museum La Pawawoi.

On 2 January 1938 the Batavian Society returned various collections from Gowa, originating with earlier military expeditions (inv. nos. 14970-5005) and from the expedition of 1905-1906 (inv. Nos. 12465-12611) to the former kingdom. This is clear from a declaration kept in the Balla 'Lampoa Museum in the Gowa district. The gist of this declaration reads: 'We, the Self Governing Authority of Gowa, have received the following state possessions from His Excellency the *Controleur* of Gowa at Soenggominasa'. The collection handed over consisted of the crown *salokoa* (inv. no. 14970), a sword *Sudanga* (inv. no. 14971), three lances (inv. nos. 14972-14973), six neck chains (inv. nos. 14975-14980), four arm bands *ponto janga jangaya* (inv.nos. 14981 to14984), eight chest ornaments *bangkara* (inv. nos. 14985-14991), nine rings (inv. nos. 14993-15001) and four buttons (inv. nos. 15002-15005). The collection deriving from the military expedition of 1905-1906 that was returned eventually to Gowa, consists of a kris (inv. no. 12486), a dish (inv. no 12484), a necklace *kelara* (inv. no. 12486) and three rings (inv. nos. 12584-12586). Today these objects

are held in the Balla 'Lampoa Museum, which was once a palace belonging to the 35th and 36th rulers of Gowa. These heirlooms are regarded as sacred to this day, something that can be deduced from the way members of the public approach them. The objects, kept in an iron chest in a closed-off space, are presented with offerings by members of the public, and are only brought out of the chest for influential visitors, and on the feast of Idul Adha (the closing festival of the pilgrimage to Mecca). The La Galigo Museum in the province of South Sulawesi has had replicas made of various objects from the kingdoms of Bone and Gowa, obtained during the military expedition of 1905 – 1906. This Gowa collection contains:

1 Jewellery and ornamental objects: ear drops (*toge*), bands for the upper arm, rings, earrings, modesty aprons and head coverings.
2 Weapons: *krisses*, swords (*kléwang*) and sword ornaments.
3 Household goods: porcelain plates, presentation trays, vases and small covers for glasses.
4 Personal possessions: *sirih* sets.

A few hundred items of jewellery and weaponry (1560 series) found their way to the National Ethnology Museum in Leiden following military engagements in South Sulawesi. A special exhibition was even devoted to this collection in the summer of 1907, when the battles were barely over. At the request of the oldest son of Gowa's king, who had died in battle, all of these treasures were returned. According to the Dutch East Indies government of the time this was done for 'reasons of fairness', especially 'from the point of view of proper political relations with the presently exceedingly loyal Gowa family'.

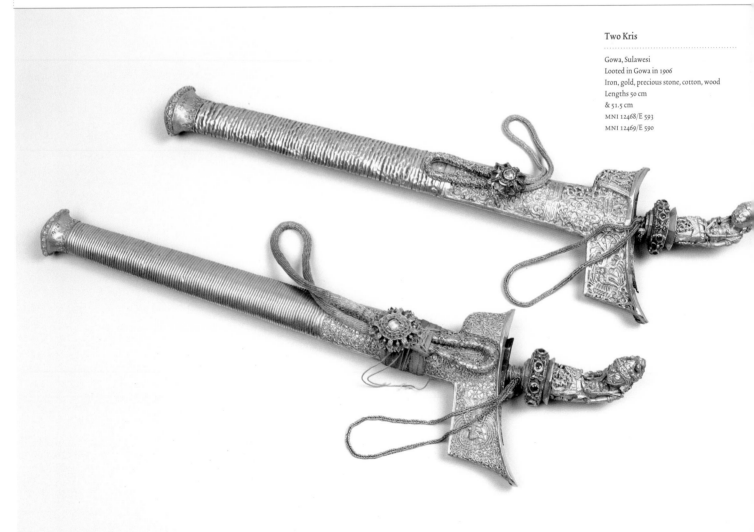

Two Kris

Gowa, Sulawesi
Looted in Gowa in 1906
Iron, gold, precious stone, cotton, wood
Lengths 50 cm
& 51.5 cm
MNI 12468/E 593
MNI 12469/E 590

III Royal gifts

The colonial period in the Dutch East Indies was not characterised only by wars in the archipelago. There were times when the colonial government and local rulers could approach each other in peace, occasions on which gifts were exchanged in order to perpetuate or reinforce relationships between the parties. When the Dutch arrived in certain areas, contact was established with the local ruler by sending a delegation with various presents. To create a smooth path for negotiations, envoys from both sides exchanged valuable gifts, accompanied by letters. For the local ruler this meant the presentation of, for example, gold objects set with precious stones, a sign of wealth and of an increase in the status of his palace.

As a consequence of this process, the National Museum in Jakarta possesses a collection of 'royal gifts' consisting of objects presented by local rulers to the government of the Dutch East Indies, and by that government to rulers. One of the objects presented to the government by the ruler of Bone in 1890 is a food dish with cover (RMV 799-11). This *baku bodo* is made of woven *lontar* leaves and gold thread, and is used for serving and eating food consumed on special occasions and at ceremonies. Royal gifts from Gowa are also to be found in the National Ethnology Museum. These include a number of precious bracelets and a necklace (RMV 808-1/3).

Conclusion

The research into the origins of objects held in museum and private collections is important if we are to know more about a society's cultural background in a particular period. The collections that came into being through the efforts of missionaries, translators of the Bible and colonial government officials, as well as objects looted during military expeditions and gifts from local rulers, constitute a significant contribution to scholarly knowledge of Sulawesi. The collections, and the written works published by the collectors involved, permit us greater insight into the way of life and the culture of Indonesian peoples in the past.

Arm bands (2 pairs), *Ponto sipappa*

Gowa, Sulawesi
Donated by the Crown Prince of Gowa to the
National Ethnographic Museum in 1890
Silver, gold leaf, precious stone
Diameters 12 cm and 10 cm
RMV 808-1
RMV 808-2

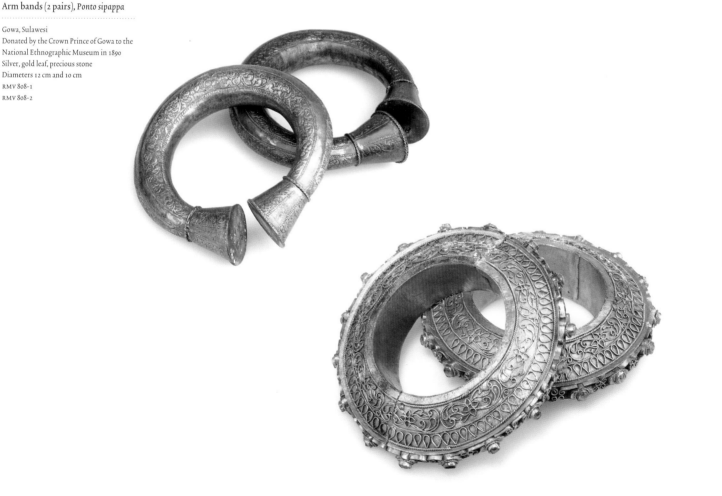

East Indonesia is not a clearly defined region. In this catalogue, the area comprises the Lesser Sunda Islands (except for Bali and Lombok), Sulawesi, the Moluccan Islands and the Indonesian half of New Guinea. The article by Hari Budiati deals with Sulawesi, and this contribution looks at the other East Indonesian territories. Sulawesi does come up on a few occasions here as well.

In the history of the region a number of 'collection periods' can be distinguished, during which ethnological collections were established. However, the key period was undoubtedly between 1875 and 1925, when the majority of the islands were opened up by the Dutch. This was founded upon a modern scientific interest in exotic cultures, interlinked with political aims and trade considerations.

The overview that follows about a number of collectors in East Indonesia reflects this key period: the majority of them were active in the late nineteenth and early twentieth centuries. In presenting them, I have subdivided them into four categories according to their professional backgrounds. On this basis, collections assembled by colonial administrators, clergy, military officers and scientists are dealt with below in this order.

The colonial administrator

J.G.F. Riedel: investigator of adat law One of the most controversial colonial administrators active in the field of ethnology was undoubtedly Johann Gerard Friedrich Riedel (1832 – 1911). His pride, propensity for self-glorification and sometimes blunt manner often provoked opposition. Moreover, the contents of his ethnological publications were often disputed. Riedel nevertheless made a valuable contribution to the ethnology of

Indonesia, certainly as a collector of ethnographic material. He founded the Minahasa collection of the Museum of the Batavian Society (in Jakarta), and established an early Moluccan collection for the State Ethnography Museum (the current National Museum of Ethnology) in Leiden.

Like his father, Riedel was a striking personality. The only son of a German missionary and a Moluccan-European mother, he was born in Tondano, in the Minahasa region of North Sulawesi. He grew up with four sisters in an extraordinary environment: an area new to missionary exploration, where the Riedel family was an object of considerable interest. The young Riedel was sent to Europe for his education, probably to Erfurt in Germany, home of his father's family. The plan was for him to become a missionary like his father, but this was not to be. Riedel returned to the East in 1853 as a colonial administrator in the Dutch East Indies service. His career began in a familiar environment: he began in the position of *Controleur* in the district in which he was born.

This was the start of a thirty-year career, spent chiefly in East Indonesia. After spending more than ten years as an *Controleur* in the Minahasa district, Riedel became Assistant Resident of Gorontalo, also in North Sulawesi, in 1864. Here too he worked for many years. After a brief period holding the same post on the island of Billiton (now Belitung, east of Sumatra), he was promoted in the late 1870s to Resident of Timor and Dependencies. In 1880 he was transferred to Ambon, where he was Resident of Amboina (Moluccan Islands) until his retirement. Wherever he worked, he tried to stimulate trade and put forward ideas to improve the structure of administration. His proposals were usually put into practice.

Nico de Jonge

Collectors on distant islands

East Indonesia

In the mid-nineteenth century, many of the areas in which Riedel stayed were still unknown territory. Dutch administration was limited to centres of trade and areas along the coast. The interior of Sulawesi and Timor, for example, had hardly been visited by foreiners, and dozens of Moluccan islands were only known by name. Riedel saw it as an important part of his duties to explore these regions and bring them under Dutch authority. He proudly set off to open up new areas accompanied by only a very small armed escort. His journey across Timor, where he introduced the 'barbarian population' to the intentions of the colonial government, is legendary. In publications about this achievement, Riedel presented himself as a marvel, at the expense of other administrators.

> After been warned, two of my predecessors, the Residents Hazaardt and Baron van Lijnden, were driven from the interior. My successor Sikman met with a similar experience. It was thus unprecedented when in September 1879 I made the journey through the interior as far as the Portuguese borders without molestation. On the contrary, the savage head-hunting chiefs bade me farewell with tears in their eyes.

Riedel accounted for his success by pointing out that he travelled 'without breechloader and revolver' and – equally importantly if not more so – he was aware of the local customary law, or *adat*: 'My so-called armed force consisted merely of a certain degree of knowledge of Timorese customs and practices.'

This was in fact Riedel's hobbyhorse. He had already become interested in local traditions early in his career. *Adat* law was the particular focus of this interest. He was aware that knowledge 'of justice and injustice, crime and misdemeanour, murder

and manslaughter, punishment and retribution, possession and ownership and much more' was of great importance to an administrator. Moreover, his knowledge of and partial respect for the *adat* was seen by the members of the population groups, governed by him, as a token of respect for their ancestors. And this inspired confidence in colonial politics. In this attitude towards *adat* law, Riedel differed from many of his colleagues. In the training of Dutch East Indies civil servants, there was indeed an emphasis on the importance of ethnology, but this was not the case in the practice of government in the mid-nineteenth century. In the foreword of Riedel's most important work, published in 1886, *The straight and curly-haired races between Selebes and Papua (De sluik- en kroesharige rassen tusschen Selebes en Papua)*, he writes:

> Thirty years ago when, as a young civil servant with the Department of Internal Affairs on North Selebes, I began to record ethnological facts, there were many who informed me that such labour was pointless and ridiculous. Older fellow civil servants and friends earnestly and forcefully advised me instead to study the Holy Books of the East Indies Government, the so-called Bulletin of Acts, Orders and Decrees (Staatsbladen), as being all that is needed to make a shining career in the service of one's country.

Riedel received recognition in a standard work by the authoritative Leiden lawyer, C. van Vollenhoven. This characterized him as anticipating the work of C. Snouck Hurgronje and G.A. Wilken, the two researchers with whom the scholarly investigation of *adat* law began.

Many of Riedel's ethnological activities were reflected in publications, chiefly articles in journals. The emphasis lay on

J.G.F. Riedel

C. 1900

Knob of a priest's staff, *Seka'd*

Minahasa, Sulawesi
Collected by J.G.F. Riedel; to Batavia in 1905
Copper
Height 10.5 cm
MNI 11707

This decorative copper knob from the
Minahasa is one of the most beautiful
objects collected by J.G.F. Riedel for the
Batavian Museum. Knobs of this kind,
attached to priest's staffs, were cast in
regional workshops, and were known as
seka'd. In the documentation supplied with
the object, Riedel characteristically had a
different opinion on this point; in his view
the knobs were called olat and originated
from outside the Minahasa.

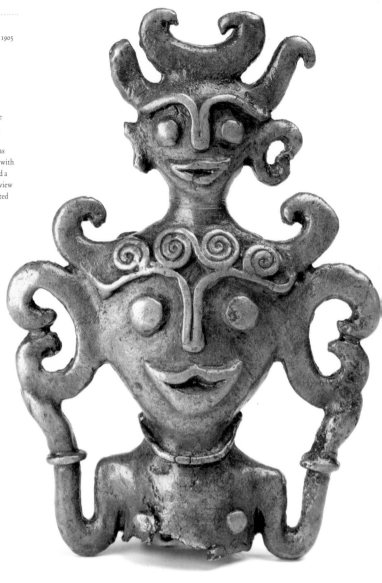

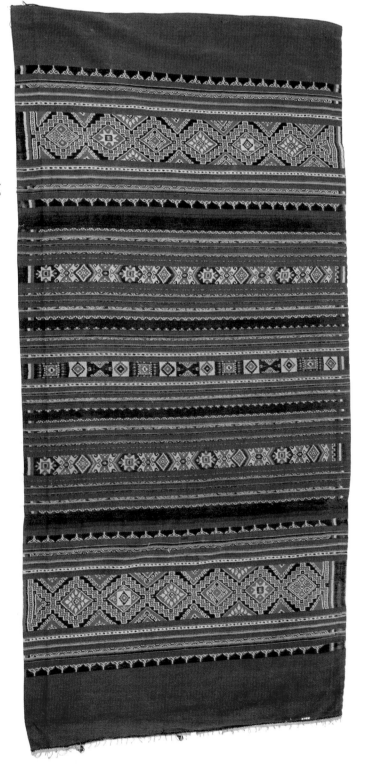

Woman's sarong, *Kain bentenan*

Minahasa, Sulawesi
Collected by J.G.F. Riedel; to Batavia in 1885
Cotton
Length 167 cm, width 82 cm
MNI 2766

North Sulawesi, his home country, about which he continued to write long after his retirement. The themes varied from contributions on local languages and descriptions of rituals in the life-cycle, to matters of religion and geography. Furthermore, he usually made public the knowledge he acquired during his later official postings; he described his experiences on Timor and Savu, and also devoted attention to the Moluccan Islands.

Riedel was also active as a collector. In this capacity, as already mentioned, he played an important role in establishing the collection of the Museum of the Batavian Society. It appears from the first museum catalogue that Riedel had made a major contribution to the core collection concerning North Sulawesi (Minahasa and Gorontalo). His attention to textiles was especially notable (see, for example, MNI 2766). From the Society's minutes it appears that Riedel aimed at creating representative collections that gave as complete a picture as possible of the material culture. He asked what was still missing, and then traced and dispatched objects to Batavia. For his efforts, the governing body rewarded him with an honorary membership of the Society. The Moluccan collection that he assembled for the State Ethnography Museum in Leiden presents a similar picture. It comprises a large number of objects that cover many different areas of life (RMV series 355, c.160 objects). The accompanying documentation was remarkably professional. Riedel sent photographs of the objects, each with a number corresponding with a list of descriptions and places of origin.

Much of the ethnographic material Riedel collected is pictured and described in his magnum opus mentioned above, *The straight and curly-haired races between Selebes and Papua*. This substantial work, comprising more than 500 pages, gained Riedel a doctorate (from the University of Leipzig), but also encountered fierce criticism. Central to this was the degree of reliability of the material presented. Both in the East Indies and in Europe, on the basis of direct observations and knowledge from other sources, there were doubts as to the accuracy of Riedel's information. Moreover, it was suggested that the author could not have been to all the places described, and that he leaned too heavily on the unverified reports of assistants ('reliable natives, both men and women').

This criticism was largely justified. Scholars who travelled in the region with Riedel's book at hand, in the late nineteenth and early twentieth centuries, often encountered devastating criticism of its contents. Illustrative are the (unpublished) diaries of the German ethnologist W. Müller-Wismar, who in 1913 – 1914 visited the remote islands of Maluku Tenggara. With increasing irritation he corrects Riedel's information, culminating here and there in unconcealed cynicism: 'The stoty told by Riedel, that Mother Earth would becom fertilized at the onset of the west monsoon with the help of a waringin tree as the male reproductive organ, on all the islands gave rise to hilarity' The continuing reference to Riedel as a reliable source by some ethnologists interested in the southern Moluccas is partly the due to Müller-Wismar's early death.

An intriguing contribution to the debate on Riedel's work in the Dutch press, was made by the Leiden professor G.A. Wilken. He defended the book through thick and thin, despite the errors and omissions noted by him. His friendship with Riedel probably played a role in this. The basis for this friendship undoubtedly lay in their identical pasts: like Riedel, Wilken was the son of a German missionary and an Indo-European mother, was also born

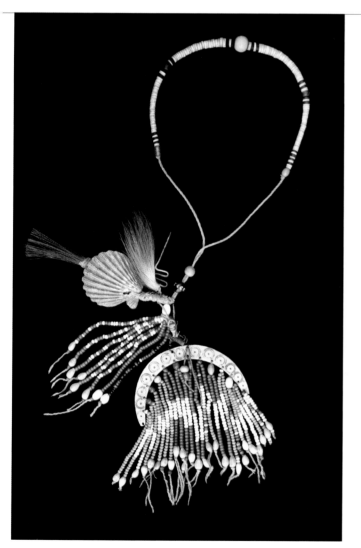

Neck ornament

Wetar, Moluccas
Collected by J.G.F. Riedel; to Leiden in 1883
Beads, feathers, shell
Length 32 cm
RMV 355-111

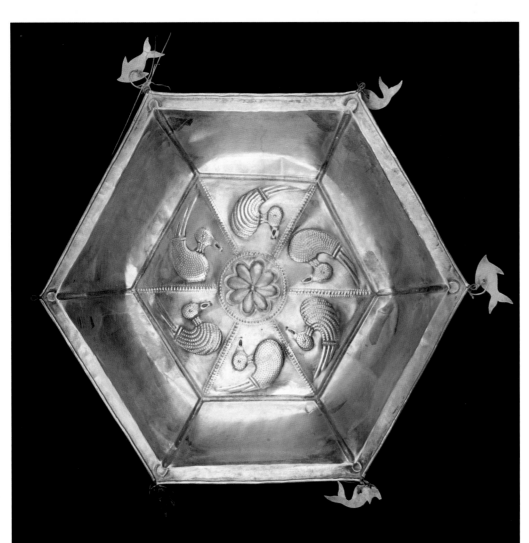

Gold plate, Mas piring

Leti, Moluccas
Acquired through the government of the
Dutch East Indies (1887)
Gold-silver alloy
Diameter 20 cm
MNI 6791 a/e 1103

In the second half of the nineteenth century,
government officials in the Moluccas
administered justice in the course of their
tours of duty. When *adat* (custom) was
infringed, these officials often imposed fines
that accorded with local tradition. On Leti,
several gold plates, and other slabs of gold,
came into the possession of the colonial
government. These were stored at the
Museum of the Batavian Society in 1887

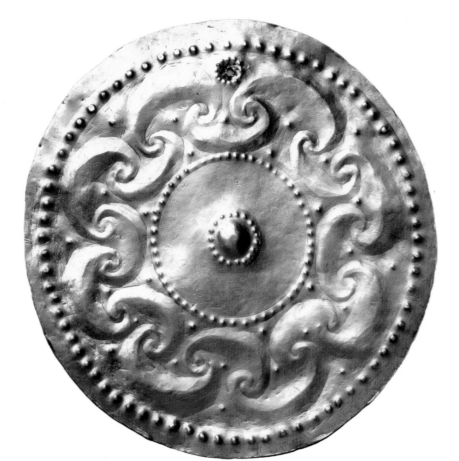

Gold plate, Mas bulan

Leti, Moluccas
Acquired through the government of the
Dutch East Indies (1887)
Gold-silver alloy
Diameter 20 cm
MNI 6791d/E 1129

in the Minahasa and moreover also worked for some years as a colonial administrator. Wilken also came forward to support Riedel regarding other publications for which he came under fire. An example is the attack made by the English scholar H.O. Forbes in his famous book *A naturalist's wanderings in the Eastern Archipelago* (1885). Forbes extensively describes the obstructive and insulting attitude of Resident Riedel on his arrival in Ambon; in response, Wilken devoted a whole page to defending Riedel in a review filled with his disbelief.

On his retirement, Riedel left with his wife for Europe, where he lived in Utrecht, The Hague and Brussels. However, a yearning for the East led him to return to Asia, and he spent his last years in Batavia. A few years before his death he gave the Museum of the Batavian Society a rare and exceptionally beautiful object from the Minahasa: the decorative bronze handle of a priests staff (MNI 11707). Riedel died in 1911, having received German, Italian and Russian honours granted to him as an 'ethnologist of significance'. With his death, however, came new criticism. Unaware of their damaging contents, Riedel's widow decided to donate some files from her husband's estate to the Batavian Society. The authority on Sulawesi, N. Adriani (see the article by Hari Budiarti), found in them two reports about the discovery of Lake Poso in 1865/1869. They were drawn up by two of Riedel's young subordinates, but never published. Adriani suspected Riedel of having a hand in this, and forcefully accused him of misappropriating the reports so that he could one day be able to parade himself as the lake's discoverer. Unfortunately for Riedel, due to Wilkens' death in 1891, Adriani's charges were never refuted.

G.W.W.C. van Hoëvell: better Heathen than Mohammedan

Less controversial, but at least as important for the ethnology of Indonesia, was Gerrit Willem Wolter Carel baron van Hoëvell (1848 – 1920). This colonial administrator also established collections and published ethnological papers, but his greatest merits lay in another sphere. In particular, Van Hoëvell contributed to scholarship by stimulating and supporting the research work of others. He did not mind operating in the background and subordinating himself to the accumulation of knowledge. In this respect he was the opposite of Riedel.

Van Hoëvell was born in Dordrecht in 1848, where his father was a headmaster. Having attended various secondary schools, at the instigation of his uncle – the famous politician W.R. van Hoëvell – he chose to study in Delft to be a colonial administrator in the East Indies. He graduated in 1868 and left for the East, where as *Controleur* he took his first administrative steps in Sulawesi (1869) and Ambon (1870 – 1875). After a period of sick leave in the Netherlands, Van Hoëvell continued his administrative career in 1877 on Sumatra. The high point of his stay was his participation in the first expedition to Lake Toba in 1878. In 1885 Van Hoëvell returned to the east of the archipelago. He was appointed Assistant Resident of Gorontalo on North Sulawesi, a function in which he successfully implemented administrative changes. His good reputation led in 1891 to his appointment as resident of Ambon and in 1898 – after leave in Europe and two periods acting as deputy – as Governor of Celebes (now Sulawesi) and Dependencies. Van Hoëvell remained in this post until his retirement in 1903.

He proved his value to ethnology in particular during the second part of his career, after his return to the East Indies. He regularly documented unrecorded facts, asked others to do the

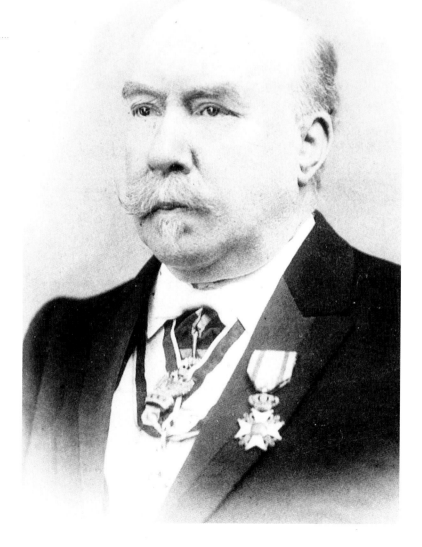

G.W.W.C. van Hoëvell

At the age of 68

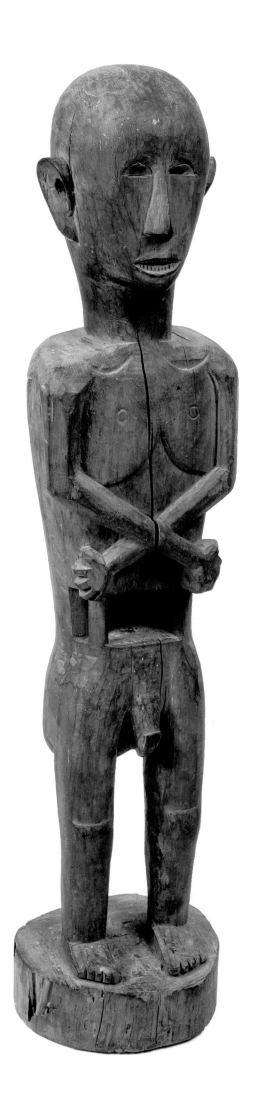

same, and offered help to researchers in the field. Direct benefit to the colonial administration played a lesser role here than it did in Riedel's case. It is significant that from 1892 Van Hoëvell acted as a correspondent for the Royal Academy of Science (Koninklijke Academie van Wetenschappen). He was also knighted for services both to his country and to science.

Most striking was his help to the Swiss cousins, Paul and Fritz Sarasin. In the years 1893 – 1896 and 1902 – 1903 they made two major research expeditions through the interior of Sulawesi. Many parts of the island were blank areas on the map, which the cousins were able to fill in partly due to the actions of Van Hoëvell. Van Hoëvell provided support during the two voyages of exploration, while he was governor of Celebes and Dependencies. In this position he had the power and resources to offer assistance, something that was particularly useful when in Palu the Sarasins met with obstructive chiefs and a hostile population that blocked the expedition's progress. Van Hoëvell saved the project by sending ships with troops, an act for which Paul and Fritz thank him in the foreword of their report: 'The despatch of ships and troops to the bay of Palu to secure the progress of our threatened expedition through Central Sulawesi was a support for science such as has seldom before been granted.' And this was not all. In honour of Van Hoëvell, the Sarasins named a new species of bird, which they discovered in the Gulf of Boni, *Siphia Hoevelli*.

Van Hoëvell would seem to have used his political power in the service of science, but the reality was somewhat different. Shortly after his retirement, under pressure of growing criticism, he made public his motives for providing such extensive assistance. From this, it appears that, alongside his love of science, he had a hidden agenda with national honour as its spearhead:

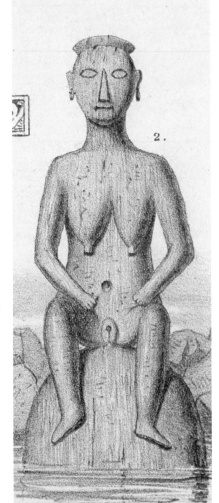

Copy of an ancestor figure *Sedeu*

Kai, Moluccas
Carved by order of G.W.W.C. van Hoëvell; to Batavia in 1888
Wood
Height 84 cm
MNI 6705

During his residence on the Kai islands in 1887, G.W.W.C. van Hoëvell allowed local ancestor statues (sedeu) to remain standing In this way he avoided a 'religious vacuum' from which Islam might profit. Instead of taking away the statues, Van Hoëvell had several drawings prepared, plus a scale copy He sent this copy, probably inspired by the sedeu Werwat from the village of Gelanit, to the Batavian Museum. Eventually the *Sedeu* Werwat itself arrived at the National Ethnographic Museum in Leiden in 1914, within the context of the Military Exploration of New Guinea (RMV 1889-2, see the continuation of this chapter, page 192).

I knew that the eyes of the entire world were fixed on these expeditions, that I was not dealing with adventurers or fortune-hunters but with respectable scholars who had only the interests of science in mind, and that any secondary political aims were excluded as a matter of course. How would it have been had their expeditions, in traversing Celebes (as was the case in August when they wished to travel across Duri to Paloppo), again failed or been frustrated by the resistance and opposition of the chiefs and population involved? Would not those abroad have been justified, then, in speaking scornfully of our pretence at colonial possession and in decrying us as a nation unable even to secure the passage of peaceable travellers through its territory?

Actually this was typical of Van Hoëvell. However important he found science to be, and ethnology in particular, he remained in the first place a politician. This can also be seen in his own work. Where possible he allowed the exercise of administrative authority and the pursuit of science to go hand in hand – for example during his official journeys – but sometimes the administrator in him pushed the scientist firmly into the background. However, he then sought solutions that might ease the 'scientific pain'.

A fine example of this can be found in a series of articles that Van Hoëvell wrote as the result of a government mission in 1887. Still acting as Assistant Resident of Gorontalo, he was to investigate the southern Moluccas geographically, ethnographically and commercially. In late 1887 he visited Kai, Tanimbar, Babar and Leti and in early 1888 Kisar and Aru. In his report on Kai it becomes clear that Van Hoëvell saw advancing Islam as the most significant impediment to the improvement of living standards on the islands. He describes the 'Mohammedan' in extremely negative terms (sly, full of tricks, treacherous, shifty, scheming and double-

◄
Ancestor statue, *Pemia*

..

Poso, Sulawesi
Collected by G.W.W.C. van Hoëvell; to Leiden in 1890
Wood
Height 47 cm
RMV 776-37

►
Ancestor statue

..

Leti, Moluccas
Collected by G.W.W.C. van Hoëvell; to Leiden in 1890
Wood
Height 85 cm
RMV 776-68

..

The statue represents the founder of a 'house' (lineage of a local descent group)

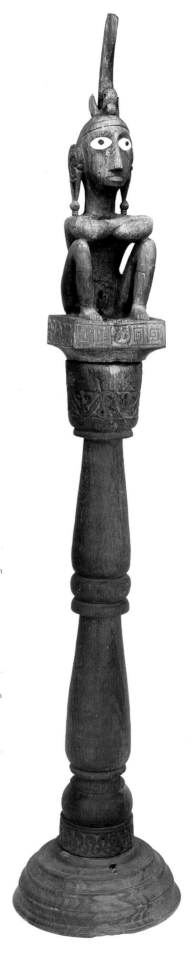

dealing, excessively proud and too lazy to work) and thinks that the Muslims instil the 'Kai Heathen' with 'a deadly hatred of all infidels and thus also of the European administration'. The 'Kai Heathen' on the other hand was worthy of sympathy: 'After all, no one who observes him in his daily life will deny that through his natural aptitude, quick-wittedness, urge to investigate, liveliness and industriousness he may be elevated.' In his eyes, it was to be avoided that the 'Kai Heathen' should be driven into the arms of the 'Mohammedan'. In the absence of a strong Christian alternative (missionary work was still in its infancy) he saw only one solution: temporarily to maintain a strong and lively local religion. The consequence of this position was that Van Hoëvell placed a strict limitation on himself in the collection of ethnographic material: he left alone the great statues of ancestors (known as *sedeu*) on the islands, so as not to create a 'religious vacuum' that Islam could exploit. At the same time he eased the scientific harm by having a half-scale model *sedeu* carved, while recording other statue in its place as well as possible on paper. In passing, he accused the old resident, Riedel, of having no eye to the situation:

> Resident Riedel has perhaps unintentionally contributed greatly to the discredit of heathenism. All idols that he was able to trace, he removed or had removed, thus to enrich ethnological collections, thereby bringing the populace under the misapprehension that the Government thereafter forbade them to remain faithful to their old religion.

For the rest, the trip to the southern Moluccas was important both for the Museum of the Batavian Society and the State Ethnography Museum in Leiden. Both received highly interesting objects collected by Van Hoëvell, including a variety of unique items. Leiden obtained a finely carved ancestor statue from Leti, which depicts the founder of a 'house', or family (RMV 766-68). To Batavia, Van Hoëvell sent a variety of beautiful stylised ancestor statues from the same island (MNI 6799). Unfortunately a number of these – as part of the Dutch East Indies contribution – were burnt during the Paris World Fair of 1931. The Batavian Society also received the model *sedeu* made on Kai (MNI 6705). The *sedeu* on which it was based was to end up in Leiden at the beginning of the twentieth century (see later in this chapter, in the section on military officers as collectors).

Apart from these two museums, Emperor Franz Ferdinand of Austria also received a considerable number of objects from Van Hoëvell, collected during his research on the Moluccan Islands. The Emperor called in at Ambon during a world tour in 1892 – 1893 and was impressed by Van Hoëvell's collection, which occupied 'two large rooms of the Resident's house'. The imperial items are currently housed at the Museum of Ethnology (Museum für Völkerkunde) in Vienna.

However committed Van Hoëvell showed himself to be in his articles on the southern Moluccas, his true ethnological love was the peoples around Tomini Bay in North Sulawesi. From his station in Gorontalo, he visited the area, whenever he had the opportunity, over a number of years. As Assistant Resident he brought the region under direct Dutch administration and later took a stand for the introduction of Christianity. For the most part the local people adhered to their own religion and as on Kai, Van Hoëvell feared the increasing influence of Islam, which was already present on the coast. The arrival of missionary A.C. Kruyt was the result of his initiative (see the article by Hari Budiarti). Kruyt

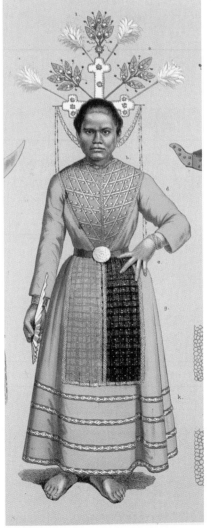

Collar of a dance costume, *Apela*

Gorontalo, Sulawesi
Collected by G.W.W.C. van Hoëvell; to Leiden in 1890
Cotton, silver braid, flannel
Width 54 cm
RMV 776-13 b

G.W.W.C. van Hoëvell collected both men's and women's dance costumes in Gorontalo. He sent these, together with photographs of dancers (male and female) to the National Ethnographic Museum in 1890. Shortly after this he published work on the subject, using photographs as the basis for coloured illustrations. Shown here is a woman dancer from Gorontalo, finely dressed in her prominent cotton collar.

stayed for some weeks as a guest in Van Hoëvell's house before Van Hoëvell had him taken to Poso by government schooner, inspiring him to carry out ethnological research.

Van Hoëvell also collected ethnographic material in Tomini Bay and Gorontalo itself. These objects also ended up mainly in Leiden and Batavia. Again Van Hoëvell's fondness for unique items stands out. He was clearly intent on collecting unusual objects and was a highly discerning collector. This can be seen, for example, in an article published in 1895, in which he comments on a number of Moluccan statues forming part of his gift to the Austrian Emperor:

> In collecting such items one must be extremely careful, particularly in places which are visited by the packet boat and are commonly visited by travellers. There the frequent demand for statues of ancestors has resulted in an industry, and they are specially manufactured for trade. The form of these statues often differs from the norm, they are unrelated to traditional notions, and are naturally of no value to science.

The question is, of course, how much 'official pressure' did Van Hoëvell bring to bear to assemble his striking collections? Little can be gathered from the documentation that accompanied the collections to the museums. The cultural context of virtually all the objects was briefly outlined and the local name provided; here and there, we may read the comment 'extremely rare' or 'extremely difficult to obtain'. This is the case, for example, with the wooden ancestor statue, *pemia*, collected in Tomini Bay (RMV 776-37). As to how he 'obtained' it, Van Hoëvell remains silent.

Van Hoëvell devoted articles to a number of exceptional objects, generally published in the Leiden journal *Internationales Archiv für Ethnographie (International Archive for Ethnography)*. After his

retirement, he settled in The Hague and around 1908 he joined the journal's advisory board. From his writings it is apparent how widely read he was in the field of ethnology, with references to peoples in Africa, India and Australia. There are also comparisons with Sumatra, the island on which Van Hoëvell also spent eight years during his long career. He died in 1920 in The Hague at the age of 72.

The clergyman

B.A.G. Vroklage: ethnologist with a mission

For the colonial administrator, ethnology was a political matter, Van Hoëvell being the proverbial exception. Knowledge of local customs made it considerably easier to exercise power. However, it was quite a different story for the missionary. They too often carried out ethnographic work, but here the knowledge was gained in the service of Christianity. Conversion was the keyword and to find acceptance among 'heathen' peoples it was necessary to have an insight into local culture. Usually it was the missionaries who – with this 'sacred purpose' in mind – described the *adat* of their place of posting, drew up glossaries and collected ethnographic material. Although fewer in number, there were also fully trained ecclesiastical ethnologists and linguists who performed this work. One of them was Bernhard Andreas Gregorius Vroklage (1897 – 1951). As 'missionary ethnologist' in the service of the Catholic church, he worked in various places in Nusa Tenggara (Lesser Sunda Islands). His scientific enthusiasm led to the establishment of extensive ethnological collections.

Vroklage was born in 1897 in Oldemarkt in the Dutch province of Overijssel. Early in his youth he already expressed the wish to become a missionary, a calling that led him to an education at

Dancer's head-dress, *Tamada*

Gorontalo, Sulawesi
Collected by G.W.W.C. van Hoëvell; to Leiden in 1890
Cotton, feathers, rattan, silver thread
Height 24 cm (excl. feathers)
Part of a dance costume
RMV 776-14

the mission of the Societas Verbi Divini order (SVD – Society of the Divine Word) at Uden in the province of North Brabant. From the outset this order, founded in 1873 by the Dutchman Arnold Janssen, placed a strong emphasis on ethnology. Janssen taught that a missionary could only be successful if he studied in depth the culture of the people among whom he worked. Moreover, he had to be willing to share their poverty.

In 1919 Vroklage continued his study at the SVD mission in Teteringen, North Brabant. Here he was ordained as a priest five years later. He did not then leave for the mission fields, however: after his ordination Vroklage remained in Teteringen as a lecturer in philosophy and theology, where he taught until 1930. He then left for Rome to obtain a doctorate on the relationship between Christianity and Buddhism. To write a second thesis on the cultures of Kalimantan, he went on to Vienna. At the Ethnological Institute (Institut für Völkerkunde) of the local university, he attended the lectures by SVD fathers Wilhelm Schmidt and Wilhelm Koppers, two leading lights in the *Kulturkreis-richting*, a school dedicated to cultural history. His stay in Vienna, and especially his fervent embrace of the ideas of the two fathers, would greatly influence the rest of his career.

During the time that Vroklage studied in Vienna, the *Kulturkreis* (or cultural circle) theory was already under attack. This school arose in reaction to the evolutionist model in terms of which ethnological data was ordered right up to the beginning of the twentieth century. The idea of a uniform, gradual development of all peoples was abandoned and cultural change was now chiefly explained by cultural diffusion: the transfer of cultural traits from one culture to another. Schmidt and Koppers had their own particular interpretation of this. They both assumed that cultural

elements were not transferred seperately but together as organic complexes. Such complexes they named 'cultural circles'. They made a distinction between older and younger cultural spheres. Throughout history, they claimed, younger cultural complexes had continually 'covered over' older ones either partially or entirely. This succession led back to a 'primal culture', the first and oldest cultural circle on earth.

The most important critics of the 'Vienna School' in the Netherlands were the ethnologists H.Th. Fischer en J.J. Fahrenfort. Fischer saw in the ideas of Schmidt and Koppers a direct return to the evolutionist model: their focus was not the history of a specific people, but the origin of humanity as a whole. Fahrenfort resisted the picture that both fathers painted of a 'primal culture'. The religious core of this was a creating 'godhead' (*Hochgott*), entirely in concordance with the biblical creation story.

Elsewhere too there were sceptical reactions and, as adherent of a school that clearly preached the primacy of Christianity, things were not easy for Vroklage. In 1934 – the year in which he defended his thesis on Kalimantan, filled with Viennese concepts – he experienced his first disappointment. Although in Leiden his name headed the list of nominations, the Chair of Geography and Ethnology of the Dutch East Indies passed him by (it was previously occupied by A.W. Nieuwenhuis, on whom see the article by Irwan Zulkarnain in this catalogue). The liberal minister Marchant decided to favour the faculty candidate J.P.B. de Josselin de Jong, thereby either consciously or unconsciously settling the conflict between two schools. In his oration, Vroklage's adversary gave the adherents of the Vienna School a piece of his mind. In the opening passages, De Josselin de Jong called the delineation of cultural spheres a 'perilous undertaking' and mocked the

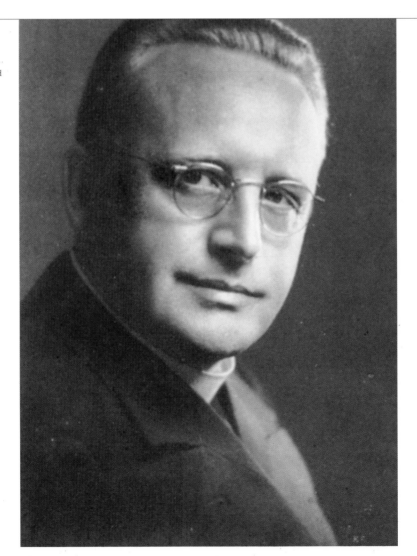

B.A.G. Vroklage
..
As portrayed in his posthumously published three-volume work on the Belu of Central Timor (1953-53)

Princely shoulder cloth
..
Manamas, Timor
Collected by B.A.G. Vroklage; to Leiden in 1939
Cotton
Length 206 cm, width 119 cm
RMV 2380-251

Drum
..

Belu, Timor
Collected by B.A.G. Vroklage; to Leiden
in 1939
Wood, goatskin, rattan, string
Height 103 cm
RMV 2380-255

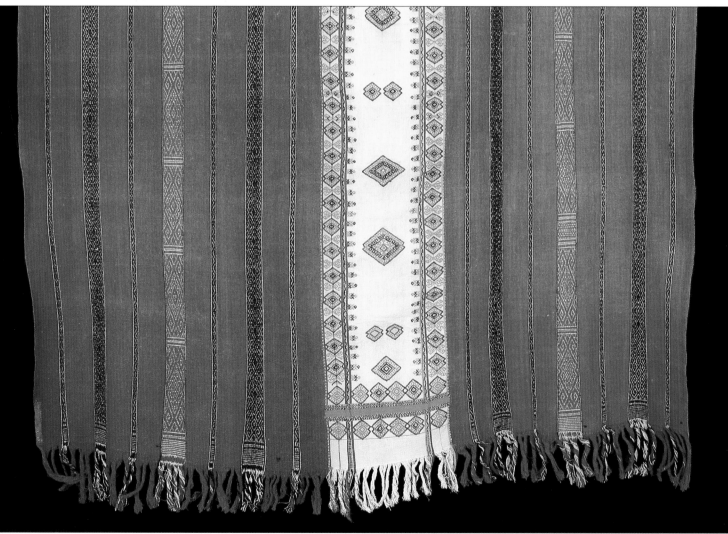

construction of cultural genealogies ('whereby some among us are apparently informed even of the primal civilisation of an as yet undivided humanity'). As an alternative, De Josselin de Jong expounded his ideas on the 'field of ethnological study', an approach that later became known as the Leiden School.

Meanwhile Vroklage threw himself into a study based on original sources in preparation for fieldwork in East Indonesia. For almost two years, he worked in the major libraries of Amsterdam and Leiden on a publication about Sulawesi, Kalimantan and the Moluccas. In 1936 his efforts resulted in the work *Die sozialen Verhältnisse Indonesiens. Eine kulturgeschichtlichen Untersuchung (The Social Condition of Indonesia. A Cultural Historical Study)*, a book that produced another disappointment because of his application of the *Kulturkreis* theory to the cultures of Indonesia: the verdict on the book by his peers from outside his own professional circle was decidedly negative. Vroklage did receive admiration for the quantity of material he had managed to collate.

The fieldwork itself, sponsored by the SVD and the Royal Dutch Geographical Society (Koninklijk Nederlands Aardrijkskundig Genootschap), began very successfully late in 1936. Vroklage first worked for seven months in the Timorese Belu area (an SVD mission field), made a short exploratory visit to Alor, and then travelled from east to west across Flores. Here in the Manggarai district (also an SVD enclave) he took up the thread of his study once again. He worked for more than six months before travelling to Java via Sumba, Lombok and Bali. A short trip across this island and the southernmost tip of Sumatra brought his study tour to a close at the end of 1938. The expedition was actually a Viennese idea, proposed by Wilhelm Schmidt himself, and despite the years of persistent criticism, Vroklage conducted himself in the field as Schmidt's ideal pupil. From interim reports published chiefly in missionary journals, it appears that Vroklage was constantly occupied with the identification of cultural complexes. Roughly speaking, in East Indonesia he saw a totemic 'primal culture' (naturally with a higher being as creator), later invaded by a 'matriarchal megalithic culture', and a bronze culture with a patrilineal organisation, which arrived later still. Partly to substantiate these ideas he established his large ethnological collection.

Vroklage sought to collect objects in particular on Timor and Flores, paying special attention to their form and decoration. In the early 1930s, the Austrian archaeologist R. Heine-Geldern had pointed out two characteristic stylistic periods in South-East Asian art. These appeared to support Vroklage's ideas. Heine-Geldern distinguished a 'monumental style' with robust forms, which he related to a Neolithic cultural complex that had come to Indonesia from the Asian continent a few millennia before Christ. He also noted a younger metal culture, equally originating from the Asian mainland, with highly characteristic decorative motifs ('ornamental style'). In this distinction Vroklage saw proof of his theories: he linked the monumental style with his 'matriarchal megalithic culture' and the ornamental style with his 'patriarchal bronze culture'.

In field report about a pair of stone statues (MNI 22463a/b) and a wooden drum (RMV 2380-255) which he had come across, Vroklage's comments are illustrative. After giving the local name and the place in which they were found, he remarks of the statues: 'The sacrificial posts with representations of ancestors belong to the megalithic culture, but the additional decoration comes

Detail of an ancestor statue, *Ai tos*

Belu, Timor
Collected by B.A.G. Vroklage; to Batavia
in 1938
Stone
Height 107 cm
MNI 22463a

Finger ring with female figure

Lio, Flores
Collected by B.A.G. Vroklage; to Leiden
in 1939
Brass
Length 5.5 cm
RMV 2416-1

undoubtedly from the bronze culture.' And of the drum, found high in the mountains: 'The ornamentation again comes from the bronze culture, and if one looks at the old form of the bronze drums on neighbouring Alor, it seems to me that the form of this drum is a modification in wood of the bronze drum. This would then be convincing proof of the influence of the bronze culture in Central Timor.' In this way Vroklage placed all kinds of object in his own self-created historical framework. Apart from material expressions of culture, physical anthropological measurements also served to underline Vroklage's argument. In Timor alone, helped by SVD staff, he made around 1700 skull measurements, took 2500 blood samples and collected 180 hand and finger prints. While still in the field he concluded: 'In general we see a very mixed population, entirely in accordance with the cultural mixture.'

Once back in the Netherlands, Vroklage sold the greater part of the ethnographic material he collected to the National Museum of Ethnology in Leiden (the series 2380, 2416 and 2449). A limited number of objects ended up in Batavia. The Leiden collection comprises hundreds of objects; notable among many outstanding items are a series of beautiful fabrics and a sub-collection of bronze ornaments.

Immediately on his return Vroklage also began to elaborate on his field notes. This resulted in a few short articles on the material culture of Nusa Tenggara. In them among other things he discussed boat symbolism on Flores, a concept that he considered to be closely linked to the bronze culture, and some large stone statues he had housed at the Museum of the Batavian Society. Furthermore he started to process his findings on the Timorese Belu, the people he had studied the most intensively. However, his work was rudely interrupted by the Second World

War. Vroklage was asked to put his energy into other matters. He attached himself to various seminaries to teach ethnology to future missionaries. Only in 1951, after Vroklage's sudden death, would the Belu publication see the light of day, under the title *Ethnographie der Belu in Zentral-Timor* (*The Ethnography of the Belu in Central Timor*). This work in three parts (including an ethnographic, photographic and linguistic section) is considered to be Vroklage's most important publication. The quantity of information presented is impressive and moreover the cultural sphere approach is absent. The manuscript was finally made ready for publication by F. Bornemann, director of the Anthropos Institute, an SVD research institute in which Vroklage had played an active role since 1935.

Vroklage's career had already turned out well. In 1948 he was appointed Extraordinary Professor of Ethnology to the Roman Catholic University of Nijmegen, which was regarded here as an 'auxiliary subject' to missiology. It was whispered that in occupying this position he took some distance from the Vienna School. However, in the introductory part of the ambitious series of books *Godsdiensten der mensheid* (*Religions of Humanity* – 1949) he firmly defended the 'cultural historical method'. Three years after his appointment as professor, Vroklage died unexpectedly after an accident on his moped. A cruel irony was that due to road safety considerations, he had asked the SVD directors for a scooter some months before. The order could not permit such a luxury; however. Vroklage was buried in Teteringen, in the cemetery of his beloved mission.

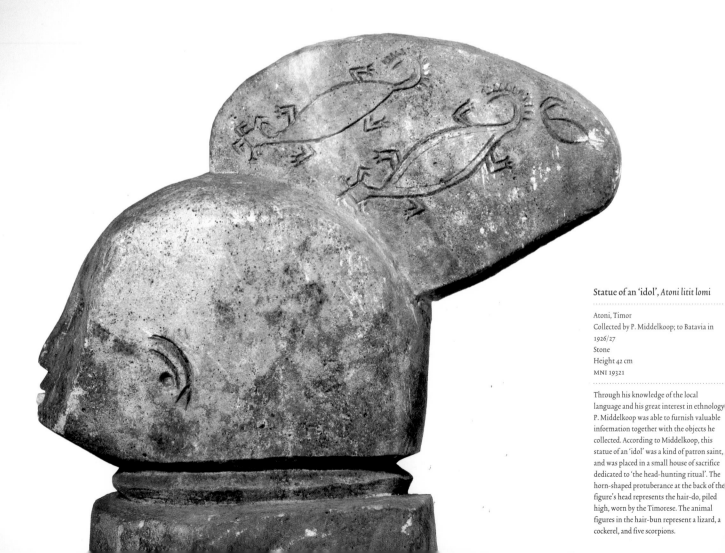

Statue of an 'idol', *Atoni litit lomi*

Atoni, Timor
Collected by P. Middelkoop; to Batavia in 1926/27
Stone
Height 42 cm
MNI 19321

Through his knowledge of the local language and his great interest in ethnology P. Middelkoop was able to furnish valuable information together with the objects he collected. According to Middelkoop, this statue of an 'idol' was a kind of patron saint, and was placed in a small house of sacrifice dedicated to 'the head-hunting ritual'. The horn-shaped protuberance at the back of the figure's head represents the hair-do, piled high, worn by the Timorese. The animal figures in the hair-bun represent a lizard, a cockerel, and five scorpions.

P. Middelkoop: servant of church and science

If Vroklage was a specialist who supported the expansion of Christianity as ethnologist, Pieter Middelkoop (1895 – 1973) did so as philologist. He spent a large part of his working life on Timor, first as a clergyman with a linguistic interest, later as a professional linguist with a commission to translate the bible into Timorese. During his 35-year stay on the island, Middelkoop grew to become the Netherlands' leading authority on Timor, with a long list of ethnological publications to his name. At the same time his deep religious belief, certainly early in his career, led him into entirely different activities. As a servant of the church he had to eradicate many expressions of ancestor worship from the island. Fortunately for science, Middelkoop set about doing so selectively. As a result, the Museum of the Batavian Society and the National Museum of Ethnology in Leiden received some rare religious objects.

How could someone who embraced Timorese culture at the same time radically alter it? The answer to this intriguing question chiefly lies in local circumstances, the period and Middelkoop's personality. The sense of religious duty and cultural fascination constantly struggled in him for priority, with his unshakable belief in God and church finally dominating.

Two matters seem to have lain at the root of Middelkoop's attitude: a missionary calling and a unique talent for languages. He was born in Amsterdam in 1895. Early in his youth he already felt a 'certain missionary calling' and after secondary school he joined the Dutch Missionary Society (Nederlandsch Zendelingen Genootschap) in Rotterdam. What followed was an eight-year training in a highly varied and practice-oriented range of subjects. When Middelkoop heard that he was to be sent as a missionary clergyman to the Dutch East Indies, he extended his studies by a year. He wanted to learn Malay and went to study with the East Indies expert H. Kraemer in Oegstgeest and the philologist O. Dempwolff in Hamburg. After marrying, Middelkoop and his wife set off for Batavia in the summer of 1922. Only there would they hear where they were to be posted.

This turned out to be the village of Kapan in the interior of western Timor. Kapan lay in the middle of the Atoni region where the Dawan language was spoken, popularly known as 'Timorese'. From the very beginning Middelkoop took a different approach from that of his colleagues. This was principally a matter of language. Within the protestant church it was usual for clergymen to be allocated a new posting every two or three years. Partly as a result of this they limited themselves to speaking Malay. There was little point in learning the local language; they preached with the aid of interpreters. Middelkoop broke with this pattern. He was keen to learn Timorese as quickly as possible to gain direct access to the hearts of 'his' people. He succeeded in this aim within a few months, partly owing to his great feeling for languages. Thus he was able to preach in the local language, while incidentally obtaining access to the Atoni culture.

Through his knowledge of Timorese, Middelkoop entered a strange indigenous world which fascinated him in every respect and roused in him a great ethnological interest. Full of enthusiasm he explored the thinking of the Atoni, learned their ideas about life after death, became acquainted with the basis of headhunting expeditions and other rituals, and gained insight into the history and mythology of the people. He wrote everything down and everything was published – language being the starting point – first in missionary journals, and not long afterwards in scientific series. Middelkoop soon felt himself to be the 'interpreter' of the

P. Middelkoop

In 1924, with his wife H.C.de Zwart and his young son Herman, in front of their home in the Timorese village of Kapan.

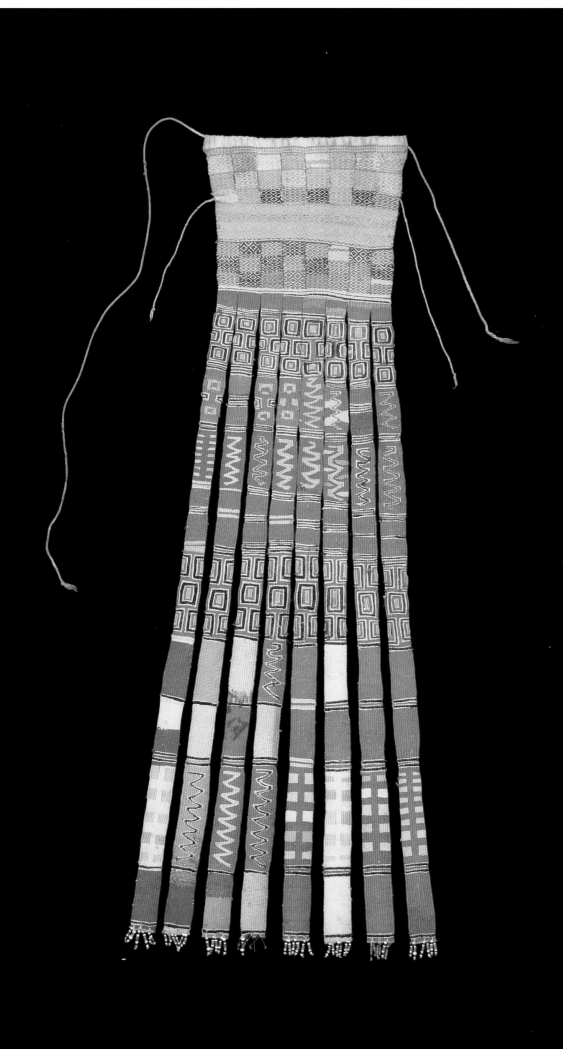

Head band, *Pilu saluf*

...

Atoni, Timor
Collected by P. Middelkoop; to Leiden in 1947
Cotton
Length 82 cm
Part of the head-hunter's ceremonial
clothing
RMV 2663-7

...

The wearing of ceremonial head bands
was already more or less obsolete by
Middelkoop's time. This unique shot 'in
the field', taken in the hamlet of Sebau by a
colleague of Middelkoop, dates from 1941.

▸

Head band, *Pilu saluf*

...

Atoni, Timor
Collected by P. Middelkoop; to Leiden in 1947
Cotton
Length 36 cm
Part of the head-hunter's ceremonial
clothing
RMV 2663-5

Atoni's way of thinking and feeling and became increasingly attached to their culture.

Despite the flourishing demand for ethnology, Middelkoop did not forget his main task, missionary work. Although he was impressed by the way the Atoni experienced their culture, he placed his ethnological observations in the service of Christianisation. And because he was not transferred to another posting, he would with time come to integrate more and more Atoni concepts into this approach. Moreover, his relegation of ethnology to second place could be seen in his cooperation in the ritual burnings that were intended to suppress the local ancestor worship – the heart of the Atoni religion. Simular ritual burnings took place in various missionary fields in East Indonesia and were probably the consequence of an ecclesiastical guideline. On the Southeast Molucca, for example, statues of ancestors were destroyed, as were magical *naga* sculptures on Alor. With the Timorese Atoni, various kinds of ancestral objects were involved. It appears that these objects were collected at village schools (controlled by the mission), after which the Dutch clergyman performed the burning ritual. A letter from Middelkoop to his parents-in-law contains a unique report of this ceremony:

> I saw them collected at the school. Old swords, lances, home-made woven baskets (so-called poni) of which one part slides over the other with all kinds of relics of deceased parents or relations, amulet bags, silver plates, large pots (so-called anar), in many of which child's hair was kept. One by one I investigated baskets and bags, with a wide variety of contents such as coins, English-Indian or English-Chinese money, Dutch money, large and small half-decayed cloths, beads, bottles, bundles of wood, a porcelain bowl, smooth stones, a water

> buffalo hoof spurs, etc. As they were opened, they stood around us, men and women; among all these objects there were many that were keepsakes of their deceased loved ones. In this respect these things have far more attraction for them than they do for us. Such a tangible memory of relations is precious to them, even though this attachment is also associated with the secret fear of the power that resides within them, fear too for the trait d'union it forms between them and the spirits of the deceased owners.

The burning itself was introduced by a prayer. Middelkoop writes about this in the same letter:

> Returning to the Atoni and their break with the past, I would like briefly to give you an impression of the burning. Of course we felt something of the gravity of this deed. Thus, when we first came together in prayer, I spoke to them saying: 'Thou art bound to all these remembrances, thou lovest them dearly and fearest them. In sickness or distress, in war or peace, it is your custom to make known your hopes and fears to these objects; if you wanted to make a garden to plant maize, or if you desired to increase the number of your water buffalo, your wishes were laid in supplication before these holy objects. If your house remained childless, it was here you poured out your woes. But now you are changed, from now on you will make known the desires of thy heart, the afflictions of your soul, your joy and sorrow to Oeis Neno (the Lord in Heaven) and His Son, our Lord Jesus. You now know that neither wood, nor stone, nor objects kept in remembrance of the deceased, has any power whatsoever. You now declare that only Oeis Neno is mighty and strong, that his Son, Oeis Jesoes, has come to take away the fears of men, be they of Evil, of spirits and witches (lasi ala 'oet), because he is stronger than them. Neither shall you fear death, because the Lord Jesus gives a strong soul

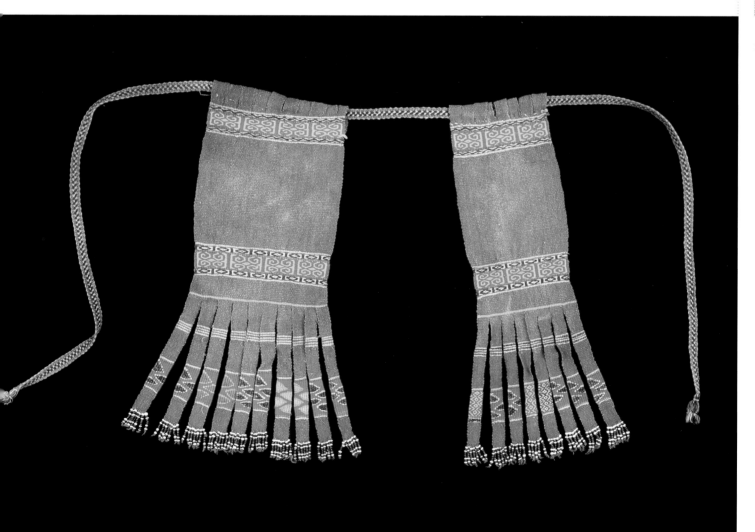

and a new body. Although this body shall die, your soul shall live and from the Lord Jesus you shall receive a new body, shall live in his Soenaf (palace), afflicted neither by sickness, suffering or death. May great joy be in your heart.' We prayed, and then went outside. It was already dark. The pile was brought outside, large dry leaves of the gewang, a sort of wild palm, were added. I helped to light it myself, some young Atoni did so with all their heart and soul. The small flames hesitated a moment at the edges, but soon they reached higher and higher. The fire crackled from the big leaves, the flames leapt up, and sparks flew. The people watched in silence, the men with arms folded, the women squatting on the ground. We all were silent – above us arched the starry sky; in heaven and on earth this flaming fire declared that something was under way. The old went up in flames, also in men's hearts. Certainly, the smouldering remains will remain for a time, but still, God is working here to make a new beginning in these hearts. It made a strong impression on us all.

However much he wanted to serve his God with such actions, Middelkoop could not find it in his heart to throw all the Atoni objects that were collected onto the fire. Before the ritual described here, he set aside some old headhunting swords. Also on other occasions on which the Atoni 'wanted to break with the past', handing over significant objects to him, he spared them. In many cases they were objects that because of his in-depth knowledge of Atoni culture, Middelkoop knew to have great ethnological value. Torn between missionary calling and ethnological passion, he gave priority to the latter.

Already on his arrival in Batavia in 1922, learning that he was to be posted to Timor, Middelkoop visited the Museum of the Batavian Society to gain an impression of the island and its people.

There he also met linguist P. Voorhoeve, who gave him a first glossary of the Timorese language. It was logical therefore that in 1927 Middelkoop should donate his first collection of Atoni objects to the museum in Batavia. Among the items in the collection were six 'very old (probably 200 to 300 years) champion's swords with sheaths (pedang meo), which are worshipped as holy objects'. Most likely these were specimens saved from the ritual fire. Not surprisingly, the entire collection was excellently documented (MNI 19321). After the Second World War, the museum in Batavia received a few more gifts from Middelkoop, and the National Museum of Ethnology in Leiden was also a grateful recipient. In 1947 more than sixty objects arrived at the latter museum (RMV series 2663), among which were a number of rare pilu saluf, headbands belonging to the traditional dress of the meo, men with the status of head hunter. In his book Head hunting in Timor and its historical implications (published in 1963, but based on data collected before the Second World War) Middelkoop describes these cloths and their origins: inhabitants of the village Bi Naus gave them to him on their conversion to Christianity.

Meanwhile Middelkoop had become a professional bible translator. As clergyman, and due to his knowledge of Timorese, he had already translated many bible stories and through the intercession of Kraemer, his old Malay teacher, in 1937, this became his main occupation. The translation would take him twenty years. He worked in the tradition of N. Adriani (see the article by Hari Budiarti) and completed the task in 1957. In this year, he also left Timor and returned to his native country. Also in the Netherlands, his love of both God and the Atoni determined a large part of his life. In 1960, at the age of 65, he received a doctorate in theology concerning the confrontation of Atoni culture with

190

Ceremonial sword, Le'u musu

Atoni, Timor
Collected by P. Middelkoop; to Batavia in 1948-51
Metal, wood, hair, cotton
Length 84 cm, height 96 cm
Furnished with decorated shoulder clasp
MNI 26685

Staff of the southern exploration detachment, in 1908

Sitting, with cap A.J. Gooszen (2); far right, sitting, J.H. Daam (3); behind Gooszen stands B. Branderhorst (7); to his right J.M. Dumas (6); far right, standing, O.G. Heldring (4).

the Holy Scriptures. He then combined activities at the Dutch Bible Society with lectures on Timorese at the University of Leiden.

Middelkoop died in 1973 in Driebergen, but he lives on in memory. In ethnological circles in the Netherlands he is still known as 'the great Timor authority'. And in Indonesia he is praised as the man who made the *Gereja Masehi Injili Timor* (the Protestant Church of Timor) flourish. Thus, both in life and death Middelkoop's name is associated with ethnology and religion.

The military officer
Pioneers in New Guinea
During the heyday of imperialism, military force in the East was not an unusual phenomenon. Various examples of this have been discussed here previously. At the same time the Dutch East Indies administration also deployed the colonial army in more peaceful ways. In 1906, government advisor on overseas possessions H. Colijn (later prime minister of the Netherlands) proposed a plan to have military units explore the interior of Dutch New Guinea; this was intended to put the political claim to the territory on a firmer basis. Colijn made one proviso: 'In the unlikely event that the penetration of the interior were to require a degree of force, the exploration should be halted immediately, as this would be to embark on a road of which the end, even after an appraisal, is impossible to determine.'

In 1907 the plan became a reality. It was decided to mobilise three detachments for the exploration of the south, west and north of the island. They were to set off from Merauke on the south coast. Eight years later the expeditions came to an end on the north coast, in the Mamberamo River Basin. Despite the often hostile attitude of the inhabitants and the nearly always extreme circumstances of the terrain – from virtually impenetrable swamps to barely accessible mountain ranges – the expeditions were a success. Extensive areas were mapped, extremely isolated peoples discovered, and thousands of objects collected, including ones of an ethnological nature. By order of the Dutch East Indies government these were transferred to the Museum of the Batavian Society. The State Ethnography Museum in Leiden would receive duplicates.

Of the activities of the military explorers, it is primarily those of the southern detachment that have become well known. This was thanks to a series of newspaper articles in which Commander A.J. Gooszen, under the pseudonym Pioneer, reported his experiences to the home front. The unit was to cross an immense area of rivers – 'the devil's own country [in English]'. They did so by travelling as much as possible by river, and then continuing on foot from base camps. In this way they pushed slowly westwards from Merauke. In Gooszen's articles, the rigours of the journeys on foot is a recurring theme:

> The exploration is starting to become difficult due to lack of water. Before the end of each day's march, a place with water must be found. It would be too heavy a load to carry cooking and drinking water for 20 to 30 men. We now have to travel distances that the indigenous inhabitants usually cover in three to four days, without interruption, which means marching 30 to 40 km. This at a temperature of 34 to 37°C! These fellows shake their heads when they hear of such achievements and think us very strange. They simply cannot understand it.

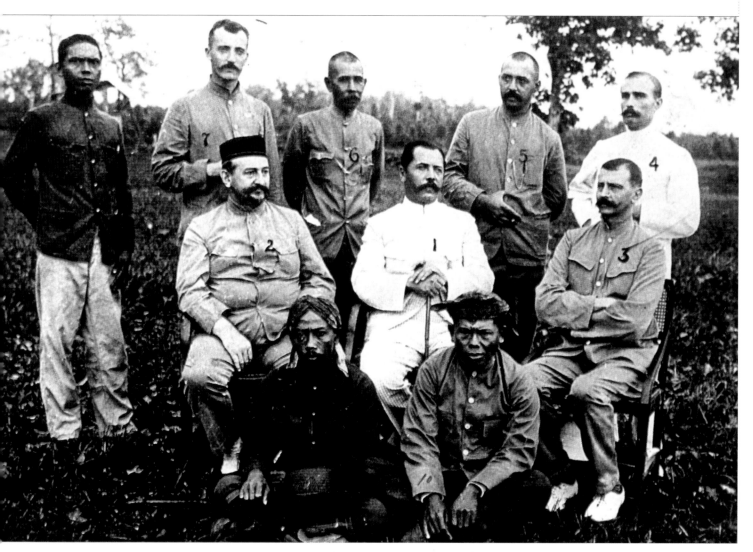

The southern detachment finally finished its task in 1913, after six years of exploration. Already, soon after its beginning, in 1907, accompanied by more than 80 soldiers and the same number of forced labourers, few remained of the original staff. Despite his enthusiastic reporting, Gooszen gave up the journey after a year, exhausted by bouts of malaria. Fellow commander J.H. Daam, jointly responsible with Gooszen for the cartographical survey, dropped out with him. And Medical Officer B. Branderhorst, who led the ethnological and botanical study, turned his back on the detachment in 1910, together with geologist O.G. Heldring. It was the 'general naturalist' J.M. Dumas who had the greatest stamina, taking part in the expedition for more than four of the six years. But owing to his participation in the earlier Wichmann expedition (see below) it was he who had the most experience of New Guinea.

Neither of the other detachments had a 'travelling reporter' among their ranks. Their findings therefore never reached a wide public. Nevertheless, the challenges faced by the northern and western detachments were not less exciting. In the north, a coastal strip and beyond it a mountain range shrouded in mist were yet to give up their secrets, and in the west the intriguing Bird's Head (Vogelkop) awaited exploration.

In 1909 the northern detachment landed to the east, in Humboldt Bay. The choice of this location was partly the result of a political assignment. In 1910 a Dutch-German border commission was to determine the exact border between the two territories and in preparation for this it was the detachment's task to look for 'natural frontiers'. With a large bivouac (named Hollandia, now Jayapura) as a base, they first explored the coasts of the border area, and then a large patrol – including members of the border commission, who had since arrived – departed for the mouth of the

Sepik River. To determine the border in the hinterland, the patrol travelled more than 800 kilometres upriver, mapping as far as the upper reaches. The political excursion was followed by a further exploration of the north coast, alternating with 'thrusts into the interior'. Early in 1912 the unit moved to Manokwari, where the expedition ended with an extensive exploration of Geelvink Bay.

The western detachment only became operational in 1910; the group originated from a column of military police already stationed in Fakfak. During the four years that the unit was active, it made a number of impressive 'traverses' from coast to coast. Its base remained in Fakfak; from here patrols were taken by sea to a starting point and later picked up on the other side of the country. To reach the sea, they regularly ventured through the dark forests of the lowlands, with all the risks this involved: 'We were now walking chest deep in water. I could see that the water, which was flowing rapidly through the forest, was rising. The guides said that a hill was not far off and urged us to go faster. We then exerted all our strength to reach this hill, and succeeded.' As this passage shows, the official reports could hold their own with articles by Pioneer.

The work in New Guinea ended with the exploration of the Mamberamo River Basin, the largest river in the Dutch territory. To do this, in 1913, the northern and southern detachments were combined to form a group of around 400 men, half of whom were forced labourers. The unit built on earlier expeditions by Captain A. Franssen Herderschee (1909) and Lieutenant J.T.J. de Wal (1911). Here, early in 1915, the last blank areas of the map were filled in.

As with the southern detachment, the leaders of the northern and western units worked according to a 'classic' model, whereby the medical officers performed the ethnological

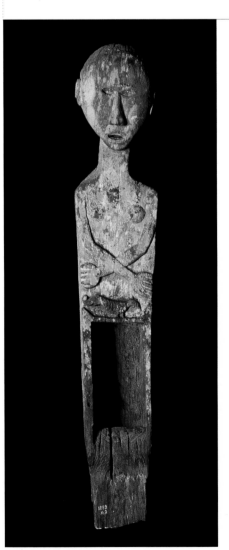

◄◄
Ancestor figure, *Sedeu*

Kai, Moluccas
Collected by A.J. Gooszen; to Leiden in 1914
Wood
Height 165 cm
RMV 1889-2

The statue represents *Werwat*, an important ancestor

◄
Ancestor figure

Kai, Moluccas
Collected by A.J. Gooszen; to Leiden in 1914
Wood
Height 80 cm
RMV 1889-15

The statue may represent the 'daughter' of *Werwat* (RMV 1889-2)

►
Werwat and 'daughter'

Photographed is situ in 1911/12, at the ritual centre of the hamlet of *Gelanit*. Not long afterwards, both statues would be removed from the Kai islands by a subordinate to the military Commander A.J. Gooszen.

research. In addition to general 'anthropological' descriptions (volksbeschrijvingen), their task was to acquire ethnographic material. They did this chiefly by means of barter; the army had funds in the budget allocated to 'goods for exchange'. In general the medical officers worked hard to document their collections as fully as possible. They were very aware that the scientific value of a collection depended on this. The documentation accompanying the dispatched objects nearly always included the local nomenclature, place of origin and information on the object's use.

During and after the military expeditions, the Department of War supplied an impressive number of crates containing ethnographic material to the Museum of the Batavian Society. To the Dutch East Indies Army, this Society was the obvious partner to manage these collections. The institute operated as a semi-governmental organisation and it seemed sensible practice to place in its custody any 'officially obtained' objects of art or culture (including spoils of war; see for example the articles by Francine Brinkgreve, Wahyu Ernawati and Hari Budiarti). Not all the objects acquired in New Guinea reached Batavia, however. The material from the south and north was indeed delivered, but in the case of western New Guinea something went wrong. According to the official report: 'Due to a misunderstanding, of the ethnographic material collected in the western part of the Dutch territory, only those originating from the region to the south of the Charles Louis and Nassau Mountains have been passed on to the Society, and other institutions have received the others'. What these other institutions were is unclear.

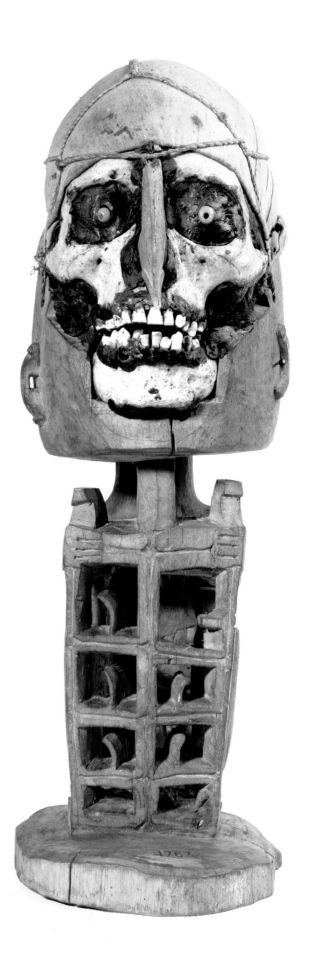

Ancestor figure, *Korwar*

Biak, New Guinea
Collected by W.K.H. Feuilletau de Bruyn; to Batavia in 1916
Wood, skull, clay, cotton, string
Height 50 cm
MNI 17632

Despite this 'western gap', the New Guinea collection in Batavia was more than tripled: more than 2450 new objects were registered. Three types of acquisition stood out: religious artefacts, clothing and jewellery, and – not surprisingly – 'battle equipment'. By far the greater part of the collection came from the southern regions. Here, Medical Officer Branderhorst was assisted by Commander Gooszen and geologist Heldring. However, the Geelvink Bay area was also well represented. More than three hundred objects from the Sepik Basin formed an exceptional collection, a souvenir from the Dutch-German border survey, assembled by Medical Officer K. Gjellerup.

In one fell swoop the museum apparently possessed the world's largest New Guinea collection, but this was not the reality. While the Department of War delivered one batch after another to Batavia, in the same period Pioneer Gooszen sent around 6250 objects to the National Museum of Ethnology in Leiden. Whether the Society in Batavia was aware of this remains an open question. Given the uniqueness of many items – these were definitely not duplicates – the alarm should have been raised when the objects left the port of Batavia. Gooszen's objects reached the Netherlands in three batches, in 1911 (RMV series 1779) and 1914 (series 1889 and 1971). The bulk of the ethnographic material – around 6200 objects – arrived in the latter year. But it is precisely for this impressive batch (in total more than 13.5 cubic metres!) that the documentation leaves much to be desired.

The reason lay probably in the method of collection. After a period of recovery in Europe, Pioneer returned to East Indonesia in 1913, as military commander of Amboina and Ternate. In this position he took command of all the exploration work and had ethnographic material collected on a large scale and in a short period of time – by subordinates of all kinds. In New Guinea this method produced more than 5000 objects, among them several dozen unique Mimika items. In passing, the neighbouring Moluccan Islands, such as Seram, Buru, Kai and Tanimbar, were 'plundered' (yielding around a thousand objects) and the large wooden ancestor statue *Werwat* (RMV 1889-2), for example, was taken from the village of Gelanit on Kai Kecil. The colonial administrator Van Hoëvell, by this time retired, who had taken care to leave this statue in place (see earlier in this chapter), probably knew nothing of it.

Gooszen had private plans for the collection which he – probably quite deliberately – sent on to the Netherlands avoiding the Society: they were intended to obtain him a position at the State Ethnography Museum at the end of his military career. His (unfulfilled) wish was to be able to establish a representative New Guinea department, ordered according to river areas. Moreover, he wanted to make a political point: in his eyes it was not the museum in Batavia but the one in Leiden that was the proper institution to house ethnological collections from the Dutch East Indies. Aside from this, Gooszen also provided duplicates to other Dutch museums. The present-day Tropenmuseum in Amsterdam (Royal Institute for the Language, Geography and Ethnology, or KITLV) and the World Museum (Wereldmuseum) in Rotterdam received objects, as did the ethnological museums of the Royal Military Academy (Koninklijke Militaire Academie) and the College of Tropical Agriculture (Landbouwhogeschool) in Deventer, both of which no longer exist. Gooszen also gave duplicates to the Musée de l'Armée in Paris and the Museum of Ethnology (Museum für Völkerkunde) in München. Appreciation for this came from many directions, and he received honours in the Netherlands, Germany and France.

Decoration for a prow

Asmat, New Guinea
Collected by the southern detachment of the
Military Exploration team; to Batavia in 1910
Wood
Length 72 cm
MNI 14674

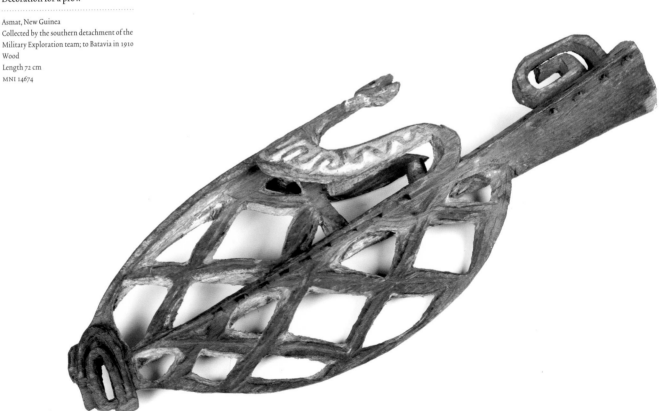

Had Gooszen's practices in Batavia been known, legal action would probably have been taken against him. The society's governing body did not generally allow itself to be ridiculed and in this case – because of the government decision to grant all ethnographic material that was collected to the Batavian Society – it would have been entirely in the right. The pugnacious attitude of the governing body appeared from the vicissitudes surrounding a third 'exploration collection', assembled by Infantry Lieutenant W.K.H. Feuilletau de Bruyn. He had served in both the southern detachment and the Mamberamo unit and in continuation of the exploration he was sent in 1915 to the Schouten and Padaido Islands. There he stayed for more than a year on Biak, where he assembled an ethnological collection.

Early in 1916, Feuilletau de Bruyn decided to send his collection to the Department of War in Batavia, with the request that it should be forwarded to the Colonial Institute (the present-day Tropenmuseum) in Amsterdam. When asked to authorise the export, the governing body of the society agreed, on condition that it would be given the opportunity to add the collection to the museum in Batavia 'as first claimant'. It was not the government order that was decisive here – by the time the Biak collection was established the military exploration had in any case come to an end – but the thought that this was an officially obtained collection, which was in fact government property. In this light, the collection's destination was also called into question: where objects acquired by public servants were exported, they should properly have gone to the State Ethnography Museum in Leiden.

With the law on his side, Feuilletau de Bruyn protested and via the Department of War informed the society that there was 'no known government decision that might grant the Batavian Society the right to retain for the Society's Museum ethnographical objects collected by public servants or other persons for museums in the Netherlands.' However, he was prepared to give the society some duplicate items. The question was finally settled in a 'gentleman's agreement'. The society withdrew its objections and Feuilletau de Bruyn gave it around twenty objects, including an impressive *korwar*, a statue containing the skull of an ancestor (MNI 17632). The rest, 153 items, went to Amsterdam.

In drawing up the balance it can be said that the military exploration of New Guinea had greatly enriched the collections of at least three major ethnological museums. In total nearly 8850 objects made their way to Batavia, Leiden and Amsterdam. During the exploration around 140 'explorers' lost their lives. Partly owing to this sacrifice, in just a few years the heavy veil that for centuries had hung over the unknown west of New Guinea was lifted to a great extent.

The scholar

G.A.J. van der Sande: a 'generalist' in uniform At the beginning of the twentieth century, apart from officers in the military, scholars were also interested in Dutch New Guinea. A variety of organisations, with the aim of increasing knowledge and commercially exploiting the Dutch tropics, financed study tours of the region. Most active of these were the Royal Dutch Geographical Society (Koninklijk Nederlandsch Aardrijkskundig Genootschap) and the Society for the Advancement of Physical Research in the Dutch Colonies (Maatschappij ter Bevordering van het Natuurkundig Onderzoek der Nederlandsche Koloniën), otherwise known as the Treub Society. In 1903 the latter initiated a

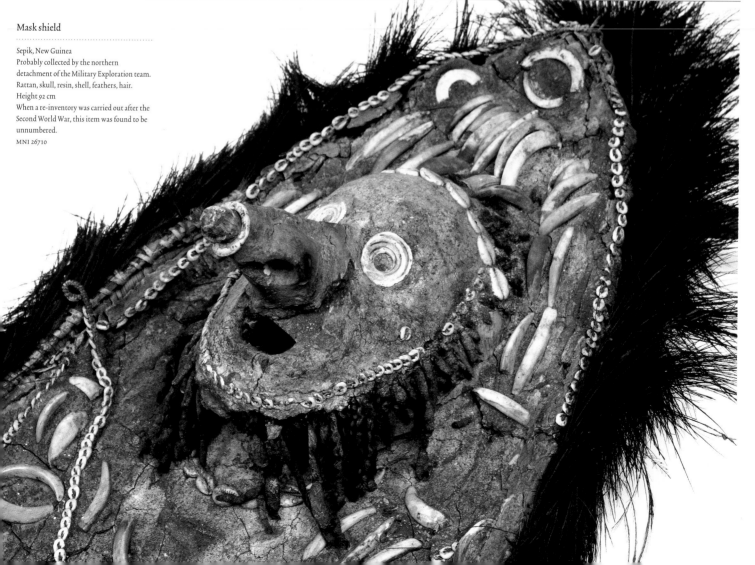

Mask shield

Sepik, New Guinea
Probably collected by the northern detachment of the Military Exploration team.
Rattan, skull, resin, shell, feathers, hair.
Height 92 cm
When a re-inventory was carried out after the Second World War, this item was found to be unnumbered.
MNI 26710

scientific expedition to the north coast of the island.

Among the members of the team was Gijsbertus Adrian Johan van der Sande (1863 – 1910). This broadly-oriented army medical officer had a dual task: he was to study the population in terms of physical anthropology and at the same time record them ethnologically. Partly thanks to Van der Sande's results, which brought with them well-documented ethnographic material, the expedition was a success. The medical officer himself did well out of this: as a 'reward' his superiors gave him plenty of room to continue his scholarly work.

Van der Sande arrived in the East at the age of 30. Born in Arnhem, the Netherlands, in 1863, he already cherished ambitions in his youth to join the army, attracted by the physical challenge. At first, however, an eye-defect prevented him from taking up a military career. As an alternative, he studied medicine in Amsterdam. Having completed this, however, he was able to fulfil his dream after all: in 1890 he was appointed as a medical officer in the navy. After two years stationed in the Netherlands, Van der Sande left for the Dutch East Indies. There he arrived in an entirely new world, which stimulated his scientific curiosity in many respects. During tours of duty he soon began – alongside his medical work – to 'record' the animal world around him. Everywhere he went he collected species which, once preserved in alcohol or stuffed, were sent to the National Museum of Natural History (Rijksmuseum van Natuurlijke Historie, the present day Naturalis) in Leiden. In 1895 this pasttime gained him an official decoration: the 'silver medal for services regarding the national collection of science and art'.

At the beginning of the twentieth century, Van der Sande decided to start performing his extra activities on a more professional basis. In 1901, on surviving the Aceh war in one piece and with a knighthood, he returned to Europe to qualify in photography and physical anthropology. He learnt the finer points of skull measurement in Zürich, Switzerland, from the expert R. Martin. The expenses for this training were paid by the Treub Society probably in preparation for the New Guinea expedition of 1903, which the organisation also financed. This expedition, lasting almost seven months, brought Van der Sande everything he wished: a combination of scientific and sporting adventure.

The expedition, customarily named after its leader C.E.A. Wichmann, was intended as a general exploration of northern Dutch New Guinea. More specifically, it aimed to explore the Geelvink and Humboldt Bay areas, including Lake Sentani. An important spearhead of the expedition was a study of commercially exploitable coal fields. Besides geologist Wichmann, the expedition team comprised L.F. de Beaufort, a zoologist, and the naturalist J.M. Dumas, 'familiar with life in the jungle'. Moreover, H.A. Lorentz, a self-made biologist who supported De Beaufort, also joined the expedition at his own expense. Van der Sande participated as doctor, ethnographer and physical anthropologist; he was also responsible for a great deal of the photography.

An important base for the expedition was a house that had been specially built on an island in Humboldt Bay, from which many different kinds of journeys were undertaken using a ship provided by the government. This way of performing the research meant that the emphasis lay on observations in the coastal areas, supplemented by various trips into the interior on foot, lasting

G.A.J. van der Sande

During his consultations on the north coast of New Guinea (1903)

The team of the 1903 Wichmann expedition

Far left, G.A.J. van der Sande

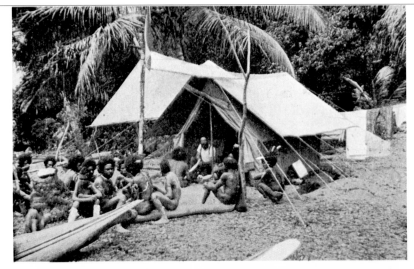

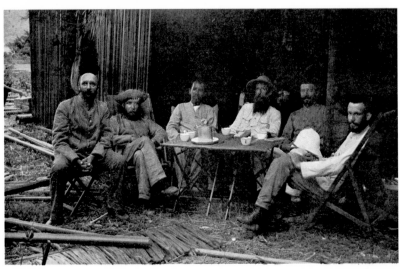

several days. Lake Sentani was also explored by boat; to do so the expedition had a lifeboat carried by dozens of bearers from the research ship to the lake. At the end of each trip, the ship's deck became an improvised laboratory: 'There were stones laid out to dry here, bottles and tubes of alcohol there, and numerous ethnographic objects piled up ready to be loaded into crates.'

From Ternate, the place where they had 'left civilisation behind them', Van der Sande had brought a complete set of medical equipment, including a pharmacy and operating table. During the fieldwork he continually took the time to help the local population. In Humboldt Bay he held a surgery in the newly built house; during the trips on foot he often received his patients in a tent. As in Aceh he came across war wounds. Instead of bullets, however, he had in New Guinea to remove arrow heads. The medical work brought him into close contact with the population and it was a good point of entry for the collection of ethnographic material. While Van der Sande certainly had an eye for aesthetic quality, his collection was above all an inventory. In principle everything in the field of material culture was eligible; the limitation lay in the fact that people were not always willing to part with certain objects. Although a wide range of goods for barter had been brought (tobacco, beads, knives, axes, cotton and even harmonicas), Van der Sande failed to obtain, for example, highly valued glass arm rings in Humboldt Bay. Even the huge offer of 'thirty axes' was turned down: 'The owner turned with a laugh and disappeared.'

Although it is never stated explicitly, such incidents must have rankled with Van der Sande. His scientific passion to establish a collection that was as complete as possible in the space of a few months did not allow for many hindrances. Nevertheless, in general he continued to treat 'recalcitrants' with respect. He lost control only on Biak, during a brief stop on the home journey. Under protest from bystanders, he cut a lock of hair from someone, with eight large beads attached to it. It later appeared that it was not jewellery he had removed from the victim, but mourning dress.

Fortunately, Van der Sande's enthusiasm was also expressed in quite different ways. To further his study of physical anthropology, he lived alone for a month in the village of Ase on Lake Sentani. He believed that this would increase his chances of being able to measure and photograph the shy female inhabitants. But by participating in village life he also aimed to bring greater depth to his ethnological work. With this approach, Van der Sande in fact became an early 'modern' field worker. Only more than a decade later, in 1915, did 'participant observation' become a worldwide standard method of ethnological research.

The Wichmann expedition supplied both the ethnological museum in Leiden and the Museum of the Batavian Society with a wealth of well-documented ethnographic material. Van der Sande donated the material to the two institutions in 1906, via the Treub Society which, having financed the project, was formally the owner. He did this after completing his study report, which he wrote during a long leave in Amsterdam. For this purpose, the entire collection (more than 900 objects) was first shipped to Europe; more than a third of the objects then went back to the Dutch East Indies. In the report, Van der Sande presents a detailed overview of the material culture of northern Dutch New Guinea, on the basis of a large number of functional categories. Many of the objects collected can be found – described and illustrated – in the report, while it also contains analysis of the material relating

Small jacket, *Runga*

Runga Flores
Collected by G.A.J. van der Sande; to Leiden in 1909
Fibre, cotton
Height 47 cm, width 42 cm
RMV 1710-49

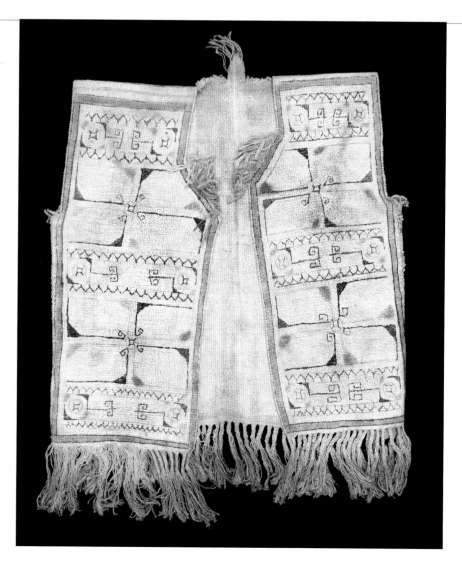

to physical anthropology. Although it is a substantial volume, the researcher does show himself to be conscious of the limitations of his data: 'It will easily be understood that in short visits and with scanty knowledge of the language, little information can be obtained with regard to the life of the Papuan.'

From letters written in 1907 to Lorentz, who had also been a member of the expedition, it appears just how much trouble Van der Sande had in producing his report. He clearly valued desk work less than physical work. Referring to the fact that Lorentz had just completed a second trip to New Guinea, Van der Sande wrote to him: 'You'll certainly be writing up some material now, won't you? That's not as jolly as the sporting pleasures of the expedition itself! It's given me the jitters too, swotting away on the 3rd book of the 1903 expedition [his report]. In fact I've given up my entire Dutch leave for it, time and money.'

His efforts were not wasted, however. Returning to the navy in 1907, Van der Sande was given every opportunity to continue his scientific work, this time within a hydrological project in the waters around the Lesser Sunda islands. Apart from medical work, this focused on the collection of zoological material – ethnography and physical anthropology came in second place. This time too Van der Sande made preparations in Europe. He was trained by the Amsterdam zoologist M.W.C. Weber, a specialist in deep sea research. His employer did not do badly by him either. A small laboratory was specially installed for him on board the research vessel Van Doorn. The material collected could thus be correctly prepared and conserved. In essence the project involved charting the coasts of Flores, Sumba and Timor. The level of the seabed was measured and beacons were placed on land in strategic places. Alongside his zoological work, Van der Sande regularly found

time for ethnological and anthropological exploration. Here he followed the successful pattern established in New Guinea: he made contact by offering medical help and then attempted to take measurements and collect ethnographic material, again in an encyclopedic fashion.

As far as it is known this two year project only produced acquisitions for the State Ethnography Museum in Leiden. Van der Sande sent around two hundred ethnological objects to the Netherlands, of which almost half were household objects and tools (RMV series 1671 and 1710). A fault this time was the incomplete documentation: the shipments were only accompanied by a few diaries, containing individual notes on the objects and their cultural context. For Van der Sande, the ethnography of the Lesser Sunda Islands was clearly a side issue. After the project ended, in 1909, this scientific all-rounder requested a transfer to a guard ship in Surabaya. The navy's support for his 'extra activities' was dwindling and he wanted to settle down to an existence as doctor. The self-imposed end of his career as a researcher was graced with an honorary doctorate from the University of Utrecht. His stay in Surabaya did not last long, however. Early in 1910, Van der Sande died unexpectedly at the age of 47.

P. Wirz: a collector in paradise

The Wichmann expedition and the military exploration were part of a series of exploratory expeditions that, at the beginning of the twentieth century, aimed at a more thorough mapping of New Guinea. Although, in many respects, it is true that they added to the knowledge of the country and its people, only fleeting encounters were actually involved. The expeditions never stayed long in one place and the researchers focused on collecting a wide variety of facts and objects. Depth – for

Ceremonial sago pot

Humboldt Bay, New Guinea
Collected by G.A.J. van der Sande; to Leiden in 1906
Pottery
Diameter 32 cm
Vertebrate animal on the side of the pot
RMV 1528-37

A colour plate from Van der Sande's report on the 1903 research published in 1907. Shown here are two of the sago pots he collected, combined with drawings of the decorations on the walls of the pots

example a record of social relations, creation myths or religious concepts – was lacking.

This changed with the coming of the first professional ethnologists to the island. One of them was the Swiss ethnologist, Paul Wirz (1892 – 1955). From the 1920s onwards he regularly visited New Guinea to carry out long-term field work with a variety of ethnic groups. Wirz felt a connection with the island and saw it as a second home. Moreover, he became fascinated by the material culture. During a collecting trip, he died is his boots and was buried in New Guinea.

At first it did not seem likely that Wirz would become an ethnologist. After a youth spent in Moscow, where he was born in 1892, the son of a Swiss industrialist, he studied technical science in Zurich. However, as a student he travelled widely and was deeply affected by the traditional cultures of Africa and Indonesia, and in particular of New Guinea. This was the reason for his switch to ethnology. The profession suited his personality: as an ethnologist he could work independently and do so in an exotic environment in which adventure and romance usually went hand in hand. In 1920 he gained a doctorate in the religion and material culture of the Marind-anim. He got to know this people during his first introduction to New Guinea. Together with his wife he stayed from 1915 to 1918 in the Merauke area on the south coast. Here there were villages that had still hardly been touched by Western culture. As one of the first outsiders, Wirz was given the chance to attend ancient rituals belonging to the *dema* cult. His detailed reports on this later proved to have authoritative value.

New Guinea would continue to exert a strong attraction on Wirz. He returned there six times more, sometimes for years, always staying in a different region. He thus explored Geelvink and Humboldt Bay, climbed the western and eastern mountain ranges, performed research in the Gulf of Papua and visited the Sepik Basin. His love for the island was based on a deeply-rooted antipathy for modern Western civilisation, which he felt did not allow for a harmony with nature. Wirz was searching for a 'South Sea Paradise' (*Südseeparadies*) with 'natural peoples' (*Naturvölker*), and thought he had found it in New Guinea. On his stay there he wrote: 'No, it was this free life, at one with nature, that here, and only here, even though it was only for a short time, I was able to share with the children of nature. [...] Only here was I allowed to feel truly human.'

During his travels on the island, Wirz collected large quantities of ethnological objects. His motives were various. His collecting began from a purely scientific point of view, but soon gained another element: a fear that characteristic cultural objects would disappear because of the rapid advance of Western culture. A third motive that began to play a role was of an economic nature: by taking on collecting commissions for museums he was partly able to finance his expensive trips.

The scientific motivation lay behind the first two collections that Wirz assembled on New Guinea. During his stay with the Marind-anim in the years 1915 – 1918, he collected hundreds of objects, many of which were of a ritual nature. The collection was important in many respects. Firstly the objects provided a virtually complete overview of the material culture of an unknown people. Furthermore, they functioned as objects of study within the evolutionist pattern of thought that dominated Wirz's time: the objects were thought to say something of the Marind-anim's 'degree of civilisation'. During a second major trip (1920 – 1924) a collection was assembled on the same

grounds. In Batavia, on his way to renew his acquaintance with the Marind-anim, Wirz was invited to take part in the final exploration of the Central New Guinea Expedition. During this journey, made in 1921, as a member of a multidisciplinary team his task was to explore the western Dani in terms of ethnology and physical anthropology. He completed the task with verve, and this time too his scientific report was supported by an extensive ethnographic collection.

For the idealistic Wirz, at the end of this last expedition, a dream-world unexpectedly collapsed. On his return to the Marind-anim in 1922 he discovered to his dismay that 'model kampongs' along colonial lines had taken the place of traditional settlements. His 'children of nature' were at school or in church. For Wirz, the transition to 'civilisation' was the beginning of a battle with the missionaries that could not be won. He wrote for help to the governing body of the Batavian Society, among others, in the hope that it would convince the government to intervene. However, the governing body concluded that 'the transition to Christianity gives new meaning to the lives of the Papua tribes and villages, and much of the old must irrevocably move aside. This should be seen as a healthy process of growth that cannot be checked without impeding the growth of the mission itself.' In short, Wirz had to save whatever he could on his own.

Consequently, apart from being scientifically motivated, his later trips to New Guinea were firmly focused on cultural conservation. He went about this in many ways (film, photography, sound recording and of course publication), but in particular by collecting ethnological objects. He was especially active in the Gulf of Papua, in the north-east of New Guinea. In doing so he increasingly had the feeling, certainly after the

Second World War, that he was in a race against time. In the opening sentences of a book on his stay in the Sepik region in the early 1950s, he writes:

In a few years, the age of collecting will also have passed by forever in the Sepik area. While before the outbreak of war with Japan, the Sepik culture appeared to be an inexhaustible source for the ethnographer, relations there are now profoundly altered. [...] Yes, it is high time that we collect what may still be collected, and – as long as it lasts – preserve the objects from total ruin.

Economic considerations were of the least importance in Wirz's collecting on New Guinea. At first he financed his expeditions by stopping over on other islands (for example on Bali and Nias) on his outward and return journeys, when carrying out collecting commissions. Only later, from around 1950, did the economic motive also play a role on New Guinea itself. In the Sepik region, for example, he consciously sought items that would fill gaps in museum collections. For the rest, Wirz carried out his largest collecting commissions in the mid-1930s; his trips to Africa, Sri Lanka (Ceylon) and India were made primarily for this reason.

Wirz donated the greater part of his New Guinea material to the present-day Museum of Cultures (Museum der Kulturen) in Basel, Switzerland (more than 2800 items); here the accent lay on objects he had collected during his pre-war trips. However, the Amsterdam KIT Tropenmuseum also received a large number of objects (more than 1200), particularly from north-eastern New Guinea. For a long time Wirz maintained a special relationship with both of these museums. Other European museums have generally acquired objects collected by Wirz, by purchasing them.

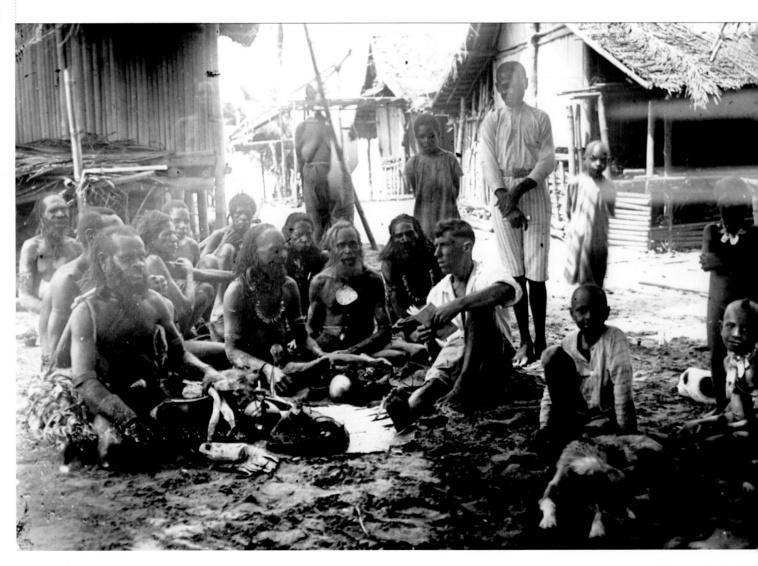

In this way the National Museum of Ethnology in Leiden obtained an interesting collection originating from the Gulf of Papua (RMV series 2403).

Beyond Europe, the National Museum in Jakarta holds Wirz's most important collection. It houses the items he obtained during the Central New Guinea Expedition of 1921, as well as a number of Marind-anim objects collected in 1922. The museum also possesses a valuable collection of objects originating from the north-west coast. While waiting to join the expedition to the central highlands, in early 1921, Wirz killed time by exploring the Geelvink and Humboldt Bay areas, including Lake Sentani. In doing so he collected ethnographic material on a large scale, which he later had to hand over to the Batavian Society. This was a consequence of a contract with the Dutch East Indies Committee for Scientific Research (Nederlandsch-Indisch Comité voor Natuurwetenschappelijke Onderzoekingen), which financed the expedition. On the basis of this contract, a collection Wirz had sent from the same area to the ethnological museum in Basel was reclaimed in 1924. The then director in Basel, the Sulawesi researcher, P. Sarasin, 'was kind enough to return the entire collection to the East Indies'. Wirz was himself able to process the material housed in Batavia. Early in 1923 he was given a temporary position at the museum with the task of compiling a *Beschrijvende catalogus van 's Genootschaps ethnographische collectie betreffende Nieuw Guinea (Descriptive catalogue of the Society's ethnographic collection concerning New Guinea)*. The publication appeared in July of the same year and contained descriptions of around 4500 items.

Wirz's last major journey to New-Guinea took place in the mid-1950s. He visited the Maprik region in present-day Papua New Guinea to acquire as many authentic items as possible. In 1955, just before he left the area, he died of a heart attack. He was buried in Wewak, in the province of East Sepik, and thus – as G.L. Tichelman would later aptly put it – was united in death with the land he loved.

P. Wirz
...
During his first visit to the Marind-anim
(1915 – 1918)

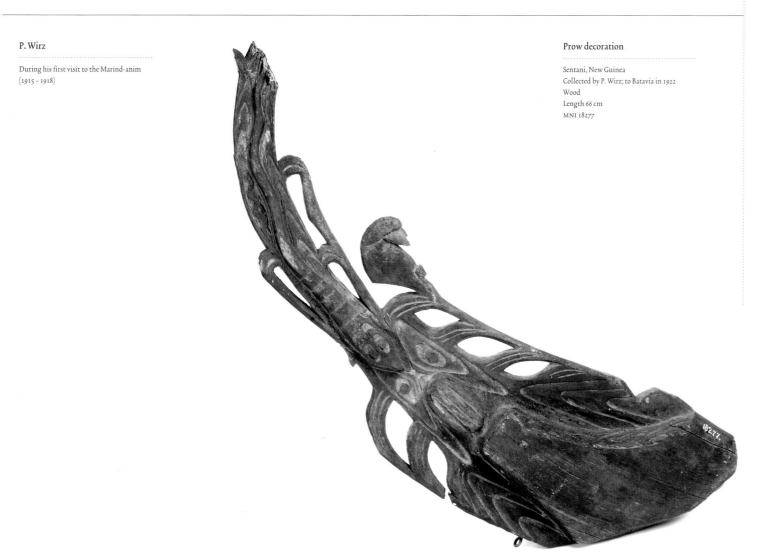

Prow decoration
...
Sentani, New Guinea
Collected by P. Wirz; to Batavia in 1922
Wood
Length 66 cm
MNI 18277

201

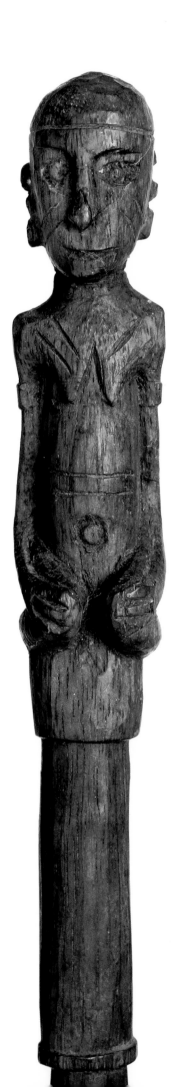

Ceremonial staff (detail)

Sentani, New Guinea
Collected by P. Wirz; to Batavia in 1922
Wood
Length 52 cm
MNI 18365

The Indonesian National Museum and the National Museum of Ethnology in Leiden together have the largest and the best collections of Indonesian artefacts in the world. The way, and the context, in which these collections were compiled, was the subject of this book. However, we should be clear that the search for a common history, and accounting for the differences, has only just began. We concentrated on collections divided between the two museums, but some were not broken up, and others were destined not for Batavia or Leiden, but for other Indonesian or Dutch museums. It would most certainly be very fruitful to extend to a national level the approach we advocate in this book, both on the Indonesian and Dutch side. We should, for example, further investigate the background of the collections of the Museum Sonobudoyo in Yogyakarta, or the Bali Museum in Denpasar. Other Dutch museums, not only ethnological ones, should also participate; one might even consider involving museums in other European countries, since the historical contexts of most European ethnological museums are similar. Dutch colonial officers also collected objects for Berlin, Vienna or Paris.

In this catalogue we have shown that it is worth researching the history of the collection of cultural heritage, since it helps us to understand historical processes. Often these processes reveal themselves to be more complex than anticipated. This type of work throws light on the complex history of contact between two, or more, cultures. It exposes the power relations involved, but also the appreciation for each other's cultural expressions. It illustrates how representatives of one culture saw 'the other', how perceptions of 'the other' were constructed, influencing actions, and how things can go amiss as a result. Indeed, ultimately, such work has a moral dimension. It is our conviction that scholarly, in this case historical, research, should never claim an independent, objective role in culture. Historical analysis is always influenced by value judgements: how 'the other' is perceived and judged.

However, an historical approach to museum collections also has its limitations. There is more at stake. The danger of focusing too much on historical research alone is that it might leads to an aloofness from current themes, that in turn comes close to the isolation of a scholar in his 'ivory tower'. Such distance serves no one's interests. History is interesting only in so far as it aids the understanding of the present. Museums such as the two main partners in the Shared Cultural Heritage project should not, therefore, concentrate only on the past. Museums have a responsibility to use the knowledge available to them in order to become active players in modern culture, nationally and internationally. In this respect, there is still much work to be done.

Endang Sri Hardiati & Pieter ter Keurs

Concluding Remarks

Endang Sri Hardiati
From the BatavianSociety to the Indonesian National Museum

Bernet Kempers, A.J, 'Bataviaasch Genootschap van 1778'. In: *Spiegel Historiael*, 14 (1979): 165-173.

Hamzuri (ed.), *Directory of Museum in Indonesia*. Department of Education and Culture, 1999.

Hardiati, Endang Sri, 'Precious collections of the National Museum Indonesia, introduction'. In: *Arts of Asia*, 33 (2003) 5.

Schefold, Reimar and Han F. Vermeulen (ed.), *Treasure hunting? Collectors and collections of Indonesian artefacts*. Leiden: University of Leiden/National Museum of Ethnology, 2002.

Sedyawati, Edi (ed.), *Treasures of National Museum, Jakarta*. Jakarta: Buku Antar Bangsa, 1997.

Pieter ter Keurs
The National Museum of Ethnology, Leiden

Dongen, P.L.F. van, M. Forrer and W.R. van Gulik (ed.), *Topstukken uit het Rijksmuseum voor Volkenkunde*. Leiden: National Museum of Etnology, 1987.

Effert, R., *Volkenkundig verzamelen. Het Koninklijk Kabinet van Zeldzaamheden en het Rijks Ethnographisch Museum, 1816 – 1883*. Leiden: PhD thesis, 2003.

Gerbrands, A.A., *Wow-Ipits. Eight Asmat woodcarvers of New Guinea*. The Hague/Paris: Mouton & Co., 1967.

Roux, C.C.F.M. le, *Overzicht van de geschiedenis van het Rijksmuseum voor Volkenkunde, 1837 – 1937*. Leiden: Sijthoff, 1937.

Wengen, G.W. van, *Wat is er te doen in volkenkunde? De bewogen geschiedenis van het Rijksmuseum voor Volkenkunde, Leiden*. Leiden: Natonal Museum of Ethnology, 2002.

Edi Sedyawati and Pieter ter Keurs
Scholarship, Curiosity and Politics

Bloembergen, M., *De koloniale vertoning. Nederland en Indië op de wereldtentoonstellingen (1880 – 1931)*. Amsterdam: Wereldbibliotheek, 2002.

Gerbrands, A.A., *Wow-Ipits. Eight Asmat woodcarvers of New Guinea*. The Hague/Paris: Mouton & Co., 1967.

Groot, J.P.M., *Van de Grote Rivier naar het Koningsplein. Het Bataviaasch Genootschap van Kunsten en Wetenschappen, 1778 – 1867*. Leiden: PhD thesis, 2006 (to appear).

Keurs, P.J. ter, 'Things of the past? Museums and ethnographic objects'. In: *Journal des Africanistes*, 69 (1999) 1: 67-80.

Müller, S., *Reizen en onderzoekingen in den Indischen archipel, gedaan op last der Nederlandsche Indische regering tusschen de jaren 1828 en 1836*. 2 vols. Amsterdam: Frederik Muller, 1857.

Rosenberg, C.B.H. von, *Der Malayische Archipel. Land und Leute*. Leipzig: Verlag Gustav Weigel, 1878.

Edi Sedyawati
The Sculpture of the Singasari Period

Dumarçay, Jacques, 'Stone architecture of East Java'. In: John Miksic, *Indonesian heritage*. Vol. 6: Architecture. Jakarta/Singapore: Archipelago Press, 1996: 68-69.

Pigeaud, Th.G.Th, *Java in the 14th century. A study in cultural history. The Nāgara-kertāgama by Rakawi Prapañca of Majapahit, 1365 ad*. Vol. 1. The Hague: Martinus Nijhoff, 1960: 26-33.

Sedyawati, Edi, *Ganesa statuary of the Kadiri and Singasari periods. A study of art history*. Leiden: KITLV Press, 1994: 204-205.

Sedyawati, Edi, 'Quantitative analysis on the problem of "local genius"'. In: Marijke J. Klokke and Karel R. van Kooij, *Fruits of inspiration. Studies in honour of prof. J.G. de Casparis*. Groningen: Egbert Forsten, 2001: 435-446.

Nandana Chutiwongs
Pieces of the Borobudur Puzzle Re-Examined

Bernet Kempers, A.J., *Ageless Borobudur*. Wassenaar: Servire, 1976.

Boeles, J.J., *The secret of Borobudur*. Bangkok: Boeles, 1985.

Bosch, F.D.K., 'Buddhist data from Balinese texts'. In: F.D.K. Bosch, *Selected studies in Indonesian archaeology*. The Hague: Martinus Nijhoff, 1961: 109-133.

Casparis, J.G. de, 'New evidence in cultural relations between Java and Ceylon in ancient times'. In: *Artibus Asiae*, 24 (1961): 241-248.

Casparis, J.G. de, 'The dual nature of Barabudur'. In: L.O. Gomez and H.W. Woodward jr. (ed.), *Barabudur. History and significance of a Buddhist monument*. Berkeley: University of California, 1981: 47-83.

Chandra, L., *A ninth century scroll of the Vajradhatu Mandala*. New Delhi: Jayyed Press, 1986.

Diskul, S. (ed.), *The art of Srivijaya*. Kuala Lumpur: Unesco, 1980.

Dumarcay, J., *Borobudur*. Kuala Lumpur: Oxford University Press, 1978.

Duuren, D. van, *De kris. Een aardse benadering van een kosmisch symbool*. Amsterdam: KIT/Tropenmuseum, 1996.

Fontein, J., *The pilgrimage of Sudhana*. The Hague/Paris: Mouton & Co., 1967.

Fontein, J., R. Soekmono and E. Sedyawati, *The sculpture of Indonesia*. Washington: National Gallery of Art, 1991.

Gomez, L.O. and H.W. Woodward jr. (ed.), *Barabudur. History and significance of a Buddhist monument*. Berkeley: University of California, 1981.

Kats, J., *Sang Hyang Kamahayanikan. Oud-Javaansche tekst met inleiding, vertaling en aantekeningen*. The Hague: Martinus Nijhoff, 1910.

Krom, N.J. and T. van Erp, *Beschrijving van Barabudur. Archeologisch onderzoek in Nederlandsch-Indie, III*. The Hague: Martinus Nijhoff, 1920.

Lohuizen-De Leeuw, J.E. van, 'The Dhyani-Buddhas of Barabudur'. In: *Bijdragen tot de Taal-, Land- en Volkenkunde*, 121 (1965): 389-416.

Mus, P., *Barabudur: esquisse d'une histoire du Bouddhisme fondée sur la critique archeologique des texts*. 2 vols. Hanoi: Imprimerie d'Extrème-Orient, 1935.

Scheltema, J.F., *Monumental Java*. London: Macmillan & Co., 1912.

Soekmono, R., *Chandi Borobudur. A monument of mankind*. Assen/Amsterdam: Van Gorcum, 1976.

Stutterheim, W.F., 'Chandi Borobudur, name, form and meaning'. In: W.F. Stutterheim, *Studies in Indonesian archaeology*. The Hague: Martinus Nijhoff, 1956: 1-62.

Endang Sri Hardiati
The Borobudur Temple as a Place of Pilrgrimage

Boechari et.al., 'Report on clay votive stupas from the Borobudur site'. In: *Pelita Borobudur Seri cc no. 8, Proyek Pemugaran Borobudur*, 1982: 115-118.

Guy, John, 'Offering up a rare jewel: buddhist merit-making and votive tablets in early Burma'. In: T. Richard Blurton and Alexandra Green (ed.), *Burma: art and archaeology*. London: British Museum Press, 2002: 23-33.

Santiko, Hariani, 'Some remarks on votive stupas and votive tablets from Borobudur'. In: *Majalah Arkeologi*, 1 (1977) 1: 68-76.

Pauline Lunsingh Scheurleer
The Discoveries from Muteran and Wonoboyo

Barret-Jones, Antoinette, *Early tenth century Java from the inscriptions. A study of economic, social and administrative conditions in the first quarter of the century*. Dordrecht/Cinnaminson: Foris Publications, 1984.

Béguin, Gilles, 'A propos d'une tiare d'officiant bouddhique'. In: *Le Revue du Louvre*, 1984, no. 3: 176-183.

Bernet Kempers, A.J., *Ancient Indonesian art*. Amsterdam: C.P.J. van der Peet, 1959.

Literature and Sources

Bernet Kempers, A.J., *Ageless Borobudur. Buddhist mystery in stone; decay and restauration, menut and pawon, folklore in ancient Java*. Wassenaar: Servire, 1976.

Bosch, F.D.K. and C.C.F.M. le Roux, 'Wat te Parijs verloren ging'. In: *Tijdschrift voor Indische Taal-, Land- en Volkenkunde*, 71 (1931): 663-683.

Bosch, F.D.K., 'The Oldjavanese bathing place Jalatunda'. In: F.D.K. Bosch, *Selected studies in Indonesian archaeology*. The Hague: Martinus Nijhoff, 1961: 47-108.

Casparis, J.G. de, 'Where was Pu Sindok's capital situated?'. In: H.I.R. Hinzler (ed.), *Studies in South- and Southeast Asian archaeology. Essays offered to dr. Soekmono*. Leiden: Kuntji Press, 1988: 39-52.

Casparis, J.G. de, 'The epigraphic legacy of king Sindok'. In: Marijke J. Klokke en Thomas de Bruijn (ed.), *Southeast Asian archaeology 1996. Proceedings of the 6th International Conference of the European Association of Southeast Asian Archaeologists, Leiden, 2-6 September 1996*. Hull: University of Hull, 1998: 163-174.

Christie, Jan Wisseman, *A preliminary survey of Early Javanese coinage held in Javanese collections*. Jakarta, 1995.

Damais, L.C., *Répertoire onomastique de l'épigraphie javanaise*. Paris: École Française d'Extrême-Orient, 1970.

Fontein, Jan, *The sculpture of Indonesia*. Washington/New York: National Gallery of Art/Harry Abrams, 1990.

Groeneveldt, W.P., *Catalogus der archeologische verzameling van het Bataviaasch Genootschap van Kunsten en Wetenschappen*. Batavia: Albrecht en Co., 1887.

Indonesian gold. Treasures from the National Museum, Jakarta. Queensland: Queensland Art Gallery, 1999.

Jaarboek van het Koninklijk Bataviaasch Genootschap van Kunsten en Wetenschappen. Vol. 10. Batavia, 1948 – 1951.

Jessup, H.I., *Court arts of Indonesia*. New York: The Asia Society/Harry Abrams, 1990.

Kartik, Kalpana, 'The gold treasure of Wonoboyo at the Jakarta National Museum'. In: *Arts of Asia*, 1995 (july-aug.): 96-102.

Kriss en sarong. Masculin et féminin dans l'archipel Indonesien. Nice:Musée des Arts Asiatiques, 2002.

Krom N.J., *Inleiding tot de Hindoe-Javaansche kunst*. Vol. 2. The Hague: Martinus Nijhoff, 1923 (2e revised edn.).

Les ors de l'archipel Indonésien. Paris: Musée National des Arts Asiatiques/Guimet, 1995.

Levin, Cecilia, 'Classical Javanese gold reflects some new light on the Ramayana'. In: W.H. Kal (ed.), *Precious metals in early South East Asia. Proceedings of the Second Seminar on Gold Studies*. Amsterdam: KIT, 1999: 39-44.

Loebèr, J.A., 'Antiquiteiten op Java'. In: *Nederlandsch-Indië, Oud en Nieuw*, 6 (1921) 8: 261-274.

Lohuizen, J.E. van, *Indo-Javanese metalwork*. Stuttgart: Linden-Museum, 1984.

Lunsingh Scheurleer, Pauline (ed.), *Asiatic art in the Rijksmuseum*. Amsterdam: Meulenhoff/Landshoff, 1985.

Lunsingh Scheurleer, Pauline, 'Gold Javanese jewellery'. In: *Arts of Asia*, 1994 (july-aug.): 44-54.

Lunsingh Scheurleer, Pauline, 'Meandering clouds for earrings. The stylistic approach to dating'. In: W.H. Kal (ed.), *Old Javanese gold (4th-15th century). An archaeometrical approach*. Amsterdam: KIT, 1994.

Lunsingh Scheurleer, Pauline en Marijke J. Klokke, *Divine bronze. Ancient Indonesian bronzes from AD 600 to 1600*. Amsterdam/Leiden: Rijksmuseum/E.J. Brill, 1988.

Mardiana, Intan, 'Ancient Javanese gold artefacts. Collection of the Jakarta National Museum'. In: *Arts of Asia*, 23 (2003) 5: 57-65.

Miksic, John, *Old Javanese gold*. Singapore: Ideation, 1990.

Moeller, Volker, *Javanische Bronzen*. Berlin: Staatlichen Museen Preussischer Kulturbesitz, 1985.

Molen, Willem van der, 'Rama and Sita in Wonoboyo'. In: *Bijdragen tot de Taal-, Land- en Volkenkunde*, 159 (2003) 2-3: 389-403.

Pott, P.H., 'On a silver figure of Bhatara Guru from Sumatra'. In: *Ethnologische Zeitschrift Zürich*, 1 (1972): 291-295.

Stutterheim, W.F., *Rama-legenden und Rama-reliefs in Indonesien*. Munich: Georg Müller Verlag, 1925.

Stutterheim, W.F., 'Een oudheden-collectie van Z.H. Mangkoenagoro vii te Soerakarta'. In: *Djawa*, 17 (1937) 1-2: 3-112.

Treasures of ancient Indonesian kingdoms. Tokyo: Tokyo National Museum, 1997.

Versunkene Königreiche Indonesiens. Mainz: Verlag Philip von Zabern, 1995.

Wahyono Martowikrido, 'The gold of Wonoboyo. Preliminary notes'. In: W.H. Kal (ed.), *Old Javanese gold (4th-15th century). An archaeometrical approach*. Amsterdam: KIT, 1994: 30-45.

Zandvliet, Kees, *De Nederlandse ontmoeting met Azië, 1600-1950*. Amsterdam/Zwolle: Rijksmuseum/Waanders, 2000.

Zoetmulder, P.J., *Kalangwan. A survey of old Javanese literature*. The Hague: Martinus Nijhoff, 1974.

Intan Mardiana Napitupulu

The Buddha Statues from Combre and Puger Wetan

Bernet Kempers, A.J., *Ancient Indonesian art*. Amsterdam: C.P.J. van der Peet, 1959.

Brandes, J.L.A. 'Oud Javaansche oorkonde'. Nagelaten transcripties van wijlen dr. J.L.A. Brandes, uitgegeven door dr. N.J. Krom. In: *Verhandelingen van het Bataviaasch Genootschap van Kunsten en Wetenschappen*, 60 (1913). 60 (1913).

Chutiwongs, Nandana, 'Some ancient Indonesian gold and silver

images and other objects in the National Museum of Ethnology, Leiden'. In: Marijke J. Klokke and Thomas de Bruijn (ed.), *Southeast Asian archaeology 1996. Proceedings of the 6th International Conference of the European Association of Southeast Asian Archaeologists, Leiden, 2-6 September 1996*. Hull: University of Hull, 1998: 218-226.

Haryono, Timbul, 'Analisis metalurgi: peranannya dalam eksplanasi arkeologi'. In: *Humaniora*, 13 (2001) 1. Magetsari, Noerhadi, Candi Borobudur. Rekonstruksi agama dan filsafat. Depok: fsui, 1997.

Moens, J.L., 'Het buddhisme op Java en Sumatra in zijn laatste bloeiperiode'. In: *Tijdschrift voor Indische Taal-, Land- en Volkenkunde*, 64 (1924): 521-579.

Napitupulu, Intan Mardiana, Teknik pembuatan artefak emas Jawa Kuna abad VIII - XV masehi. Depok: Program Pasca Sarjana UI, 1999.

Poerbatjaraka, R.M. Ng, *Tjerita pandji dalam perbandingan*. Jakarta: Gunung Agung, 1968.

Poerbatjaraka, R.M. Ng, 'Cerita panji dalam perbandingan, sebuah pembicaraan umum'. In: Achadiati Ichram (red.), *Bunga rampai bahasa, sastra dan budaya*. Jakarta: Intermasa, 1988: 209-244.

Raharjo, Supratikno, *Peradaban Jawa, dinamika pranata politik, agama, dan ekonomi Jawa Kuna*. Jakarta: Komunitas Bambu, 2002.

Santiko, Hariani, 'Mandala (kedewaguruan) pada masyarakat majapahit'. In: *pia*, 4 (1986) 2b: 149-169.

Sedyawati, Edi, *Pengarcaan ganesa masa Kadiri dan Singasari: sebuah tinjauan kesenian*. Jakarta/Leiden: efeo-lipi en Rijksuniversiteit Leiden, 1994.

Shadily, Hassan e.a., *Ensiklopedia Indonesia*, deel 5. Jakarta: P.T. Ichtiar Baru-Van Hoeve, 1984.

Zoetmulder, P.J., *Kalangwan, sastra Jawa kuno selayang pandang*. Jakarta: Penerbit Djambatan, 1985.

Harm Stevens

Collecting and 'The Rough Work of Subjugation'.

Archief Van Daalen, *Internationaal Instituut voor Sociale Geschiedenis*, Amsterdam.

Bouman, B., 'G.C.E. van Daalen (1863 – 1930)'. In: G. Teitler en W. Klinkert (ed.), *Kopstukken uit de krijgsmacht. Nederlandse vlag- en opperofficieren, 1815 – 1955*. Amsterdam: De Bataafsche Leeuw, 1997: 161-182.

Fischer, H.W., *Catalogus van 's Rijks Ethnografisch Museum. Deel 6: Atjèh, Gajo- en Alaslanden (Sumatra I)*. Leiden: E.J. Brill, 1912.

Gobée, E. and C. Adriaanse (ed.), *Ambtelijke adviezen van C. Snouck Hurgronje, 1889 – 1936*. Vol. 1. The Hague: Martinus Nijhoff, 1957.

Groeneveld, Anneke, 'Excursie naar de Gajo- en Alaslanden, 1904'. Een visueel-antropologische analyse van de foto's van legerarts H.M. Neeb. Waddinxveen 2001 (unpublished Master's thesis).

Kempees, J.C.J., *De tocht van overste Van Daalen door de Gajo-, Alas- en Bataklanden, 8 february to 23 july 1904*. Amsterdam: Dalmeijer, 1905.

Notulen van de algemeene en directievergaderingen van het Bataviaasch Genootschap van Kunsten en Wetenschappen, 1904 (Vol. 42). Batavia: Lange & Co., 1905.

Veer, Paul van 't, *De Atjeh-oorlog*. Amsterdam: Arbeiderspers, 1969.

Pieter ter Keurs

Collecting in Central and South Sumatra

Brink, P.P.W.J. van den and P. Moree (ed.), *Met kapmes en kompas. Vier eeuwen Nederlandse ontdekkingen en reisverslagen*. The Hague: Koninklijke Bibliotheek, 1996.

Fischer, H.W., *Catalogus van 's Rijks Ethnographisch Museum*. Vol. 12: Zuid-Sumatra. Leiden: E.J. Brill, 1918.

Korn, V.E., 'Oscar Louis Helfrich'. In: *Jaarboek van de Maatschappij der Nederlandse Letterkunde te Leiden, 1958 – 1959*. Leiden, 1960: 72-77.

Veth, P.J. (ed.), *Midden-Sumatra. Reizen en onderzoekingen der Sumatra-Expeditie, uitgerust door het Aardrijkskundig Genootschap*. 4 vols. Leiden: E.J. Brill, 1882.

Voorhoeve, P., 'In memoriam O.L. Helfrich (1860 – 1958)'. In: *Bijdragen tot de Taal-, Land- en Volkenkunde*, 114 (1958) 3: 249-253.

Wentholt, A. (ed.), *In kaart gebracht met kapmes en kompas: met het Koninklijk Nederlands Aardrijkskundig Genootschap op expeditie tussen 1873 en 1960*. Heerlen/Utrecht: Abp/Knag, 2003.

Irwan Zulkarnain

Kalimantan and the Expeditions of Nieuwenhuis and Van Walchren

Avé, J.B. and V.T. King, *Borneo, the people of the weeping forest. Tradition and change in Borneo*. Leiden: National Museum of Ethnology, 1986.

Ihromi, T.O., *Beberapa pokok antropologi sosial*. Jakarta: Dian Rakyat, 1992.

King, Victor T., *The peoples of South-East Asia and the Pacific. The peoples of Borneo*. Oxford: Blackwell Publishers, 1993.

Low, Hugh, *Sarawak, notes during a residence in that country with H.H. the Rajah Brooke*. London: Richard Bently, 1848.

MacKinnon, Kathy, *Ekologi Kalimantan*. Jakarta: Prenhallindo, 2000.

Nieuwenhuis, Anton W., *Di Pedalaman Borneo: Perjalanan dari Pontianak ke Samarinda, 1894*. Jakarta: Gramedia, 1994.

Schefold, Reimar and Han F. Vermeulen (ed.), *Treasure hunting? Collectors and collections of Indonesian artefacts*. Leiden: National Museum of Ethnology, 2002.

Sellato, Bernard, *Naga dan burung enggang*. Jakarta: Elf Aquitaine Indonésie, 1989.

Vredenbregt, J., *Hampatong. Kebudayaan material suku Dayak di Kalimantan/The material culture of the Dayak of Kalimantan*. Jakarta: Gramedia, 1981.

Francine Brinkgreve and Itie van Hout

Java: Gifts, Scholarship and Colonial Rule

Brakel, Clara, 'Javaanse maskerdansen en het Panji-thema. Een probleem belicht vanuit de theaterpraktijk in Javaanse dorpen'. In: *Scenarium*, 9 (1985): 56-72.

Buur, D., *Inventaris collectie G.P. Rouffaer*. Leiden: KITLV, 1990.

Chijs, J.A. van der, *Catalogus der Ethnologische Afdeeling van het museum van het Bataviaasch Genootschap van Kunsten en Wetenschappen*. Batavia: Lange en Co., 1877 (2e edn.), 1880 (3e edn.), 1885 (4e edn.).

Clara van Groenendael, Victoria, *Wayang theatre in Indonesia; an annotated bibliography*. Dordrecht: Foris Publications, 1987.

Grever, M. and B. Waaldijk, *Feministische dilemma's. De Nationale Tentoonstelling van Vrouwenarbeid in 1898*. Amsterdam: IISG/IIAV, 1998.

Jacobson, Edw. and J.H. van Hasselt, *Gong-fabricatie te Semarang*. Leiden: E.J. Brill, 1907.

Jasper, J.E., 'Inlandsche kleurmethoden'. In: *Tijdschrift voor het Binnenlandsch Bestuur*, 22 (1902): 345-358.

Jasper, J.E., *Verslag van de eerste tentoonstelling-jaarmarkt te Soerabaja*. Batavia: Landsdrukkerij, 1906.

Jasper, J.E., 'Een Javaansche schilder-teekenaar'. In: *Het Koloniaal Weekblad*, 6-1-1910: 2-3.

Jasper, J.E. and Mas Pirngadie, *De Inlandsche kunstnijverheid in Nederlandsch Indië*. Deel I, *Het vlechtwerk*. The Hague: Mouton, 1912.

Jessup, Helen Ibbitson, *Court arts of Indonesia*. New York: The Asia Society Galleries, 1990.

Juynboll, H.H., *Catalogus van 's Rijks Ethnografisch Museum*. Delen 9, 11, 13 en 15. Leiden: E.J. Brill.

Kate, H. ten, *Lindor Serrurier herdacht*. Tokyo, 1902.

Krom, N.J., 'Herdenking van dr. G.P. Rouffaer'. In: *Bijdragen tot de Taal-, Land- en Volkenkunde van Nederlandsch-Indië*, 84 (1928).

Legêne, S. and B. Waaldijk, 'Reverse images – patterns of absence'. In: I. van Hout (ed.), *Batik – drawn in wax*. Amsterdam: KIT Publishers, 2001.

Levyssohn Norman, E.D., *Katalogus der Ethnologische Afdeeling van het museum van het Bataviaasch Genootschap van Kunsten en Wetenschappen*. Batavia: Lange en Co., 1868.

Notulen van de Algemeene en Bestuursvergaderingen van het Bataviaasch Genootschap van Kunsten en Wetenschappen. Batavia: Lange en Co.

Rouffaer, G.P., 'Opschrijfboekje eerste reis'. KITLV, archiefno. H722.

Rouffaer, G.P. and H.H. Juynboll, *De batikkunst in Nederlandsch-Indië en haar geschiedenis*. 2 vols. Haarlem, 1900 – 1914.

Rouffaer, G.P., 'De noodzakelijkheid van een technisch-artistiek onderzoek in Nederlandsch-Indië'. In: *De Indische Gids*, october 1901.

Rouffaer, G.P., *Tentoonstelling van Oost-Indische weefsels en batik*. Den Haag, 1902.

Rouffaer, G.P., 'Nieuwe wegen voor Indische volkenkunde'. In: *De Gids*, februari 1904.

Rouffaer, G.P., 'Beeldende kunst in Nederlandsch-Indië'. In: *Bijdragen tot de Taal-, Land- en Volkenkunde van Nederlandsch-Indië*, 89 (1932).

Schmeltz, J.D.E., 'Indonesische Prunkwaffen'. In: *Internationales Archiv fur Ethnographie*, 3 (1890): 85-118.

Serrurier, L., *Wajang poerwa: eene ethnologische studie*. Leiden: E.J. Brill, 1896.

Wronska-Friend, M., 'Javanese batik for European artists'. In: I. van Hout (red.), *Batik – drawn in wax*. Amsterdam: KIT Publishers, 2001.

Francine Brinkgreve

Balinese Chiefs and Dutch Dominion. Building a Collection and Politics

Anoniem, 'De excursie naar Bali'. In: *De Locomotief*, 9 and 11 May 1908: 1-2.

Anoniem, Beschrijving van eenige tijdens de Zuid-Bali Expeditie (1906 - 1908) buitgemaakte vorstelijke poesaka-wapens. Z.j.

Juynboll, H.H., *Catalogus van 's Rijks Ethnografisch Museum*. Deel 7, Bali en Lombok. Leiden: E.J. Brill.

Nieuwenkamp, W.O.J., *Bali en Lombok*. Edam: De Zwerver, 1906 - 1910.

Nieuwenkamp, W.O.J., *Leven en werken, bouwen en zwerven van de kunstenaar W.O.J. Nieuwenkamp*. Utrecht: Bruna, 1979.

Notulen van de Algemeene en Bestuursvergaderingen van het Bataviaasch Genootschap van Kunsten en wetenschappen. Batavia: Lange en Co.

Pringle, Robert, *A short history of Bali, Indonesia's hindu realm*. Crows Nest, NSW: Allen & Unwin, 2004.

Resink, Th.A., *De kunst van Bali; verleden en heden*. The Hague: Haags Gemeentemuseum, 1961.

Schwartz, H.J.E.F., *Gids voor den bezoeker van de ethnographische verzameling. Zaal B, Bali en Lombok*. Batavia: Ruygrok & Co., 1920.

Stutterheim, W.F., 'De oudheden-collectie Resink-Wilkens te Jogyakarta'. In: *Djawa*, 14 (1934): 167-197.

Wassing-Visser, Rita, *Koninklijke geschenken uit Indonesië. Historische banden met het Huis Oranje-Nassau (1600 - 1938)*. Zwolle: Waanders, 1995.

Weede, H.M. van, *Indische reiseherinneringen*. Haarlem: Tjeenk Willink, 1908.

Wiener, Margaret J., 'Object lessons: Dutch colonialism and the looting of Bali'. In: *History and Anthropology*, 1994: 347-370.

Wiener, Margaret J., *Visible and invisible realms. Power, magic and colonial conquest in Bali*. Chicago: The University of Chicago Press, 1995.

Wahyu Ernawati
The Lombok Treasure

Anak Agung Gde Ketut Agung, *Kupu-kupu kuning yang terbang di Selat Lombok. Lintasan sejarah Kerajaan Karangasem (1661 – 1950).* Denpasar: Upada Sastra, 1991.

Departemen Pendidikan dan Kebudayaan, *Sejarah daerah nusa tenggara barat.* Jakarta: Pusat Penelitian Sejarah dan Budaya, Proyek Penelitian dan Pencatatan Kebudayaan Daerah, 1977/1978.

Departemen Pendidikan dan Kebudayaan, *Peninggalan sejarah dan kepurbakalaan.* Jakarta: Proyek Pembinaan Permuseuman Nusa Tenggara Barat, 1977/1978.

Departemen Pendidikan dan Kebudayaan, *Babad selaparang.* Jakarta: Proyek Pengembangan Permuseuman Daerah Nusa Tenggara Barat, 1979.

Departemen Pendidikan dan Kebudayaan, *Peninggalan sejarah dan kepurbakalaan.* Jakarta: Proyek Pembinaan Permuseuman Nusa Tenggara Barat, 2001.

Kessler, Cristina, *Lombok diseberang Bali.* Jakarta: Indira, 1985.

Lalu Djelenga, H., *Keris di Lombok.* Mataram: Yayasan Pusaka Selaparang, 2000.

Melalatoa, M. Junus, *Ensiklopedi suku bangsa di Indonesia.* Vol. L-Z. Jakarta: Departemen Pendidikan Nasional, 1994.

Pott, Peter H. and M. Amir Sutaarga, 'Arrangements concluded or in progress for the return of objects: the Nederlands-Indonesia'. In: Unesco Museum International, 31 (1979): 38-42.

Vanvugt, Ewald, *De schatten van Lombok. Honderd jaar Nederlandse oorlogsbuit uit Indonesië.* Amsterdam: Jan Mets, 1995.

Zakaria, Fath, *Mozaik Budaya Orang Mataram.* Mataram: Yayasan Sumurmas Al Hamidy, 1998.

Hari Budiarti
The Sulawesi Collections. Missionaries, Chiefs and Military Expeditions

Abduh, Muhammad et.al., *Perlawanan terhadap imperialisme dan kolonialisme di Sulawesi Selatan.* Jakarta: Direktorat Sejarah Nilai dan Tradisional, Departemen p dan k, 1985.

Adriani, N. and A.C. Kruyt, *De Bare'e-sprekende Toraja's van Midden-Celebes.* 3 vols. Batavia: Landsdrukkerij, 1912 – 1914.

Aragon, L.V., 'Sulawesi'. In: P.M. Taylor and L.V. Aragon (ed.), *Beyond the Java Sea: art of Indonesia's outer islands.* Washington DC/New York: Smithsonian Institution and Harry N. Abrams, 1991: 172-201.

Bezemer, T.J., *Encyclopaedie van Nederlandsch-Indie*, vol III. The Hague: Martinus Nijhoff, 1921.

Bigalke, Terence W., *A social history of 'Tana Toraja', 1870 – 1965.* Madison: University of Wisconsin, 1986.

Kaudern, Walter, *Anthropological notes from Celebes.* Göteborg: Elanders Boktryckeri Aktiebolag, 1937.

Kaudern, Walter, *Ethnographical studies in Celebes. Results of the author's expedition to Celebes 1917 – 1920. Vol VI: art in Central Celebes.* Gothenborg: Elanders Boktryckeri Aktiebolag, 1944.

Keurs, P. ter and L. Ouwehand, 'Indonesian bark cloth in the collection of the Rijksmuseum voor Volkenkunde'. Unpublished paper, Leiden, z.j.

Koentjaraningrat, R.M., *Metode-metode antropologi dalam penyelidikanpenyelidikan masyarakat dan kebudayaan di Indonesia.* Jakarta: ui, 1961.

Kooijman, S., 'Ornamented bark-cloth in Indonesia'. In: *Mededelingen van het Rijksmuseum voor Volkenkunde*, 16 (1963).

Kotilainen, Eija-Maija, *When the bones are left: a study of the material culture of Central Sulawesi.* Helsinki: The Finnish Anthropological Society,1992.

Kruyt, A.C., *De West-Toraja's op Midden Celebes.* 4 vols. Amsterdam, 1938.

Kruyt, A.C., *Keluar dari agama suku masuk ke agama Kristen.* Jakarta: Bpk Gunung Mulia, 1976.

Lukman, Najamuddin, *Dari animisme ke monoteisme: Kristenisasi di Poso, 1892 – 1942.* Yogyakarta: Pps Ugm, 2000.

Mattulada, A., *Latoa: satu lukisan analitis terhadap antropologi politik Orang Bugis.* Jakarta: Ui, 1975.

Nooy-Palm, Hetty, *The Sa'dan Toraja: a study of their social life and religion.* Vol. I. The Hague: Martinus Nijhoff, 1979.

Poesponegoro, M.D. and N. Notosusanto, *Sejarah nasional Indonesia*, Vols. III en IV. Jakarta: PN Balai Pustaka, 1984.

Rahim, Rahman, *Nilai-nilai utama Kebudayaan Bugis.* Ujung Pandang: Hasanuddin University Press, 1992.

Sagimun, M.D., *Pahlawan nasional Sultan Hasanudin: ayam jantan dari ufuk timur.* Jakarta: Balai Pustaka, 1992.

Schefold, Reimar and Han F. Vermeulen (ed.), *Treasure hunting? Collectors and collections of Indonesian artefacts.* Leiden: National Museum of Ethnology, 2002.

Schrauwers, Albert, *Colonial 'reformation' in the highlands of Central Sulawesi. Sulawesi, Indonesia, 1892 – 1995.* Toronto: University of Toronto Press, 1999.

Sophiaan, Mania, *Perang Gowa terakhir.* Jakarta: Yayasan Mencerdaskan Kehidupan Bangsa, 1995.

Veen, H.V.D., 'In memoriam Dr. Alb. C. Kruyt: 10 Oct 1869-19 Jan 1949'. In: *Tijdschrift voor Indische Taal-, Land- en Volkenkunde*, 83 (1949) I: I-VIII.

Archival sources
Inventaris van de rijksornamenten van Bone. Museum van het Koninklijk Bataviaasch Genootschap van Kunsten en Wetenschappen, 1931.

Notulen van de Algemeene en Bestuursvergaderingen van het Bataviaasch Genootschap van Kunsten en Wetenschappen, 5 February 1900, no. VI.

Notulen van de Algemeene en Bestuursvergaderingen van het Bataviaasch Genootschap van Kunsten en Wetenschappen, July 1905, no. VII.

Notulen van de Algemeene en Bestuursvergaderingen van het Bataviaasch Genootschap van Kunsten en Wetenschappen, 1906.

Verklaring van de Zelfbestuurder van Gowa, 2 January 1938.

Nico de Jonge
Collectors on Distant Islands

Riedel
A.G., 'In memoriam dr. J.G.F. Riedel'. In: *Weekblad voor Indië*, 8 (1911 – 1912) 41: 963-964.

Heeren-Palm, C.H.M., 'De Minahassische priesterstaf'. In: *Tijdschrift voor Indische Taal-, Land- en Volkenkunde*, 85 (1952): 310-321.

Riedel, J.G.F., *De sluik- en kroesharige rassen tusschen Selebes en Papoea.* Den Haag: Martinus Nijhoff, 1886.

Van Hoëvell
Bruyn Kops, G.F. de, 'Levensbericht van G.W.W.C. van Hoëvell'. In: *Handelingen van de Maatschappij der Nederlandsche Letterkunde te Leiden en levensberichten harer afgestorven medeleden, 1921 – 1922.* Leiden, 1922: 101-109.

Hoëvell, G.W.W.C. baron van, 'De Kei-eilanden'. In: *Tijdschrift voor Indische Taal-, Land- en Volkenkunde*, 33 (1890): 102-159.

Hoëvell, G.W.W.C. baron van, 'Einige weitere Notizen über die Formen der Götterverehrung auf den Süd-Wester und Süd-Oster Inseln'. In: *Internationales Archiv für Ethnographie*, 8 (1895): 133-137.

Vroklage
Meurkens, P., *Vragen omtrent de mensheid. Culturele antropologie in Nijmegen (1948 – 1998).* Aalten: Fagus, 1998.

Vroklage, B.A.G., *Die sozialen Verhältnisse Indonesiens: Eine kulturgeschichtliche Untersuchung. Band I: Borneo, Celebes und Molukken.* Münster: Aschendorffsche Verlagsbuchhandlung, 1936.

Vroklage, B.A.G., *Ethnographie der Belu in Zentral-Timor.* Leiden: E.J. Brill, 1952 – 1953.

Middelkoop
Middelkoop, P., *Een studie van het Timoreesche doodenritueel.* Verhandelingen van het Koninklijk Bataviaasch Genootschap van Kunsten en Wetenschappen, 76. Bandoeng: A.C. Nix & Co., 1949.

Middelkoop, P., *Curse, retribution, enmity as data in natural religion, especially in Timor, confronted with the scripture.* Amsterdam: Jacob van Campen, 1960.

Middelkoop, P., *Head hunting in Timor and its historical implications.* Sydney: University of Sydney, 1963.

Militaire exploratie Nieuw-Guinea
Anonymus, *Verslag van de militaire exploratie van Nederlandsch-Nieuw-Guinee 1907 – 1915.* Weltevreden: Landsdrukkerij, 1920.

Feuilletau de Bruyn, W.K.H., *Schouten- en Padaido-eilanden.* Mededeelingen van het Bureau voor de bestuurszaken der buitengewesten, 21. Batavia: Javasche Boekhandel & Drukkerij, 1920.

Lamme, A., *Van pioniers en koppensnellers. De militaire exploratie van de Zuidkust van Nieuw-Guinea, 1907 – 1908.* Arnhem, 1987.

Van der Sande
Limburg, S. van, G.A.J. van der Sande; *Een case-study over een verzamelaar aan het begin van de twintigste eeuw.* Leiden, 1993.

Lorentz, H.A., *Eenige maanden onder de Papoea's.* Leiden: E.J. Brill, 1905.

Sande, G.A.J. van der, *Ethnography and anthropology. Vol. III, Nova Guinea.* Leiden: E.J. Brill, 1907.

Wirz
Schmidt, A.E., *Paul Wirz. Ein Wanderer auf der Suche nach der 'wahren Natur'.* Basel: Ethnologisches Seminar der Universität und Museum der Kulturen, 1998.

Tichelman, G.L., 'In memoriam dr. Paul Wirz'. In: *Nieuw-Guinea*, 15 (1954 – 1955) 1-6: 161-163.

Wirz, P., *Wildnis und Freiheit. Aus dem Tagebuch eines Weltvaganten.* Stuttgart, 1933.

Wirz, P., *Kunst und Kult des Sepik-Gebietes (Neu-Guinea).* Amsterdam: Koninklijk Instituut voor de Tropen, 1959.

Organisation The Nieuwe Kerk, Amsterdam

Director
 Ernst W. Veen

Exhibitions
 Marlies Kleiterp (head)
 Vincent Boele

Communication, education and marketing
 Frans van der Avert (head)
 Paulanha van den Berg-Diamant
 Heleen van Ketwich Verschuur
 Huibje Laumen
 Sylvie Schärlig
 Noepy Testa
 Wieke van Veggel
 Julie Vegter
 Anna van Lingen (stagiaire)
 Geraldine Sleijpen (stagiaire)

Business management
 Cathelijne Broers (head)
 Paul Brekelmans
 Margreet van 't Hoff
 Roelof van der Kooi
 Marianne de Molennaar
 Nasar Ahmed Qazi
 Ad Schmitt
 Peter Sombogaart
 Carla Spaansen
 Krijn van Veggel

Directional Support
 Martijn van Seventer
 Else Valk

Museum Shop
 Heleen van Ketwich Verschuur (manager)
 Viviën Entius
 Mascha van der Kroon
 Simone Schaeffer

Organisation National Museum of Ethnology, Leiden

Director
 Steven Engelsman

Project Group
 Pieter ter Keurs
 Francine Brinkgreve
 Nico de Jonge
 Graeme Scott
 Birgit Maas
 Margit Reuss
 Farideh Fekrsanati
 Agniet van de Sande
 Geke Vinke
 Annemarie Woerlee

With thanks to
 Monique Koek
 Ester de Bruin
 Dorus Kop Jansen
 Nel van Hove
 David Stuart Fox

Organisation Museum Nasional, Jakarta

Director
 Intan Mardiana Napitupulu

Project Group
 Hari Budiarti
 Wahyu Ernawati
 Irwan Zulkarnain
 Diani Purwandari
 Sumardjo
 Widodo

With thanks to
 Staff of the National Museum
 Wawan Yogaswara
 Haryanti
 Nusi Lisabila E.
 Ita Yulita
 Sutrisno
 Pauline Suitela
 Syafei
 Tarmini
 Mustar
 Muhyoko
 Vivi
 Collaborators of the National Museum

Translations
 Enid Perlin is responsible for the English translation of the texts and
 captions accompanying the exhibition.

Exhibition Acknowledgements

Concept and Coordination
André Cremer
UNA (Amsterdam) designers
Heleen van Ketwich Verschuur
Projects Foundation De Nieuwe Kerk, Amsterdam
Pieter ter Keurs
National Museum of Ethnology, Leiden
Frank Vermeer
KIT Publishers, Amsterdam

Academic editors
Endang Sri Hardiati
Pieter ter Keurs

Authors
Endang Sri Hardiati
Former Director of the National Museum, Jakarta
Edi Sedyawati
Emeritas Professor of the Indonesian University (Universitas Indonesia), Jakarta
Pieter ter Keurs
National Museum of Ethnology, Leiden
Nandana Chutiwongs
National Museum of Ethnology, Leiden
Pauline Lunsingh Scheurleer
University of Amsterdam, Department of Asian Art
Intan Mardiana Napitupulu
Director of the National Museum, Jakarta
Harm Stevens
Army Museum, Delft
Irwan Zulkarnain
National Museum, Jakarta
Francine Brinkgreve
National Museum of Ethnology, Leiden
Itie van Hout
KIT Tropical Museum, Amsterdam
Wahyu Ernawati
National Museum, Jakarta
Hari Budiarti
National Museum, Jakarta
Nico de Jonge
University Museum, Groningen
National Museum of Ethnology, Leiden

Text organisation
Hansje Galesloot

Translations
Enid Perlin is responsible for the translation of the English-language volume, excepting the article by Nico de Jonge, translated by Michael Blass, and three texts supplied in English and edited by Stephen Green (the first of E. Hardiati's two articles; that by W. Ernawati; and the conclusion by E.S. Hardiati and P. ter Keurs). Enid Perlin is also responsible for the coordination of the translations and other English texts making up the volume.
Dr. Mariah Waworuntu
Dra. Sri Soeyatmi Satari
Drs. Hubertus Sadirin
Ibu Eveline Adhiyasa
Ibu Totok Tazir
Ibu Hertini Adiwoso
Ibu Hetty Badrun
Lena Julien
Joice Holmes Richardson
Dr. Krista Knirck-Bumke
Debbie Larssen
Peggy Ball
Belen Ponferada
Jacklyn Fam
Bruce van Rijk

Photography
Ben Grishaaver

Graphical conception
André Cremer
UNA (Amsterdam) designers

Production
Meester & De Jonge, Lochem

With thanks to
C. Brakel
B.Th. Ligthart
Mrs. C. Middelkoop-Koning
Th. Resink
P. Terwen
H.F. Vermeulen
Monique Koek

This catalogue has been published on the occasion of the exhibition, Indonesia: the Discovery of the Past, held at the National Museum in Jakarta (15th August 2005 - 13th November 2005) and in The Nieuwe Kerk (The New Church) in Amsterdam from 15th December 2005 to 17th April 2006. It has been organised by the National Museum of Ethnology in Leiden, the National Museum in Jakarta, and Stichting Projecten (Projects Foundation) of De Nieuwe Kerk in Amsterdam., together with the bibliography (list of Literature).

ISBN

NL edition	90 6832 497 7
IND edition	90 6832 493 4
ENG edition	90 6832 494 2

NUR 640, 644

Publishers
KIT Publishers, Amsterdam

Information concerning
KIT Publishers, Amsterdam
www.kit.nl/publishers
www.hotei-publishing.com
Museum Nasional, Jakarta
www.museumnasional.org
National Museum of Ethnology, Leiden
www.rmv.nl
De Nieuwe Kerk (The New Church), Amsterdam
www.nieuwekerk.nl

Catalogue Acknowledgements